I HAD NOWHERE TO GO

by Jonas Mekas

W0006107

Spector
Books

CONTENTS

Author with father, 1928, age 6

W hen I left my home, when I left my small village
(when I was twelve I made a list of all the people
in my village and I came up with—if I remember it
right—22 families and 98 heads); when I left on a trip that
eventually landed me in New York, I was 22 years old.
I was a young man of some reputation. For over a year I
had worked as editor-in-chief of a provincial weekly
paper. I had worked as the technical editor of a national
semi-literary weekly for another year. I had published
my first poems and had created a scandal in the literary
"world" of Lithuania with what I would now call vicious
and foolish attacks on some of the writers and poets of
the generation that preceded me.

So that I was, obviously, quite involved in the life
around me.

But I had this strange thing in me: I was totally oblivious of my own life, my own past, my roots, ancestors. I
had a total disinterest in life, in my immediate surroundings. For instance, I have no memory of what we ate
until I was twenty. All I remember is that my mother
used to constantly urge me: "Eat, eat, put that book
away. Always with your nose in the book. You never eat
anything." When someone asks me, today, what do Lithuanians eat, I answer: "I don't know."

By the time I was seventeen I had read probably
everything that there ever was written in Lithuanian,
including all the past volumes of magazines and newspapers. I had read them all and memorized them all. So
much that some of my older literary friends from the
capital, when they couldn't remember where this or that
item had appeared in print, they used to say, "Ah, but
there is this kid in that village there, why don't you
ask him, he'll tell you." And I always knew it. But I didn't
know who my nieces or cousins or aunts were or any

other relative of any kind. My ancestors were all the living and dead poets, philosophers, encyclopedists.

I know nothing about my father's early life. Or that of my mother's. I never asked them about it. I know only a few very general facts. I have never seen my grandfather. I presume he was a farmer. He died before I became aware of him. My grandmother lived a long life, she was over 90 when she died (I was about ten). I remember liking her very much. One time when I was five or so and we were visiting her with my mother—she lived in another village, about five miles away—we walked on foot—I insisted that I would stay with her for a week, I climbed up on the oven, one of those huge clay ovens used for baking of bread and which during the cold winter months are used to sleep on—that's where my grandmother slept. But when I heard my mother leave I suddenly panicked and started howling. My mother came back and took me with her. We walked home. Every now and then I lagged behind her, stopping to listen to the singing of the wooden telephone poles.

My grandfather (my father's father): I do remember some of my mother's remarks about him. He used to sit day after day by the roadside, by the entrance into our house, and throw little jokes at the passers-by, little jibes, insults. But they never picked a fight with him no matter what he said. I got the impression he was missing a few screws. There was another crazy member in the family tree—actually, there were two. Maybe they were cousins, I don't know. One, I think his name was Jonas, while mowing grass one day by the swamp, began to talk gibberish. So they took him to the nuthouse. Another one, also named Jonas, kept talking gibberish all his life, but they kept him around. For years I was obsessed with the thought that some day I may myself end up deranged because I had read in some book that those things can be

hereditary. I was almost disappointed when I reached thirty and was still in comparatively one piece. I guess my mother's tree won over that of my father's. There was never talk about any crazies on my mother's side.

The family name, Mekas, can be found in old, 14th century Lithuanian records. The name appears in political records. Whenever some Lithuanian poet or playwright writes a piece with historical background, one of the characters usually is called Mekas. No real important historical figure is known by that name. The name is there, however, and it belongs to some nondescript personage so that one can project into that name whatever one wants. *Tabula rasa*, so to speak. I was surprised to see our name used even in a contemporary play, written a few years ago in the Soviet, "socialist" Lithuania, one protagonist was called Mekas. Flatteringly enough he represented an idealist.

Anyway, it would seem that the name Mekas is an old Lithuanian family name. Why there are so few families carrying that name today, in Lithuania, is a little mystery.

But then there was always a rumor going, promoted with great enthusiasm by my brother Adolfas, that we are really of Irish origin. The matter, however, got somewhat complicated in 1962 when two old sad Jews appeared at our 515 East 13th Street door, late at night, maybe three in the morning. They announced that their names were Mekas, and they had just come by plane from Buenos Aires because they had heard that Jonas Mekas lived in New York. Their little boy Jonas got lost in Vilnius, Lithuania, in 1943 during the German liquidation of Jews. They stood there in the doorway and they looked at us and we looked at them, and they cried, and we cried, because they realized I wasn't the son they were hoping-for. It was really very heartbreaking. So we gave them our

3

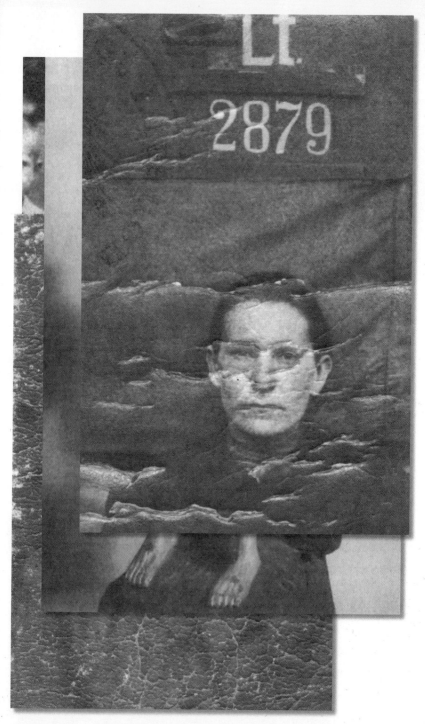

Elžbieta Mekas, my mother, in a passport picture taken c. 1917

beds, and we fed them and showed them New York for 24 hours, and then we put them on the plane. It was one of the saddest stories of our New York life. They run a bookshop in Buenos Aires.

Anyway, there are Jews, and Lithuanians, and Greeks, and Irishmen (so I am told), and Hungarians who carry the name of Mekas. When I revisited Lithuania, in 1971, my uncle Povilas Jašinskas promised to produce our family tree. He put some five years of work into this project, but he died before he could finish it. He was a Protestant pastor and still had some records available, the Church records, to check the names and dates. But most of them have been destroyed or carted away to unknown destinations for unknown purposes by the industrious Soviets. So that I don't know if that tree was ever finished. There may have been a wisdom behind my uncle's not being in a hurry to finish it. Having your family tree on the paper, in the Soviet Union, you are running a risk. When they get mad there, they uproot the entire tree, from the roots...

Our religion, for several centuries, since the days of Janušas Radvilas (or as he is known in Poland, Janusz Radziwil) (1612–1655) has been Reformed Protestant (Jan Hus, Zwingli). Until the times of Jogaila (a.k.a. Jagiello), which practically means 15th century, Lithuanians were pantheists. Their gods were the trees, sun, moon, earth. Jogaila christianized or rather catholicized Lithuania, at least formally so. All for a woman—which is to his credit; for Jadwiga, the teenage Polish princess. In the 17th century, the Radziwils came and, again formally, turned Lithuania, much of it, over to Luther and Hus. The Radziwils were based just a few miles from where I was born and grew up. The ruins of their castle are still there. The mighty Swedes, on one of their hunt-

ing expeditions (they hunted Poles and Lithuanians, for sport), destroyed the Radziwils, and with them went Luther and Hus, they carted them away to Stockholm. Lithuania returned to Catholicism, at least formally. Only a few villages around the old Radziwil castle remained Protestant. A few thousand families, that's all. My parents belonged to that small, oppressed minority... Although Christianized, Lithuania, particularly the western parts of it (I come from the very North, some fifty miles south of Riga) remained pantheist. There are many records in the Vatican, going back as far (or as close) as the second half of nineteenth century, of the Bishops complaining about the rampant "paganism" of Lithuanians. In the middle of the nineteenth century there were parts in Lithuania where people kept sacred serpents in their homes which they worshipped or at least kept in great respect, and fed with fresh milk. As for the sweet Jesus, Lithuanians seem not to have taken to him. The main Christian deity in Lithuania became Mary, Jesus' mother. They built, they carved, they sculpted thousands of little shrines for her throughout the villages; they sang hymns to her, she took the place of God and Jesus in practically all religious (Catholic) ceremonies, and they called her Saint Mary of the Gates of Dawn, Our Lady of Vilnius. This may be for the reason that Earth (*žemė*) and Sun (*saulė*), two of their main pantheist gods, in Lithuanian are of feminine gender; the Moon (*mėnulis*) is masculine. The feminine principle (Earth and Sun) won over the masculine principle of Jesus. What they did with Jesus was this: they made him (Him) into a subject of folk sculpture of a very special kind. He is always portrayed as sitting (very rarely on the cross!), leaning His head on the right palm and looking at the landscape with face very sad. There are thousands and thousands of them, sitting by

Rūpintojėlis, 18th century

the roadsides and looking very very sadly at the passers-by.

I should add here, since I have strayed away anyhow—it must be true that religion leads people off the straight path—I should add here something about the Lithuanian devil.

The Lithuanian devil is never evil. The Lithuanian devil, as portrayed in thousands of folk tales, is rather mischievous, faun-like, an elf who likes fun, helps people out, then gets into trouble for it. Simply put: he has a weakness for people. In Lithuanian homes, it means luck and happiness to have many sculpted little devils around the place.

To return to the subject:

As far as I know, all my ancestors have been farmers. Neither my mother nor my father have ever mentioned anything else. But it was my father who was destined to break the chain. He was set to become a master carpenter. He spent a great part of his early life as a carpenter. He could make anything out of wood. I watched him build looms, houses, carriages, musical instruments, chairs.

Carriages, that was something very special. Sunday mornings, when farmers used to rush past, on their way to the church, my mother would sit by the window and point out to us carriages my father had built: they were certainly the most spectacular, most ornate, most beautiful. She never stopped reproaching him for not returning to carpentry, for settling down on a farm instead, something she said he knew little about and had no heart for, he just made his life miserable, she said. Probably hundreds of times I heard her say that. And he always said, yes, he would go back to it some day, some day he would catch up with all the farm work and would go back to carpentry. Or he would say nothing, just look

Povilas Mekas, my father, in a passport picture taken c. 1917

down at the floor. And I always had great sympathy for him during those moments. I saw a great sadness in him. Something had gone wrong there, I felt, something, some time in the past, when we were too little to understand it.

As a child, I watched him build, work with wood, make wooden spoons, plows, chairs, tables, rakes, and we children we used to play on the floor with the wood shavings and build the same things our father built. As a matter of fact, I did build miniature looms, carriages, chairs, very fancy chairs, and did it all so well that my father used to show them to the neighbors and everybody thought I would grow up to be his carpenter son. Even today, I am convinced, I can build anything I want, absolutely anything, from a loom to a house.

For two years, until I was twelve, I played a lot of mandolin, freely and from scores. Later, when I was about fifteen, I borrowed a violin and, high up in my uncle's attic where I spent my student days, I played and played and played, driving everybody crazy, with nobody to teach me. I knew nothing about teachers. I thought that you were supposed to learn it all by yourself. I was so totally naive. Either that, or obsessed. I played for two winters that way. I learned to read the scores, and I played Mendelssohn and Paganini. I didn't have scores for the violin: I played from the scores my uncle had for the church organ.

Anyway, I was playing and playing. So everybody began making jokes about me and they began calling me Paganini. That became so annoying that I eventually stopped playing. I sat in the attic, overlooking my uncle's church, read books and listened to him play the big church organ. He played organ twice every day, once early in the morning, for an hour or so, when everybody was still sleeping; and again, around sunset. He sat there

alone, at the organ, in the empty church, and he played. Early in the morning, I could hear it, lying in my bed. It remains one of my most beautiful memories, the sound of the organ music as it came into my little attic.

The name calling. Paganini. I was very sensitive to name calling because they always called me some very undesirable name. Around the age of four or five I had suffered for about a year from some terrible disease that kept me in bed most of the time and the village women used to stand around my bed and look at me very sorrowfully and say, "Oh, poor boy, I don't think he'll live long." Oh, how I hated them.

Anyway, this disease left me very thin and bony for years and years to come so that by the time I started school everybody called me Death. I was a walking skeleton, and I walked with that name for years. The disease also left me very silent, closed into myself. I never spoke to anybody until I was fifteen or so. If I ever managed to survive all this and gain a comparatively remarkable measure of health, it must be due either to the inherited longevity or my later passion for light athletics—I am not sure I should say "later" since I was only thirteen at the time of the 1936 Olympics—but I credit my health of later years a lot to the 1936 Olympics. Due to the Olympics, my brother Adolfas and I got very involved in athletics, and especially in one kilometer run. We had measured off a distance of one kilometer and, to the great amazement of our neighbors, we used to run it three, four times every day, usually in the evening, after the day's work was done. They thought we were a little bit out of our heads. One time I even collected my courage to run a mini-marathon that was held in Biržai, a town some 20 miles away. But I refused to wear sports shoes. I insisted on running in sandals. I cannot begin to tell you how my feet felt, running over the cobble stones,

and up and down the hills, and dusty roads. But I had to do it because my whole village was there, rooting for me. Somewhere around the middle of the run, I threw my sandals away and ran barefoot, as a good farmer boy should. I made second place, and in a good time. I can still run a mile at a terrific speed, even today. I hate jogging, by the way. When I run, I run fast, competition speed…

So, where was I? Ah, my father. He used to say, "Some day I'll drop this whole farm business, I'll go back to carpentry and I'll make carriages again, I'll make everything I ever wanted to make. This is only temporary." But the war came, and then he died. My mother told me, years later, when I finally could visit her—years, years later–that the secret police did it. First the Germans, then the Russians. They kept working on him, and kept after him, kept on interrogating, threatening to shoot him, while asking about Adolfas' and my whereabouts.

I remember the one time when I was sleeping in the back room the Germans walked in and put him against the wall and had a gun on him and were shouting and my mother was crying. I was in the other room behind the wall and the window was open. I jumped out and crawled down low under thick blooming potato plants. I still remember the whiteness of the blossoms as I lay there. I saw the Germans take my father into the barn. I saw him hitch the horse to the wagon, and they left, with my father driving. We thought we would never see him again, and my mother kept crying. But late that afternoon as I was looking for a stray cow, in the woods, there he was, deep inside the woods, sitting under an alder bush, with the horse grazing by his side. He said, the Germans had walked into a house for something, so he unhitched the

horse and rode away. For days he stayed hiding in the woods, but the Germans never came back, they were on their way to Stalingrad.

As I already mentioned, my uncle (my mother's brother) was a Protestant pastor. My mother's maiden name was Jašinskas and she came from the next village. One of her neighbors became posthumously Lithuania's most honored revolutionary poet, a red Rimbaud, if you can imagine one, Julius Janonis. He committed suicide at the age of twenty. I had heard stories about him ever since I was a child. One of the saddest was about little Janonis working as a shepherd in Latvia, just across the border from us. His mother was so poor that she had to send him out while he was still a very young boy, to earn his own bread. But soon she missed him so much that once a week she would trot across the Latvian border to see him. But she knew that if she met him, it would break his little heart to have to part with her, to see her go away again. So she used to come to the edge of the woods, no closer, and just look out at him, sitting there by the cows on the field's edge—she'd watch her child from behind the trees—and then walk all the way back home again.

Anyway, about this uncle who was a pastor. He studied in Switzerland and his colored mountain post-cards, and worn out, beat up geography books, in strange foreign languages, provided me with the first glimpses of a world beyond the boundaries of our village. It was like a dream. And there was one book, again in a strange language, with a picture of Prometheus and the eagle pecking at his liver. It made an impression on me I cannot even begin to describe. Later, of course, it was his library that changed my life's direction. And when he told me that he was a friend of Spengler—that was later, already in my student days—and gave me his books—this

opened yet another world. He had a fantastic library. When the Soviets came, he burned some, others were carted away. When I visited him in 1971, there was no more library. My own library was gone too, including all my early poems, all my diaries, all the writing I did before age 22.

Which brings me to the subject of the various libraries of my childhood.

First, there was the library of my brother Povilas. He was fifteen years older than I, and he had collected some 500 books. As soon as I learned to read I plowed through them. A lot of it was Marxist, socialist literature. As a student, my brother Povilas got very involved in Marx. After all, the October Revolution was still very close to him. He was very much in support of it and in step with it. From 1918 to 1940, the years of Lithuania's independence, he was working in various clandestine socialist and communist groups. The true scope of his political involvement I'll never know, it was all very secret, forbidden, not to say dangerous. All I know is, when the Soviets pushed the Germans out of Lithuania, in 1945, he was one of the people asked to form the new government. Which simply means, he had to have been very much involved. But by that time, however, a disappointment had taken root in his heart and mind, regarding Soviet intentions in Lithuania—he told me as much in 1971—and he said no. He died in 1973.

After I zoomed through my brother's library, I discovered that two villages away there lived a young farmer—again, of leftist persuasion—as a matter of fact, he had just come home from several years of political imprisonment—and he was known to have many books. So one day I collected my courage, put my brother Adolfas in charge of the cows, and ran through fields and woods to Valkiunas—that was his name. I found him

working in the field and told him I wanted to borrow some books. He got very excited. He interrupted his work and went to his house. He pulled from under the bed a huge trunk of books and selected a few for me to read, and told me something about each author. It was all very exciting. Unlike my brother's library, his library didn't contain a single political text. I guess, the police had weeded them out. His was a library of Dumas, Hugo, Dickens, Jules Verne, all the adventure books, and all the humanists, and yes, Dostoyevsky and Gogol and Turgenev—he had them all. Once a week I used to visit him and come back with my shirt bulging with books—I used to carry them next to my body, inside my shirt, since I had no pockets. I carried them everywhere with me and I read and I read and I read—while sitting by the cows, while eating, and while everybody else was sleeping or taking a siesta—I read and read until I got through his entire library.

Later they shot him. I don't know whether the Nazis did it or the Russians. He was doomed, he was too bright and too good. He always asked me not to tell anybody where I got the books, he was paranoid. The jails did it to him. And the people of the village avoided him. They said he was a bad influence, a corruptor.

My next library was that of another neighbor, only half-a-mile away, Čigas by name. He was known all over the region for his "socialist" activities and for his atheism. They called him the worst names possible, and the police used to visit him monthly searching for subversive literature. This was still under the "independent," pre-Soviet Lithuanian government. But I liked him. He was the only one in the whole region subscribing to a daily newspaper that, among other things, had a column on cinema! Every second day or so I used to visit him and borrow old newspapers along with some books. He lent me

15

Sinclair Lewis and Bernard Shaw. He also lent me
Tolstoy and Huxley. He was around 35 and everybody
said he was a devil. And then, one day, lightning struck
him. They covered him with earth, tried to revive him,
but nothing worked. He was dead. Which, to all good
Christians of the region was perfect proof that Adolfas
Čigas was evil and was deservedly punished, or rather
eliminated, by God himself. This opinion was so popular
and persuasive that it was unanimously accepted by all
my classmates in the fourth grade. This got me so mad
that I decided to take a stand for my friend. On hearing
me defend him, the other children attacked me with fists
and nails. I defended myself as best as I could. Not being
very strong, I resorted to my pen and started frantically
swinging it in front of me. It was one of those old-
fashioned, steel-nibbed pens you have to dip into the
inkwell. When I stuck it into the thumb of one of the
attackers—I remember his name was Tamulėnas, later
we became good friends—they all retreated. But the boy
panicked. We had heard about ink poisoning the blood.
So I said I would suck the ink out, like they suck snake
poison out. Which then I did. I sucked the inky spot and
spat the blood out. And that was the culmination of the
first political violence I encountered in my life. This
occurrence remained vivid in my mind for many years
to come. But they left me alone after that. They thought
I was irrational, strange. They considered me an outcast,
not exactly one of their own. They respected me, but I
was not one of them.

There was something else that contributed to my
being an outcast, and this, very possibly, was the most
crucial influence of my life.

Our little village was situated about five miles from
the post office. The post office was in Papilys—that's
where Radziwil had built his first castle of which there

is nothing left by now. Twice a week someone from our village had to go to Papilys to pick up newspapers and letters. Most of the time it was me.

The post office was small, with two employees. Around three o'clock in the afternoon the mail buggy used to arrive with the newest mail from another, larger town, in which, incidentally, there were ruins of Radziwil's second castle... I used to sit in a corner and wait for the mail to arrive. And every time I saw this tall, gaunt, black–haired, sensitive-looking man come in with a batch of envelopes to mail, and then pick up a batch of very interesting looking magazines and newspapers. With his impressive countenance every eye immediately turned towards him. But he never said anything. He went about his business routinely and then walked out.

One day I summoned all my courage, shy as I was, to ask the postman who this person was. I was told, very respectfully, that he was a very famous Jewish poet and that the letters he was mailing contained poems that were then printed in all those magazines, copies of which he would receive here.

You cannot believe how impressed I was. From that time on I was no longer going to the post office to pick up village mail: I was going to see the poet, this famous Jewish poet... A real poet, in my own town... I wanted nothing else but to be like him. I was about ten or eleven. But I knew that I wanted nothing less from my life than to be a writer, a poet, like this gaunt, black-haired, ascetic, tall Jew. My life's direction was suddenly set.

When the Germans came, they shot him. I never found out who he was. They shot the post office guy, too. Someone fired a shot at passing German soldiers from inside the post office. The Germans stopped, and shot everybody in the building. I don't know what this tells about the times we live in, or about where I come from,

17

but most of the protagonists of my childhood are dead. Untimely dead.

As I reread these diaries I do not know any more, is this truth or fiction. It all comes back again, with the vividness of a bad dream that makes you jump up in bed all trembling; I am reading this not as my own life but someone else's, as if these miseries were never my own. How could I have survived it? This must be somebody else I am reading about.

When I began making these entries, I was in Germany in a forced labor camp. Some things had to be kept out of the diary. Among them was the main reason for my being in Germany, Nazi Germany.

During the years 1941–1944, during which time Lithuania was under German occupation, I got involved, like many other people my age, in various anti-German activities. I joined a small underground group which, among other things, was publishing a weekly underground bulletin. This consisted mostly of news transcribed from BBC broadcasts. It informed people about German activities in Lithuania and other occupied countries. It was one of several such bulletins published by underground groups during the German occupation. The German secret police did everything to uncover the publishers. The only clues they had were the typefaces of the typewriters used to type up the bulletins. The way I come into this is that I was assigned to do the typing. Once a week information materials were delivered to me, and I prepared the pages. I lived at that time in the attic of my uncle's house in Biržai. My uncle was a Protestant pastor and the house in which he lived belonged to the church and stood on a lake shore, quite remote from other houses. There was a barn there too, and a huge stack of firewood for heating the house in winter. I used

to hide the typewriter in the firewood stack. I felt it was quite safe there. But I was wrong. One night I went to pick it up, to do the typing—but the typewriter was gone! I had no other explanation but that a thief was snooping around, found the typewriter and stole it. I reported this to my underground friends and we all agreed that the best thing for me was to disappear. We couldn't take chances on the thief selling the typewriter and Germans discovering the typeface they had been desperately searching for. It was clear to us, that in such a case, the thief would reveal the source of the typewriter.

I had to make fast decisions.

There were several ways of "disappearing." One possibility was to join the partisans and wait for the German retreat. But there were two big problems there. One was my very fragile constitution in those years; the other thing was, there were two partisan groups, the pro-communist, pro-Soviet partisans, and the national-ist partisans. The communists I couldn't join. I had published an anti-Stalin poem and I knew I was a marked man. In 1971, during my visit to Lithuania, my mother told me, that the Russian secret police were waiting every night, for a year, behind the house, in the bushes, hoping I'd come home—they thought I had joined the nationalist partisans. All my early writings were carted away, my brothers arrested, my father interrogated again and again.

The nationalists I did not want to join either. I was seriously and wisely advised by some older people with much more experience than myself—and, in the first place, by my uncle—and only years later I was to find out how right he was—and it's to him that I must be grateful for being alive today—that it made no sense joining either group: all diverse groups were sure to be wiped out, either by retreating Germans, or the advancing

Soviets. What I was advised to do, was to immediately leave for Vienna. My uncle's opinion was that it was best for both of us, myself and Adolfas, to disappear, and the further the better. So, now, according to our carefully fabricated papers, we were students on our way to the University of Vienna. Once in Vienna, our uncle had given us names to contact there. Of course, we expected to run into troubles and questions, but, we figured, we could talk our way out. It was a risk we had to take. The Vienna contacts would then lead us into Switzerland.

In two days we were on our way, into the unknown. And it's here that my diary begins.

August 1985

1. FORCED LABOR CAMP

The author's failed attempt to reach Vienna. Eight months in a Nazi forced labor camp, in a Hamburg suburb. The daily life and miseries of forced laborers and war prisoners. Inspired by a heavy bombardment by Allied Forces the author and his brother made a move to escape to Denmark.

July 19, 1944

Today our train pulled into Dirschau, near Danzig. This is our eighth day on the road.

I am neither a soldier nor a partisan. I am neither physically nor mentally fit for such life. I am a poet.

Let the big countries fight. Lithuania is small. Throughout our entire history the big powers have been marching over our heads. If you resist or aren't careful—you'll be ground to dust between the wheels of East and West. The only thing we can do, we, the small ones, is try to survive, somehow. That's why, if luck stays with us, we are on our way to the University of Vienna. I do not want any part of this war. This war is not mine.

Many are fleeing Vilnius and Kaunas. The Germans are throwing in more divisions, but they can't hold the Soviets. The fighting spirit is dropping, the retreat is disorderly.

Nearer to the front lines, around Biržai and Panevėžys, there are bands of partisans and German deserters. Those who can put their hands on any weapon run into the woods, hide. Since I have no wish to live in the woods and, what's more, I have no knowledge of guns, my decision is to leave, and the further the better.

If you want to criticize me for my lack of "patriotism" or "courage"—you can go to hell! You created this civilization, these boundaries, and these wars, and I

21

neither can nor want to understand you and your wars. Please, keep away from me and look after your own affairs. That is, if you still understand them yourselves! As for me—I am free even in your wars!

The train is full of refugees. There are about forty of us in our small car. The train is moving slowly. All railroads have been taken by military transports. For hours and hours our train waits in the stations. We thought it would take us only two days to Vienna! In Panevėžys alone we waited three days.

Now we see how unpractical and unrealistic we are. We took nothing with us when we left, no food of any kind. Others are more practical, they are all eating something. They are all dragging loads of things. One woman, who's obviously lacking a few screws in her head, is dragging a bunch of artificial flowers; dusty window shades; an empty barrel; and many other such things. Now she is deeply engaged in rechecking them all. She takes each thing, turns it around, puts it back again, she keeps working. That will keep her busy until Neumünster.

We crossed Nemunas river at Tilžė (Tilsit). I thought of Vydūnas and the *Bhagavad Gita*; I read it first in his translation, and it's the only book that I took with me, on the train. This is his town. He must be somewhere out there, in one of those little houses.

We reached Königsberg at sunset. The setting sun was burning like gold on the steeples of Kant's churches. In the harbor, waters were red with the heat of the day and the rumble of war.

The posters shout: EVERY TURN OF THE WHEEL IS FOR THE VICTORY! Yes, always the wheels! I look at their faces, good solid German faces, and I see death. Every turn of the wheel betrays death. The train is moving across the countryside, we are look-

ing at the clean, very orderly houses. In a few days they'll be nothing but rubble.

July 21, 1944

Good-bye, Vienna! At least temporarily.

Oh, how naive we were! Even after all these years of war, we haven't really understood yet that THIS IS REALLY WAR.

Yesterday they brought us to Elmshorn, a suburb of Hamburg. We protested. We insisted that we were students and that we were on our way to Vienna. There must be a mistake here, we said. But the Germans looked at us and laughed. "Vienna?" they said. "Now you are here and you'll be here until we tell you. Germany doesn't need students: Germany needs workers. Every wheel for the victory!"

Soldiers took us to a war prisoners camp. They informed us that we'll have to live and work with war prisoners. I tried to protest but someone whispered that I shouldn't be too insistent because human life costs little here. I remembered how one soldier hit Adolfas across the face, in Dirschau, when he left the train to look for water. I immediately shut up.

July 23, 1944

Sunday. Elmshorn. A bombed out suburb of Hamburg. It was a beautiful town once. Still, it's amazing, how many factories are working. They don't rebuild the living houses, but they keep rebuilding the fucking factories. The factory where they take us to work is in the eastern part of town, a *Maschinenfabrik*, run by *Gebrüder Neunert*, Brothers Neunert. The prison camp is in the western part of town. It's a group of three camps—one for Rus-

sian, one for French war prisoners, and one for all the others—Dutch, Italians, Belgians. We were placed in the mixed one. For all practical purposes, we suddenly became war prisoners. War prisoners of no army.

July 27, 1944

Adolfas was assigned to a machine, I am working in the assembly department. I am turning the screws, I am cleaning, rubbing, oily to my ears. Good they gave us special work clothes and good heavy factory shoes.

Only the foreman and special technicians are German. All workers—a hundred and some—are from prisoner of war camps. Italians, Russians, French, Yugoslavs, Ukrainians, Poles. We are the only Lithuanians.

Our work hours are from 6 AM to 6 PM, with fifteen minutes for breakfast and forty-five minutes for lunch. Very very boring. Only four days, and I am bored to the very ends of my nerves.

We eat our lunch at the factory. Supper we eat in the barracks. As far as our food goes, I can't complain. I am eating better than I was eating in Biržai. It sounds incredible, but it's true. The truth is, in Biržai, during my student years, I was eating so miserably that I was practically starving. Here they give us little, but regularly.

Every night air raid alarms. All around us bombs are blasting. Lights cover the sky. I get up and go to the window, to size up the situation. Adolfas doesn't even leave his bed, what will be will be.

Whatever little time we have now, we spend on languages.

Pierre Tastet, a French war prisoner, works in the factory with us. He came to me today and pointed at his hair. His hair is all white. He said, he is 33. Fourth year in the slave camp.

FORCED LABOR CAMP

August 23, 1944

A month of the factory. It's bad enough to work in a factory, for me, who grew up in the freedom of a farm; to be forced to work in a factory is ten times worse.

Everybody tries to fake working as much as it's safe to do so. But to fake working for twelve hours makes one even more tired and bored than real work. The evening comes, and the only thing I can think about is bed. Half the time we have to work in the night shift. Be damned! We work also Sundays. All the time on your feet, no sitting, no resting allowed.

We really hate the night shifts. You don't know, if you are awake or asleep. You stand by your machine, you do the things you're supposed to do, but you are really sleeping. Sleeping we work, sleeping we walk—our little miserable group—through the dead early morning streets, back to the barracks, and we collapse into our bunks.

Everybody's waiting for the end of war. The British are already this side of Paris. French prisoners cannot hide their joy. Some of the Germans in our factory do not hide their joy either. In our factory only the owner believes in "victory." When he is around, we all try to give the impression of working hard for the "victory." Yesterday, after eleven hours on my feet, I just couldn't hold, I had to sit down for a minute. As soon as I sat down, I felt a kick. Neunert kicked the wooden box from under me and I fell on the floor. Workers avoid him and fear him like the devil. His tactics are sneaky, he likes to surprise you from behind.

Long lines of birds are flying over the city.

Freedom in their wings.

I HAD NOWHERE TO GO

August 27, 1944

Air raid. "Tommys" will be over Elmshorn any second. The factory vibrates with the sound of sirens. The sound is frightful, all pervasive. But the workers, that is, slaves, greet air raids with joy. Air raids mean one hour of rest. The factory stops, we run into the shelters. That is, some of us. Others are simply lying outside, on the grass, sleeping. The bombs fall on other parts of the town, they don't budge. Still others are sitting on steel pipes, talking, in their international jargons. Half of the words are curse words.

The siren keeps wailing.

Germans—that is, women, children, invalids and old people—with whatever means they have available to them, are running out of town. Most of them use bikes which they keep specifically for this purpose.

The radio with its blurry voice keeps announcing kilometers, minutes.

Ten minutes. Five minutes. Five minutes means that the bombers are now flying over our heads, five minutes air time to Hamburg.

The white bellies of the bombers shine in the sun. Very very beautiful. Four minutes. A few bombs explode on Elmshorn. Three minutes. Two. Now from the Hamburg side begins to come a loud thundering. One can hear Germany's Gateway to the World falling down. Another and another wave of bombers move across the sky. One hour. Two hours. Three. The thundering continues. Then, suddenly—complete silence. Only a cloud of smoke covers the city.

A siren announces the end of air raid. The workers stand up, go back to the machines. *Für den Sieg*. For the victory.

FORCED LABOR CAMP

And so every day, every night.

During the lunch breaks, the wives of some Russian prisoners bring their little children to see their fathers. How miserable, thin, hungry they are! They look so miserable. But the fathers and mothers look at them as if they were the greatest and most beautiful things in the world. Which probably they are.

The German supervisors look at them, giggle and make jokes.

September 18, 1944

We visited Hamburg. The city is a shambles. Just a field of rubble.

But even through the ruins you can feel the spirit of a once huge, international city.

Black crosses painted on many of the brick piles. That means the occupants of those buildings are still buried under the rubble.

The river Elbe moves slowly and solemnly across the invalid city. Occasional cries of boats pierce the air.

There are some parts that are still sound. We bought a few books in a small bookshop near the Altona railroad station.

As our train was pulling out of Altona, the sirens announced an air raid. The conductor moved the train out of the station in a hurry. They bomb the station every time there is an air raid. The train was stopped a few miles outside Hamburg and we sat in place for two hours, listening to bomb music over Hamburg.

Nazi (German) factories, now run by millions of slaves, still look terrifically neat. Every little thing, hammers, screwdrivers, wrenches are neatly in their places. This is not because the forced laborers have suddenly become as neat as the Germans: it's only because they

have discovered that to put the tools neatly and *putzen putzen** is by far an easier work than dragging steel slabs. So they keep putzing. The slaves have turned the German craving for neatness and order to their own profit.

September 23, 1944

It's raining. It's not drizzling: it's really pouring. We are sitting in the barracks waiting for six o'clock to come. At six they serve the food. We'll have a snack. A snack, because you can't really call it a meal.

For some ten days now they have been feeding us with a pea soup full of fat white worms. You brush them to the side, and you eat. But eventually they get on your nerves.

The barracks delegated me to complain to the *Lagerführer* (camp commandant) about the worms. He listened to me, looked at me, and said: "What do you want? Everything is fine, *prima*. The food is *prima*. The kitchen is *prima*. Don't you know we are fighting *für den Sieg*?" After that magical phrase I shut up. With arguments one has to be very careful here, you have to know your limits. We are seven in the room. We are three Lithuanians now, a week ago they moved Dominykas into our room. A tall, lanky, gangly man of about fifty.

Dominykas will eventually drive us all crazy with his continuous complaints and curses. "They will kill us with hunger," he keeps repeating. "They will."** He works in a smithshop, he needs a lot of food.

* An admonition often heard, throughout Germany: "clean and keep cleaning."

** Little he knew, though, how right he was. Dominykas died of hunger one week before the armistice.

FORCED LABOR CAMP

They put two Italians with us. They were transferred from Kiel. Nerri and Jimmy. Both are war prisoners. Nerri is sort of a painter, from Ferrara; Jimmy is, or rather was, a student, he says. He was twenty-two when he was drafted by Duce. Now he is thirty.

The least sympathetic of our comrades is a Russian "white" émigré. We hate his aristocratic manners which he tries to demonstrate on every possible occasion. He doesn't talk with us, he dislikes us openly. He thinks we are all a lower breed and deserve our fates; he himself, however, is an innocent victim and the world eventually will avenge his suffering.

Anyway, aristocrat or not, he has to drag heavy sacks to the fourth floor, in the factory where he works.

Two days ago they moved a Gypsy in with us. He says he comes from Sicily, but the two other Italians do not seem to understand him at all.

October 8, 1944

The Belgian who works next to me had his birthday today. He has been in slavery four years. During the lunch break other workers brought flowers and placed them on his machine.

Flowers and machines. Life and misery. Red, blue, yellow field flowers. We stood, looking at them, remembering the flowers of our own fields.

October 10, 1944

For over an hour now Dominykas has been fussing angrily around the stove. He came back from work all wet and drenched, and there is no fire. He's cursing the Italians—why didn't they get firewood some place. Finally he got really mad, pulled out a plank from his own bed, trampled it to pieces, and started the fire.

When you blow out the air and it doesn't freeze in thick grey clouds in front of you, ah! then it's nice to sit around the table with the rest of our "family." We forget the factory, the air raids.

Arrigo (Nerri) scrounged up some drawing paper today, he's happy. Drawing is the only thing that interests him. The other day when the military police were searching our room, he jumped around them, trying to sketch their portraits. Yesterday in the French barracks I found a book on Renoir, now I can't pull it out of his hands.

Jimmy is trying to patch his pants. Until now he practically walked without pants. Today someone gave him a pair.

The Gypsy is already snoring. There is nothing to steal... Occasionally, in his sleep, he pulls on his empty pipe, the snoring stops, then it resumes again.

Tomas, the Italian, is crawling on the floor right now, on all fours, searching for the tobacco dust. He gives away all his food for tobacco. Early in the morning, or at night, when nobody sees him, he crawls around on the floor picking up whatever looks like tobacco. The other night he took some of Dominykas' tobacco and there was a tremendous fight.

November 5, 1944

Air raids day and night. Now during the air raids we, too, are allowed to run to the suburbs. The bombing became too heavy. The Elbe river is full of mines and sunken ships.

The front lines are moving closer and closer. Slowly but surely.

Köln. Gumbinė. Budapest. Bologna.

Autumn. The city is full of wind, water and leaves. The sidewalks are muddy. People are rushing by, hurrying to die.

Self-portrait by Nerri

Newspapers are talking about the Ultimate Victory. The Victor, of course, will be Germany...

The barracks, our room, heavy with air which during the night has passed through the lungs of eight people, is beginning to wake up. It's Sunday morning. No work today. Some of the slaves will go for a walk, others will sleep all day. We are allowed to walk into the town, go to the movies, and even take a train into Hamburg. As long as we are back when the barracks close and the inspection comes.

Nerri will finish his self-portrait. He has been working at it all week. On his knee he has a huge suitcase. That is his drawing board. He can't draw on the table: the table is constantly shaking under the elbows of his comrades.

The Gypsy is patching his socks. There must be already twenty patches on them, but he's sewing on the twenty-first patch. With his small, fast eyes he is following the mouths of those who are eating. He gave his food away for tobacco. Now, both, food and tobacco are gone. He left his family, he says, in Bulgaria, because of his Gypsy curiosity. He wanted to see, he says, "how other people and countries live." So now he saw it, and I bet he'll never want to see it again.

Dominykas is still mumbling. "We are nothing here, motherfuckers."

After he's through with his breakfast, he'll go he says to see "the Pole, the little goose," he'll beg him for some tobacco or bread. The Pole, the little goose, is his best friend in the Polish barracks. Yesterday I came home and found Dominykas sitting on his bed almost crying. He said, he hadn't had one smoke all day. So I went out and got two cigarettes from the French barracks. French war prisoners are richer: they are allowed to receive packages from home.

Portrait of Jimmy by Nerri

No work today. Every fourth Sunday is, usually, free.

In the factory—nothing new. The slaves are turning the wheels, are looking at the clock, are counting the endless hours, are trying to work as slowly as they can.

One group came back from digging trenches. They were taken to work on the fortifications of Hamburg. It's very wet there, they say. They had to sleep in water, standing. They were constantly being sprayed by bullets by the British planes.

Behind the barracks I can hear the sounds of drums and marching songs. The Hitlerjugend are marching by.

The Russian prisoners are singing a song:

"My rabotayem sdies kak sobaki,
ne emeyem tschassy utdychat.
Chlieba niet, shira niet, y tabaki,
tolka v dien sto yoptvayumat."

(We are working here like dogs,
with no time to catch our breath.
No bread, no bacon, no tobacco,
just a 100 of *yoptvayumat** every day.)

Have a good look at the children! Watch, how they grow. Watch how, gradually, on their faces appear tracks of shrewdness, brutality, greed—all the lines that characterize the human race.

November, 1944

The smell of burning meat tickles the nose. The barracks are cooking their daily share of meat which was just distributed. The amount of meat per person is such

* One of the heaviest curses in Russian.

that we can cook it in a spoon. That's exactly what we're doing.

The air raid just ended. The Italians are coming back from the suburbs, where they run during the air raids. Myself and Adolfas we have been ordered to go to the factory during the raids, day or night—to help to protect it from fires. So we just came back. Dominykas has warmed up the room nicely. That's his profession. In Lithuania, in Biržai, he worked as a railroad stoker.

It's more quiet today, somehow, in our barracks. It's even possible to read a book. Which doesn't happen too often. Too much shouting. They come even from other barracks, into our room, and they keep yapping.

Oh, hell. Another air raid. Second time today. Again hundreds of bikes pedal along the streets, and women push baby carriages with babies and junk.

Jimmy is showing us his wife's photograph.

"After the war I go to America or England. I drink a lot of alcohol. I drink until I forget everything," he says. He hasn't seen his wife for six years.

Adolfas and myself leave for the factory, hoping the bombs will hit it before we reach it. But the goddamn bombs always manage to miss it.

I am working and I keep looking at the clock behind me, on the wall. Everybody's looking at the clock. Six o'clock will never come! The hands seem stuck on one spot.

Stupid Nazis. They want to win a war with the help of slaves whose thoughts are on the clock, not on the Ultimate Victory.

November 12, 1944

Twelve hours in the factory. One hour spent on walking to, and from the factory. Eight hours for sleep.

One hour for eating. Two hours for living. One hundred twenty minutes.

Another prisoner was brought into our room two days ago. A Lithuanian from Panevėžys. Twenty-two years old, a simple worker. Everybody was sleeping when the police brought him in, late at night.

Yesterday, in our factory they arrested eight Russian war prisoners. They took them out of town. They spoke too much, weren't careful enough. The factory has many ears. In our factory the ones to watch for are Ukrainians. There are three Ukrainian policemen in our factory. They have very good ears. They come from General Vlasov's army. They will do everything to get revenge on the Russians.*

All nature is full of hatred for humans. I don't think man has any friends among plants or animals. I suspect that even dogs and cats, those so-called best friends of man, are only pretending friendship to man in order to spy on his misdeeds, and they would betray him without blinking an eye the first chance they had. They know that Man is the worst of the beasts.

November 26, 1944

The Russian engineer who works on the machine next to me, had his fortieth birthday today. On that occasion the foreman gave him half an hour off, at the end of the day.

* Andrej Vlasov, a Soviet (Russian) General. Taken as a war prisoner, by Nazi Germany, he helped to organize an anticommunist army for the liberation of Soviet occupied countries. It's estimated that close to one million Russian and Ukrainian war prisoners joined Vlasov's army. During the last weeks of the war, Vlasov's army turned against both, Soviets and Germans. He was hanged by Stalin after the war.

FORCED LABOR CAMP

He looks like sixty. His hair is all white. His head is bent down, in humility, or despair, like that of a slave. He comes from Moscow where he was a young promising chess player. Now, he says, "*ya vsio zabil*," he forgot everything. When he left the factory, his steps were heavy and tired.

"I'll get a larger portion of cabbage soup today," he said.

"I hope that your forty-first will take place in Moscow," I said.

He brushed it off, in a gesture of hopelessness.

We have one old German foreman, he came a week ago. The Russians call him "*diadia*," grandpa. He speaks English. He must be about seventy. He is bent with the weight of his body and age. His trousers hang loose around his dry legs. He always wears the same black smock which hangs on his dry shoulders. His pockets are full of things, sagging down. Down on his chest hangs an eye-glass case. From one of his many pockets sticks a notebook made up from stapled office receipts; from another—a long yellow ruler. Nobody is afraid of him. He noticed that on my machine I have little pieces of paper with German words which I am trying to memorize—to kill the boredom. So now he comes and examines me. Sometimes he recites all the forms of a more difficult verb.

He tries to be very serious and strict, tries to scold the workers. But as soon as he starts to do so, he breaks into laughter and the workers begin to laugh with him. He can't keep his face serious and strict. Sometimes he disappears for hours into the bathroom with a book. We don't think he knows much about machines.

Two weeks ago they moved a Croatian into our room. Since then our room has been sheer hell. They shout, they wrestle, they sing, they argue. It's impossible to

concentrate. My nerves are falling to pieces. I am trying to write, but by the time I reach the end of the line I forget what I started to write. This is because while I write, at the same time I am trying to avoid having the salt shaker, shoes, and other flying objects land on my back. At the other end of the table Jimmy and the Croatian are involved in a game (they have been at it for the last few days) and, as part of the game (I guess) they keep hitting the table with their fists and they keep shouting: UNO! DUE! SETTE! Sometimes—with a very regular frequency—their game ends up in an argument. Then you better find a good hiding place! Particularly when both tables get involved in the same argument. Things fly around, they bloody their noses with bottles, they split their lips. After such fights, usually, for two evenings they don't speak to each other and it's quiet. Even Nerri can go back to his rings. He is sort of a jeweler, on the side, he knows how to make rings out of copper coins. There is a great demand for rings in the barracks…

Wenck, the large heavy German who works next to Adolfas' machine, was telling me today how he wanted to study. He couldn't, because his parents didn't have money. He keeps cursing capitalists. He says, he is a communist. He says, capitalism is preventing good ideas from taking root in society. No matter how good your ideas are they'll come to nothing if the capitalists don't like them. They have complete control of things…

What a laugh, what a laugh! They ran out of steel! So now Neunert had to shorten our working hours. Now we are working from 8 AM to 4 PM only. The factory ran out of steel, coal, oil. The spirits of the prisoners are rising. They know that the shortening of the working hours means a shorter distance to the end of war.

FORCED LABOR CAMP

I am reading about a *putsch* in Bolivia. Good! There will be another government. The old government will go to the devil. Some they'll shoot; some they'll jail; and some will go free. And then, in another year or two—there will be another *putsch*, and the story will repeat itself from the beginning: some they'll shoot; some they'll jail; etc.

There are many many books about ideal governments, about how to improve life. But nothing works in practice.

Even about communism, they say: Oh, the theory is terrific—but the practice stinks!

So here I am, sitting here, in these rotten barracks, and thinking. And the only thing I can say is: in view of all the ideals written down in books, the trouble is not with the books but with people who are so rotten that they'll transform even the most beautiful ideas into hell. These barracks, these people here, and myself, sitting here and thinking, we are the perfect specimen of that hell.

Oh, man is too stupid to govern this earth!

We are dreaming bread and liberty.
We'll dream the same when we die.
Hungry, imprisoned, enslaved,
and scattered across the face of earth.

December 3, 1944

It's Sunday. The Italians are working on their rings and they're constantly growling at Adolfas and myself, why aren't we Catholics. When I told them that Catholics aren't supposed to work on Sundays, even if it's only copper coin rings, they went into a long discourse on things allowed on Sundays and things not allowed. It's

impossible to discuss such matters with Italians. How could one? They probably ran around with the Pope himself when they were still shitting in their pants.

December 5, 1944

They transferred us (Adolfas and myself) to another room. Just in time. Our room became too crowded with Bulgarians and Croatians. Terrible noisemakers and pigs. They are real pigs although they all claim aristocratic blood. I have no idea where that kind of ambition comes from.

For one thing I have to give them credit: they are perfect fakers, there they are masters. They rub themselves with all kinds of plants until they are all swollen up, with blisters on their feet and arms, and they get a doctor's permission not to go to work. They fake entire blister epidemics and scare the Germans.

Nicola, the Bulgarian, keeps talking about liberty all the time. He really is getting on our nerves. He works twelve hours and is always tired. He resembles Don Quijote. He is tall, skinny, and his legs are long and thin, his neck is long and thin. I think he posed for Doré. His head is an inexhaustible source of all kinds of ideas on liberty and humanism. He insists that the present European culture should be drenched in kerosene and have a match put to it.

One of the Croatians is a barber. I have never met such a loudmouth. Now, separated by three rooms, we can still hear his sharp, piercing voice.

The old Italian is snoring, the barracks are trembling. Nerri has a string attached to the old man's bed, and when the snoring becomes too unbearable he yanks on the string a few times.

...the barracks, our room...

Night!

People speak of you as something mysterious, dark, menacing.

Ah, man is always suspicious of what he can't have completely, he fills you with his own darkness.

But now man is sleeping, and all his fears and evils are sleeping with him.

Christmas 1944

Our first Christmas away from home. Dominykas is talking about Christmas in Biržai, with home-made beer, plenty of food. The Italians, too, are talking in voices full of memories, as they walk around the room, aimlessly.

They say Hamburg winters are mild. But yesterday the temperature dropped to eight degrees. For Christmas we received some coal to heat the iron stove which usually sits cold. But around morning the temperature in the room dropped to zero. Till now they haven't given us any winter clothes. No gloves, no scarfs, nothing. I still walk around with my summer jacket and a raincoat, both hands deep in my pockets, collar as high as possible. My raincoat used to be white; now it's dark.

When we go for a walk, everybody's looking at us. There is nobody here like us, even among the prisoners. They can't tell exactly why, but they say we look strange. The moviehouse owner lifts his hat to us and lets us in free.

What is the difference between man and animal?

Animals eat each other; and so do men.

They say, animals have no conscience; but where is the human conscience?

Larger and stronger animals kill the smaller ones; and so does man.

Large countries enslave the little ones; rich and powerful people exploit small and poor people.

Oh, what's the use writing this down! What is the use.

Bells are ringing. Their sound floats out on the wind.

I remember a small town, a lake, a very quiet Sunday.

The barracks are listening. Very silent.

Only the bells are ringing.

In a German church. In the middle of war.

It's very possible that others are also remembering their towns, villages, mountains.

Dominykas is whistling under his nose, trying to hide his true emotions.

December 30, 1944

Another Italian was just moved into the room next to us. Now the Italians in our room are carrying on a conversation with him right through the wall! You can imagine what shouting is going on, all the time. When they get tired shouting, the neighbors begin to slink into our room. They stand and they look with their mouths open at Adolfas and myself, reading. Look, look, they are READING!

I know I shouldn't be angry. What else is there for them to do. Still, it's maddening.

Air raid. Bombs will fall soon on your junk.

I don't understand how you can die and leave all your miserable belongings behind! Maybe that's why you keep coming back, as ghosts!

Oh, yes, grab it, fast, run with it!

But you can't take it all with you. So I stand here and I laugh.

Ha ha ha ha. Hear that: Ha ha ha ha.
Only two suitcases, that's all you can take with you!

Eh, myself, I am not free either. I still have fear.
I don't dare do and say everything I want.
War has no conscience and it takes no pity on those
who have one.

I must work for you.
I am a small part in your machinery.
Murderers!
Thieves who steal my time!

Children.
They crawl on the ground, they laugh.
I am sitting under a tree and I am watching them.
This tree is in Germany, and I am a German prisoner.
The children are playing with sand and they seem
happy.
Sand, nothing else.
They watch how the sand runs through their fingers.
This sand is in Germany too.
And the fingers.

December 31, 1944

I don't understand them, Italians.
They walk around in their dirty work clothes all day
long. But in their army bags, somewhere deep, they keep
their Sunday clothes. They are rumpled, all right, but
they are impeccable!
They put all their heart into their Sunday clothes.
They pull them out, dress up, walk around and they think
they look real dandy!

They don't know how ridiculous they look, in the impeccably clean bourgeois clothes, in the barracks!

They walk around the barracks, they go to the movies— especially, when they go to the movies! Myself and Adolfas, we go to the movies in our regular everyday clothes—but they have to dress up to see stupid Nazi movies!

In the evening, they come back, they undress and they hide their clothes again deep in their army bags, until the next Sunday.

I am living with these pigs, with these horses and with these cows.

Every day I have to look at their blank eyes, their stupid bellies.

They call themselves by the names of various nationalities. As if that would make any difference!

Germans, French, Italians, Croatians, Russians, Poles, and other animals.

Thank you for the pleasure!

I love animals, but only real animals.

I love animals who do not pretend to be humans.

You should look, sometimes, into the eyes of real cows. They are serene, quiet, round. They are good, so good. Like medicine.

I like being with cows. I have spent much of my life with them. They do not know greed, they do not play politics. I love them.

Protect me from human beings!

Let me live with cows!

I'll live as a shepherd, if that's the only way.

You are driving me out of my mind, you, the Thinking Animals!

Even now, when I am writing these angry words, your eyes are staring at my hands, your heavy bellies are

shaking my table, your sharp voices are attacking my ears!

We got mad, finally! Adolfas and myself, we chased the Italians out of the room. Now it's more quiet. But we can still hear their voices in the next room.

January 1, 1945

Late this evening, the French prisoners brought a young Latvian into our room. He was near Hamburg, digging trenches, together with other prisoners, when British planes bombed them out. He escaped. The French officer asked us to hide him overnight. So I put him under my bed. At 5:30, on my way to work, I took him to the railroad station. I walked, he followed me some twenty steps behind. The train was just leaving for Flensburg. He jumped on.

January 28, 1945

I do not understand how they can live like this. For hours and hours they talk only about the cigarette paper. And they keep disturbing me. I have no idea how to get rid of them.

Pigs, pigs, those Italians! They ate and they went— but the table is just the way they left it, like pigs. The dishes are lying around unwashed.

Dominykas is snoring. A powerful nose! I bet he's dreaming of his boss, the smith, whom he calls "tiger." The last of the Italians are leaving the room. They'll visit their neighbors, or they'll drink. From nine o'clock in the morning they have been brushing and combing themselves, getting ready (it's 3 PM now), licking their worthless hair—and now they are going. I think they are going to the dingy German bar, near the railroad station. The bar owner discovered that French and Italians have

cigarettes and food, sent to them from home, so he treats them with beer and women, in exchange. The place is crowded, smoky, noisy.

Nicola came to visit us. He is in a very bad stage of rheumatism. One of his arms is constantly trembling. His father wanted him to be a priest, take over the village church. But Nicola kept reading. Lenin, Marx, Hugo, Hamsun. He read a lot, and dug into all kinds of ideologies, poets, and became a convinced communist. The Bulgarian government went after him. For two years he couldn't get any work, because of his beliefs. Like Hamsun, he wanted to see other countries. But there was no money. He was dreaming of making money in America, but the Bulgarian government refused him a visa. Came the war. With a group of students he went to Berlin. There, like Adolfas and myself, they closed them all in a railroad car and brought them to Hamburg, to forced labor. For three years he worked in a margarine factory, lost his health. Now, because of his rheumatism, they gave him three months "vacation." All he can do is sleep, day and night. Or he walks around the room, silently, like a ghost. It's very cold in the room.

"I wish a bomb would fall on my head. But even those miss me," he says.

There are a few other Lithuanians in nearby camps. Not all of them came here by force. They are more free in their movements than we.

They come to visit us, sometimes, and they gossip. Small talk. The most persistent subject of these talks is tobacco and food. They shove their food coupons under our noses, they count and recount endlessly how many ounces of bread they get, or sugar, and how many ounces of meat. Hell, that is really really interesting!

I'd like to know what a twentieth century man would do in Paradise, a Paradise as we find described in old books.

February 11, 1945

For two days Jimmy burned, smoked, cooked, worked hard, didn't sleep till two. Today he finished it, today he's done it: he made for himself a huge plate of dumplings! And he ate it all in two minutes. In two minutes it was all gone. But what pleasure! What satisfaction, what happiness, to have your belly full of dumplings!

Now he is lying on his bed and hiccupping.

Oh, creatures of this world!

Only a year ago I imagined you differently. I used to divide you into animals and Homo sapiens. I followed the textbook.

But today I see both groups coming together, closer and closer. And in real life.

I'll have to work for you, I'll have to love you, I'll have to give you my life.

Yes.

I'll do it all, so that the point, the center would begin to divide itself again.

The horrible amoeba must split again!

They cut off the electricity for our factory. Things are going badly in Germany.

They changed our work. Now we are cutting down the trees. We are cutting them in the streets, on the roadsides. Trees must die to serve the war! Everything *für den Sieg!*

The trees are crying, the trees are falling, the trees are caressing the earth with their dying branches. Old, proud, hundred-year-old trees.

FORCED LABOR CAMP

The work is harder here, but we have fresh air. Luck was on our side. Lucky to be out of the factory.

Almost all the wood workers are Russian war prisoners. When nobody sees, they take some wood to the Germans, for bread and clothes. Of course, it's forbidden. But Germans do not have firewood, they'd give anything for a log. The supervisors close their eyes to these activities, they don't believe in war either.

February 25, 1945

We are still working as woodcutters. German women come to us, they complain about the wood shortage. These trees that we are cutting, this wood is for the war factories.

Our daily meals consist, these days, of one loaf of bread (one kilo) for seven persons; cabbage soup for lunch, with a tiny piece of margarine. That's all. Always the same.

The Russian prisoners do not understand why myself and Adolfas aren't doing any firewood business with Germans. Everybody's doing it, the French, the Italians. But we can't do it. We just can't. We'd feel like goddamn beggars.

There are Germans who help us anyway. Since we started working on this job, it's very often that German women run to us, from the houses, push sandwiches into our pockets, in a hurry, and back they run.

Now we have five, six air raids every day. Plane fights take place over our heads, we run to the shelters. Bullets pop over the shelters and barracks. Yesterday they destroyed our railroad station, three blocks from our barracks. Believe it or not, we slept through it all.

It's time to get out of Elmshorn. The bombing, during last few days, became more than we can take. The planes fly skimming rooftops, spraying everything with

bombs and bullets. They no longer have any fear. All around the mouth of the river Elbe Germans are building fortifications.

We are still cutting trees. We are walking through the woods, among the pine trees, by a small lake—it's almost like Paradise. However, just to bring us down to reality, this little forest is called Sibirien (Siberia).

The supervisors have a good eye on us and they always give us more interesting work. Our present foreman, before he was drafted to the army works*, was a teacher. He says, his entire family, his mother, his grandmother and his grand-grandmother were teachers. A very good man. He constantly mumbles under his nose, it doesn't matter whether you listen or not. He grew up in the forest, he says, spent his whole life in this forest. He walks and talks with the trees. I started talking with trees myself. So he lifts his head from the marker, and he looks at me and laughs. I do it to amuse him.

Adolfas' job, these days, is to cart the food from the barracks, to the work sites. Huge containers of cabbage soup.

Oh, but the poor Russians! How they work, how they suffer. Shriveled, from hunger and misery, almost like animals. They have been here so many years longer than we. They get much worse treatment than the French or Italian war prisoners.

Still, when I compare them with other prisoners— the Russians have remained more human, somehow, than the others. They sit down, they begin to sing, and the tears are falling, falling. The others, French and Italians, all they know is to complain.

* Civilians and prisoners of war were often sent to work on defense installations, fortifications, or assisted on transportation (loading supplies, etc.).

FORCED LABOR CAMP

March 17, 1945

Temporarily, we are in Husum.

We left Elmshorn a week ago. Our aim was to reach Friedrichstadt. There we had to make contact with Jonas Kregžde. He is supposed to give us information about how to get to Sweden. He has addresses of fishermen in Denmark who are in the refugee transport business. He got them from Belgian war prisoners in Elmshorn. Kregžde is working in Friedrichstadt as a medic, as an intern in a hospital. We came on the same train from Panevėžys. After a few months in Elmshorn, he was permitted to relocate to Friedrichstadt. We have been in contact with him through an old priest, a friend of our uncle's, who lives there.

To bring the things up to date:

Our factory, finally, was shut down completely, because of a shortage of materials.

Even when working on woodcutting, officially we remained under the authority of the Neunert factory. Neunert remained responsible for us to the barracks and the police. In the old slave trade tradition, he sort of owns us.

Since the tree cutting was coming to an end, we asked Neunert to send us to Kiel. "There are many factories in Kiel, there is a lot of work there," we said.

In truth, Kiel is the last place in the world we want to be. Every prisoner who was transferred from Kiel gave us the same report: They bomb Kiel day and night, they bomb the fucking factories, stay out of Kiel! Our real plan was to pass Kiel, to the other side of the canal, to reach Kregžde, get the information, and proceed to Denmark. From Denmark—to Sweden.

Neunert wasn't too happy about our plan. I have no idea what plans he has for us, his factory is closed. So I

spoke to our good friend, the forest supervisor. He spoke to Neunert and managed to persuade him to let us go.

The first part of our plan—to pass Kiel—worked fine. As soon as we passed Kiel, we destroyed our transfer papers (which in short, clear language told us to report to the labor camp in Kiel). We mixed ourselves in with German refugees from the East. We decided to stay with them and behave and do everything just as they did.

In Friedrichstadt German military police singled us out. They went through everything we had. So, we say, we are from Stettin, we worked on a farm, the front lines pushed us out, and here we are, looking for farm work. And, of course, we are *für den Sieg*.

They took us to the Mayor's office. The Mayor almost chased us out. Get out, get out! No work, no room, no bread! Just get out! It didn't look at all as if he believed in *den Sieg*...

We found Kregžde, slept on his sofa. He is a medical doctor, the Germans are permitting him certain liberties, and he lives comparatively free. We went over the Swedish plan and we had to agree that our plan was pretty shaky. Still, we thought it was worth trying. The thing was to get to Denmark and meet our fishermen contacts. There and then we can decide, to proceed or not. In the worst case, the British army will be closer there. The check up, passing the Danish border, we were told was very light.

Next day, we went to the municipal office, to get food permits. They chased us out. They gave us food only for one day. Too many refugees. No food.

Thursday morning, early, we left for Husum.

In Husum, following a lead from Kregžde, we located the Lithuanian refugee colony. It consisted mostly of teachers, lawyers, government workers. No farmers.

They were spread over a few rooms of the Hotel Stadt Hamburg.

They received us in a friendly manner. The food problem is not too desperate here, there is a lot of fish in Husum. You can eat fish in some places without any coupons. Fish and potatoes. For us, who had just emerged from eight months of forced labor life, Husum and this hotel looked like Paradise. We couldn't understand how these people, these refugees could live so freely in Nazi Germany, in the middle of war. The way we see it, they live here almost as well as back home. Peace or war, there are always people who know how to live... Maybe you have to live through at least one war, in order to know how to survive another war in style. For us, however, this is our first war, and we are perfect victims.

I'll never forget the words of our uncle, when we were leaving. He said, "Work honestly, wherever you are. Act accordingly to your conscience. After you see the world, you'll look back at your little country and you'll see things you never saw in it before. As for survival—don't worry. I know people like you can live a month on a single potato and survive."

After two days in Husum we became nervous. We were afraid that Neunert may be checking on us, in Kiel. He was that kind of German. We were certain he would send the police on our tails. We boarded a train for Flensburg, last stop before Denmark.

In Flensburg, in the railroad station, the German police singled us out. Who are you? Where are your papers? Where from? We repeated our Stettin story. Refugees. Looking for work. *Für den Sieg*.

They believed our story, took us to the *Arbeitsamt* (Office of Labor), and left us there.

The *Arbeitsamt* told us to go wherever we came from. No work. No food. Go back to the police.

Out in the street we decided not to go back to the police. We were too paranoid about Neunert. We made a big circle. It took us a long time to get back into the station. The entrances into the railroad stations are guarded by the military police. With our bundles, we looked pretty noticeable. But we managed to lose ourselves among German refugees. We jumped into the first train leaving the station. We thought it was bound for Denmark. It was, we discovered soon, taking us back to Husum.

2. TOWARDS FREEDOM

About the failed attempt to reach Denmark and how the author and his brother land on a German farm in Schleswig-Holstein. The end of war. He becomes a Displaced Person. Life in a D.P. camp in Flensburg. A desperate journey to the South, through the devastation of war. He reaches Würzburg.

March 24, 1945

Travel, young man, travel...

How happy we were to finally find a place to stop.

Now we are on a small farm near Schleswig, in the village of Neuhof.

Here is a summary of last few days:

Afraid to remain too long in Husum, we departed for Schleswig. There, after a series of adventures, we ended up in a refugee reception office. They ordered us to report to Camp Kottebey.

Camp Kottebey was set up in an old, dilapidated restaurant. Straw on the floor for sleeping, dirt everywhere, every inch of the place cluttered with the "treasures" the refugees are dragging with them.

A circle of elderly men were playing cards around a big wooden table. One stood up and came to us.

"The strong ones were sent to work on fortifications," he informed us. "We've been here for three weeks and we have no idea what they are going to do with us. The children are sick, lice all over the place—this camp is quarantined. You better go somewhere else, while you can."

We were out in the street fast. Back to Schleswig. On our way we wondered why these people ran into the depths of Germany. Why should they run from the Soviets? They are poorer than the poorest of Russians.

Dominykas never stopped reproaching himself for leaving:

"We'll die, we'll all die of hunger here," I can still hear him talking.

"No, we are not going to last, no, brother Lithuanians. What kind of food this is? Tears, only tears. And you work all day long. The tiger keeps watching me, doesn't let me rest. Outside—cold, raining. By the time the evening comes I am frozen like a dog. You tire yourself out, in the smithshop, the muscles tremble. They'll kill me here. Why, why did I run to this kingdom of hunger and death? Nobody would have harmed me there, me, a simple worker. Oh, oh, brother Lithuanians, we are not going to last. We'll die, we'll die here. And you, who are still young and in your best years…"

I can hear him going like this, all day long, all evening. I refuse to listen, I run to my bed, I hide my eyes in a book—and I still hear him, talking to himself. He sits down on bis bedside, places a chair next to himself, and starts chopping tobacco stems. I can hear his knife, chuck, chuck, chuck, chuck. The stems are hard and tasteless, but nobody will give him the leaves, not even the Pole, the little goose…

We spent a night in a German refugee camp. A small classroom, in a public school. Forty people are sleeping in this room. I gasp for air. But it's clean. After all, this is Germany and they are Germans. *Putzen, putzen.* Women, children, old men. No young women. They, too, are in the *Wehrmacht.**

* The regular army.

TOWARDS FREEDOM

When Lithuanians or Russians run—they run with all their belongings. Chairs, beds, barrels, laundry utensils. But Germans run with little suitcases—very neat. Blankets and other basic necessities are given to them wherever they go, at the refugee centers. And no panic. Only apathy, resignation. I am surveying them, in the stations, I am looking at them here, in this school, sleeping now, and they look just like any other traveller, no different. *Hitlerjugend* take them to their assigned places, put everything in order. *Ordnung muss sein.* Order must prevail. Only when you begin to look at their faces, their eyes, you begin to see how tired they really are. There is a death in every family.

Next morning, still asleep, I hear voices in the corridor. A farmer apparently had sent a notice that field workers were needed.

I get up fast and I report to the desk.

"Can you do farm work?" the woman asks me.

"Oh, yes, we are farm boys, we grew up on a farm."

"Fine. We have a truck ready outside."

We missed the truck. We dumped our bags inside the Post Office. I remained to watch the bags while Adolfas went out to look for food.

A weird thing happened, while I was waiting. One of those supernatural things. A very sharp and clear image suddenly appeared in front of me: in the street, on the other side of the wall I was leaning against, a biker was struck by a truck. I saw a lot of red, and the biker.

Same instant Adolfas returned. He said, he found no food, but he saw a dead cyclist outside, right by the wall, run over by a truck. I guess, when you haven't eaten for a day or two, you can see all kinds of things you can't see with your belly full. And if your belly is full, why would you want to see anything anyway.

We walk on foot.

We found Otto Thiessen—the farmer we had to report to—between Schleswig and Flensburg, in the village of Neuhof. The old man is still strong but it's his mother who has the upper hand in the house, and she is really old.

They gave us a small room in the attic. The window (we gave that name to a hole two feet by two) faces to the south. We have electricity (that is, on the ceiling we can still see leftovers of electrical wires...). We also have a separate, "private" entrance (a passage extending through the entire attic, past the sacks of grain, past the scales, past the dusty utensils that have been lying there untouched for two generations, and down the rickety narrow ladder). At night you better be careful if you don't want to kill yourself or lose both eyes.

In our room, on the wall hang reins, bridles, harnesses. In the center of the floor—a pile of barley. The farm is old, built in 1840. One end of the living house looks as if it was hit by a bomb. But in reality it collapsed by itself. Just a pile of bricks and rotten wood. For six years no repairing, according to the old man. Everything's for the war... Otherwise, there are signs indicating that long ago this farm had seen better days. They have electricity, too. And the radio. Newspapers are delivered the same day, from Flensburg. The farm is equipped with all the necessary machinery, most of which I've never seen in my life... Twenty cows, four horses, and a colt.

The old man, we find, is not so bad. His mother is pure gold. She is old, never leaves the house, and she's terribly concerned about us. We are eating as much as we want, and she's still urging us to eat more. She's Old Mother Germany, she's whatever there was good about it.

For a few days our work was to feed the cattle and chop firewood. But now for several days I have been plowing the fields. Adolfas is trimming the hedges, the rose bushes. Very very romantic…

Until I really began to plow I was afraid I would fail the old man. At home, it was always our father or the older brothers who did all the plowing. I was entrusted only with lighter work. But everything went fine. Only the first few feet were zig-zagged.

Plowing requires much more muscle than other farm work. But since they are feeding us well—we'll work well. We are working honestly here, not like at Neunert's. It's not proper to eat and not work, Germany or no Germany, such is a farmer's ethic. The farmer is good to us—we'll be good to him. That's what our mother taught us.

The surroundings are very pretty. There is even a small lake here. But most important: suddenly it's all very very quiet. No visitors, no endless complaints, blabber. And no air raids. Occasionally our ears catch a distant rumble of the bombers—probably they are beating the shit out of the Kiel factories—but a village remains a village, you don't panic about things like that. Neuhof is a real hole. We haven't seen a single soldier yet.

Our first acquaintances: a young Russian war prisoner, sufficiently sympathetic; and a weird looking Pole, also a war prisoner, six years in this village. After his last visit I am missing my pocket watch, it's gone. And there is a lisping plump Russian girl, on our farm. She sleeps in the same attic, but separated by a thin wall.

At the eating table we are five. The old man practically doesn't eat; the grandmother has no appetite; the lisping girl only picks, like a chicken. We two are the only eaters. We clean the table like locusts.

I HAD NOWHERE TO GO

April 15, 1945

We are working for Thiessen and waiting for the war to end. During the last four weeks the Allies have moved forward in big jumps. Köln, Essen, Kassel, Hannover, Bremen—they are all gone. One hundred kilometers to Berlin. I haven't seen Hamburg mentioned yet but the rumor is going that Hamburg is *kaputt*. Schleswig-Holstein has been cut off and they are beginning to close in on it. Two days ago they smashed to dust the airport ten kilometers from us. For a few hours it sounded like hell. I was plowing the field, so I pulled the horse under the hedges and let it go free. The bombers were going right over our heads, right over the rooftops. During the night they repeated the bombing. One stray bomb fell on the edge of our farm.

The farmers are waiting for the British. They say, it can't be any worse. Everything is rotting, falling to pieces, buildings, utensils.

I got mad on the old man today. It's Sunday, it's the only time that we have for ourselves, but he runs up to our attic and says, come down and rake the yard, it will look better. To hell with beauty! I have no time to think about the prettiness of your yard on Sunday, I have to read Hölderlin! Why didn't you ask me to do it yesterday? No time for rakes and brooms. Just wait, the British will come and rake your ass with bombs.

But I drop everything and I climb down and clean the front yard. After all, the British are only in Hamburg.

Went to Schleswig, with the horses and wagon, for the army transport works. The yoke broke in half, they loaded too many *panzerfaust* bazookas into my cart. I left the cart with the fucking bazookas on the road and rode the horses back, it took me all night to reach home. The old man was angry like hell, why is the mare out all night, the colt is wheeling in the stable, wants milk. It's

60

your own fucking army, not mine, I say. And it's not my fault that your tools are falling to pieces. Yesterday, while plowing, I broke another yoke. The horse just pulled a little bit stronger over a stone and—pop! His fields are full of stones, a devil would break his legs here. Now the old man is angry with me. The only thing I have on my side are the British.

We get up at six, before sunrise. We feed the cattle, we clean the stables, we brush the horses, we pump the water. That keeps us busy until breakfast.

Our breakfast at first was only some black coffee and a sandwich. But when the grandma noticed that we are good eaters she added a plate of barley soup. The thing that we can't understand is the milk. Twenty cows—but they wouldn't give us even a drop of milk. Everything goes to the milk center. It makes us mad. Adolfas now found a way to the milk while it's still in the stables, he drinks directly from the milk pails. What can you do if the old man is scroogy even for himself: everything's for the war. He never really eats. A spoon of this, a spoon of that—and there he sits, hands in lap. He makes us very uncomfortable. So we throw our spoons on the table and go. We have learned to eat very fast. Still, it's difficult to compete with him.

After breakfast we go to chop firewood. After that, one of us usually has to help in the vegetable garden, the other at field work, usually plowing. Until now all field work and the care of horses was my department. As of yesterday the old man switched us around.

At noon we eat. We eat well, especially when they leave us alone at the table.

After that we have half-an-hour free time—unless we have to go to the barn to do some threshing. Otherwise,

we climb up to our attic and we stick our noses into a book or a dictionary. Then—back to the fields. From four to six we feed the cattle. At six we eat. The rest of the time is ours. We climb back into the attic and we stick our noses into the books again or we sit and memorize words.

The mailman brought yesterday's *Flensburger Nachrichten.* A large headline tells us that Roosevelt died. The paper doesn't fail to tell us that Roosevelt was responsible for this whole war... Truman is now President of the United States.

Easter Day passed unnoticed, like any other day. You need children around to make Easter look like Easter. Children are the true choreographers of Easter.

April 17, 1945

Suddenly it's Spring. Everything's earlier here than in Lithuania, because of the sea. Only the nights are cold, full of icy winds.

Adolfas is plowing, and I am working around the house or flattening the molehills. I am working with an old, skinny, blind and deaf horse some refugees left on our farm. I can't make him understand me, no matter how I talk or shout at him.

It makes me mad, to work like this, to slave.
Everything's so senseless.
There is so much to read, to learn, to see, to live. And here I am, pushing a wheelbarrow full of cow dung, working for a German. And for no pay.
And the time goes.
I've never appreciated time as much as I do now.
It's difficult to read, you can't concentrate, each thought runs its own way.

TOWARDS FREEDOM

Now even during the day there is no peace. The bombers are flying without interruption. It's becoming dangerous to work in the fields—sometimes they spray us with bullets. When I see a plane coming I drop the horses and run to the hedges.

I am working on a farm. I am dealing with earth, fields. It is the most honorable of all occupations. Goethe, Rousseau, Voltaire... All the romantics praised it. Drop your culture and return to earth; plow the fields, plant gardens...

Yes, but when this most honorable of human occupations is forced upon you, then there is no pleasure in it. The civility of the land and the barbarism of humans just do not blend.

April 22, 1945

Yesterday our old man's brother appeared on the farm. We didn't even know he had a brother. An engineer, from Berlin. He says, everything's lost, everything's *kaputt*, Berlin is about to fall any day.

I remember reading Hamsun and Gorki and London, and I remember envying them, envying their universities of life...

Yes, we too are going through our universities of life, blown left and right by the winds of war—but we hate these universities!

Instead, give us the universities of Erasmus, of Giordano Bruno—universities with books, not universities of bombs.

In our attic it's dark. I can barely see the north wall on which hang the towels and our work clothes. By the south wall, by the little window, a large bed, we both sleep in it. This bed is also our table and our chair. In the corner a shelf on which lie our books and papers.

A pitcher with drinking water, a stool with a large bowl for washing our faces—that's our toilette.

From below, through the ceiling, comes the sound of pots and pans: soon they'll call us for supper. But it won't be immediately. Our plump Russian girl came home crying: some neighbors beat her up. Now she ran out again and said she will be back soon, we have to wait with supper. I suspect she is having some trouble with her boyfriend, the Russian prisoner who works on the neighboring farm. He visits her every night, we can hear them fucking behind the thin wall, where she sleeps.

April 29, 1945

This morning the earth was white with snow. Hail is coming down, water everywhere. The cold and humidity is grabbing through the holes of my old pants, open shirt. My feet are freezing.

Below, in the living quarters, we can hear the clock strike six. We get up and we go to feed the cows. We can hear the old man turn over in his bed. His bed squeaks. We drag the hay, we pump the water. Hell, if the brain would get as much exercise here as the muscles do, one could become a genius. The golden rule of Akuraters: God never lacks days, and the farmer never lacks work*.

We are chopping firewood. Yesterday we cut down a tree. In the woodshed, a hen got into the habit of laying eggs—so now we have our own egg supply. We suck them raw, through a little hole, like weasels do.

The old man is very disappointed in us. He says, he has to teach us everything: how to hold the rake, how to hold the pitchfork, how to hang an empty sack on the wall, how to prepare a stake for the peas, and so on and on. His German pedantry doesn't permit him to allow us

* Janis Akuraters (1876–1937), a Latvian writer.

do things our own way: it must be always done his way, to the smallest, insignificant detail. If you don't do it his way he calls you an idiot or a barbarian. His favorite word is barbarian. "Lithuanian barbarians," he calls us.

The British are slow in arriving. Only a distant and constant rumble in the south. Two days ago they wiped out the village next to ours. I don't know what was in it. All our windows fell out. Now, for the second day, it's overcast and raining, no bombers. As for the German planes—we haven't seen them for weeks now. Mornings, in the fields we find newspapers and leaflets the Allies drop from planes.

May 8, 1945

We are cleaning the stables, moving out deep layers of manure. We load huge cartfuls, we walk knee-deep in dung.

It's spring. The hedge rows suddenly opened up green, exploded. Wherever we go, all the hedges, all the road-sides, everything's blooming.

Five days ago Germany capitulated to the British and the United States. We found out today. But the Germans in Berlin are still holding against the Soviets.

May 9, 1945

Our plan is to spend another two weeks here with the Thiessens. Around us it is still very chaotic, nobody knows what's what. In two weeks things should become more normal, more clear. Then we'll go to Flensburg, to sniff around. Our main concern is that the British stay where they are, and wouldn't permit the Soviets to sneak into Schleswig-Holstein.

It's the height of spring and there is a lot to do. We are working fourteen hours a day. Beautiful, the spring all around us, what more should we want?

But we are working and our heads are full of plans. We are not thinking about the beauty of spring. We are thinking how, through Husum, we could get over to England.

May 19, 1945

The last day at Thiessen's. Monday, that is, after to-morrow, whatever happens, we are going. The other day I walked to Flensburg to look around. A whole other world! There is a feeling that the war really has ended. The sun is shining, everything's blooming, another spirit, another rhythm. The roads are full of people. War prisoners and forced labor workers sit around the bar-racks, waiting for the news about going home.

The barracks, how ugly they look now, how bleak. How heavy their rhythm is next to the new life that is beginning to open. Their gray lumber walls, their double bunks, their sweaty, lice ridden mattresses.

The roadsides are all abloom. A sea of white blossoms. And the lilacs. On the roads—little groups of tired, uni-formed men, going home. They are not marching: they are just walking. They'll walk hundreds of kilometers, to the south. Every ten kilometers—small British military detachments.

In the bushes that run from the lake up to our house, nightingales are making a lot of noise, all night long. The soft cooing voices of wild pigeons come from the trees. I am walking across the clover field, wet, covered with dew, with the bridle over my shoulder. I am looking for the horses. I can hear their snorting behind the bushes. The sun just finished rolling out from behind the hill and the morning is exploding over the field. Ah, there you are, Blackie. You are running away from me, afraid of

the plow... Ah, you'll have to do it, I'll catch you, Blackie. And what is the colt doing? He is lying in the wet morning grass and is moving his head now one way, now another. A smart, beautiful head.

Ah, what a difference to walk across this field, now, when I know that it is my own free choice to do so!

May 23, 1945

Two days ago we left Havetoft. The old man's brother took us to Flensburg.

Oh, there is nothing as beautiful as a horse-and-buggy ride. No train, no automobile can replace it. Blackie is running a light step, everything moves past us with the same light, meditative clip—fields in full bloom, acacias, lilacs, the hedge rows, the plains, the marshes, the clay hills. Blackie is carrying us past it all, into our freedom, into the unknown.

We are taking all our belongings with us. Six tiny bundles. The first one contains a sack with blankets and some clothing. The second—heaviest of all—is a bundle of books. Two small suitcases with basic necessities such as shirts, some food, scissors, dictionary, two cups. A satchel with manuscripts. That's all.

Our uncle, seeing us out, that day, he said: "Oh, you won't get lost. Good people will always help you out as long as you are good yourselves." We have been trying to follow his advice, and it has been going well, so far. With Germans, be polite and honest, and be so all the time—and you'll have their respect. How many times I've heard people cursing the Germans, all Germans. Maybe it's our good luck. I guess, it is. The Thiessens saw us out almost like their own children. The old grandmother, she almost cried.

I HAD NOWHERE TO GO

May 29, 1945

We are at Camp Mürwik.*

We are with the Baltic refugees. There are over forty Lithuanians here and many Estonians and Latvians. We sleep on the floor, on blankets. No beds.

Again we are in barracks. But there is a difference now: the war is over. Everybody's in high spirits. And they give us more to eat. Every second day, besides our regular daily rations, the Red Cross gives us 300 grams of black bread, 50 grams of butter, plus some biscuits, marmalade, chocolate.

They moved the German sailors out of the barracks next to ours. They didn't allow them to take any of their belongings. You had to see how the inhabitants of our barracks rushed for these miserable "treasures." They are dragging, they are carrying anything they can lift, like ants. Shoes, rucksacks, cigarettes, beds, chairs.

Right now they are after the cars. It's an epidemic. They found one in the forest, and they drove it in. Now they all want one. A bunch of them went out, to a German

* These camps became known as Displaced Persons camps, or D.P. camps. They were established by the Allied Forces to accommodate 8,000,000 forced laborers, survivors of KZ camps, war prisoners and political refugees (mainly anti-Soviet), liberated by the Allies. Within a year after the German surrender some 6,000,000 of them returned of their own will or were pressed into returning (as some of the Soviet war prisoners were) to their respective countries. The other 2,000,000, among them Lithuanians, Latvians and Estonians, refused, mainly for political reasons, to return to their homelands, now occupied by the Soviet Union. The United Nations created a special International Refugee Organization (I.R.O.) to take care of the political refugees. Although there were no restrictions on the movements of the refugees, every refugee had to belong to a D.P. camp in order to receive food and lodging, and to receive assistance with emigration.

farm, and simply drove the German's car out of his garden. A hundred yards further they rammed it into a tree and left it there, smashed. Now they are hunting for other possibilities.

Yesterday, the last French prisoners left our barracks for home. Tomorrow the Dutch go and a few days later, the Russians.

How happy they are to be leaving!

I am looking at them. No, they don't look like slaves any longer. They are slowly regaining their lost centers. It will take a long time to heal all the wounds, many deep, invisible wounds—but who wants to think about that now? Their eyes are focused on their homelands. Their voices are exulted, their faces. I see it all, and I silently reflect on my own state. Ah, what will happen to us? When are we, Lithuanians, going home? No ecstasy in our faces.

I am sick of their talking. Banalities. Eternal complaining even now. They are driving me out of my mind.

Terrible noise in our room. Can't read, can't write. Maybe I should get up earlier. I could write while they sleep.

June 3, 1945

Yesterday we celebrated the birthday of George VI. This is our first contact with a King. On that occasion they gave us a bar of chocolate each.

We are getting more to eat now. Still, that doesn't mean that we are eating normally.

Stasys works in a butcher shop, for the Army. Every evening he brings home a few pounds of ham and sausages. He goes to work in a special suit, with oversized pants, and long boots twice his size. He comes home with sausages and hams tied with strings around his legs.

The only money now is cigarettes. A loaf of bread costs ten cigarettes. If you have some vodka—still better. For example, a bicycle costs two bottles (small) of vodka.

You can't buy anything in the stores, with the permit or without the permit. The stores are empty.

On the roads—long lines of German war prisoners. Some of them still carry their guns. On the roadsides huge piles of guns and ammunition rust. Iron and steel junk piles. Collapsed trucks. Tanks. Big guns.

There were several German families, refugees, staying in our barracks. Today they were thrown out. Go where your legs will lead you, they were told. So they packed up what they could carry, took their children by the hand, and walked out, to look for better people.

We are still sleeping on the floor. When you get used to it—it's very fine. Only during the night you have to be careful that nobody steps on your head.

June 9, 1945

The last Russian war prisoners left our barracks today. For home. The "official" communists are leaving in raised, or more correctly, loud spirits, cursing Germany and all those who remain in it. Others are more silent. There are rumors that those who refuse to leave are taken by force. Some, they say, have been shot by *politruks*. Still others have committed suicide. If you don't want to go home—you are an enemy of the State. A simple logic. The British and the Americans are playing "neutrals," permitting the Soviet army to manipulate the prisoners.

Dimitri, from our barracks, racked his brain the whole week. To go or not to go. In the evening he decides one thing, in the morning another.

TOWARDS FREEDOM

"You know, I can't sleep at night. All night long I am thinking, thinking. And I am not any wiser, I can't think it out. You understand—at home: wife and children. I haven't seen them for four years. I have no news about them. I will go, what happens—happens. I am a simple worker. And even if they take me to Siberia—Siberia is also Russian land..."

This morning he made up his mind, collected all his things, and walked out, still thinking, loud:

"I'll go home. Ah, in what times we live! Four years I slaved, like a dog. I didn't come here of my own free will: they brought me here directly from the battlefield, I defended my country. And now, when we have been liberated, I am afraid to go home. What times! You won't understand how I feel, what's happening inside. You go home to your own country trembling, even if you know that you are not a thief but only a poor sailor."

Lithuanians are afraid that the Allies may send them home by force. Some didn't sleep in the barracks last night.

The barracks—noisy, too many people around. I can't write, I can't read, I can't think.

I walk out into the fields.

I'm going through disturbing changes.
Maybe it's my mind, maybe it's my nerves.
Very little firm ground left under my feet.
Everything's moving.
I argue a lot. I am criticizing everything. I disagree.
The things I believed in are in a shambles.
I don't believe anymore in any final, categorical ideas.
I prefer chaos, anarchy.
I am reading Lessing, Hegel, Nietzsche, Hölderlin, Spengler.

Sometimes we go out into the fields. It's beautiful around Mürwik. Harbor. We walk, we look.

June 15, 1945

I am beginning to find out that most of the Lithuanians we are meeting here in the camps, came here, to Germany, by their own choice. They weren't brought here to work in forced labor camps. A good number of them served in the army—in the German army. No good Lithuanian went into the German army. Only the criminal and idiot types joined it. In the neighboring barracks there are over twenty such "soldiers." Day and night they play cards. When they don't play cards, they go to look for "treasures," as they call it. By that they mean stealing from Germans. They steal everything: bicycles, cars, pigs, chickens—anything they can get their hands on. I am aware that many young Lithuanians were actually force-drafted into the German army, Germans did that in all their occupied lands. But these people, here, that I meet now, admit that they actually did it by their own free choice. And they brag about their exploits.

I myself escaped the draft only by luck.

The Germans, not being able to persuade young Lithuanians to join the *Wehrmacht*, surrounded the town of Biržai, where I was living at the time, and began a house-to-house search, drafting every young man they could find.

The day it happened, I was at the house of two girls who I was helping with math. A neighbor ran in and told us that Germans had surrounded the town. The girls quickly dressed me up as a woman. My constitution being very frail in those days, the transformation wasn't too difficult to achieve. The three of us traipsed out into the evening and by way of the dark tiny side streets, walked out of the town.

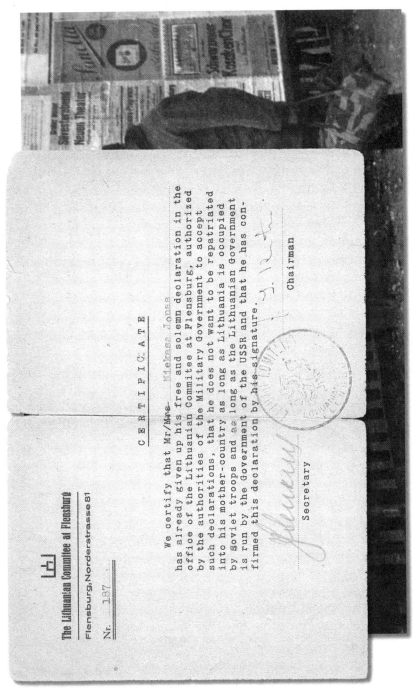

Since not returning home was considered a crime by the Soviets, we lived under the assumed name of Niekasa ("Nobody") in order to protect our parents during the immediate postwar months.

Petronis, one of my closest school friends, didn't have such luck. He was sitting by a linotype machine when the Germans walked in—we were both editors at the local, provincial weekly paper. He was drafted into the army. Six months later he deserted with the gun and all. He was the last person I saw, when I left Lithuania. He was hiding in the village, hoping that his gun would be useful against retreating Germans or the Russians*.

June 24, 1945

Two days ago we left Mürwik. They moved us to Flensburg. Until now the Displaced Persons camps—that's how they call us now—were mixed. Now they are beginning to separate us according to nationalities.

The barracks here are depressing. Gray, dirty, many families are sleeping on the floor. They need 200 more beds. The place is crawling with lice.

In the faces and eyes—hunger. When the Red Cross shipment arrives, they stare at it with hungry, intense eyes. They are ready to start a loud scandal—it happens often—if one gets an ounce less of egg powder than a neighbor.

June 26, 1945

The Flensburg D.P. camp is a huge market. Noisy. The newly arrived are looking for familiar faces. They tell their life stories, their real and imagined adventures. A boxer from Šiauliai is playing accordion. In the room there is no place to turn around, but some are trying to dance.

* In 1971, when I visited my mother, in Lithuania, she told me, that Petronis was shot by the Soviets, together with several other of my classmates. Their bodies were laid out in the town's market, for several days, to discourage "anti-soviet" activities.

TOWARDS FREEDOM

Butėnas, a former teacher, crouched under his bunk bed, is writing. He's writing—so goes the rumor—the rules for an ideal D.P. camp. His head is not very sound, we are afraid. I had a peek at his rules. One paragraph says that nobody should wear a hat in the room. He says, he will hand the rules, when he's done with them, to the Higher Authorities. Now he's writing and mumbling under his nose.

Last night I went to bed at ten. The idea was to get up early, at six. That way I'll have a couple of hours of silence, to work on languages. But at midnight they woke me up. The men sleeping at the other end of the room were in the middle of a violent argument with the men sleeping at my end of the room about the necessity of silence after midnight. I warned them to choose a better time for their discussion.

"Ah, there is one who wants to sleep! Shut up! We do what we want—it's a democracy now."

They put me in my place. I had to shut up. If not—they would have come and turned my bed upside down. It wouldn't be the first time they've done it to me.

July 2, 1945

The barracks are waking up. Along the corridors, with towels under their arms, men are running to the wash house. For the third day, it's raining. We run through water and mud.

Through the streets and parks of Flensburg walks a young crazy German soldier. Often the children surround him and give him military orders. Lie down! Get up! Run! Crawl!

Painfully and conscientiously he tries to execute their orders.

75

But the children have little pity (they are such little nazis...). They tire him out to the point of collapse. Sweating and tired, he executes the orders of his imaginary superiors, his little torturers—and he trembles before them and is full of fear.

July 4, 1945

Today we made up our minds: we have to leave Flensburg. We've had enough. We have to go South. Maybe to Frankfurt. From there, further South, maybe to Switzerland or France.

There are very few trains. We sold everything that would weigh us down and bought two old bikes.

To test the bicycles yesterday we pedaled to Glücksburg, ten kilometers South.

Glücksburg is hidden in the woods. Natural ponds, seashore vegetation, hills. A boat is leaving for Flensburg. On the shore people are waving.

We turn our bikes back. Slowly we pedal, past the blooming trees, past the pine alleys, apple orchards, past the freshly cut hay. Hot highway pavement is melting like silver before us. We are exulted by the feeling of freedom. We feel we are ready for anything.

July 8, 1945

I can neither write nor read in the barracks. The noise is unbearable.

We go into the city.

In the park.

Children are playing in the sandboxes.

They laugh, they jump, they pick up handfuls of sand and are happy.

A little wagon on a string, in the wagon a little bear beats a drum.

TOWARDS FREEDOM

Three German soldiers come. Young, very young. All three with walking sticks, all three have yellow bands on their sleeves, yellow bands with three black dots.

They are blind.

Holding hands, silently, one or two words, slowly they walk.

I can hear the fresh gravel on the path under their feet. Crossroads.

They go to one side: they walk into the flowers. They turn to the other: they walk into the shrubs.

Two teenage girls ahead of them. They take them by the hand and lead them onto the path.

I am looking at the park, the trees, the pond, the water lilies.

On the bench, in front of me, sits a young German soldier reading a book.

Comes a policeman, a white band on his sleeve, he checks the soldier's documents, makes a note, walks away.

A hefty German sits next to me. For the second hour he keeps staring at the same spot. Maybe he's blind. Maybe he's insane. Maybe he's perfectly normal.

Now it's completely silent.

In the very center of the park.

Only the birds are singing.

July 10, 1945

There are twenty of us in this room. The room: a school classroom. On the wall hangs a blackboard. In the corner, on the shelf, a pile of textbooks. We use them for wrapping and cleaning. Nazi textbooks. Pictures of the leaders, portraits of Hitler we are using to keep our mattresses flat.

Most of our roommates are civilian refugees. In the next bunk, next to us, sleeps a taxi driver with his son,

a captain from the Independence Wars of 1918–20, he keeps torturing us with his endless boring stories, from his wars with the Germans, Poles, and Bolsheviks. When he doesn't talk, he's very useful to everybody. He can patch up pants, he repairs shoes, bikes, anything.

They all play cards incessantly. Every day in our room the hard core members of the card player's club gather. From morning till late into the night they work at it, leaning on the table. They lose everything, they gain it back, they lose all over again.

July 13, 1945

Two days ago we tied all our belongings to the bikes and started our journey South.

Everybody's telling us that the trains aren't running yet. On our way out, before embarking on our bicycle journey, we decided to check at the railroad station, just in case. To our pleasant surprise we discovered that the train service had just resumed. So we purchased tickets to Neumünster and boarded the train, bicycles and all.

Everyone warned us not to travel to the American Zone without permits. But when we went to get permits, we were told to come back in eight days.

Eight days! They may drive us out of our minds, in eight days. We must go now! It's time to move South. And so to the South we go!

We were also told that this kind of journey is impossible and even dangerous, at this time. Permits, checkpoints everywhere; no food, no bridges, no trains, and no water.

But luck is with us. Our train is moving ahead. Most of our books, over a hundred of them, we left with a German family in Flensburg. Our train is a livestock transport train. It stinks of pigs and sheep.

TOWARDS FREEDOM

July 14, 1945

The Neumünster station is completely *kaputt*. The entire railroad station area is one huge junk pile. Somehow they cleaned up one track, to allow passage. Other tracks are wrenched into the air, rearing up, next to the mammoth craters. Cars squashed, on top of each other, on their sides and on their heads, jumbled, scattered all over the place. The frame of the station fell on its face, locomotives lie on their wounded sides, some broken in half, helpless, a sorry sight.

Our train stopped in the suburb of Hamburg, some fifteen kilometers from Ochsenzoll where we were told there was a refugee camp. The rails are not fixed, we cannot go further. We load everything on the bikes and slowly move ahead.

While on the train, we were beginning to reproach ourselves for buying the bicycles. Now, seeing how others were dragging their belongings we were happy to have them. In good spirits, whistling and singing we pushed our bikes. On both sides lines of red-brick workingmen's houses, long green lushy tree alleys—untouched by our axes—almost ripe fields, orchards.

Ah, summer!

Ah, freedom!

My bike, with a smaller load, runs quite well. Adolfas' bike is overloaded. One suitcase on the left handle bar, another on the right. He needs a lot of road space, his bike goes where it wants. Because of the suitcases he can't move his legs freely, no clear space for the knees. He pedals with his legs spread wide, a very comic figure.

Very slowly we continue our journey.

We reached Ochsenzoll after sunset. We were happy to find a cup of cold coffee and a bed.

The D.P. camp grounds are neglected, dirty. There they are, sleeping till eleven, their bellies up, spitting at the ceiling all day, all night. And around them—pure dirt. I don't understand how people can live like pigs, refugees or no refugees.

We spat at it and left for Hamburg, to look for bookshops.

July 15, 1945

Met a couple of ex-prisoners from Elmshorn. It seems we left it just in time. The approaching Allies wiped out most of it. Dominykas died of hunger, just as he had predicted. He died one week before the armistice. His body was too weak to hold any longer.

We visited the Hamburg zoo—that is, what is left of it. Cages empty. One chimpanzee survived. Now everybody's around that cage. The chimp is very quiet, doesn't jump around without a reason. With her quiet good eyes she is looking at the circle of men, women and children. "Ah, you fools," she's thinking. "You killed my comrades, you starved them to death."

The gorilla is more agile. He's angry. He hates people. He doesn't look at them. He sends out angry cries, now and then. He's combing his silvery fur and is not looking at the people. He is silently cursing them.

July 21, 1945

A long week.

Evenings, until eleven-thirty they all dance in the camp hall, or they drink. Those are the only peaceful hours in the room. Around midnight, together with all the bad spirits, they gather in the room. Then you better run out, or stuff your ears and retreat into the least ac-

cessible corner. You won't remain in your bed for very long, that's for sure. Those who go to bed before 3 AM are punished. The most common punishment is to pull the boards from under the bed, "to let one down." Arguments, races across the beds, acrobatic numbers. If you try to sleep, as I have tried, they'll step on you at full running speed.

When this creative stage is exhausted, the second stage of the night's program begins: attacks on the Latvians, in the next barracks.

The cause of these attacks is a young Yugoslav, the only Yugoslav left in Ochsenzoll, whom Lithuanians have adopted. He says he's a real Count, and he may as well be one, from his looks. Otherwise he's just a dentist.

The problem is his good looks. All the Latvian girls fell in love with him. So the Latvian men, in order to defend their own honor, are out to get the Yugoslav. Of course, Lithuanians do not defend him because of his women, no: they defend him because he's a dentist. You see, they need him to fix the teeth they lose in their nightly battles. During the day the Latvians do not dare to come into our barracks. But as soon as the night comes they begin to peek through the windows, looking for the Count. As soon as the first heads appear, the Lithuanians spill out through the door and with fists and bed boards flatten the Latvians to the ground. The British MPs come running to see what the racket is all about—but they're always too late, everybody's gone.

Same story every night.

Prostitution is rampant in the barracks. Dr. Vileišis, and Dr. Antanaitis, the two medics working in the barracks, told me that half of the people here have one or another kind of venereal disease. Italians have the highest percentage; next are Estonians; then, Lithuanians.

Every evening they go to Hamburg, to the brothels. But you don't have to go that far. Yesterday one man in our barracks was bragging that he managed to "do it" right here, in our room, while we went out to pick up our coffee, with an Estonian woman.

Our best friend here is the doctor of the Italian barracks, Dr. Antanaitis. At one time he wanted to be a writer, but then he turned to medicine. We do a lot of walking and talking. He even helps with some extra food. He's mainly interested, at this point, in psychiatry.*

July 27, 1945

Finally—we are in Würzburg!
After seven long days and nights without sleep.
The head is dizzy.

A little bit about our journey from Hamburg:
After a full week of trying to secure permits to cross the river Elbe, after one week of incredible bureaucracy, we spat at it and decided to go without permits. All we had in our hands was a filled-out questionnaire, which we signed ourselves; the British captain refused to sign it.

"You cannot travel now. You have to stay here," he told us.

We were angry. We came back to the barracks, looked around. No, we said. We are going, permit or no permit. They cannot treat us like children. We go South. To the South, where the magnolia trees bloom!

* A note made on July 5, 1949: A man I met today told me that Dr. Antanaitis is now in a mental hospital, somewhere in Germany, he broke down.

TOWARDS FREEDOM

Bridges in the rivers. Huge craters on both sides of the rails. Junkyards of dead war machinery.

Only the small towns are still there. Hannover, Kassel, Gießen, Würzburg: completely leveled, gone.

The trains are overcrowded with German refugees. They are going home. Some of them. Others, they are searching for home. They are just going. Anywhere, no matter where, like us. Some carry nothing but a suitcase: that's all they have left.

Then you see others, sitting on the platforms, with piles of sacks and boxes, waiting for trains. The trains are going without timetables, any time. If you travel light and alone, you can, somehow, jump into the train, any train. But if you are loaded with boxes and sacks—good-bye! You may sit on the platform for days, and the trains will come and go. Every train, every car is full. The heat is unbearable. And no water.

Some are returning to their home towns. As the train pulls into the town, they squeeze to the windows, to the door. They search for their streets, houses. But all they can see is a field of bricks. No streets. No houses. And nobody waiting.

A trainload of Russian war prisoners passes by, on their way home. Their cars are decorated with red flags, portraits of all the "saints," *na rodinu* (to the homeland), singing Katiusha, they shake their fists at our train, they shout curses, they stick their tongues out, they throw stones.

On Sunday we came to Bremen. The train stopped a few miles before the station. Had to walk. We sold our bikes in Hamburg. The worst part is that nobody knows where the station is. One gets easily lost in the labyrinth of broken cars and ruins. After walking a mile we sent out a sentry, to climb the mountain of bricks. He comes back and reports that there is absolutely nothing in sight—

nothing to the north, nothing to the south, nothing to the east and nothing to the west. No station. A child who happened to be passing by shows us the direction to the station.

Ten at night we arrive in Hannover—that is, what's left of it. We sleep right there, in the station, crouched on our suitcases, with our feet in the broken bricks. Tired, uncomfortable sleep. All kinds of types slinking around, looking for something to steal. We lie, half-awake, and we listen to the whistles of the locomotives in the canyons of the destroyed station.

Arriving in Göttingen we find out that there is only one small train going from there, once a day. It's only for the military workers. No civilian travelling. You need a special permit. From here on begins the American Zone.

We ran out of our food coupons a few days ago. In Flensburg they've told us that there was a Lithuanian refugee committee in Göttingen. We decided to find it.

We found the Committee. They gave us some soup and a place to sleep. They live like kings here. They have private apartments and their own restaurant. They aren't really refugees: they are kings. Professor Skardžius, the linguist, works for the Committee. It's a closed camp for some privileged refugees, they don't permit new ones.

We revived a little bit.

The next day we go back to the station. This time we manage to get tickets. We leave for Kassel.

In Kassel we ran out of food and water. We walked miles through the ruins of Kassel searching for *Ernähr-ungsamt* (Food Permit Office). Nobody in sight. Only occasionally we met someone, walking through the clay and concrete path dug out across the mountains of devastation. Sometimes on the piles of rubbish we saw men and women cleaning, collecting the bricks, putting

them in neat piles. From another mountain of debris you could see smoke rising: someone must be living deep under there, under the bricks. And here—it looks like there was a church here. Their broken arms pointing upwards, without heads, scattered lie the saints.

I don't have any idea how they're going to clean up this mess. It's easier to build another city in another place, and leave the old city as is, as a testimonial.

All along the road, along the railroad line, countless military trucks, guns, railroad cars, burned out tanks. Persistent young grass and tall weeds are beginning to cover everything. The weeds are reaching up to the backs of the trucks, are growing into the mouths of huge guns. Some burned out trucks have been made into living, or rather "living," homes. Families of refugees, children. On the burned out tanks they are drying lines of clothes. Children are climbing the guns, it's their playground, their kindergarten. These will be the great memories of their lives.

We see many children on the road. Alone. Here is one, maybe ten years old, maybe eleven. A great time to be a child... He is pulling his rucksack with him, trying to hold onto a moving train. We help him in. His father was killed at the front. His mother was killed by bombs. He had to join' *Hitlerjugend*, was taken into the depths of Germany from Strassburg.

"There is one thing of which we have a lot," say the Germans, "and that is time."

"Time will straighten out everything," they say. Nobody's in a hurry. Apathy in their faces, in their bodies.

A young woman, her face looks as if she lived one hundred years.

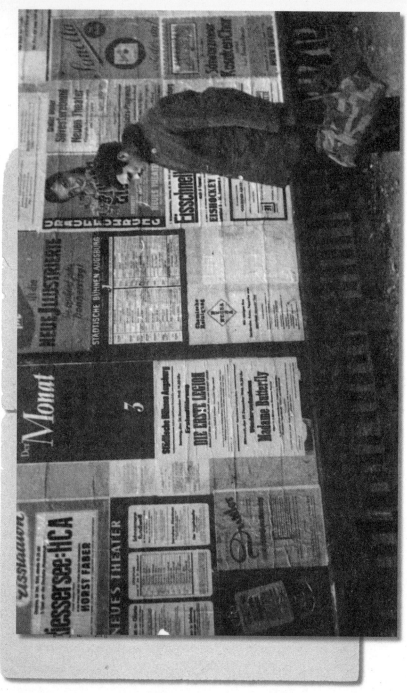

... standing in front of the missing persons boards, searching...

TOWARDS FREEDOM

A young man, his face without a drop of energy. He has resigned himself to his fate.

Oh, yes. Time will straighten out everything.

Time.

He walks around the pile of rubble, picks up a brick here, a brick there.

In the American Zone the railroads are worse than in the British Zone. The journey is much slower. In Münden we have to disembark: there is no bridge ahead of us. The river is there, all right... For two kilometers we drag our bundles, to the other side of the river, across a newly built foot bridge. There we sit all day, waiting for another train. The train comes, we board, we continue towards Gießen. After ten miles the train stops again. We have to disembark. They aren't sure the bridge will hold. We cross the bridge on foot. The train inches across the bridge. It holds. Only yesterday they finished this bridge. Ours is the first train to cross it.

The train is more than overcrowded. People hanging on to the sides, sitting on roofs of cars. Even women with children are on roofs. Long waiting's in stations and before the semaphores. People jump off the trains, run into the fields to pick up some fruit, and jump back on.

Late at night we arrive in Gießen. A huge crowd waiting in the station. Nobody knows when the next train will come or go. You have to wait and be very fast when you hear a train coming. We don't sleep all night. Around three in the morning we jump on a coal transport train going to Austria. That's what we overheard somebody say. It runs via Würzburg, they said. We left Gießen early in the morning. Huge crowds of people on both sides, tired, sleepless.

Transport trains move faster. They seldom stop in stations and when they do, the stops are brief. We covered a lot of distance.

From the coal and the wind we soon became completely black. The coal dust got into everything: our clothes, our bags, our hands, our skin. We tried to hang to the outside of the car, but in our sleepy, tired state it was too dangerous. We crawled back on top of the coal pile.

Near Hanau we decided to jump off. It became too unbearable. Our lungs were full of coal dust. We were spitting pure coal.

We found ourselves near a small, dirty stream. We washed ourselves as much as we could. Still, we looked like chimney sweeps. The hunger kept eating at our stomachs. On the railroad tracks we found some green apples. We tried to eat them but they were too green, too sour.

We dragged ourselves to Hanau, to the railroad station. We found the station empty and bombed out. No trains. I left Adolfas with the bundles and went to search for water and food. I soon found out that there was no water here. All the wells are contaminated. Signs everywhere: DANGER. CONTAMINATED WATER.

After hours of walking and asking I located the local refugee camp. They told me that there was an active railroad station on the other side of town, a few kilometers further.

The camp looked so dreary, so depressing that I decided we should move on.

The day is hot, sizzling. We are dead tired, hungry, sleepy. Every two minutes we have to stop to rest. Our suitcases and bundles fall out of our hands, our legs sink. We leave a few heavy books on the roadside, including the collected writings of Goethe.

TOWARDS FREEDOM

I don't know how we managed to reach the station. A train was just leaving for Würzburg. We jumped on.

You cannot sleep in the train. It's all standing, and you can't sleep standing. At least I can't. Some do, I've been told. They slept standing in water, working on the Hamburg fortifications.

We pulled into Würzburg early in the morning.

We had barely enough energy left to find the refugee center. There, we collapsed in the corner and we slept, right there, on the floor, oblivious of whatever was going on around us. We slept like stones, all day, and all night.

Slowly, very slowly we woke up.
It was like waking up from a long nightmare.
The sun was hot and bright, the sky was blue.
Around us—hills, orchards.

And the people—they are somehow different here. Not the hard Hamburg types, with their faces full of wind and salt. None of that hard character here.

Maybe the sun, or the orchards—but the people seem to me much more open here, there is more sun and light in their faces.

We walk through Würzburg. We look to the left, we look to the right: it's a desert, there is nothing in sight. Not even a ghost. Nothing moves. Nobody's walking through these streets now, on no business. Not a single sound building in sight. The air smells of smoke, and decomposing bodies, deep under the bricks and concrete. Here are the ruins of a theater; and here are the leftovers of a church. Here, it looks like there was a university here.

I HAD NOWHERE TO GO

August 11, 1945

We decided to remain in Würzburg for a week. To regain our strength.

The refugee center is in the suburb, on the side of a green hill.

Orchards.

The only person we feel like talking to is Butėnas. We brought him a letter from his father, from Flensburg—the teacher who was writing the rules for the ideal D. P. camp...A very bright young man. We talk a lot about languages and literature.*

We are walking through the fields: We climb the hills, we look down into the valley of the Main. Its bridges fallen in, a maze of steel and iron.

Steep slopes, vineyards run down the hills, summer.

I am sitting on a hill and I am looking down.

Würzburg below, in ruins, a river, a blue mist covering all. Ah, how different is this landscape from the landscape of my childhood!

Breathing heavily I climb to the very top of the hill.

* He was shot by the Soviets around 1950 while attempting to bring a message from Lithuanian anti-Soviet partisans, out to the West, while crossing the boarder from East Germany to West Germany.

3. LIFE IN A DISPLACED PERSONS CAMP

The author settles down in the Wiesbaden D.P. camp. Editing the camp's daily bulletin. The growing disillusionment with the Big Powers, hopes dim for a quick return home and for a free Lithuania. Miseries of communal living. The cold. At the University of Mainz. About eating unearned bread without feeling guilt. The camp is transferred to Kassel. Days of hunger and travel.

August 12, 1945

We eat and sleep in the refugee transit house.

There are no beds. We sleep on the floor.

Our "mattress" neighbor has been just released from the German army. He says, he was drafted during the last month of war. Twenty six years old. In his muscle sits a bullet.

"When I go home to my father," he says, "I'll be a perfect barometer, the bullet always tells me the weather."

In Italy, he says, Lithuanians used to desert from the *Wehrmacht*, run for the mountains. But without any contact with the Italian partisans, tired and hungry they used to come back again.

Regaining our strength, reviving. Making plans.

Our first thought was to try, again, to go to Vienna. But they tell us that Austria is keeping out all refugees. Our second option is to go towards the Rhine. We are leaving tomorrow. Everybody tells us to stay in Würzburg. But we say, no, it's too depressing to stare at the ruins all the time.

I HAD NOWHERE TO GO

August 13, 1945

We arrived in Mannheim.

We slept in the basement of a bombed out factory, in the suburbs.

In the morning we took a trolley towards the center of town.

In Würzburg we ate too much butter and too many apples. My stomach gave up. I vomited all the way. I thought I would die. The Germans were urging me to go to the hospital, but I survived.

We found the barracks of the local refugee camp. No, they say, they have no room for us. We are welcome to stay and live in a room with twenty others, but a room just for the two of us—that's ridiculous.

We took the trolley back to the station. Our minds are made up: never never again do we want to live in a communal room. The war is over, gentlemen! We want our privacy! Privacy will save the world.

August 14, 1945

Arrived in Heidelberg. Once you leave organized D.P. camps, nobody gives you food. We are hungry, our heads are dizzy. But at least we are free. At least we know why we are hungry. We figured we can last 3–4 days without food. On the fifth day we must find a place to settle down.

Ah, Heidelberg!

Ah, what a good feeling here.

Ah, mountains, hills, bridges, the Neckar!

Many bookshops. But our rucksacks are too heavy already. Ah, how we'd like to have all these books. But we can't carry them with us.

We sleep at Marienhaus, Luisenstrasse.

LIFE IN A DISPLACED PERSONS CAMP

August 15, 1945

All day we wander through Heidelberg, drinking it in.

Here is a board with an inscription. In this house slept Goethe. And in this one, during his professorship days, lived Hegel. In this one—Brentano. And in this one—Hölderlin.

The university is still closed. It's going to open soon, we were told. We asked if there is any way for us to get in, to register, and get food. No, nothing doing. Only the medical department is open. But ready as we are, for anything, we don't feel we are ready for medicine.

In the afternoon we leave for Frankfurt.

We sleep in the station's bar. Somebody is playing accordion. Some are dancing. Others are drinking beer. Still others are sleeping. We put our heads on the table and sleep.

August 19, 1945

We are in Wiesbaden.

We decided to put end an to our travels. We just can't take any more. We need rest and food.

The first impressions of Wiesbaden helped us decide to stay. White. Sunny. The Rhine is nearby. Orchards. Vineyards.

The D.P. camp of Wiesbaden is a city in itself. Army barracks. There are over 1600 Lithuanians here, several thousand Poles, Latvians, Estonians and Yugoslavs.

All rooms have been taken. They gave us a room with six or seven other families, but no beds. Since we promised never again to live in a communal room, we established ourselves on a large table, in the corridor. It's a large table used to distribute the food. A ping-pong table of sorts. A good table. Since all the windows in the corridors

93

Wiesbaden, Displaced Persons camp

have been blown out by the bombs, we have a lot of fresh air. At night a strong cold wind comes from the Rhine valley and blows around our heads. But it's fine. What matters is that we are free!

In the morning, with the first noises, we get up, take our bundles under our arms, and we go. Cheap and practical. We have become the talk of the barracks. Some tell us it's no good to sleep like that, not healthy. Come, boys, they say, we'll make room for you inside.

But we prefer our corridor table.

"How can you sleep on such a hard table?" they ask us. We have no mattresses.

"Ah, the boards of this table are sweeter than your noisy company!"

On our arrival in Wiesbaden, they, stopped us at the camp's gate. An MP came up to us, looked us over, called for help. "Take a good look," he said. "See what's in those suitcases and bags."

They open one bag—books. They open another—books... They open the suitcases—more books.

They are shaking their heads. They don't understand.

"Where are your things?" one asks.

"We have no things," we say.

We point at our books, we say these are our things.

They look at us as one looks at the insane, they shake their heads again.

"O.K., let them in," says the MP.

The food is better here. Yesterday they gave us 200 grams of bread, five biscuits, half a bar of chocolate, and some egg powder.

The worst part is standing in lines. You have to stand in line for everything. If not—you won't get anything. It gets on one's nerves. Sometimes I feel like climbing the walls. Particularly when some former bureaucrat or

member of the "intelligentsia" (of the free, independent Lithuania) begins to argue and shout because he got one ounce less of egg powder than his neighbor. Look, how they stretch their fingers, with their miserable bowls. Look, how their fingers tense...

The intelligentsia, by the way, is a breed I have never seen before. I think it's the invention of the Soviets. They split the population into the workers and the intelligentsia, the friends and the enemies. Now, somehow, all the bureaucrats decided that since they aren't workers they are, of course, intelligentsia, whatever that means. It doesn't mean anything good, from what I can see.

The most popular entertainment here is soccer.

On one side of the field, the Poles are watching; on the other, the Yugoslavs. If the Yugoslav team succeeds at kicking in the ball—the Yugoslav side of the watchers gets wild. They shout, they shriek, they gallop across the field, they jump up and down, they throw biscuit boxes in the air. Over the field rises such a thick cloud of dust that you can't see further than ten feet.

If the Poles score the point—the Polish fans go wild. I have no idea why they don't crack their skulls, with all the things that are being thrown around. As for myself, as soon as I see one side scoring, I give my legs full freedom to run. Then I stop and I look back at the battlefield, at the cloud of dust covering the field, listening to the sound of falling biscuit boxes and the most excellent collection of curses in Polish, Yugoslav, German and Russian tongues.

In the evenings, in a huge army barn which they call the "auditorium," they have their "cultural" evenings They run across the stage, they shout. The "soloists" sing with their groggy voices. The orchestra bangs and tor-

tures mazurkas. Chopin turns in his grave and grinds his teeth. The audience cries where they should laugh, and laughs where they should cry.

We have learned to eat like snakes. When there is something to eat—we eat enough to last for a week. When there is nothing—we don't eat. Now, when we get our food supply, we eat it all, right there, we leave nothing for tomorrow. Like the birds. And then we read our books. We go after spiritual food...

From morning till noon they talk here about what they're going to eat at lunch; from noon till evening they talk about what's coming for supper. Sometimes I am not sure where I am. I feel like I am in an insane asylum. Particularly when I begin to look at their faces, or talk to them. One of them comes, sits next to you, and begins to tell you his wartime experiences. It's not important, it doesn't matter at all whether you answer or not, listen or not. Their wives sit on the sacks of belongings they took with them when they left Lithuania. They never leave them out of their sight. Most of them are small government officials from the old, independent Lithuania. Government workers, teachers, army captains, town mayors. I know, they are just the kind of people that the Russians would immediately send to Siberia. Still, I look at them, I listen (sometimes), and I can't help thinking: my God, they are crazy. These were the people who governed Lithuania! These are the women who taught and educated the children of Lithuania, the children who are now plundering whatever comes within their reach.

August 21, 1945

Finally!

Finally we have a room of our own, just the two of us. And a bed, a table, two chairs. A real room which we nailed together in the attic of building "N." Now, after a full day's work, we are sitting—for the first time since we left Lithuania—we are sitting at a table covered with books and papers knowing that nobody's staring at us when we read or write, nobody's shouting and screaming. The monsters of Bosch are gone.

It all came about when the Yugoslavs left. They were moved to some other camp. The Lithuanians took over the three army barracks. However, we were too slow: by the time we arrived, all the rooms were taken. So we climbed up to the attic and, from boards, scraps and ends of wood we nailed together a little room for ourselves. We even have a window, to the south. When we look at it from the outside—it looks just like an oversized dog-house. But from the inside—ah, it's fine, very fine. Through our little window we can see the Rhine. A table covered with books and papers. A bed. Two chairs.

August 25, 1945

Our Paradise Regained lasted only two days.

Seeing what we did in the attic, and liking it, more people moved into the attic. This is the sad fate of all pioneers... The worst: on one side of us now lodges a woman teacher of sorts; on the other side—sort of an actor. They both sing cheap popular songs, they both sing terribly, and out of tune. And they sing day and night.

We are looking through an old issue of *The Herald Tribune*. We are looking through the ads. A sofa costs that

many dollars. A suit that much. A suit for the summer. A suit for the winter. A suit for the fall. Hats cost that much.

We are looking at our "suits," at our hats hanging on the door, all battered.

The seasons of the year!

Here we are, in the middle of summer, wearing the same clothes we wore in winter. The same black shirt, the same army shoes. Socks—I do not remember when I had socks on my feet. I have one pair, but I am keeping them in my suitcase, I don't know why, maybe for my wedding day. And I still have the same gray hat my brother Petras gave me when I was leaving. I wear it in the sun, I wear it in rain, I wear it in winter, and I wear it in the summer—everywhere, and always. It gets dirty—so I beat it on my knee or on the table edge, and I put it back on my head.

October 11, 1945

Got involved. Permitted myself to be persuaded to act as liaison man for "artistic" activities in the camp. I don't know how I got involved in it. Everybody refused, so I said, O.K., I'll do it. Now I am wasting a lot of my time organizing music and literary evenings, organizing students. As if that wouldn't be enough of a punishment, I agreed to act as editor of a daily information bulletin. It's a mimeographed sheet of sometimes two, sometimes four pages. A lot of detail work. My helpers are Algirdas Landsbergis, a young poet from Kaunas; Vladas Šaltmiras, a student of Slavic languages and literature (who constantly recites Pushkin, he knows him by heart); Antanas Bendorius, a professor of geography; and Prof. Česnulevičius. Their function is basically simple: to listen to the radio (which they do anyway) and write down all the "interesting" news. I myself collect the "local," camp

Back row: Adolfas Mekas, Vladas Šaltmiras, Algirdas Landsbergis; front row:
Jonas Mekas, Leonas (Leo) Lėtas—Wiesbaden D.P. camp, 1945

news. Every Saturday we bring out a larger issue, with a "literary" supplement.

We are still in our attic.

The weather got cold. A thick mist seeps through the cracks around the window. Without an overcoat (which I bought yesterday) it would be impossible to work.

Nights are cold, very cold.

Our neighbors have jobs with the American army. In the evening they come home drunk. A lot of singing and hollering.

Yesterday I saw Chaplin's *Gold Rush*.

Slowly, slowly the war misery is leaving the body and spirit, slowly.

No date, 1945

I prefer to go into the future blindly. I do not want to take any of your junk on this blind journey. This blind journey is not of my choice. The generation before me, your generation, the generation that put me on this journey, didn't produce any reliable maps or compasses I can trust.

No, I don't want any life preservers.

I plunge into the deepest unknown.

Those who are afraid—let them cling to the carcass of Western Civilization.

Lithuanian women, a truck full of them, single and willing, went to the army barracks to entertain American soldiers.

They found black soldiers mostly, left behind at the barracks: the white soldiers had gone their own way, with German women...

So they spent the evening with the blacks. Got drunk.

At some point, two dogs began to fight, outside the

barracks. So the drunk soldiers left the women alone and gathered around the fighting dogs, urging them, very excited:

"Get him, get him!"

"Bite, bite!"

The women waited for some time, then they went back to the truck and were driven home.

June 1946

I wasted eight months editing the camp's daily bulletin. Now—it's finished. I quit.

In May, Adolfas and I registered at the University of Mainz to study philosophy.

Why did I choose philosophy and not literature? I don't know.

You can't learn to write in universities.

Of course, they can't teach you to think, either.

Every day we take the Mainz-Kastel trolley. One hour and a half one way; one hour and a half the other. Five to six hours at the university.

The worst part is that if I go for the 9 AM lecture I have to kill time until 3 PM for the next lecture. So I walk through the town, or I sit in on any lecture, in any department. Medicine, or art history (I sat through a series of lectures on the cave of Altamira). Shakespeare. Some Swiss professor has a series on Joyce, I sat there. Anything.

We eat once a day, in the morning, and take some sandwiches with us, for the rest of the day. We eat them with wine, in town. We arrive back home late, tired like dogs.

LIFE IN A DISPLACED PERSONS CAMP

MEMORY

Summer evening.
We are sitting under the lilac bushes, on a wooden bench.
We can hear a motorbike, somewhere, very far away, in another village, behind the river.

Spent a few days in Tübingen. I stayed at the Gasthof zur Linde.

Snooping through the bookshops. Rich in religion and philosophy. No money to buy any. I was amazed, how much one can get from a book, just by holding it in your hands, looking at a page here, a page there. There are many ways of absorbing a book.

I tried to enlist in the Philosophy/Theology department. Failed. They told me to come back in two weeks, the head of the faculty was out of town, it's he who makes all the decisions.

Visited Heidelberg, Stuttgart. On foot.

Walked through the villages, orchards, dusty little roads. Slept in the triple-soft beds in small Bavarian villages, in rooms smelling of two centuries.

June 1946

We are sitting and talking about what we'd do if we were to come to America.

Vaitkus: "I have so much unfinished work. I would work and work and work."

Vladas: "I would eat. That would be the main point of my first day in America. On the first day I'd do nothing but eat and eat and eat. On the second day I'd read Ibsen. But I wouldn't finish it, I'd only read the beginning, ten pages maximum. On the third day I'd work on my English, for three hours…"

The author, April 1946

Puzinas: (putting in order some sheets of paper) "No, they aren't waiting there for that sort of people, no."

Levis: "The first day I'll get drunk. On the second day, I'll sleep with a hangover."

Puzinas: "I'd wash dishes probably."

Giedraitis: "I grew up without sentimentality... Whatever comes, comes..."

In the street, under my window, three old men. One is Lithuanian, one Polish, one is Yugoslav, I think. None of them speaks the other's language. I watch them about thirty minutes, through the open window, and they keep "talking," and laughing. But the only sounds that I can hear are:

"Hmm ... hmm..."

"Ha ... ha ... ha..."

"Hmm ... hmmm ... hmm..."

"Ohoho ... ohoho ... oh..."

They are perfectly happy and gay and it looks to me as if they understand each other perfectly within the laws of their strange Esperanto.

I leave the window and go back to my books, abandoning the three old men to the life of the street.

My political statement/warning to the Big Powers:

"...Giants dwelt therein in old times ... but the Lord destroyed them..." (Book 5 of Moses, 2:20)

Blessed is the yawn, for it betrays our politely hidden boredom.

Blessed are auditoriums in which we are allowed to whistle and boo.

I have seen people made of dreams; but these here are made of boredom.

I HAD NOWHERE TO GO

July 1946

The Poles crashed a Lithuanian dance party. A panic in the barracks… Some are jumping through the windows, some through the door… The Poles are trying to catch the cashier…

The Lithuanian barber announced that he won't serve Poles this week. So the Poles came and turned the place upside down.

MEMORY

green lizards on warm moss

Mouths are atrophying. The tongue is in the process of atrophy. The words—yes, we can still pronounce the words… But we do not know the sounds any longer. Nobody makes any foolish sounds, silly sounds; nobody can imitate (or wants to imitate) birds, animals, nature sounds.

A new thought is like a newborn baby—it can't be brought into the bright sun immediately.

I was wondering today, what would happen if everybody in the Soviet Union would stick to the Jesus principle: give God what belongs to God, and give

Caesar what belongs to Caesar. Would the government need to use all the terrible means it has been using? But while the communists are promoting atheism, they don't realize that they aren't dealing with Christians: they are dealing with pagans. These people—so called civilized westerners & Christians—they don't want to give anything, either to Caesar or God: they want to keep everything for themselves.

LIFE IN A DISPLACED PERSONS CAMP

I hear that word every day. Every hour.
The word is WORK.
And I see a robot.
A steel robot going through its motions.
Ah, time is money!
How much is your heart? I'll buy it.
WORK!
I see millions of slaves digging canals, damming rivers, hacking out tunnels, building roads, sweating in factories,
and the whole globe of earth begins to stir and move like a huge oil drill.
There they make the torpedoes, tanks, atom bombs, needles to stick under fingernails, scalpels to peel the nails off—everything and anything.
WORK, WORK, WORK!
No heart trembles, no hand.
I am getting cold and I am searching for a warm heart, eyes—
but the machines have blended all eyes and hearts and hands into one big molten mass.
THE MASSES.

Stop working! Stop!
Ah, the dry rivers, bare fields, poisoned waters!
Iron dust, bombs falling on a screaming terrified city.
Lay down your hammers, gas pipes, dynamite—
close all the horror factories,
walk out into the fields.
Let everything stop.
Let the grass grow over everything.
Let the snakes and tigers come, and let them multiply.
We are celebrating the death of the robot.

I HAD NOWHERE TO GO

July 8, 1946

The partisans in Lithuania, die nameless for their freedom and for our freedom, while we, here, free, we make sure that someone will carve our names on the side of a mountain before we consider moving even one finger for the sake of others: we have to negotiate the price first, how much we'll be paid. The partisans, they come from earth, and they disappear back into earth, nameless ... so that we could live and earn our hell free.

Why is Petravičius' art so Lithuanian?* Because he is Lithuanian and he is an artist. That's why. How could I tell you why his work is Lithuanian when there is no such formula yet and there won't be as long as Lithuania is alive. Every new artist will contribute something new to it, and will change it, will sculpt new lines into the soul, form and content of a nation.

No date, 1946

It's more difficult for a mother to forget one child than for living humanity to forget all the millions who died in this war.

A German woman on the train from Munich to Frankfurt. She is talking to a wounded soldier.

"I understand you," she says, "I also had a son, he is dead now. I had only one son and he died in Stalingrad."

The wounded soldier is looking at her, listening, but he doesn't seem to understand what the woman is saying. He giggles, laughs. He doesn't understand German.

* Viktoras Petravičius (1906–1989), Lithuanian painter.

LIFE IN A DISPLACED PERSONS CAMP

I am looking at these people, lodged here in these dark corridors, attic spaces, crowded into the tiny rooms, these army barracks, and I am thinking how much they resemble the dusty old useless objects—cast-offs that are usually thrown into attics, or get piled up in corridor corners. Even their conversations do not lift them above such objects. They are all about bread, eating, and some primitive scheming (how to get more food, where to find women). Their faces: when I look at their faces, this could be an insane asylum. Even their songs, they aren't folk songs—they are weird collages of international pop junk songs, never in tune and never in melody. The largest part of their vocabulary is an amazing conglomeration of curses: from their own national vocabularies, tripled and quadrupled now with the best of Russian, German, French and American. So they seem to fit perfectly here, in these miserable bombed-out military barracks. War scrap.

When a crowd of them, twenty or fifteen get together—which in these rooms is very natural—and I find myself inescapably there—I don't know why I haven't lost my mind yet. Sometimes I just run out of the room.

But now, we have what we call our own room, "our own" in quotation marks. The only thing that separates us from them are these thin wooden boards. We can hear every sound behind them, their vapid conversations, jokes, every fart. And nights, when they bring home German and international prostitutes, we hear their fucking too, and we can see their insane faces, eyes bulging out from eating too much fat in the American army kitchens, where they work.

Does the baby, about to be born, in the mother's womb, as we two, as we work on ourselves in this little room—our own little womb—trying to be born for the second time—does an unborn baby hear the clatter and

109

stupidity of the world outside in the same way, through the thin walls of a mother's womb—as we do now, from behind these thin walls—and is it equally upset and does it curse the outside world, as we do? ...

No date, 1946

When my head becomes dizzy from walking back and forth in our ten-by-six foot attic room, I settle down, collapsing into the chair and I begin to look through my books. I try to read, but soon have to put the book down.

I walk to the shelf and check if there is anything left to eat. No, nothing there.

I lie down on the cot.

"Oh, hell, you there, can't you keep quiet there? Who is hollering behind the wall?"—I shout.

For a minute it sort of quiets down. Then they resume it again.

November 1946

When I was a child, I often watched the gypsy wagons roll along the muddy, wet roads. They would sit surrounded by bundles and crates, wrapped up, with their faces hidden, wet, cold, blown by the winds.

But whenever we spoke to them, they seemed to be very happy.

At the edge of the woods, where our village ends, there they used to set up their tents and we saw their fires burn all through the night. A miserable bunch, but they danced and they sang. Their wagons contained all their belongings. They carried their world with them. While their civilized brothers had the rest of it.

In the morning, they would be gone. We used to run, we children, to where their tents and fires had been—but they were gone, and the fires were out.

LIFE IN A DISPLACED PERSONS CAMP

How we envied them of their freedom! We ourselves dreamed about travels, distant countries.

Many years have passed since then. Now I am myself on a train, with only what I can carry along, without possessions and without a country.

I am a gypsy. I am the eternal Jew. I am a D.P.

But I neither dance nor sing.

No date, 1946

Newspapers. Every day I go to the kiosk, I look through the papers, knowing that it's all the same, exactly like yesterday.

The stupid, empty reportings on the political flirtations of corrupt politicians. Giving all that space to them, wasting good wood!

I pick up a leftover of bread from the shelf and I slowly eat it. White bread. They say white bread is good. I don't know. But I know that I don't feel any guilt eating it. I didn't earn it, I didn't pay for it, so I should feel miserable with guilt eating it, no?

No. Such feelings, that kind of guilt has died in me. The idea that one has to earn one's bread... I eat what I get. I eat what they give me. I eat carefully every bit of what I get, knowing that tomorrow they'll give me another portion. Why should I worry about it? Do animals worry about it?

No, this bread doesn't burn a hole in my hands, my consciousness doesn't reproach me when I eat it. It's you who messed up this world, not me.

I lie down on my cot, calmed down now, and fall asleep.

I see people all around me, and their closeness irks and offends me. Their rottenness makes me sick. Their very misery makes me angry.

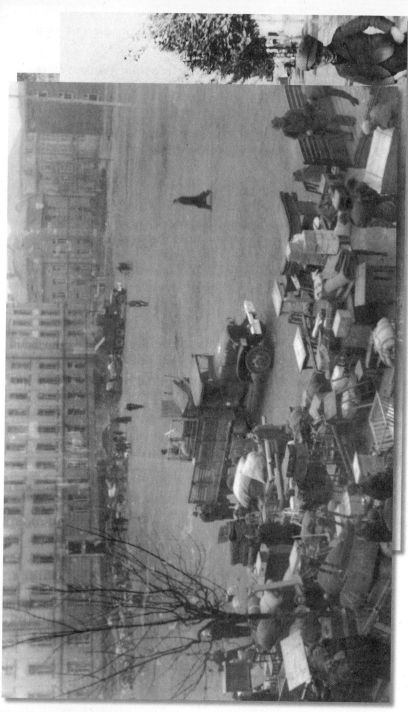

"Good-bye Wiesbaden"

I consider them inmates of an insane asylum. I am in it myself, I have been punished, and the only thing I can do is to try to keep away from them.

I remember seeing people in insane asylums. They always seem to crouch in corners, seeking loneliness. Seeking loneliness in the incredible loneliness where they already are. Are they also trying to escape their fellow inmates, as I am now? Am I insane?

I talk to myself. I say, "God, I shouldn't blame them for being as they are. I know, their bodies are sick, their souls have atrophied; They think it's very normal to steal, to swindle, to cheat, to outsmart, to prostitute, to kill. But terrible things have been done to them."

Whom should I accuse? Civilization? War? Their fathers, mothers?

Ah, whoever it was who invented the idea of privacy, of a private home—was the greatest genius of all time.

But I sit here, alone and in my own privacy and I can't even shout *J'ACCUSE*!

August 1947

Good-bye Wiesbaden.
Good-bye Rhine.
Good-bye orchards.

They moved us to Kassel. Actually, it's a suburb of Kassel, about five miles from the center of the city. In the small town of Mattenberg. Most of the Lithuanians and Yugoslavs from Wiesbaden were transferred to these miserable structures built as housing for workers. We got a room of our own. So that is progress, if nothing else.

The bad part is now we cannot take the trolley to the University of Mainz. We are a ten-hour train ride away. We must stay in Kassel, nobody will keep us in Wiesbaden or Mainz: there are no longer D.P. camps there, they have been closed. They are concentrating all D.P.'s

in certain selected camps. So we have no choice but sit here and think about what to do.

One thing is good: there is a fine American library in Kassel. So we are catching up with literature.

MEMORY

Three miles to school. We walk, stopping, occasionally, by the brooks, to play. After the rain, the rivers and brooks are swollen, overflown, rapid.

Kassel 1947

A big tiger cat is crossing the street.

"Go, go, you thief!" a woman's voice.

"Look at him, that bandit—he ate all my chicks!"

The woman runs into the street, tries to chase the cat. The cat looks very happy, content, doesn't want to run, just walks. Doesn't show any guilt.

The woman goes back into the house.

"Received a letter from America, from my boyfriend."

"Inviting you to America?"

"Yes, wants to marry me. But I say, you'll have to bring us both, me and my father, I can't leave my old father here alone. So he is stalling."

Sound of a plane.

The women are sitting outside by the entrance, on a patch of grass. The wind is swirling around dry crinkly candy wrappers. A woman, with a child, carrying a can of milk. On a lump of concrete in the sun an older man sits, brown jacket, gray hat, he keeps playing with a stick in his hand, age about fifty. Near him two women, with blue kerchiefs, black dots on blue. One is standing, with her hands on her sides, red apron, green skirt. A hen cackles, it must have laid an egg in the basement.

"It's warm."

"Warm."

A man is passing by, I have seen him before.

"I am going swimming."

"Go. What about eating?" the woman says. She is not asking; it's more a statement.

A jeep passes by, a cloud of dust. Somebody's blowing a trumpet, same single note.

A cart with a bag of potatoes. Another plane.

"I have a headache."

"You see, the doctor is stupid. I asked for something for the appetite so he gave me for everything, made me sick."

Lunch time. I see the office workers walking home.

August 1947

Two children, four or five years old, are building something among some broken bricks.

"Look, look, the ant!"

"Give it some poison."

"Ah, it's eating, it's eating."

"Let's go get the brush."

"I have the brush."

"Ah, let's clean it, like this, like this."

"Let them die, those snakes. They bite terribly. Let them die."

"Lizards do not bite."

"Are there lizards here?"

"There are, at the other end. But they don't bite."

"Are there snakes here?"

Now they are throwing bricks at the ants.

"They don't break."

"This is my side. Let's make a garden."

They are working with the bricks now.

"I saw a little snake moving there."

"Where?"

"There."

Both are watching an earthworm now.

"I'll break its neck with the brick."

"I am tired."

"Ah, you want to buy some flour?"

He is rubbing one brick to another and collecting brown dust into a pile. His shirt is red, black trousers, they barely reach his knees. The other one has on a blue sweater, with red stripes on his belly.

"These are good snakes."

"The whole party."

"Those are black ones."

"The brown ones, when they piss on you, it hurts."

"Where did that snake go?"

"Where is it?"

"Gone."

"My room is full of them."

"Look, look, he is undressing."

A man is lying in the sun. He just took off his shirt.

"If he'd take off his pants you could see his ass."

"I'll kill the snake."

Throws a brick.

"Killed."

"Let's go somewhere into the shadow."

"Let's make a bridge."

With a piece of brick he covers the dead ant.

MEMORY

Summer noon. Siesta time.

The older brothers are pulling the net along the river, wading in water up to their chests. We children follow them along the shore, and they throw fish at us, and we collect them in wet dripping bags.

LIFE IN A DISPLACED PERSONS CAMP

A TALE

Do you know the story of the man who could not live anymore without knowing what's at the end of the road and what he found there when he reached it? He found a pile, a small pile of rabbit shit at the end of the road. And back he went. And when people used to ask him, "Eh, where does the road lead to?" he used to answer: "Nowhere, the road leads nowhere, and there is nothing at the end of the road but a pile of rabbit shit." So he told them. But nobody believed him.

(To be continued)

September 3, 1947

I stare through the window.

Should I go to Mainz?

I packed up my bread for the week. Stuck papers into the bag.

But what's there? In Mainz?

Ten hours of slow, hot, crowded train ride.

Occasionally, it's O.K., for a change. It gives me time to be with myself. (I don't see the other travelers, I am oblivious of them.)

Since they moved us from Wiesbaden to Kassel, it takes ten hours to get to Mainz. Once a week I have to come back to pick up the food ration.

Mainz?

We were walking with Vladas through the University grounds and he said:

"I feel good here. Something warm and noble surrounds me when I step into the university."

But I don't give a damn. This afternoon I am going for a walk, through the orchards, into the countryside. The university buildings have disappeared behind my back, behind the orchards.

117

Why should I sit here and listen to some professorial type? Maritain?

A strange hate for these buildings, these auditoriums, these army structures, has suddenly appeared in me. I suspect I hate them because I don't have enough will-power to leave them. Not immediately.

Algis says, don't worry. It's good to have the signatures, he says. Algis is a devil, he tempts. Be practical, he says, a degree may be useful some day, you could get a job in a university.

But I sit here, in this little town cafe, drinking sweet Rhine wine and thinking: What the hell am I doing here? Why do I need a degree? I haven't heard a single sentence during all these lectures that would inspire one single line of poetry.

I read a lot. I listen a lot. I think a lot. But so little remains. The books I read, their plots, their protagonists fade. The university lectures that I had found pretty impressive on first hearing, have faded away. Now I am listening to one on Pirandello. Names of people, books, cities. They are already fading away.

Even the titles of films I've seen just recently—they have already faded. Authors of thousands of books I've read... All that remains are the colors of their bindings, their covers. I don't remember much about *Beauty and the Beast*, but I remember clearly, vividly the heat of the day as we were crossing the Rhine bridge, to see the film. Everything that I see, or read, or listen to, connects, translates into moods, bits of surroundings, colors. No, I am not a novelist. No precision of observation, detail. With me, everything is mood, mood, or else—simply nothingness.

Biaggioni, my Italian professor, asks me, after the lecture: how did I like the lecture? I mumble. Very inter-

esting, *molto interessante*... In truth, I was thinking: how does he dare talk about Pirandello, he has no madness in himself.

Later I was walking the streets, with my head dizzy, my eyes probably idiotic. I passed the students, professors.

Pirandello? No. I am thinking about that linden tree, by the water well. I helped to plant it. Ah, how it grew. Very fast, very fast. Little kittens, in the summer evenings, little kittens used to run up its young trunk, and slide down again, happy, loony. We used to hang our scythes on its branches, in the evening. Huge blue bugs used to plop down from its branches during the summer evenings, we could hear them fall. Our father used to take his siestas in its shadow.

That's what I am thinking about. I remember a lot of things that are of no use to anybody. They keep coming back to me. But I have already forgotten Pirandello's birth date.

No date, 1947

No, I have no thirst for knowing it all.

But I know 1000 songs that I have learned in my village. Their words and melodies are in the deepest atoms of my body.

Professors:

Stand up and shake your bodies.

An invigorating shake.

And then stand quietly and listen.

Can you hear any songs coming back from the depths of your flesh?

No date, 1947

When I review my childhood, when I turn its pages, I revive, it strengthens me.

In the same way I revive when I turn the pages of culture: those are the pages of my other, cultural childhood.

When one grows, one rebels against both...

You want me to be rational. The most rational thing is the machine. Go to the machines. All their separate parts work together. But I live with no purpose, irrationally.

Let us build our houses with our own hands. And grow the wheat, and bake the bread.

Then we'll know what the earth is.

Now, we turn the knob: the water runs. I have no idea from where or how.

Electricity...

We buy the bread: we don't know who bakes it, how, where.

The same with our lives now.

We live, but we don't know how, where, why.

And it has no taste.

October 12, 1947

I told the desk guy to wake me up at eight but he woke me at seven.

I decided to sleep a little more, relying on my unfailing intuition clock.

I woke up at eight, all right.

I rushed to the station, planning to eat my bread on the train. On the train I opened my bag—big holes in my bread! Mice got into my bag at the hotel and ate my bread. Nibbled out all the good parts, left me the crust, not very generous of them.

LIFE IN A DISPLACED PERSONS CAMP

This evening, before going to bed, I hung up my food bag on a nail, high up on the wall. I can't understand how in this clean white empty hotel room there can be any mice. And what's still more amazing is that they find something to eat in postwar Germany. Of course, they thrive on stupid guests such as myself.

Seagulls are crying like crazy over the Rhine. I threw them my mice bread. Not a single piece fell in the water, they caught every piece.

Breakfasted in a small cafe next to the moviehouse. Ate some strange brown soup. Probably they cooked an old rusty nail in it.

Warm, pleasant, brown (Braque).

October 13, 1947

Arrived in Flörsheim with the afternoon train (3:36 from Kassel). Slept at Vladas'.

For the first time, since war ended, they have lights in the trains. I am reading Thoreau's *Walden*.

They are very very happy here, in this village, the little family of Šaltmiras.

But what is this strange smell in the bedroom? Rotting apples under the bed.

October 29, 1947

Ah, what a night! It invaded my room through the open window and woke me up.

I got up and walked out. I walked through the damp blocks of houses, listening to my own steps on wet pavement.

Around me I could hear the silent presence of the autumn. And the wind.

My lonely steps fell on the city.

I go back to my room. I close the window, try to sleep.

I HAD NOWHERE TO GO

A TALE

A few years ago there lived in our village a devil. He didn't hide and didn't use any assumed names. He wasn't afraid of daylight, he dressed neatly, and in general his manners were quite decent. He had a calling card that said "Devil." But nobody believed him. Then, one day, he died, and he was buried, very decently.

November 2, 1947

Went to Kassel. Snooped through the bookshops. The trolley doesn't run today, had to walk on foot.

Had a haircut… Did laundry… Sold my typewriter, bought some bread and apples. Now I am writing by hand.

Snow and mud.

Children: these pieces of broken rotten wood are the sheep.

The girl is feeding the doll… Dresses it up. Takes it to bed. It is alive, there is no doubt.

The little boy is pouring sand on wheels—gasoline. And, like a motorcycle himself, beating the ground with his little feet and making the sound "pu-pu-pu" he runs across the road.

This piece of wood, this branch can magically turn into anything he wants: a sheep, a soldier, a train, a boat.

MEMORY

His life is passing through his eyes…

He sees himself as a shepherd slouched at the edge of the field, in hot sun, in rain—gathering berries, sweet red—ah, how they smell—wild strawberries—into freshly made alder tree bark baskets.

LIFE IN A DISPLACED PERSONS CAMP

November 15, 1947

A dark cloud is moving across the sky. I am looking at the hills. I see the last bits of brown and green.

I walked to the hills, and into the woods. Met some Germans coming home with baskets full of mushrooms. At the edge of the forest a farmer is plowing the oat field. A girl, ten, with a cow, sitting by the fire, bundled up.

The ground is covered with leaves. They make a damp sound under my feet. The air is full of dampness. The trunks of the trees are wet with drops of rain. I touch them: they leave a green smudge on my palm.

Further, deeper in the woods the sound of saws and axes.

In the evening it rains. Dark, can't see anything. I keep stepping into deep puddles and mud holes.

We gathered some firewood and made a fire. Cooked some potato soup. Ah, wood! How pleasant is the heat of a wood fire. Even the smoke. No, we don't mind the smoke of burning wood: it's not like that terrible gas and coal smell.

November 17, 1947

I wake up, I lift my head: it's snowing. The roofs, the ground, all white. The streets are full of shouting, screaming children.

By noon the snow melted. But the fields are still white.

I picked up three heads of cabbage—our weekly portion.

Mailed a letter to Canada, to Port Arthur, Chamber of Commerce, asking whether they need wood cutters, or workers in the paper factories. There is an epidemic here these days to send such letters.

November 18, 1947

During the night it froze. And it remained frozen all day. Some new snow fell. The winter scored one point. Bravo, winter!

The pond in front of the camp's office building is covered with ice. I threw a stone, it went bim-bim across the pond.

People are dragging bags of coal, their weekly rations.

I finished reading Thoreau. Spent three hours with Tvirbutas discussing details of the comedy evening. It's moving very slowly, this comedy. Life is not very funny here.

Algis visited us. He is sending twenty letters to Canada. We sent only one, symbolically.

Leo is reading old newspapers. I am not sure he is reading. He's maybe just looking at/through them. He says, Byrnes is switching from politics to cinema...

Somewhere, deep in the plumbing system I can hear the water gurgle. Adolfas is not back from the rehearsals. I am making potato soup. Not too bad. Simple but good. One needs a lot of imagination and courage to cook with nothing. I was reading today, Bernard Shaw says in *Nouvelles de France*, let men take over the kitchen, let women do all the other work—farming, finances, government, etc.: that would eliminate wars. I am not too sure about that. The Amazons liked wars a lot.

November 21, 1947

It seems, you live like everybody else. My life, their lives: all the same. But one never really knows. All I can see is the outside. I can never compare their lives with mine, not knowing what's really going inside.

LIFE IN A DISPLACED PERSONS CAMP

Yesterday the MPs were searching for pigs. It's forbidden to keep & grow animals in the barracks. Some bureaucrat decided so.

Algis' father stuck his pig into a bag and sat on top of it. But the stupid pig kept moving. He kicks the bag with his foot, bump bump—but the pig moves even more. So he pretends that he's itching, he keeps moving and scratching himself: to camouflage the real situation. It worked.

Everybody's signing up for Canada. Mostly they are looking for tailors, shoemakers, professions like that. It's enough to know how to sew a button on—you are hired. No requests for poets yet...

Yesterday they were signing people for Morocco—bricklayers, carpenters, and truck drivers. Somebody brought a Canadian newspaper with a huge picture of thirty men from our camp posing in a deep forest, somewhere in Canada, in front of a pile of logs.

Under our window this terrible truck noise. Hell, can't they park them somewhere else?

Our money ran out. We have ten marks, that's all. We used to sell our coffee and cigarettes, even meat—at least some of it—up to 200 marks we could collect that way weekly. Now it's finished. They give us so little food that there is nothing to sell. We'll have to earn money some other way, we'll have to invent something. I get a few marks for my journalistic scribbles weekly, but it's peanuts.

Our neighbor, Albinas, the friseur, had a party last night. Drank with his Polish buddies. Hired German musicians, an entire band. Played and made a lot of noise all night, drunk and happy.

The farmers are moving manure out of the stables into the fields. Some are plowing.

November 23, 1947

The day went by, nothing accomplished. Filled some emigration forms, I don't remember to what country... With Algis, Tvirbutas and Poškus we went to Kassel, saw a boring American movie.

Spent an hour in bread line. Got angry, went for a long walk around the barracks. I hate standing in lines, it drives me crazy.

Bought a kilo of apples. Sat by the window, eating apples, watched the street.

Now it's evening. At five thirty it gets dark.

With Leo, we wrote a letter to the Vatican about our plans to walk to Lourdes.

Reading Kaj Munk's *Dänische Predigten*.

Razminas came, he borrowed the Milosz book.

Everybody's worrying about the firewood for the winter. Everybody except us. We are like those birds of God: no worry.

Last night our neighbor's pig was stolen. They are blaming the Poles, of course, but I think their own buddies did it. Now all the pig owners are panicking. From the outdoor gardens they are taking their piggies into their rooms, into the attics, etc. I can imagine the smell.

Actually, these are tiny little pigs, baby pigs. I don't know what's there to eat in them. Everybody's trying to keep them at least until Christmas, until they grow a little bit bigger.

Apples cost 30 marks a kilo. I bought some yesterday. They were so sour I couldn't eat them. Today I was more careful. But then, you see, the salesgirl at Truman St. N. 9 is very beautiful, so the apples taste better too.

Ah, again! Again the motorcycles are making a racket outside, right under our window. Always under our window. No end to it. They just step on the gas, and sit there, with no purpose. Just sit there with the motor going full blast.

November 25, 1947

They took a truckload of us into the woods, for wood-cutting exams. They handed us the saws and axes, and said: Go ahead, chop.

The examiners, two Germans and a Pole walked around, watching how we work. There were people who had never held an ax in their hands. I was afraid they'd chop their legs off, the ax was going wildly. But they are desperate to emigrate, they are willing to try anything.

The forest is still full of snow. It's good here. Just to look at a tree makes me feel better. To touch a tree, even if I am cutting it down...

November 27, 1947

Again, to Mainz, with Algis. A beautiful, warm morning. It's raining a little. From Webern on—snow, cold... In Marburg: again raining and warm. In Gießen: snow... We left Kassel dressed up lightly, for the warm weather. Now we are freezing like dogs. We jump up and down, trying to keep ourselves warm—but nothing helps. The train is empty, cold.

Spent three hours in cold Wiesbaden. There was a student meeting announced, but it never materialized. So we went to the movies. Saw *Wir machen Musik*. After half an hour we left—too boring. Snooped through the bookshops, instead.

I HAD NOWHERE TO GO

The train is two hours late to leave for Flörsheim. A band of musicians is playing in the station, a pot-bellied fiddler. All windows in the waiting room broken, the wind is whistling even louder than the musicians. Arrived in Flörsheim frozen, drank a lot of hot tea, and snuggled into beds.

November 28, 1947

I thought I had caught pneumonia. All night I sweat and tossed around. Had terrible dreams, talked and shouted in my sleep. But towards the morning I managed to sweat it out. At seven all three of us were already in Mainz-Kastel where we took a bus for Mainz.

The Rhine is black, cold.

Movies here (in Mainz) are old, bad German movies. In Wiesbaden we saw *Gaslight*, a little bit better. Collected my monthly stipend (175 DM). Forty marks I paid for the room I was keeping in Mainz. Today I gave it up. Why waste 40 marks for two nights a week? I can stay with Vladas' family, or I can rent a room at a small cheap hotel there.

November 29, 1947

I spent the night in a small town. I got out of the train late at night, I needed some rest. I didn't see the name of town.

At midnight, suddenly I heard singing. The street was singing. I put my face close to the window and looked out into the night. It was completely dark, impenetrable. But I could hear village people somewhere deep in that darkness. I could feel them there, and they were walking and singing. They sang and they clanked with drumlike instruments. I could hear their feet on cobblestone.

Next morning I got up early and continued my journey, back to Kassel.

LIFE IN A DISPLACED PERSONS CAMP

No date, 1947

"Hunger!" said Adolfas closing the locker door with a kick of his foot and placing the last few potatoes on the table.

"Get up, or else there won't be any potatoes for you," he pulls Leo's foot. Leo is sleeping on the floor, he has no cot.

Today is Monday. We picked up our weekly food ration on Friday and, of course, we ate it all the same day. Now, the whole week to go and all we have left is this pile of boiled potatoes.

Adolfas is peeling his potatoes. Leo and I eat them just as they are—why waste good stuff? And it's faster, no work. Our cooking and our household practices have taught us a lot of new things. We learned to look at food primitively, like children do. During our shepherd years, we used to bake our potatoes in hot ashes and ember. You rub them on your pants a little bit and you eat the whole thing, with ashes and bits of amber and skin—ah, they tasted great, when you ate them like that, with the cold autumn rain falling on your neck from wet branches, the wind blowing, bending the tops of alder trees.

Later... A different life, the years went by... I forgot the baked potatoes. They were served to me clean and peeled and properly boiled, with milk and butter...

Now we are sitting on the edges of our cots, staring at five boiled potatoes on the table. We dip them into the salt and we eat them, with skin and everything. If a piece falls on the floor we pick it up, blow off the dust—symbolically, that is—and devour it.

Then we discourse on the meaning of dirt, dust, earth, floor, inside, outside.

A child will put everything in his mouth, but we are afraid to eat even a piece of bread when it falls on the floor.

129

I HAD NOWHERE TO GO

This morning, to avoid the breakfast problem, we stayed on our cots till noon. But our eyes have been open for hours, moving from object to object.

In the locker, there is some flour, I suddenly remembered. It may just do for breakfast.

The table is cluttered with books and magazines. A big pile of books in the corner. Books? On top of the locker a suitcase with old clothes. Ah, there is an extra jacket hanging.

I lift my head—Adolfas is also lying with his eyes open.

"Hm…" I say.

"Hmm."

"What the devil are we keeping those clothes for?"

"A terrific thought."

"Maybe we could sell them? Anyway—hunger. It's better a loaf of bread in the belly than a jacket on the hook."

"The idea accepted."

"Hell, how come we didn't think of it sooner? Really."

That really wakes us up. We jump out of bed, full of enthusiasm. "And what the hell are those books for?" we point our fingers to the pile in the corner.

I get up, collect all the clothes that we don't need. Which, practically, comes to every piece that isn't on us.

Leo is still in bed.

"Don't touch those!" he suddenly shouts. "Those are my pants!"

"So why are you sleeping like a log. Get up before you find yourself without pants. Then you can walk around the barracks like Adam."

I tie it all up with a scarf and take it to the cooperative store.

The supervising salesman doesn't even look at what I had brought in.

130

"Dump it in the corner," he motions.

I dump it and come to the counter.

"No," he says. "Money, I can't give you money now; wait until I sell it."

I got 100 marks for the books! Bought a kilo and a half of flour, and a loaf of bread. Now we are having a feast.

We ate the radio, we ate the typewriter, the clothes, the books. Now the room looks a little bit emptier, more space. But the stomach feels as empty as before.

Today, with whatever we had left, we bought some bread and the three of us ate it all. A lot of bread, nothing else.

By evening we all had heartburn. The bread we get here is not well baked and, we are certain, they add a pinch of sawdust. After you eat a loaf of it you begin to feel terrible. So now we sit with angry faces, suffering, trying to read.

Adolfas went for a walk, then came back with a mouth harmonica. Algis and Vladas arrived. They put me to play, and now everybody's jumping around the room, "dancing," singing. Leo is singing, that is; the others are howling. So now we feel much better.

It's good we have patient neighbors, they don't complain. Someone else would come running with a broomstick. And it's true: when you play music (or make noise, like us) and sing (or shout and shriek, like us)—it doesn't matter how—you forget the stomach. But as soon as we stop—it begins to bother us again. Caesar or no Caesar: the circus is not enough, one needs bread too... Now I understand why the old-time Lithuanians used to sing so much... Thanks to hunger, to terrible times, wars, we have all these songs now, to help us forget our hunger, here...

I HAD NOWHERE TO GO

Two days in Mainz, listening to full-bellied professors, at the University. Usually, I take a bag of books, and a smaller bag with a loaf of bread. I am eating, that is, I am biting from the end of the loaf, dry bread, or with some beer, in a bar. At the University cafeteria I pullout my huge bread loaf and I eat it. The students think I am some kind of a joker. They think I am doing it to amuse them, for fun. So they laugh, ha ha ha ha. And I do everything to encourage their illusions, I begin to put on an act, I exaggerate, why not make them laugh, laughter is good, times are poor…

I sleep in a tiny hotel. The room is as white as a dentist's chair, and very old, with two yellow beds, a locker, and a wall sink, just like the ones you see in railroad stations. Through my window I see red tile roofs, behind them—the Rhine.

Sitting through long lectures, hungry as I am, my head begins to get dizzy. Then I walk out and slowly stroll through the city. I usually go to the Gutenberg museum and stare at the old books, the old wooden block letters. Or I go to the Cathedral, it's very quiet there. I sit, listening to the huge silent ceiling, the vaulted space—the huge vast spirit wind.

Then I walk to the *Weinstube* and, if I have any money left, I buy a glass of wine and I drink it biting at the bread loaf which has shrunk considerably by now.

I walk across the bridge, I check the French bookstore for new books and journals. I spend a lot of time browsing through the shelves of a glass cabinet. It's a treasury of old back issues of literary magazines, movie publications, poetry. Then I walk back to the University and sit through another lecture.

The brain doesn't want to follow or listen. The eyes are travelling through the place, students' faces, all kinds

132

of strange thoughts come and go. I feel like I am hallu-
cinating.

I leave the classroom and walk through the Universi-
ty grounds. My head is buzzing. I walk towards the Rhine.
I stand for a long time, an hour maybe, on the bridge,
leaning on the railing, staring into the river. Barges,
seagulls. I can hear the noise of the trucks on the north
shore, cleaning the war rubble.

4. ANXIETIES. THE SEVEN KNIVES ARE BEGINNING TO PIERCE

The author has doubts about his life. His D.P. neighbors. The Blue Room. The fourth Christmas away from home. The author is 25. Lithuanian lyricism. Craving for snow. About modernism. He starts a magazine. About writing in exile. Slipping into homesickness and barracks depression. End-of-Semester party in Wiesbaden. Bread that gives no satisfaction.

No date, 1947

I just sit. Or I walk and walk.

Or I stand somewhere looking at one spot.

And it seems to me as I stand here that I am totally disconnected from the rest of the world around me. Nothing, absolutely nothing connects me with it.

The world around me goes on being busy, conducts its wars, enslaves countries, kills people, tortures. The real world...

My life till now seems to have slipped through this real world without participating in it, without caring about it, without any connection to it. Even when I was in the very middle of it, I wasn't really there.

My only life connection is in these scribbles.

Here I stand, this moment, now, with my arms hanging down, the shoulders fallen, eyes on the floor, beginning my life from point zero.

I don't want to connect myself to this world.

I am searching for another world to which it would be worth connecting myself.

December 7, 1947

Ah, these objects here. I have never seen them.

I have touched them for twenty years. Maybe every day.

But today I am seeing them for the first time.

The hardness. The softness. Colors. Smells.

The room, the table, the chairs, the stove. Everything is here for the first time and I don't know how to touch them, how they feel, what they are for.

Potatoes. Bread. Flour.

A cold stream of water on my hands. The coolness of water from the sink on my hands as it runs down my skin.

And the earth.

I step down from the sidewalk and I walk along the strip of the street not covered by concrete. I want to feel the earth under my feet.

Ah, what a feeling, this new feeling of touching the earth, my foot coming in contact with it.

Ah, finally a contact!

I am connecting. I have a connection…

With every step, every movement of my foot I can feel the earth tearing itself away, I have to tear my foot away. With every step I feel how the earth seeps, rises upwards through my body…

Yes, I am a part of it. A small fragment of it, but I am apart of it.

I keep walking. I catch myself whistling.

December 11, 1947

Mainz.

No clock in the house where I am sleeping tonight. The woman said she'll bang on my door at five-thirty. The train leaves at six-thirty. I wake up in the morning—silence everywhere. The church clock is striking four. I fall back into a deep sleep.

I wake up again—it feels like six. I grab my bag and run to the station. Just made the train.

The train crowded all the way.

In Kassel I find Leo. Brought a new issue of *Kunstwerk* devoted to abstract art. We devour it. Talk until the morning hours.

A new issue of *Gintarai*. Mazalaitė is attacking the modernists. She says, they don't suit the Lithuanian spirit. She speaks of course about us. Ah, she is so smart. She knows the Lithuanian spirit like a dead fish. I hope some day we'll be as smart.

No date, 1947

Albinas, our neighbor next door, is drunk again. I can hear his voice:

"I am going to kill you all. Where is my ax? I'll show you! Open the door, mother!"

"Stop shouting. What are you shouting for?"

"Why not? I will if I want to. Ooooooo!" He shouts. "Tara bam bam!"

Silence.

Albinas sings:

"I love you, I love you so bad... (Pause) Mother, where are the matches?"

"Go to sleep. Or I'll call the police."

"Open the door!"

"No, I won't open it."

Albinas sings:

"I was a church organist once..."

Banging at the door.

"Sleep, you bastard." (Mother's voice)

"I'll throw a broom at you." (Father's voice)

His old mother and father are trying to cope with him. They usually lock him up in the kitchen, when he comes home drunk. I guess that's where he is now.

"Give me my hat or I'll call the police!"

Now I get the picture: the guy banging at the door is Albinas' friend, a fellow drunk. He thinks Albinas took his hat. But Albinas is drunk, inside, probably locked up in the kitchen.

"Yoptvaimat!" (a heavy-duty triple-decker Russian curse) "Give me back the hat!" Albinas yelling:

"Go, ask them, ask the students" (this reference is to us, Adolfas and me), "go ask them, they'll be witnesses. He is sending his old parents to look for a hat. Go to the police, there are many around."

Voice at the door:

"Give me my hat!"

Albinas:

"Go to the police and describe your hat to them, go, go, you prick, you shit."

The man at the door, the Pole, Albinas' friend, begins to scramble down the stairs, I can hear a lot of noise.

"Oh, my dear Jesus..." Albinas sings.

December 14, 1947

Adolfas washed out the room. We are all in a very festive mood. A pot full of pea soup is boiling. Got up early—Poškus woke us up. He hauled Leo out, to work on the decor for the Christmas play.

I am reading S. Lewis's *Let's Play King*.

The weather is mild, but very damp. It's a warm winter this year. Algis opened the window and shouted, "CHRISTMAS!"

"Don't say Christmas," I said, "it doesn't look like Christmas. Look at the rainy sky. No snow."

Leo came back. He is sitting now on the edge of his bed with a piece of paper on his knees, a pencil in his hand. Translating Rilke's *Duineser Elegien*. For a change he has shaved! That is a big event. So he is shining like a

young moon. He says, he shaved only because he wants his moustache to stand out: all the girls are crazy about his moustache, he says. That is his opinion.

Adolfas and Algis just completed a game of checkers. Picked up their coats and went out somewhere.

I walk out too. I cross the sports court. Some Germans, all muddy, are playing handball.

I make a circle around the barracks and return. Leo is still working on Rilke. Poškus is visiting, but Leo doesn't want to talk to him. Poškus is looking through an old issue of *Masques*, talking mostly to himself, about how idiots and insane asylum inmates are much smarter than any of us. So I walk out again.

December 15, 1947

Snowing badly.

With Leo we travelled to Kassel to hear Beethoven's First and Ninth symphonies. Came back on foot, late at night through deep soft snow, very excited about the music and the snow.

December 16, 1947

Received log cutter's certificates.

We are reorganizing our room. We piled up everything in the middle of the room and painted all the walls and the ceiling deep blue. The only kind of paint we could get. We dusted everything off, washed everything, and now the room is neat and clean.

We decided the room now looks a little bit too clean. And too morbid. A little bit like an old castle tower attic. Leo is climbing all over the beds and books right now, with a pail of paint, writing on the walls, all around the room, a very long incomprehensible sentence—great poetry!—from Heidegger. The sentence has gone already three times around the room and no end yet in sight.

INTERNATIONAL REFUGEE ORGANIZATION

US ZONE GERMANY

AREA TEAM: 1025

THIS IS TO CERTIFY that M E K A S Jonas

born has been tested as a Logger

and has been classified as a 2nd Class worker.

Dwyer

Haultrud

AREA EMPLOYMENT OFFICER

Date: 28th November, 1947.

"AISTIA", Kassel - Mattenberg. 6000. 10. 47/225.

ANXIETIES. THE SEVEN KNIVES...

December 19, 1947

In Mainz I picked up my stipend. Sat through a long lecture on Joyce by a bearded Swiss professor. Took 9 PM train to Frankfurt. Travelled with Prof. Biaggioni, I am taking his course in Italian and Pirandello.

The night ride to Kassel. Luckily, now they have lights in some of the cars, so I can study our magazine treasures. *Lancelot. Merkur*. In the back issues of *Lancelot* I read the letters of Romain Rolland and L. Masson and the poems of Alain Borne.

My feet are freezing, wet. A lot of wet snow comes into the car at every stop.

From Kassel we walk home on foot, with Algis, through the deep, wet, mushy snow, frozen like dogs. Algis is sick, he is wobbling like a chicken, feverish. But we manage to reach the barracks alive.

December 21, 1947

Collected the weekly food ration. Did laundry.

The snow has melted. Mud and water everywhere. And the wind. Nobody dares to go out. You cross the street—you are wet to the bones. My shoes are full of holes, and they aren't waterproof. My feet are always wet now.

Leo just came home, from working on the Christmas play, making the sets. He took off his boots and now is warming his wet cold feet in front of the stove. Luckily, we have some coal left.

December 24, 1947

No more rain, but puddles and mud remain.

I am 25.

It is 1 AM, which means, it's Christmas. Just came back from church.

I am sitting alone in this blue room. The Christmas tree with half-a-dozen candles, a couple of toys strung up.

Ah, to be sitting at a table, Christmas evening, among friends and family... Maybe with a few flowers on the table. The women busy around the stove, excitement... And maybe a cat, and a dog curled under the table, snoozing...

I lived, years ago it seems, I lived at home, surrounded by the people I knew, the world I belonged to. But I neither really knew them nor really saw them. My father, my brothers, my mother, sister. And the house in which I grew up. I lived unconscious of all this. And now, when I feel I am just beginning to live, just beginning to feel that I am alive—that whole other world is gone. Only what memories call back still exists. So I am getting drunk on them.

I am 25 years old so it would seem it's time to begin to walk more firmly, to live. But it all looks like first steps.

Where is my family, home? Life is so unsure. And what I've written till now, it's all very insignificant. I have to work so much harder than my friends, Leo or Algis. They received a good, regular education, they grew up in the cities. My education was fragmentary, always in a hurry. My language—at home we didn't even speak the written dialect, we spoke a local dialect.

The fourth Christmas away from home. I have no idea, when I sit now in this blue room, if any of my brothers are alive, or my mother, or father. I don't know if they are sitting now around the table of my childhood.

I do not want to think about it now. And when you forget about it, it looks as if everything is absolutely fine.

But there, at home...

...Evenings before Christmas we used to come home from the sauna, all of us, with red burning faces, clean fresh linen shirts, and we used to sit around the richly

set table—and we all ate and drank and sat late, talking and laughing—and we slept on freshly stuffed pillows and mattresses full of fragrant hay. Ah, the smell of dry field flowers...

Our good-bye was short. We were never too sentimental, in our family. Our mother left us at our uncle's house and we stood and looked at her and she stopped just before turning the corner of the house and waved and tears were rolling down her face.

And now it's Christmas and it's night. Blue room.

New Year's Day

A lot of dancing, drinking, a lot of noise, a lot of home made vodka, singing.

After midnight we go home. Leo, Algis. A few others join in. We walk and we shout loudly on every street corner. Windows open, people stick their sleepy heads out. Some are turning the lights out—who knows, maybe a murderous gang is coming to cut their throats...

We crowd into the blue room. No light, so we sit in the dark, singing, blabbering. Some fall asleep, some go home, through mud and snow.

January 2, 1948

We spent Christmas visiting friends. I mean, the four of us, Leo, Adolfas, Algis, myself. Levis joined in, Vladas. We survived.

On New Year's day the Drama Studio presented my comic sketch. It was crowded, the theater was full, the reception was good. People are bored here, you don't need to be very funny, they laugh at anything.

After it was all over, some Poles got in. The lights went out. Women, girls screamed. Leo kicked out the window in the corridor, just in case. A grenade exploded in the corner. Only two people were lightly hit, in their

143

"...it was crowded, the theater was full..."

legs, by tiny shrapnel. In the corridor, on the floor, a huge puddle of blood, nobody can explain how it got there... Panic, memories of Piłsudski...* Somebody's running with a broom, another with a fireman's ax, still another with a shovel...

The MPs arrived, made some order, everybody's going home proud: The Polish Army beaten back.

Later the MPs told the real story. A classic story.

One Lithuanian got mad at another for dancing with his girl. So he picked up his drinking buddies, who happened to be Polish, and proceeded to punish the bad guy and everybody else.

January 4, 1948

Spring weather. Spring wind. Wet, muddy everywhere.

11:30 AM Vladas comes in. Invites us all for *kukuliai* (dumplings) this evening, his mother is cooking.

Algis, Leo, Adolfas, later Puzinas, we arrive at Vladas' for *kukuliai*. His mother declares she never promised to cook for us. So we all go for a walk, fool around.

In the street—two drunk Yugoslavs are trying to start a motorcycle. A crowd has gathered around them, they are all laughing.

They started! No, they fell down. They are trying again. A stout Yugoslav woman comes, takes one of the two men by the neck and literally drags/carries him away—home, I guess.

Finished reading Stanislavski.

* Józef Piłsudski (1867–1935), Polish general and politician. Responsible for the Polish occupation (1920) of Vilnius, the capital of Lithuania.

Leo is walking around, very very low, like a black cloud. He's complaining, he says he's afraid he has TB. And his back is aching. Maybe it's cancer, he says. He has to go for a check-up.

Therese. She said, "I am a modern woman. I accept the new trends. I consider that what there is today, must be necessary, and I comply with it and I live that way." "You are a stupid woman, not a modern woman," I told her. "You embrace fate: what comes—comes. Some day somebody may want to cut your throat: will you accept that too? Joseph picked up his family and ran away, with Mary and the Kid. We have been given the freedom of action, the choice of action. We don't have to comply with the 'fate.' We don't have to blindly follow everything that's happening today."

So she said I was a poet, and an idealist, and I will never see reality as it is. That's where I quit the conversation.

We try to hide it every way we can, but it always comes out, the lyricism. A Lithuanian cannot live without nature. You can't detach him from the wide, green fields, from the brooks, the snow, the cobwebs flying through the air in late September, or from his forests, fragrant with moss and berries.

That's why he keeps sculpting those wooden Jesuses and placing them by the roadsides, with their faces (always) turned to the fields, looking into the fields, dreaming. Their Jesuses are always dreaming. Their Jesus is a Lithuanian, the sweet Jesus of the roadsides.

Sometimes it's good to fall into emptiness. Be it another person, or oneself, or a junkyard...

ANXIETIES. THE SEVEN KNIVES...

Blessed are the hours of emptiness.

My life vacillates between the two, the emptiness and... and... whatever is the opposite of it.

Whatever it is, it isn't fullness...

Two opinions re. modernism and literature, among Lithuanian writers.

Mazalaitė: "What is there to learn from others, for us? What is there for a writer to learn, from others? A writer, an artist is like a bird: he has to sing, he has to sing no matter what."

Me: "Yes, sing! But stop, please! Enough, enough! Your singing is terrible!"

MEMORY

We are driving to the woods, with my father. The road is all beaten out, full of holes. I sit in the back of the carriage. With every bump of the wheels all my innards jump and bump—my liver, my lungs...

A TALE

Once there was a man who was asked by God to do some little thing. It was just a little thing, and I don't know what it was. Do this, he was told, and this earth will again turn into Paradise. There won't be any kings, nobody will have to work, everybody will be free and happy, etc.

Now, this man kept thinking: to do it or not to do it. One day he thinks that he should do it, next day he isn't sure, he thinks that maybe he shouldn't do it. "Why do we need a Paradise? Let the people work, a big deal? It's good for your system." Next day again he thinks: "Maybe, after all, it would be nice not to work, not to do anything." And so it went. He couldn't make up his mind. Day after day he thought about it. And so he died, one day. And it's a pity. He could have brought Paradise back to earth.

I HAD NOWHERE TO GO

A SHORT STORY

I am carrying this strange secret. It keeps eating me but I can't tell it. The thing is, this secret cannot be told in words: it can be only transmitted through laughter. But whenever I try to laugh it out, my friends all think: what a strange laugh.

This laugh resembles a child's laugh, when you tickle a child's neck with your finger, gently, gently so.

They tell me: don't destroy it if you have nothing better to put in its place.

I don't understand it. Destruction is destruction. Shit is shit—what's the difference?

MEMORY

It's Spring.
The farmers walk out into the fields.
They return home drunk with happiness.

January 10, 1948

You are welcome to read all this as fragments, from someone's life. Or as a letter from a homesick stranger. Or as a novel, pure fiction. Yes, you are welcome to read this as fiction. The subject, the plot that ties up these bits is my life, my growing up. The villain? The villain is the twentieth century.

It's a little bit sad, in the room, right now. I am sitting and I am looking out the window. Outside—sleet. Terrible winds. The wind bangs empty biscuit tins, blows skirts, people are walking sideways, with their faces turned backwards. And the clouds—ah, how the clouds are rushing by, full of cold. And I, I sit here thinking. I wonder how the clouds are now there, in Lithuania, and

the wind, how is the wind? It's really sad, sometimes, one becomes sentimental. But then, why not be sentimental? If it's sad, then sad it is, and there is nothing that you can do about it, at least not now. One can try to play an optimist, a courageous, happy person: but right under your heart you feel this great lingering sadness. You can't get away from it, from homesickness. You try to hide it, you try to talk yourself out of it, you try bluffing—but your thoughts betray you, your dreams betray you, everything betrays your homesickness. But then, that is your only comfort: as long as you feel homesickness you know that you aren't dead yet. You know that you still love something...

January 12, 1948

Today it's snowing, so beautifully, all white! And only yesterday I was very sad, I thought there won't be any winter this year. I can't imagine a winter without snow. Can a Lithuanian live without snow? Could a Lithuanian ever live only with green and brown and red? In Brazil, or Australia? Oh, my God, how would that be possible, without snow, without ice flowers on the windows, without the biting cold? You look at those white distances and something wakes up in you, something so close to you... Or when you listen to the wind banging outside, how it spills on the window glass with thin cold icy snow flakes. You put your forehead against the night window and you stare into the dark and see the snow fall, and hear a soft thumping of feet in the street below.

January 15, 1948

I can't stand nature by itself. I can't stand it, it's too strong. I need a presence of another human to share it

with. It's not necessary that the other human being be
very close, or would see or understand what I see. No.
Maybe it's just a bunch of work mates in the fields—when
we sit down on a stone, to rest, and talk nonsense and
joke—or sing. But I can't stand it alone by myself.

Children. All day long—and tomorrow too!—they
sit around doorsteps and entrances. Nothing else to do.

Anything that doesn't fit into your little brains you
call chaos.

Isn't it a little bit pretentious to try to predict the
future while basing these predictions on some present
act? If a certain act had a cause to begin, it doesn't mean
that that act will be a cause of some other act or event…
There are empty lives and empty hearts…

No date, 1948

You are asking for my opinions?
My opinions!
I don't have any. I am grounded in nothingness.
You go to schools and you learn the descriptions,
formulas about reality around you, objects, dates, events.
But I don't remember any of them.
It's O.K. to call me an ignoramus. I dump into myself
anything that comes my way. Thoughtlessly, making no
plans, I throw it all into the witch's kettle and stir it and
hope that it will give birth to something…
Most of the time it gives birth to nothing…
But you want my opinions, my answers.
I don't think in answers.
When I say something I say only what comes on my
tongue that very moment.
Sometimes it comes, sometimes it doesn't.

ANXIETIES. THE SEVEN KNIVES...

January 21, 1948

Yesterday it snowed again.

Went to the forest. Deep blue snow clouds hang over the horizon, over the forest. Towards evening it darkened even more. When you see snow so rarely, you want to walk in it and walk and walk, and touch it, hold it between your fingers. But where are those Lithuanian snow drifts, and frost, and snow storms, snow blown over the wide spaces of the fields...

January 28, 1948

Schweinfurt. From a letter to M. Bavarskas.

In the middle of February we would like to bring out a new issue of *Žvilgsniai*. I hope you won't refuse to send us one short, selected piece*.

What's happening, what are you writing? Empty winds are howling across the fields of our exile literature (not better at home either). Life is too heavy a rock, we are being pressed down by the barracks, I can hear the sad steps of people in the rooms, back and forth, back and forth all day long (and one will come to you, will put his hand on your shoulder, and will ask: Any news from home?—and away he goes, they go, these people, with their eyes somewhere, in some distant past).

* *Žvilgsniai*—translatable, approximately, as "looking around," was a literary journal of a group of Lithuanian poets and writers—all in their early twenties—who began their literary careers in exile. Published during 1947–48 in Kassel, it was the most avant-garde manifestation on the Lithuanian literary scene of the period. Four issues were published. Jonas Mekas was the editor-in-chief, with Adolfas Mekas, Leonas Lėtas (later known as Leo Adams) and Algirdas Landsbergis as assisting editors. Leonas Lėtas designed the journal. —V. B.

And then, sometimes, in the middle of writing—suddenly everything collapses: what for, for whom, for whom am I writing? Why write if nobody's going to read this. Maybe it's better to carry it, to burn it up inside, unborn, until it dies. Because they are killing, they are wiping out my country. Men with bloody fingers are walking all around the world aiming at my neck. They'll strangle all my people, they'll cut out their tongues. What sense is there then to write? For whom am I writing?

So I sit at the table again and with my eyes heavy I stare at the paper and I write. And what I write is drenched with hopelessness and the madness of the times we live in, insane crimes, insane waiting—a waiting when the only thing you have is the waiting itself. While you know that there are people, somewhere, who can work, who can do what they want—somewhere. The wheel is turning and you are such a small nothing in that huge wheel, in that huge hell brewed by the Big Powers.

Eh, but then, it would be stupid to sit and wait until they grind you up. Make them work hard, make it difficult for them... So you stand up and you begin to throw your arms one way and another and swing them around: Come, come, you there, try to swallow me! I may yet get stuck in your throats... You'll choke yet... Or maybe a miracle, who knows? Even Goliath tumbled down, once. And when I look at the world—I have to admit that the majority still want Good, even if timidly—they'll take it only when it's given them, be it bread or liberty. But to work for it—God forbid... Those good ones, those passive ones... You know what the good people need in order to overcome the evil? They need a little bit of devil in them, that's what.

So now it's up to us to defend this earth, and write...

152

ANXIETIES. THE SEVEN KNIVES...

January 29, 1948

...The barracks... Your neighbor's monotonous, even steps behind the wall... The voices...

It's so difficult to write...

Literature is supposed to be a word that takes a clear, formal shape. But all I can do is shout, and that shouting is so heavy, full of homesickness, or full of anger. Ah, green raw life is the word, and not even the whole of life, only this day and now—a slice of barracks life, not literature. Courage fails, falls to pieces, hopes crumble. I can follow how they crumble, in the faces around me. We all walk with this intense, immense homesickness in us, and the fear for our brothers there, at home...

Yes, we have a lot of survival experience. That is one thing we have.

How many times how many big armies rolled over our miserable gray backs? But we are still here, still alive, Lithuanians... We are still singing our sad songs of misery, we keep coming back, lifting our heads from under the dust after the heavy wheels have rolled over us. No, they didn't squash us. I know that this time, too, we'll survive. I am almost ashamed to think otherwise. Fool's Hope.

January 30, 1948

Adolfas came home and said:

"Gandhi was murdered."

That's all.

Hard to believe.

But newspapers have large black headlines. It's all true.

"When Gandhi fell down, he lifted his hands towards his face, as a sign that in his heart he is forgiving the killer."

Yes, no mistake, that's Gandhi.

He remained true to the end to what he preached, in these times of universal murder and betrayal.

Enlisted for railroad works, in Canada. They say, we have a good chance. But they are looking for strong, stocky types. When I saw what kind of people were registering, though, I thought we had a good chance. We do not look too great, it's true—we are thin and dry; but the others look still worse: they cough as if they were dying from TB, they gurgle, sick from vodka and too much bad tobacco. Compared to them, we both look like exemplary specimens.

Ran out of money completely. We can't even buy a newspaper. I went to borrow some from Kuliešius. He says, take it, and don't bother to return it—and gave me 200 DM. He even gave me a large loaf of bread, and some herrings. "Eat, eat," he said, "and don't write about kings, only about people, about life, the real people."

February 2, 1948

Yesterday, in Kassel, I attended a lecture on Buddhism, by a certain Tao Chu. In his soft Chinese voice—he is about sixty, I think—he spoke about differences between East and West, about *Leiden* (suffering) about the purposelessness of life, and how the arguments and disagreements about the purposelessness of life have produced Faust, and Peer Gynt, and the whole Western thought which looks very silly to the Easterners... The West, he said, is almost identical with *Denkakt*, the act of thinking, reason. He spoke about *Ich*, I, Me, which a child only around the fourth year begins to be aware of—the second birth. He also said, that the only times that we really deeply experience joy, sadness and beauty, is

154

when we do not think of it. *Denkakt kann nicht(s) geniessen.* (Thinking can experience/ enjoy nothing.)

Antaeus... Unbeatable as long as he held to Mother Earth which filled him with life and strength. Yes, Mother Earth, now cut off from under me. How long can I hold out, uprooted?

February 11, 1948

Came back from the photographer. They are issuing new identification papers. Long lines. People come out, stand, stare at their pictures skeptically, make hopeless gestures, walk away.

I spent three hours searching for flour. Suddenly we had this craving for pancakes. I couldn't find any flour to buy, gave up. So we sprinkled some sugar on bread and ate it, drinking it down with water. Then we left for Kassel. Trolley overcrowded. Spring is here. Children are making too much noise by the ditches.

February 13, 1948

The end-of-semester in Wiesbaden went O.K. Drank a lot of Rhine wine. Zita Case bought a bottle of Curaçao. The students? A mixed bunch. One old and grayish; another tiny and short and very young; one girl huge as a mountain; another like a thumbikin; still another with a mind of a thumbikin. Some refused to drink wine.

An hour later:

Juška fell off his chair, drunk. We sang a lot and shrieked a lot (mostly shrieked). Krasauskas and one female student (I never saw her before) (Vladas said, her legs weren't round, they were square) sang a duet. Algis ate a lot of brownies (I baptized them "peat cookies")—

and a lot of Beleckiene's sausage (good sausage). Šilba-
joris, with his spectacles all misty, banged away on the
piano. Beleckas, with his great engineering talents,
managed to stack all the chairs in one corner, and a few
pairs were dancing.

Dragunas got drunk first, and was going all around,
kissing everybody and everything, men, women, mineral
and plant. He grabbed Stikliute, the mountain woman,
and carried her around the room like nothing. Vladas
started attacking Algis. He said, he is my devil, he is
misleading me, tempting me with decadent literatures.
Then he turned against me and delivered a long sermon
in which he instructed me to abandon modernism in all
its forms and return to classicism and rural life. Then he
went to dance.

Late at night, the dance fever boiled over. We sat and
talked. Vladas again got involved in some argument with
Beleckas. Right now they are talking or rather arguing
about ships, Aristotle, Spinoza. Algis, Stikliute and
Dragūnas are arguing about student stipends; Zita Case
is trying to persuade me that life is nothing but sadness
and all our young dreams will soon be shattered to piec-
es. She says, her husband is an American and he isn't at
all what she thought he'd be. Juška is attempting to
change her mind, he is talking in absolutely philosophical,
abstract terms, he is talking about the meaning of life,
and is quoting Buddha, Jesus, and Aristotle. Šilbajoris is
listening and smiling through his sweating spectacles,
like Buddha. Then we sing (that is, howl), and Krasaus-
kas with his lady friend sings a duet...

Arrived at the train station dragging a huge bundle
of newly acquired journals and books. We sang all the
way to Hochheim—and then proceeded to Flörsheim—
Vladas, Algis and myself. People are staring at us, they
think we are crazy.

ANXIETIES. THE SEVEN KNIVES...

February 15, 1948

I can't sleep, I walk around drowsy, tired. At night I am watching the moon, its light falling on my bed. Maybe it's the moon. Or maybe it's the change between the seasons. Spring is coming.

Yesterday I went to Wilhelmshöhe. Walked through the woods. I come very seldom here, I am afraid to come here. It upsets me, I can't cope with it, with nature. It brings back too many memories. The slightest movement on the dark surface of the pond, the rotten, putrid, black leaves on the bottom, the willow trees leaning and dipping their branches into the water, the steep banks—everything is calling me back, wakening up the memories of Astravas and Biržai.

February 22, 1948

Ran out of money. To get to the French lessons today I travelled with no ticket. On my way back, the conductor caught me and insisted that I leave. Luckily, in Kassel I had found 2 DM torn in half, so I gave him both pieces, and he left me alone.

Leo's wife came Monday and took him back with her, almost by force. He has to do some wood chopping. The work on *Žvilgsniai* was suspended until he comes back from Schweinfurt. That's where Leo's wife lives, near Marburg. He is trying to balance his life between home (his wife) and art (our little gang). It' s not easy.

Adolfas brought home five eggs, I have no idea where he got them. Almost as big a miracle as if he'd laid them himself. So we boiled them and now we are eating. Ah, what a pleasure to eat something small and solid—you eat a couple of eggs and you can feel the strength in your belly. Most of the time we eat all kinds of unsubstantial soups—gallons and gallons. The bellies get larger and

larger, but you get no strength, no nutrition, and no satisfaction. Water, nothing else. Or we eat bread which is made of half flour, half sawdust. You eat this bread and you feel the sawmill floor. Coffee, I don't know what they make it from, but it's not coffee. You eat this bread, this food, and you hiccup, and the belly blows up—but you are still hungry. So you put something else into it. Luckily for us, our D.P. neighbors, friends, are more particular than we are: they don't eat this bread. They manage to get better bread, somehow, somewhere. They know how to live. So they give the bad bread to us, they know our voraciousness by now. We may still die from eating it. We figure we'll die if we don't eat it.

March 2, 1948

Saturday the cold spell ended. Spring is here. You walk out into the fields and you don't want to go back. Sounds and smells assault you. The birds chirp like mad.

The barracks are beginning to feel spring too. Four or five men, Poles, are throwing stones, trying to hit an empty beer can lying in a puddle. I saw them there half an hour ago. On my way back, now, I see them still working at it. Laughing, making a lot of noise, cursing. They have a bet going who'll hit the can more times.

The streets are full of people. Children and teenagers are running along the street, shouting and screaming, chasing cats, throwing stones at dogs.

The "farming" on the camp is expanding. There was a time, a year ago, when raising pigs was strictly *verboten*. Nobody has relaxed any rules, but almost every family has a pig now, some two. Some in cellars, some in holes, some in bathrooms. They drag, from the surrounding villages, any edible green junk they can find, to feed the pigs. On some evenings they take them out for a walk, you

can see young pigs running through the fields, jumping up, digging their snouts into the ground, while their owners stand by, happy, smiling as lovingly as if they were watching their children at play. Passersby stop to watch the frolicking pigs, compliment their owners. A Pole is standing by, not far away, sizing up the pigs, making plans how to steal them.

And the hens, and the chickens! They are all over the gardens, streets. Leghorns, with red coats, and white, and brown, and black, all kinds. In order not to lose them, their masters have tied all kinds of identification bands around their wings. Some have painted their backs with colors. The roosters are running, their wings cutting the ground, all excited—ko-ko-ko-koh! Mornings, when they begin to sing—there is no end, like priests. Nights they stay in cellars, like partisans.

Ah, just look at the people who grow animals and have flowers on their window sills. Compare them with those who merely live on their food rations, with no cat, and no flowers—window sills bare, dusty; walls bare too, and the cellars, empty. They sit in misery, keep complaining, keep politicking, with their wills practically atrophied. To keep a pig one needs a lot of will power...

March 24, 1948

On Tuesday we went to Eschwege for two days, to learn weaving.

We learned, all right. But I am beginning to forget it already. They gave us certificates. They'll be useful for emigration, they said.

Many are trying to acquire new professions. No profession—no America. Many are trying to learn textile crafts. Canada needs many textile workers... For a quickie course in textile arts you pay four packages of

Turkish cigarettes and a pound of coffee. If you double your fee—they'll give you a certificate without attending any of the classes…

MEMORY

We used to come home, after work, and there was the smell of the wood and moss and earth. From every object around us we felt eternity. Earth's friendship. Every object around us was touched by our hands. Our father and our older brothers cut the trees, they chopped them down, and dug out the stones, and laid the foundations for the house, made the roof, every window frame, benches, beat the clay of the floor. And we, the smallest, we watched it all, we saw it all. Everything is familiar, real, close. It's good to sit in a house like that not only when it's raining or cold—it's good to sit and do nothing, to talk with friends.

The lilacs are beginning to open. The grass is showing here and there, timidly, greenly.

A week of panic and rumors in the barracks. Afraid of the Soviets marching into West Germany. After the fall of Czechoslovakia, rumors are growing like mushrooms. Kassel is too close to East Germany.

5. HOW BEAUTIFUL YOU ARE
 FROM AFAR!

The author falls to pieces and picks himself up again. Memories of home. About modernism. Summer flies. In a YMCA camp. A regular day at Mattenberg D.P. camp. About Lithuanian folk songs. Lithuanian pantheism. Memories of home keep surging up. To go or not to go to America. Fifth Christmas away from home. Desperation.

March 28, 1948

The times are fragmented, dizzy.

I am walking, I am running with my nerves trembling.

I know nothing anymore.

I reach the edge, on one side—then turn around and move until I reach the other far side.

And so day after day.

Never remaining very long at the center. Never present in both simultaneously.

It's a case of either/or...

Reality—or fantasy.

Objects—or abstractions.

The mind—or the senses.

Never both.

Ah, you, realists! I am not ashamed of my romanticism.

Ah, you, abstractionists: I will confess to you my passion for objects, earth, nature.

Should I pretend I am a stone when emotions, memories surge and overflow me, and I am dreaming of home, and melting snow?

161

I HAD NOWHERE TO GO

April 23, 1948

What can I say? You're crying about the loss of the good, old life?

You pick up your food rations and with voices full of resignation you say:

"Ah, those were the days! Ah, when are we going home again?"

You look at the drab clothes, your tiny, crowded rooms, and you say:

"Ah, what misery! This isn't life. Ah, if only we could return to…"

Every time you complain, every time you cry, you mention home. And then I think:

Home? These people are not really thinking about their homes! They are thinking only about what they left there, their possessions. And me, what can I say, poor me? When I hear such complaints I feel like a stranger here.

No, I didn't take anything with me, when I left.

Ideas? Books? Ah, those I found here too. But what really hurts, deep inside, it's the earth I left, that sky, those hills. It's those nights that got stuck in me, deep. They hurt, they remain painful wounds inside, those evenings, those nights.

I touch the ground here—and that other soil wakes up in me. I am looking at this sky—but I see that other sky. What is there, one would think, in the objects such as wheels, rakes, plows, and dung carts; or in cobwebs glittering in the autumn air, frost on the trees, the rain on the cabbage heads, the flax-drying season? But it all got imprinted very very deep. There is something in it, in the way the rivers bend there; there is something in that. There is something in the way the rains sounded there, a different sound, not like any other rain I've ever heard in my travels.

HOW BEAUTIFUL YOU ARE...

And it's not those broad differentiations by line, angle, corner, bending, color grouping—no: it's the little differences, the almost unnoticeable details... It's in them that everything weaves together, it's there that one nation's soul separates from another.

I am looking at everything. I get attached. New things come, and I feel sad about all the things that are gone. Ah, didn't it take many thousands of years to produce a Lithuanian? And I am its last, fragile branch, produced, polished by hundreds of generations... I am their end result. I am their wooden, sculpted *Rūpintojėlis** they sculpted with their own lives through many generations on the shores of the Baltic Sea. They made me, they gathered me bit by bit, they put me together, like bees—all of me.

June 7, 1948

God bless the Mennonites. They are serving free meals at the University, one meal a day—soup, bread, a bun, some grapes. They keep me alive on my Mainz trips.

June 8, 1948

Do not wonder while reading this. If you find something in here that seems strange, say—it's perfectly all right with me: Ah, obviously, the author of these notes was one of those sickly, hypersensitive products of the postwar years.

* A small wooden statue of Christ carved by village artisans ("god makers"). The term is affectionately diminutive derivative of the Lithuanian word rūpestis (anxiety, concern, solicitude). The statue shows Christ in a sitting position, meditatively and woefully leaning on his elbow, looking at passersby.

163

I HAD NOWHERE TO GO

June 15, 1948

All fifteen people in my car are sleeping. Farmers, women. Only my eyes are wide open, awake. I haven't slept all night.

I am not tired, no, not even now.

I am looking at the fields as they pass by.

My spirit is not tired.

But it's sad and cracked deeply.

Like an ax it lodged in me and got stuck... And I'll die a Lithuanian, stub and stump of a tree, maybe an old oak, with the sharp blade of an ax stuck in me.

I have thrown myself into Western culture, tempted and seduced by it, more than many of my Lithuanian friends. It lured me, and it still does. The very desire to be a writer is a Western idea. A Lithuanian is a song spinner, an improviser. A lyricist, he is a Dzidorius,* plowman of the fields.

And those others, whose blood produced me and who built Vilnius all white, so white—weren't they too, attracted by the West for the same reasons as I am now? Ah, we are all the same, ever like bees, always carrying honey home. No matter where I am, I see you, the Lithuanian architects, sculptors of the seventeenth, sixteenth centuries, I see you in Florence, I see you sitting in the piazzas, and you are sitting there like farmers, like myself now, here, the heart wounded.

June 29, 1948

I am more quiet, more quiet.

I just came home from a movie. I didn't really see it.

* Protagonist of one of Tumas-Vaižgantas' (1869–1933) novels, an unpractical, lyrical farmer.

HOW BEAUTIFUL YOU ARE...

On my way home, I walked slowly, I looked at the landscape.

I walked and walked.

No date, 1948

A MEMORY

What is a fly? Nothing.

But now, it buzzed past my nose, this thing, this nothing, and it awakened in me one thousand memories.

It brought back those hot, steaming, flaming summer days. Noon time.

Siesta time. Find yourself a place, in whatever shadow— you're on your own!

The deeper into the shade, the better...

The house is empty, hot, flaming... Only the buzzing of the flies, an aggravating, angry buzz before the rain. Just before, when the humidity takes over with its damp flame.

You sit and you feel the silence, the incredible silence of noon as if you yourself were that noon, that heat, that lazy burning.

Out in the middle of the yard the scythes are hanging on a wooden rack. The sun burns glaring on their hard sharp steel.

In the middle of the yard.

Right in the middle of summer.

The angry buzzing of the flies.

All clear. Live on the surface, by the surface, and for the surface.

As far as you can see, behind the surface is where nothingness begins.

That's what frightens you. Given your chance to die more than once by now, you still cling stubbornly to the surface.

"Those who go beneath the surface do so at their peril." Oscar Wilde.

July 6, 1948

On the train, a man sits in front of me. He keeps looking at me. I look at him, then I look out the window. I look at him again. He keeps staring at me, I can feel his eyes studying my face, my hands. I am reading Jung.

"You must be a priest," finally he breaks the silence. "Forgive me the question."

"No," I say. "But you are very close."

"A theology student?"

"No… Poet."

The German laughs.

A TALE

As a child, I used to walk along the village street and laugh to myself. The farmers, my neighbors, used to stop and say: "Why are you laughing, is the rain coming?"

July 20, 1948

From a letter to K.

…No, we are not for the sake of the new as such. Neither are we for the sake of the old as such. Our journal doesn't seek to add to the stock of novelties. The millions of days stretching behind us are all inside us. And whatever is in me, tomorrow it may show up in you. Whatever it is I do—others did for thousands of years past. No, it has nothing to do with the fact that others have gone through it already—the Futurists, the Dadaists, the Surrealists.

No, we are not setting up any new programs. And we do not want to stir up any noise either. Our declaration that we do not support any aesthetic program, of course, could be taken for a programmatic statement. But only

God could probably create something new: we do not pretend to be gods, however. All we are doing is touching some old things, warming up some things with our young spirits and heads. And here perhaps is the crux of it: we do not want to reject our youthfulness. It would be a pretty ridiculous situation if we'd act like old people, if we'd sit with artificial beards, like old men, reciting the lines, achievements, experiences of those who lived before us, only because "they already went through it all." But we play and jump up and down and do some silly things. We are young. We cannot resist our youthfulness. What's the use blaming a young man for his brash gestures, that he walks with his head cocked—what's the use. You say, we do it "on purpose," that it's only "a pose," "a stance," "mannerism." No. It's the speed of our blood! Youthfulness is youthfulness: it's not a manner-matter; and one is young not because one is so "on purpose." Terrific, if one could be young on purpose! I advise you to try it... Elixir of life... Ah, the foolish things of youth, they are so innocent compared with the foolishness of old men, of grown-ups...

Mannerism, poise—it takes years to develop mannerism and poise, that's why only you, the Old Artists, have really developed it into a fine art.

But I don't blame you... As I said, the world is old too. What Binkis or Kossu or the Surrealists experienced—that's their business. They didn't live my life nor Leo's life: they lived their own lives. We have to do it all ourselves, to get it all the hard way. Ah, it would be good (like some bad actors do) to get everything prepared, pre-fabricated, the easy way. It's difficult to get used to the idea of loneliness, to the fact that each of us is responsible for our own salvation ... experiences...

"Searching" for the new? Are we really searching? What's the meaning of "searching"? You call it search-

ings: we call it living intensely. Or playing. Why not play? Where does the "serious" work begin and where does the playing end? Who knows... As if serious work would be more valuable than a playful one. As if creation would be only a purpose, and not the result.

All I want is to lie on my back in a field and look up at the sky past the stems of grass. And then—die... Or: to walk behind the plow, black damp earth, barefoot, and then, at night—to dream. You live because you want to write a poem. We write poems because if we didn't, we couldn't live. To be or not to be. To write or not to write. Remember, Kafka on his death bed, asked to burn all his writings...

You say, our writings are incomprehensible. Understanding is no measure of things. Measurable reality ends with our finger tips: beyond that—the abyss...

August 20, 1948

For about four weeks I have been living on the shores of lake Edersee, in a YMCA camp, working as a counselor. I am taking care of a tentful of children. The first three weeks I was entrusted with the young Lapinas brothers' jazz band. After that I had a bunch of ordinary kids, 12-13 years old, ordinary kids. Now I am in charge of a dozen Russian kids, average age 8.

The sun is burning, hot. I walked deep into the woods to gather raspberries, ate as many as I could, sat by the lake and dozed.

Ah, there is nothing like sleeping on a sunny hillside, on a hot summer day, with red ripe raspberries all around you, and the moss, and the little bugs, and the feeling, this incredible feeling of being close to earth... Am I still a pantheist?

Now, for the last few days, it has been pouring. We are sitting inside our tents, much too much so, the children

are growing noisy, it's difficult to keep them from fighting. One of them gets a few cookies from home, so the others sit close by with their mouths watering, or invent games to trick the poor kid out of his cookies, like, "Do you want to hit me on the head, for one cookie?" It works. Then suddenly one begins to howl and I waste a lot of time trying to figure out who's guilty, most of the time with no results.

Ah, the nights of Edersee, the dark blue sky reflected in water, the hooting of the owls, the night birds, somewhere in the lush brushes around the lake... In the morning we watch soft white clouds drift over the lake as the rising sun begins to paint its 100 frescoes.

In the evenings we sit and we sing. Quietly, not too loud.

I am reading *Le rouge et le noir*. Also, Jack London's biography (by his wife).

Yesterday I visited Mattenberg, our barracks. Could not believe how gray and miserable everything looks. Streets, buildings, people everything's gray. My eyes got used to the green and blue, and the red of the raspberries & the spaces of lakes, forests, hills. Here—everything's narrow. People stop you in the street and ask you about Berlin, war, politics. Bought a newspaper—the same, exactly the same news as a month ago, nothing has changed.

Dear Leonas:

You gave me this page, you said, I should write in it something. That was two days ago. But I had no time to do it. The days are so full here.

Just take yesterday. Try to remember: the sailing on the lake, the racing. Later—in the tents, with children. In the evening, you came home from a walk in the woods,

very very happy, and you said: "Ah, how beautiful every-thing is, how beautiful." In the woods you made a large fire, and there was a lot of shouting and hollering. From the lake blew a strong wind but you insisted on "one more trip" into the lake. Then came the night, but we couldn't close our eyes: too much, too much. Everything was still lingering in our eyes. Drunk with life.

And when we sit in the evenings and sing—ah, how beautiful are those evenings, those songs. Something so close to the heart—maybe it's all because the girls are sitting so close by—maybe those songs are for them... And that's why the evenings are so beautiful, too... Just one look, two eyes—and it seems it's so much... Ah, Leonas, there are some eyes in the world... They take you, they tame you like a little dog... It wakes up in you, deep deep somewhere something you didn't even know you had ... and next minute it's all gone, back to the daily reality... Yes, those are the moments you could die. It's a moment when all sins are forgiven ... what could be more beautiful than that?

Ah, and so went our days, our nights...

No date, 1948

Letter to Vileišis.

I am sending you what you asked for. My poems are not exactly what one thinks of when one hears the word poetry. It's all about the farm life, the way I remember it, the way I lived it, or rather, relive it. I sing like a true son of Papilys*... I didn't stray away from the straight, down to earth language and images. I know nothing else to write about but the farmer's world. Hell, I say, all those

* Papilys, a small town 15 miles south of Biržai, the location of Radziwils' first castle. Known for its rough, blunt, tough dialect.

Lithuanians disappearing into the factories, growing beards in coal mines—but who is trying to settle down on a farm? Shits, I say, my brother Lithuanians are shits, they are all city folks. But a true Lithuanian is a farmer and should remain a farmer. But they—hell, they always run to the cities, like they are possessed. Imagine, there stands a Lithuanian farmer in New York with his head turned upward, staring at the 100th floor of some building? What do you think he's going to do there? He's going to end up in some miserable three floor factory, he will rot there without any sun, he may even marry some potato woman, one who grew up without any sun, white, soft, bloodless—(she is working in another tiny miserable sunless factory—or an office, a big deal, an office!)—and they'll breed many children, they'll run along the streets with toy guns in their hands playing Dillinger—and that will constitute the new Lithuanian immigrant family. Very idyllic... He (they) may be dreaming some day to return to Lithuania (although I do not believe that they'll still have such dreams)—as if anybody would want them there such as they are... Hell, Lithuania doesn't need Americans: it needs Lithuanians... It needs farmers. As far as the cities, factories, offices, politicians go—they can drop dead, all of them, right now.

August 1948

Returned to Edersee.

It's raining. Every new period begins with rain. Water water everywhere—over the tents, over the lake, over the muddy courtyards. Heavy streams are beating the tarpaulin tents. The air is heavy.

You run out, you look around—and back you run again. I went out to pick up my food from the kitchen tent—my hair got soaked, water is dripping down my face and into my soup.

171

But it's good to feel around you this wild revolution of nature, this endless sound of rain, the beating on the surface of the lake. The voices in my tent are low, monotonous, fading into rain. The Russian children are sitting on the cots, silently singing some old Ukrainian Cossack song.

I am sitting and thinking, all kinds of thoughts.

Ah, the rain has slowed down. The sky seems to be getting brighter. On the other side of Edersee there are still heavy cloud gatherings, but they seem to be moving south. I don't think there will be any more rain today, judging from the speed of the clouds. A rowboat is going into the lake, a fishing boat, it won't come back until evening.

Behind the tent, the forest is echoing with the shouting of wild hens and thrushes. A whistle in the courtyard. What's happening? Ah, the preparations for the evening fire. My little Russians are determined to prepare a folk song for the evening, are asking me to help them. O.K., O.K., sing, sing.

In front of the tent: two young girls are walking back and forth—the daytime guard. All wet, their hair, their blouses are sticking to their young bodies. At eight o'clock the replacements will relieve them.

O.K., let's have a song here, kids. *Tycho svietit*? O.K. with me, I know this one too. They sing "*tycho svietit miesetz yassno…*" "silently shines a young moon…" Their voices are so sweet.

September 1948

Inscription in the autograph book, for Marija:

To write something into this autograph book? Do you really want to remember me? I don't know what these few words will bring back, years later. But here they are. Why not to play with words…

HOW BEAUTIFUL YOU ARE...

Paper is so white, so easy to write...

As for the memories—ah, those eyes, you can't restrain them, they keep running, they keep running... They keep looking, and they collect and store every image, every mood: the evenings together, the smiles, and the songs that sounded so beautiful when we stood and sang them together—and the sunsets—and the sleepless nights—everything has been stored deep behind the eyelids. We keep looking, all our lives ... until it's filled to the brim and everything begins to bubble and burp up, the springs of memories...

Some day, years later, in our memories, we'll return back to these places, and we'll toss about and we won't be able to sleep, thinking, remembering ... it will all come back and we won't be able to change anything...

So I wish that then, years later, you wouldn't regret anything and you wouldn't want to change anything at all—a life lived perfectly, a perfect memory...

But now, suddenly, I have nothing to say and the paper looks so white, so innocent. Maybe someone else will find something much more useful to say here—

A meeting with nature means to me sometimes more than meeting with a person. It wakes up feelings, memories. Its arrows shoot deep, always on target.

October 16, 1948

8:30 AM. Men are climbing into a truck to go to work. Teenagers on their way to the High School. The storekeeper is walking to the store. Office employees are on their way to their offices. Children are gathering around a frozen puddle in front of the camp's office building.

9:40 AM. Post office. Packages. A woman carrying milk. Some people are boarding the trolley for Kassel.

In the sports hall some people are playing billiards, I can hear voices and sounds. A man is sweeping the street.

10 AM. Post office. Barber. The store. Three German children walking from door to door, asking for food, money. The camp government is pasting the latest announcements on the bulletin board. A crowd gathers around it.

Twelve noon. Bhrrum. A truck returns from somewhere, full of office workers—yes, they are from the Central Refugee offices. The streets are full of office etc. workers going home to eat. Cars arriving with I.R.O. workers, Americans. A bunch of people enter the store. A little boy delivering newspapers. High School kids going home.

1 PM A crowd of primary school kids in the street. Office workers on their way back to their jobs.

4:35 PM Evening mail.

5 PM The librarian passes by followed by several children.

6 PM The sports club is livening up.

In the main auditorium—a lecture.

Movies. Something with Tarzan.

In the Yugoslav barracks—dance music.

9 PM People cruising the streets in small groups.

The reading room brightly lit.

To the city! (Kassel)

Children running along the street swinging flashlights.

Police.

A jeep rushes by. Another jeep. Five drunks walk by.

1 AM at night. A group of drunk Yugoslavs walk along the street singing. One plays *bayan*.

A jeep.

The hospital building full of light.

A policeman.

HOW BEAUTIFUL YOU ARE...

October 17, 1948

Berchtesgaden

Another evening.

Quiet. I am alone in these corridors. All the participants of the conference have departed. Somehow it's lonely now. I am walking through the corridors and I can hear my own steps.

I stand by the window and I look at the tip of Watzmann Mountain.

I didn't really know any of them, but they were here, all this time, for two weeks, and I didn't come to know any of them, we remained separate like two houses on different sides of the street. But now I seem to miss them.

My things are packed. I am leaving tomorrow morning.

October 27, 1948

Dear Pastor Trakis:

First, re. Mainz-Kastel. I checked, when I came back, and found out that the D. P. camp there has been recently closed, we can't move into it. So it's all zero. It looks now that our studies in Mainz, my own and Adolfas's, will have to end. Unless we can transfer ourselves to Munich. We don't know yet if that is possible.

Now about that other matter, my possible studies of theology.

I gave a lot of thought to it. I came to the conclusion that I cannot study theology. It would be very easy for me to accept your offer, and the stipend, and I have no doubt I would make a very good student and, later, a very good pastor... But how can I do it if I do not really feel any pull, any passion for it? To do something just purely mechanically would mean to have a mechanical relationship

175

to oneself and to God. It is true that I have a great pull towards matters of spirit, mysticism, and thus, probably, towards theology, too. But it's not the kind of pull or passion that is needed for the priesthood studies and, particularly, Protestant priesthood. I do not really think I am a Protestant, in my deepest corners. I have about equal interest in all religions, at this point. I seem to believe more in the inner church than the worldly, organized church. I have absolutely nothing against this Catholic woman, sitting here in the church, in a corner, saying her prayers and going with her fingers through her rosary, very sincerely, completely devoted to her God. If that rosary helps her, it's fine, very fine. Luther may have minded it; I am sure God doesn't. Or what can I have against those hundreds walking on their knees, down long dusty roads, to the pilgrim places, Šiluva, Lourdes? Very often I go to Catholic churches and synagogues. I listen, I look, and I have had many inspiring hours there. Religion, faith has little to do with reason, anyway. Words are only means, bridges. They do not matter much in church. You do all you're told to do and wait for the grace to descend, and it descends. I have experienced such moments in Giebelstadt, in Brasselsberg, in Mattenberg, Mainz.

So that I do not think I could at this time honestly accept your very kind offer and study Protestant theology. In order to become a minister I should first believe in the articles of the faith. But I do not really believe in them at this point of my life.

I often envy those who find God so very easily. I seem to suffer, live in pain, searching, doubting, not finding, or finding and losing again. Sometimes I think I live with a big devil inside me, one who has nothing else to do but constantly confuse me.

My life is as confusing as the mountains.

HOW BEAUTIFUL YOU ARE...

You can't get to the top of a mountain by walking straight. You walk through and around the fields, up and down, narrow passages, paths—the road that is ten times longer than the actual straight distance... And it always looks as if that peak, that summit is so near, maybe just minutes away—but you walk for three more hours, and you look up and the distance is still the same. The mountains upset the logic of lines, perspectives, time, space, distance. Everything's so different, in the mountains. So then, what about life? ...

November 7, 1948

I heard them sing. One evening, one incredibly white evening, in the very middle of the summer. After the work, when all the pails, all the barn doors are quiet, when only the chirping of night insects and the wings of bats cut the air... They stood under the lilac bushes in the warm evening and they sang.

Ah, the songs, the little songs! Their words—like drops of amber strung on a thread. Have I ever heard anyone anywhere else sing like that? So sadly and so dreamily? In the fields, walking home from work, on summer nights? Ah, they keep coming back to me, now, those summer evenings, those nights, white and full of stars. We used to sit under the linden tree on a wooden bench—artemisia bushes smell so sweetly in the hot evening air!—and we sang.

Ah, my God, what do I know, how can I tell you what the songs were all about? Simple were their words, very simple. We sang about the flower garden, about the smell of the rue flower, about the young man's, young girl's dreams, longings; about the horses; and about the flax fields we sang, and about the mothers... Those were small, simple words, and without any ornaments. We had

sung them hundreds of times before. But we sang, and we were carried away, again, very very far away... We sang, and our eyes gazed at the dark outlines of the trees submerged in the evening, and we gazed into each other's eyes, too, and we wanted nothing, absolutely nothing, we desired nothing, we only wanted to sing and sing. And it seemed to us that nobody could sing more beautifully, never. And when, after the song had ended, we sat silently, not wanting to disturb the silence and the mood—as we sat and listened, we could hear the same songs come from far away, from other villages, distant farm settlements. There, too, on the darkening porches, or walking, in little groups through the blooming field paths, they sang, the men and women of other villages; they sang, taken over by the same melancholy and pantheism, as they gazed into the evening.

They floated, the little songs, from our very souls, Lithuanian souls, and were carried by the winds into the Baltic Sea where they were caught on the branches of pine trees and fell into the waters in drops of amber.

November 8, 1948

Somebody said to me today:
"Why don't you do yourself what you tell us to do?"
But what about road signs? They tell you the directions perfectly well but they don't walk with you to town...

Leo is talking about his short story, "Apple."
"An actor speaks through or by means of something, something he's holding in his hand, perhaps. 'Apple' was that kind of thing or means for me, it's only a means. If somebody is able to see through it, O.K.; if not—it's O.K. too."

HOW BEAUTIFUL YOU ARE...

A few days ago the camp office called me and asked if we need some clothes, nobody wants them, they said; they were picked up from the room of some guy who died there. We said, we want them—the guy is dead, he doesn't need them, does he? They gave them to us. So now we are better dressed, thanks to the dead guy.

SHORT STORY

Poor devil!

He knows from the past, from the ages, that evil, doesn't pay. But because of his nature, he has to do evil, while knowing that it's all in vain, all for nothing.

That's why, whatever he does, he does with a certain resignation, and spitefully. Not a single act of the devil comes from faith. He knows perfectly well that all his acts have been undermined long long ago.

But he still has to do it!

November 20, 1948

Paul, angry, speaks regarding the exiles' dreams of returning home:

"Miracles do not happen when nobody believes in them, nobody expects them.

"Do you really want to go home? I wonder if your kind of longing, of wanting, is really real. I doubt its sincerity. I have read my St. Paul, I know what wanting means. I will tell you the truth: you want nothing. You do not really want anything, and that's why you have nothing, only misery. You will die like that. You may even become rich in the meantime. You'll die rich and in misery.

"So don't talk to me about home. Your tears are made of water.

"No salt. Nothing will collapse when you'll look back."

179

I HAD NOWHERE TO GO

No date, 1948

What kind of Christians are you, my Lithuanians! Not even one full hundred years have passed since we abandoned worshipping oak trees and adders. Even today, a Lithuanian stops somewhere in the middle of a pasture, or a forest, and doesn't know why, why suddenly the heart is so full, the trees are calling us back. The Pope's messengers wrote to the Vatican, in the middle of the nineteenth century: "We are in Lithuania, a pagan country, they still worship trees and all kinds of creeping creatures..."

It's hard to be a Catholic, for a Lithuanian, and even more foreign to him is Protestantism. He sits on the porch and carves gods out of wood, himself like a god. During baptisms or weddings, my village neighbors used to bring the wooden statue of St. John, from the little woods by the cemeteries, from the field altar. They used to place him at the end of the table and make him a part of the celebration. They couldn't separate heaven from earth.

No, it's not paganism, no. It's the lyrical Lithuanian pantheism. And it's not making fun of gods, no: his God is very close to earth. He has carved Him with his own hands and placed Him at the end of the field, and by roadsides, so that this wooden, sad and suffering God/Christ figure, head resting on one arm, would always be there, looking across the fields at him when he works.

And I think now, that probably every nation, a nation that—really is a nation, a culture, has its own God. God may be the same, but the understanding, the image of God is other, different. A farmer God. A God that comes across the white sand dunes of Neringa, out of

the Baltic Sea. A God that likes the music of *kanklės* and *skudučiai.**

November 22, 1948

Cannot work. The weather is bad. Can't concentrate.

I tried to write. Pressure on both sides of head, heavy humidity in the air.

I walk through my room and I grunt. I would like to scream, but I am afraid to hear it, I don't want my neighbors to knock on my door.

I stand in the doorway surrounded by desperation and I stare into the night.

I don't know, to walk into the black streets—or go to lie on my cot like one who is terribly sick...

November 26, 1948

Got 100 DM loan from camp's office; borrowed 50 DM from Mrs. Poškus. We are determined to publish *Idylls*. Leo finished the illustrations.

A slice of bread, with some sauerkraut on it, covered with another thin slice of bread—a terrific meal. We drink it down with tea. It's very good. To be recommended to all unemployed poets. Another recipe: a piece of bread with a slice of onion on it, sprinkled with salt.

* Considered as Lithuanian folk instruments. *Skudučiai* are whistles played as sets of either 18 or 29; *kanklės* is a string instrument played by plucking the strings.

I am ashamed of how much space in my diaries I am giving to what we eat. To the stomach. I know many a reader will put me down because of that. But that is the reality of our daily lives, these days. You try to stick to the spirit, but the stomach wins. The irregularity, the misery of the food we get keeps us constantly aware of our stomachs.

Right now, when I am writing this down, a thin, completely dried-out German is begging for bread at our door. "*Leider*," (sorry) says Adolfas; "we don't have any." We just finished the last piece, with Leo. We were amazed how good that last piece was... The German is angry, doesn't believe us, walks out.

Leo sits now, surrounded by books, clippings, tearing newspapers like mad, he is preparing himself for tomorrow's lecture. The subject of the lecture is what we should do in order to save humanity and the planet.

Vladas is laughing. He says, it makes no sense to talk to these people here about things they don't understand. He thinks Leo wants to do it from some empty ambition. He doesn't understand why Leo wants to go ahead with his apocalyptic lecture. Leo says, he has to do it. If he does not, it will tear his insides to pieces.

Right now he is desperately trying to explain it all to Vladas. He is talking fast and excited and in torrents of words. Vladas is listening, mumbling, and shaking his head.

An official woman came in from the central I.R.O. office. She said, during the winter maybe I want an office job, she knows one, I could earn some money, it would be easier to live, for food and clothes. I said, thank you, I hate offices. I am against office work in principle, I am against it. So she says, then maybe you want to emigrate. I'd like to go to Morocco, I said. Some day I'd like to go

to Morocco. So she says, that's not serious; your thinking is not serious, without a plan. It's necessary to have a plan, she says. I have a plan, I said, I am a poet, my plans are difficult to explain.

So the woman (Norwegian) looked at me with very strange eyes, very strange. She stood frozen for a long time. Then she said good-bye and walked out.

A SHORT STORY

Not that long ago, not very far from where I live, there died a man, in total misery, very very poor.

All his life he dealt in selling fortunes. But he died poor and without a penny.

All I can say is that these were poor times for his business, poor times.

December 3, 1948

A letter to Stasys Būdavas.

We would like to come to the United States and try to live there for a while. Is it possible to arrange some kind of working papers that would allow us to do that? For two not very practical but obstinate young men? As far as work goes—we can do anything, despite our firm belief that in America the only honest way of living for a poet is the life of a bum.

In short: WE ARE LOOKING FOR WORK.

Cursed be the work! That is, what is meant by work today. Consciously and of our own free will we pledge to become HORSES! What will happen a year later after we get enough of it—what will happen then, we cannot promise you anything...

When I just think, how everybody's working in offices and factories, so busily—in those insane asylums—I

fall into a green panic, as Mikšys would say. At the same time I am aware that having been at it for so long humanity doesn't know how to turn back; that humanity cannot be cured of that disease without surgery. Right now, civilization is on the "critical list." It's creeping forward through the narrow holes of its own industriousness and it cannot turn around—all it can do is to continue creeping until the noose begins to tighten...

Christmas, 1948

There, at home, among the drifts of snow, the fences crackling from cold, and the wind banging at the windows, in stormy winter nights—long long ago—I was still a little boy, in the dawn of my life—(how fast the years went, how fast!) I read, by the light of the kerosene lamp, as it threw shadows on the walls, and the wick made a silent sucking noise—late at night, as Mother's spinning wheel buzzed soothingly—I read Kossu's lines: "Ah, how beautiful you are from afar!" I read them, and I didn't understand them. Because that was long long ago. No, I didn't understand those lines then, only the words themselves, like a thistle, got attached in my memory, remained there.

Many years have passed since then, many evenings. Evenings just like those others, and days. Walking behind the plow, with the cows, or moving the hay; threshing, dust clouds, and the late fall rains and muds; and the vegetable harvest time, the crawling along the wet potato fields, with cold blue fingers. Day after day, work work work, day after day. And when you try to think, as you walk behind the full cart of manure—your thoughts are so clumsy. Maybe only in the evenings, or on holidays, or during the days of the autumn rains—you hide away in a corner, you pull the trunk of books from under the

bed—and you read. Ah, they are all well hidden in a wooden trunk under the bed... And you turn the pages, and you revive. You lie in the barn, in the hay full of the smell of flowers, by a large crack in the barn wall, the light beam falling on the book... Ah, can there be anything greater!

And later, in the city—(A city? There were a couple of fish stores in it, and a farmer's market)—other children looked at my hard, farmer's hands, as I tried to catch up with them. To catch up with others of my own age who were so much further ahead—who had gone ahead, while I walked behind the cows. I worked with my teeth tight, angry, and hungry, taking part-time jobs, living for weeks on bagels and milk.

Ah, those were miserable years. My memories are full of the sweat and war and misery which our family had to go through, a family of eight (six children, I am the fifth, Adolfas the sixth), broken by the winter of 1928, and debts, debts, debts, in order to send all the children to school, and buy clothes, to keep the lice away—yes, memories of lice, too—miserable memories.

But, ah, what has the longing for home, what has it ever to do with a good life? ... No, it's not that that I see when the homesickness overtakes me. What I see is something else. Something that I have never found anywhere else, haven't seen in these other valleys, mountains, lakes, rivers—no. And when I open pages of books, they turn into pain. No, never never to find it in the words of Mallarmé or Rilke, never. Not to find it in the blue trembling light of D'Annunzio pine trees. Nor can I find it in the salty Northern plains of Verhaeren nor those of Hamsun. No, not to find it in Faulkner's rough greenery nor Wiechert's marshy landscapes. No, never.

Then I dream. That's all I have left. And when I dream, everything comes back, it all revives. Just like

this evening, like now. I am sitting here and I am dreaming. And I am writing down the words, just to see my Lithuanian words before my eyes, even if I cannot hear them...

And it's just before Christmas.

Ah, the table is so white, so white, covered with a white linen tablecloth... And the freshly baked bread is laid out on the bed, in the back room, brushed with egg yolk, with a goose feather, smoothly... The living room freshly washed out, bulrush mats on the floor. And the conversations about tomorrow, the trip to church, about the steeply rising cold, and what the animals will talk about, at midnight... And the holiday editions of newspapers, decorated with green branches of fir trees, each member of the family has a section of his or her own, to read...

The window shutters are still banging, clanking—the wind, and the drifts of snow are piling up higher and higher around the houses and on top of the water wells. In the morning, early, on the way to the stables, it will be necessary to shovel a passage through it, to clean it out again, with freezing hands, with the wind blowing snow in your face.

Such longing suddenly takes over, overpowers me, that sometimes I think I won't be able to hold it. No. I hear the breaking of the ice on the rivers. I hear the sound of sleds on the road, the hoofs of the horses. A branch moves on a fir tree, in the forest, snow falls down. I can hear it all, see it all again. I sit and I dream. Silently the snow falls again on the landscapes of my childhood. And only when someone suddenly opens the door, the voice breaks the silence, I wake up, I startle—I wake up—and I see the table, the books, the walls...

Ah, that's nothing, friend, I was only dreaming...

Ah, how beautiful you are from afar!

HOW BEAUTIFUL YOU ARE...

Why did I need all these years, this misery, and the life of an exile, a displaced person, to understand all this, to feel them with my whole being, my body, those few words, those simple words written by another poet, in another exile, many years ago?

6. LIFE GOES ON

Loneliness. Desperation. Stefan George's books, saved from under the war rubble. A young D.P.'s suicide from homesickness. Snow! ... Emigration begins... The author's request to emigrate to Israel is turned down. The author gets an invitation to go to Chicago... About drunk singing in the streets... The disease of intellectualism... The rambles of mad Leo...

January 1, 1949

We sat this evening in our room, thinking, trying to write. From across the street we could hear voices and music. From the second floor apartment, through the closed windows, flooded with light, came drunk, confused singing. Adolfas opened the window—we listened. Outside, it's drizzling, wet, dark. The sky is cloudy. Only the street lamps glisten in the puddles. A warmly dressed policeman stands on the street corner. Lights go out in one apartment, somewhere across the street. A woman opens the window, sticks her head out. She closes the window again. A couple of people clunk by. A girl. And again empty.

We walk out into the night. We walk long, from street to street. We stop, and we look into the brightly lit rooms, through the windows, we listen. Sadly they sing, full of longing and homesickness, sitting around the tables, we can see them. Maybe drunk, maybe not—makes no difference. The streets are completely empty. It's still drizzling. We walk a long time, from street to street. A woman opens the window, sticks her head out. She closes the window again.

Ah, one gets enough of sitting in rooms, indoors, books and walls. You get bored with yourself. Even if we

Niederzwehren-Cassel. Frankfurterstraße.

Mattenberg trolley to Kassel

go to see Algis or Vladas—it's the same: more books and more walls. No, we can't escape them.

January 8, 1949

I hear, in Germany, a new development in theater is taking place, it's the *Haustheater*. Theaters in regular living rooms, not in old, specially built, large auditoriums (they are all gone…). It's for a small public.

Come and sit in our room. We'll put a few chairs in the corner—just sit there quietly. Our life will be a better theater than most of the *Haustheaters*.

January 9, 1949

Early, without breakfast, we got up and travelled to Kassel—Adolfas, Leo and myself—to the movies, to see Käutner's *Der Apfel ist ab*. I liked the beginning. It was better than most of the new German films. After the film, I had to return to Mattenberg, because of my work at the library. Leo and Adolfas went to see *The Best Years of Our Lives*. Now it's eleven in the evening, and they aren't home yet. Maybe they went to a third movie.

January 23, 1949

Yesterday we spent the evening at Vladas', listening to Mozart. Ah, what music, what perfection.

Vladas said, they give us too little to eat in the D.P. camp. I said, it's true, but since we aren't doing anything very much physically, the rations that we are getting are sufficient enough for us… Vladas laughed at me:

"See how much I am eating? I am eating and eating, and I am still hungry."

I said:

"This is so because you don't pray before you eat. You are like a crocodile or a snake. Food and eating should be a holy communion with earth and heaven, the producers of what we eat."

Vladas: "But I didn't see you pray before you started eating."

I said: "I didn't pray even in my thoughts. And that's why I am also as hungry as you are…"

January 24, 1949

Frost on the trees and hills. I stood waiting for the trolley, early in the morning, and I looked at the fields, and it was so good for the eyes. Memories of the Lithuanian winters surged up. I have been waiting for snow since Christmas. I understand the birds, how they feel when the time to migrate comes. They know it, it's a craving, it's an instinct. And so it is with snow, for me. Winter comes and I am walking with my eyes on the horizon, like a somnambulist, like a bird that was left behind. It's painful. Lonely. And miserable.

Where was I going this early frosty morning? The other day in Kassel, in a window, I saw Stefan George's books displayed, and the sign said they will be open at nine. So I am rushing now to the store. I couldn't wait.

The little antique bookshop, I was informed, belonged to Scheller's wife. That's her, running the bookshop. Scheller, I was again informed, was one of George's closest friends. Anyway, I said, no, I can't buy them, I have no money. So she lent the books to me, her personal autographed copies. She said, she is lending them to me because she likes my face. "So sensitive, so sensitive," she kept saying, to my embarrassment. The books are still full of sand. She just dug them out from under the bricks. But now they are back to being held in hands, and are being read.

LIFE GOES ON

On the way back I rode the trolley all excited, elated. (I was also carrying Valéry's *Eupalinos*.) My spirits were so high that I couldn't be disturbed even when the conductor discovered that I had only half of the fare. And I didn't feel any guilt about it. I asked the fellow riders to help me to pay the other half, and they did. George, Valéry—I know, it will seem totally silly, to some, that one can get so excited about a couple of books. But that's how I live, in a dream... There is so little good left after this war that isn't covered with dirt, shame, betrayal. So you brush away the dust and bricks and concrete and you read, black on white...

Dear B.:

I came home and I found your letter. Your letter brought me a great joy. Nobody has said anything as good about *Idylls** as you. Nobody has written with any understanding about them. Many have spoken and written about them, but mostly like teachers, looking at me like someone who is standing on his head, or something. But you are writing like a poet to a poet. You yourself went through periods of anguish and search: not to astonish the reader, not because you wanted to walk on high wires—but because you were exploding. No, there is nothing modern about it; there is no "searching," "experimenting." And that's why Idylls is my first real work. It came out naturally, of its own necessity, by its own force. It burned, it pressed heavily, it hurt. I had to let it out.

* *Semeniškiu Idilės (Idylls of Semeniškiai)*. The author's first published book of poems, a seasonal cycle that follows the farm calendar, breathing nostalgia for a village childhood and the harsh realities of the farmer's fate. The lines are vivid with rough district dialect. —V. B.

No, I am not ashamed of my homesickness, my long-ing for Lithuania, the old village.

I know I am only at the beginning. There is so much to take in, to burn, so that the word would really gain form, take shape.

January 25, 1949

This girl comes almost every day to exchange books. Her face... I can imagine St. Bernadette looked like her. Child's eyes. Those few seconds—maybe a couple of minutes when she is in the library, makes my day. I am counting my working hours now not by the clock but by her coming and going. Huge time jumps across space, pauses.

This childlike purity and innocence versus the misery, corruption of the grown-up world around me.

Yesterday Leonas was telling me that he has never seen me in love yet. "Fall in love," he said.

I think I am always in love. Falling in and out of love, constantly. That's my trouble. Everytime I see a girl, my heart goes tuk-tuk-tuk.

Leonas says, that is not normal. What kind of love is this! Nothing real!

Eh, what do we know about love? It's more difficult to love a woman like a flower than to love a woman like a woman; and rarer, too...

The love of flowers is the love of children and poets... Poets can love unseen subtleties that they glimpse here and there, that are missing in the world but which they want to bring back into the world...

One such quality is innocence.

Eh, they are like dreams, the young girls, they come and they go...

Thus wrote the librarian in his diary...

LIFE GOES ON

January 26, 1949

These refugees, I doubt they will ever see their home-lands again. This one, for instance, does he deserve to return to his home when here, now, he permits bread to get stale and throws the loaves into the garbage cans, outside, while around us, German children are walking with their eyes deep, hungry, literally dying.

I don't think they really want to return home. I see no real urge in them. Was it the same way that the Jews wanted to return home? Is a return home possible without breaking your own proud pomposity to pieces? For the Jews, it took 2000 years. It's not easy.

Where are they, the homesickness tears? Where are the homesickness songs?

God punishes one for all, and all for one...

February 3, 1949

In grade school, they used to pick on me. They said, I laugh like a girl. They used to do everything to provoke me to laughter so that they could laugh at my laughing. They called me Jonyte, which is the feminine diminutive variant of Jonas, in Lithuanian.

At home, I spent a lot of time in the kitchen: my mother needed help. For several years I performed the duties of a housemaid. The neighbors seeing me do that kind of work, used to call me a housemaid.

Maybe until the sixth year of my life I ran around—as is the custom in those parts—wearing a jupe, no pants. I must have been around the age of five or six when I got my first pair of pants, and they had to put them on me by force, I was howling like a pig led to slaughter.

In the higher grades, I was already fourteen, maybe even fifteen, the girls liked me very much, but in a very funny way. They used to grab me and carry me around. I was thin and light, they could carry me very easily.

They did that because they knew I was very shy and I would never touch them. So they would grab me by the waist from behind, lift me up in the air and carry me around for their own entertainment.

February 10, 1949

I dream about spending some time in Spain, and in France, and maybe North Africa. To go to America? Can I expect any other work there but one that could be as well if not better performed by a robot? I have no profession, and I don't want to have any. To compete there with brute physical force, muscle? No, my muscles can't compete there for very long. What's more, I have no wish or intention to compete. I simply hate work that can be done better by a robot.

But as long as the I.R.O. is feeding me, I'll stay here, right where I am. I'll end up in America only by bad luck.

My love of Europe is strange, full of contradictions and, I am afraid, superstitions. Lithuanians were always attracted by the West, but we came from some Asian place... We still speak Sanskrit...

No, we are not going to save Lithuania. Only those who remained there, will. As for the refugees, exiles: they'll disappear like sand, they'll vanish among the cities, countries, women, money, and homesickness.

(Two days ago, in our barracks, one young man wrote a farewell letter, lay down on his bed, turned on the gas, and went home... The letter said:, "No, I can't any longer, I don't see any end... I can't take the exile, and I see no sun...")

Plans? We are working on ourselves. In total loneliness, like old hermits...

LIFE GOES ON

February 22, 1949

Smithshops. They have always attracted me. A smith-shop is like the mind of an artist. Every corner filled with junk. Soot, hammers, wheels, nails, iron shavings, everything in one massive pile, and in the middle of it all, and in perfect control, stands the smith himself. His hands, his eyes pick out what is needed. He will pick out an item from the chaos where everything looks so totally useless and make something new out of it.

I bought a *bayan*. Fooling around now. Leo is directing a play for Tvirbutas,* he wants me to play polka in it. Again, we are slaving, with Algis, cursing, writing a "libretto."

Big news: in Hanau they sold four copies of *Idylls*...

How to live? To fall, to fall, with eyes closed, to fall into every occasion, into everything.

March 1949

Vladas speaking about Leo:

"Lack of logic... Russian blood is dominating... Lack of elementary philosophical education. First you should study philosophy for twenty years before you can talk about it. How can you shit on Heidegger after a mere perusal? He has a mania of grandeur."

Me: "A poet doesn't have to go to schools. A poet grows out from the center and then shoots out, and burns like a firework. He can smell shit after ten pages, he doesn't have to read the collected works: his nose is not yet ruined. Leo doesn't want to be a philosopher: he wants to live intensely."

* Ipolitas Tvirbutas (1899-1968), actor and director, student of Stanislavski.

Author, overlooking Mattenberg D.P. camp

LIFE GOES ON

Leo: "Logic? It's very possible that all philosophers till now were nothing but shits.

"A philosopher is an artist, not a specialist."

March 2, 1949

Hemingway, *In Another Country*.

I am reading it slowly, saving some for the next time. I like his epic style, pacing, his attachment to objects, earth. And very direct, no philosophy. It's amazing how it all comes through even in German translation. I don't know what there is about the German language, but even Russian classics come out well in German translations. Not talking about Shakespeare...

Valéry, *Album de vers anciens*, Giovanni di Boccaccio, *Das Leben Dantes*, Valéry, *Die Politik des Geistes*.

Today we mailed "leftovers" of *Žvilgsniai* N. 3 & 4, and *Idylls*, with discount, to bookshops in the various D.P. camps. I took a bagful to the post office. Tomorrow, one more bag.

Picked up February salary (library), 100 DM.

They paid me 35 DM for the "libretto" I wrote for the camp's Christmas show. Paid back some debts and had exactly 4 DM left to live on. So we bought some potatoes and some apple jam. Going to make potato pancakes.

Some weather! Wind, snow, sleet all day. Roof tiles are flying from the buildings, searching for heads, landing in muddy snow and dirt. Cans, boxes, crates are rolling along the streets. You can't walk against the wind. You try to pull yourself forward, working hard with both hands—and you can't. Cold, hard snow slashes across the face. You stand in the middle of the street and howl. It stops for a minute, it subsides, even the sun comes out—a blue hole opens in the oceans of the sky. Then

again heavy clouds descend upon the fields and streets, houses, everything.

During the night it subsided. And froze. It looks almost like winter now. I read in the paper, it was classified as a hurricane, 175 kilometers per hour ran the wind, did a lot of damage. In Kassel, five were killed by falling war damaged buildings. Ten were killed in Köln.

March 4, 1949

We are having a real winter. Not too much snow, but still it's winter, for a change. Today the weather was especially divine. I walked to the top of the hill where children were playing—it was around noon. Our little town was lying down below, the red roofs of Mattenberg, Oberzwehren, and further in the blue misty distance, Kassel. It was so incredibly beautiful. From afar, from the mist, you could hear distant, very distant city noise. Distant vague voices could be heard in the valley, in the barracks. I almost couldn't believe that I could find such poetry in this foreign town. I suddenly felt very very close to it. Like my second home. Kassel? Who would ever believe it!

In the late afternoon, Levis, Irena, Bronius, we borrowed sleds and climbed on the hill. Bronius broke his on the first ride. Mine survived to the honorable end. From the very top of the hill, over the bare molehills, we rode down, at breakneck speeds, spilling out and falling, and screaming and shouting, and ending up in one big heap, at the bottom of the hill. We drank the winter with our bodies, our skins, bones, lungs, eyes, hearts. We wanted to lose ourselves in the snow, to touch it, to wallow in it, like children, again. The snow is our mud of Lourdes.

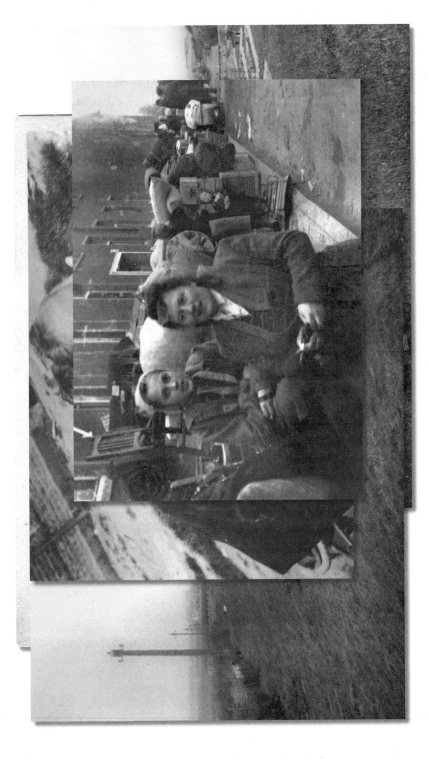

The next morning we stood in the courtyard in front of the office barracks. A full truck was leaving, for Australia. We waved, they sang, some cried. How easily we part… After years of being together…Togetherness that was imposed, artificial. A woman is crying. I don't know who is departing, must be a relative. Another woman is trying to calm her.

"Don't cry, he's going to a better life."

A voice: "Do not forget to write!"

"As soon as I land!"

"Here, take the cigarettes, will last to the boat."

"The driver wants a nice girl next to him, doesn't want to drive alone…"

"Everything's ready?"

Someone begins to sing *Sudiev kvietkeli tu brangiausias* others join in ("Good-bye, my sweetheart…")

"Look, look, don't fall out … drunk…"

The driver starts the engine.

March 17, 1949

A few expressions of Tarosas:

"Tell me, Tarosas, how is life?"

"Ah, prick this is, not life."

"How are the children?"

"Ah, what can I tell you? With food like this? Body goes one way, the balls another."

"And how are you yourself?"

"Ah, as long as the balls are still hanging, I move somehow."

"Are you planning to go anywhere, to emigrate?"

"Ah, mister, no place is ours, no matter where. We'll move from place to place, like Jews, until the last shit."

LIFE GOES ON

April 1, 1949

Is this an April Fools' joke? Povilas Variakojis, from Chicago, sent us guarantees for a job there, in a bakery. So, now, we can apply for our visas to the U.S.A. Why not?

Variakojis, was a good friend of my uncle, in Biržai. He was the director of a bank branch there. Now he's in Chicago.

April 5, 1949

Moleris talks about his years in Lida, Lithuania, as a government official, under the German occupation. A small official.

The forests were full of partisans. He went to visit a friend, to drink some vodka. Turns around—the village is burning, partisans attacked Germans. He never went back.

Drinking, all the time drinking.

His sister came to visit him—stayed for two weeks waiting for him to sober up so she could talk to him. She left two weeks later, without talking to him, he never sobered up.

Many are emigrating.

Our barracks are getting thinner and thinner. They are planning to close our camp soon, they'll move us South. Soon everybody will leave, only the two of us will remain here like ghosts. The Eternal D.P.'s...

Today I packed up the library. We are shipping it to Hanau.

Reading Hofmannsthal. Thomas Wolfe.
Révész, *Ursprung und Vorgeschichte der Sprache.*
Heidegger, *Sein und Zeit.*
Bought a photo camera, Zeiss Ikon. First steps.
Saw *Martin Roumagnac.*

I HAD NOWHERE TO GO

Ah, hell, this civilized world! You can't walk bare-footed here, you can't take off your clothes. Always jackets, suits, shoes, pants.

This evening, before going to bed, I took off my clothes and ran around the room and jumped, in my underwear, almost in ecstasy. Ah, how good it feels, how free, how light—almost like during the haymaking season. In the civilized West, you have to close the windows to enjoy the freedom of bare feet. Ah, it's difficult for a farmer to get used to the city.

Vladas, Algis, Leo—they are living an extension of their lives in Kaunas, without any drastic changes. But myself and Adolfas, we came here from a completely different world. From a farmer's world into a world of intelligentsia, literary people, educated people... Very very different... And now, glue these two worlds together, if you are that smart... So we are trying to suck out the best from both, without poisoning or betraying our origins. Sometimes the origins dominate, sometimes the newly acquired life takes the lead. Twenty one years... For twenty one years I lived and thought differently, very very differently.

And this new life is so tempting, you want to drink it all, right now—while your friends who were born into such life, got it all slowly, naturally, normally.

So you grab this, and you grab that, full hands, full head, trying to get it all in a few years... Yes, we made it. Now some suspect us being real city folks... But behind it all—a farmer boy who, when the night comes, when nobody sees, behind the closed windows, jumps around in his underwear ecstatic about his bare foot freedom... Not unlike any other prisoner in any other prison...

LIFE GOES ON

In the street, with a white apron, white jacket and a white cap—and a white pushcart!—where Eisenhower street cuts across the Truman Street—a German is selling ice cream. Around him a crowd of children. Some are licking the dripping, syrupy sugar substances. It's dripping all over their fingers, belly buttons.

It's not too hot, the weather. We had a few warmer days, but now it cooled down again. Rainy, windy.

The ice cream man cleans up the top of his cart with a rag, is pushing it to the next street corner.

April 7, 1949

I bought a still camera... I bought a radio... I even go to the movies and to the opera... But I do it from curiosity, not from a necessity. Monkeys do the same. I am playing at a game of civilization. A temporary entertainment.

Not the same with Algis. When Algis buys a radio, he does it from a necessity, his life style demands it, his blood. Blood of a civilized man. Civilization as a routine. To him, it's all very natural, very normal and it all fits together, all these gadgets of civilization.

But when Adolfas or I, when we do the same thing—everybody's staring at us—if not laughing. Right now they are laughing about the basque berets we are wearing. None of it really fits us organically. We are not civilized.

April 10, 1949

Today we decided that Israel is the place for us. We decided to enlist as volunteers to help to rebuild Israel. We got so excited about it, we couldn't sleep.

The director of the emigration office stared at us incredulously when we told him our plan. He looked and looked, shook his head, and looked again.

"What? What?" he kept saying. "Everybody wants to go to Canada, U.S.A., all kinds of serious countries, for serious work. And you, you want to go to Israel? Israel takes only Jews, there is no quota for Lithuanians. Are you Jews?" he asked.

"No," we say, "we are plain Lithuanians."

"Then why do you want to go to Israel?"

"It feels exciting to us," I say. "There is a new state there coming into existence, we'd like to help it."

Again the man stares at us, shakes his head.

"No, not to Israel," he says. "Nothing doing."

"Then we'd like to go to Egypt," I said. "We can walk on foot from Egypt to Israel."

"No," he says, "Egypt has no quota for Lithuanian refugees."

We went home depressed. Now we are making plans to go to Australia. They pay well there, they say. We'll earn money there, then we can go to Israel with our own money. And start their film production, we have plans. Despite the offer from Chicago, we do not think America is the country for us.

Today, after a good sleep, I woke up and suddenly I felt very very happy right here where I am, living like an earthworm, on nothing. Without Australia, without Israel. Where are you going, where are you rushing, brothers? What are you searching for? I have no plans, I have no maps. I am happy where I am. I think I will be redeemed and delivered right here. My father lived in one place all his life and was happier than I am. So why should I be so anxious to go anywhere? Unless they let me go where I really want to, what difference does it make where they drop me? Let them take me where they

want, it's their business, not mine... It was Churchill, de Gaulle and Roosevelt who gave away my country to the Russians. So now, let them deal with me. I am staying where I am.

I came home and found Leo. Later Bronius came, started talking. Leo says, intellectualism is like a disease: once you get it, you have to go through it in order to get rid of it, otherwise you'll be hanging in between, without a center, like a bird with one wing. That's what he's saying right now. He's talking so fast I can't write it down.

Purpose? Does an apple have a purpose? It is, *es ist so*. Purpose to life? Purpose to an apple? There is only the point of impulse, impulsive point, at which an apple begins to grow, somewhere deep, in the seed, and then slowly further and further...

As long as you don't want to understand everything...

Nature is generous, doesn't save anything, doesn't count generations, doesn't count time—it has no purpose. Be what you are and be fully—like nature.

April 28, 1949

Everybody's leaving, emigrating. Now there is more space in the barracks. The camp government, as a reward for our services to the camp community, gave us a work room of our own... So we threw out every piece of furniture. The room is totally empty now. The only piece of furniture is a table, in the middle of the room.

This morning over 100 people left for Australia. Two days ago we said good-bye to Levis. He left for Canada. Ah, one after another, just like that. Algis is waiting for his date, he is next on the line. Every morning, in front of the camp's office building, at seven in the morning, there gathers a small crowd of people to say good-bye

to the departing ones. Brothers, sisters, mothers. Some have to remain behind because of old age, bad health or other reasons. Canada, Australia, U.S.A., they are looking only for healthy specimens—like in the good old slave-trade days... I am looking at the faces of the departing ones, in the truck, under the tarpaulin, they are full of exultation: finally, finally the war is ending for them.

For the two of us, the war is still here.

Walked out into the fields, behind the barracks. The Germans are plowing the fields, planting potatoes. Huge carts stand by the field's edge. The fields and gardens are full of people, cleaning, digging, carrying. A spring wind is blowing very softly from the fields, now, after the rain. Pleasantly green, spring green. Ah, here nature and men are working together again, in harmony. And next to it—the barracks... How different is our life, how abnormal. But a few more months, years will pass, and these barracks will be empty, and the camp will close. Only the fields, these woods, these hills will remain, and the wind will still blow, as if there never was anything else.

The streets are full of German children, teenagers. With bags on their shoulders, they scrounge through garbage cans, dirt, junk piles. The emigrating D.P.'s sometimes throw out some usable items. They also come to our door.

April 29, 1949

This morning another group of D.P.'s left our barracks. For the United States and Australia.

Usually, after 11 PM it's forbidden to sing in the streets. But on the evenings before departures all regulations are usually suspended. If not suspended then they

209

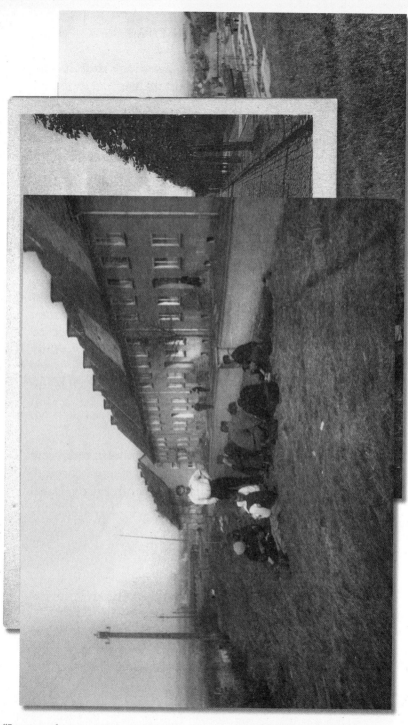

"I saw not long ago a group of men and women walk out into the fields..."

are simply ignored. Everybody's drinking, singing, saying good-bye. All night the streets are full of drunken voices, *bayan* music.

This morning a dozen men left from our block. At midnight, with bottles of vodka, they settled down in our doorway and started singing. Does anyone expect them to sleep, this last night together? Only vodka will put them to sleep.

I was lying in my bed, and I was listening, I couldn't sleep.

Yesterday, a drunk man stood in the middle of the street and sang. He sang loud and freely and from his very heart. So we tried to help him and we joined in, our little gang. But his voice carried over our voices, his voice went to the very end of Mattenberg—as he sang of his homesickness, his Lithuania.

"You won't last, you son of the North, your chains will break..."

And:

"The forests whisper, and cry sadly..."

He sang with a feeling I have seldom heard anybody sing. Then he stopped and said:

"No, you don't understand me, you don't understand me no matter what..."

We say:

"Ah, but we sing together with you, we understand you..."

"No," he says, "you don't understand me. You are book people... You have your books. But what do I have left? Ah, Lithuania won't perish, no..."

And the people are looking out the windows, they can't take that kind of openness, they don't admit or feel their own homesickness that openly, not in that way;

they would be embarrassed. But to this man, everything is beautiful, there is no shame for him.

Then came the policeman:

"Don't howl. Don't you see it's midnight? Go home and sleep it off, or else…"

But the man didn't hear him. He continued singing. And I don't know what happened, we walked away.

Eh, do whatever you want: but please do not forbid a man to sing. Skip your sleep, but permit him to sing. Let it be midnight, but let him sing. Drunk? How could he sing, not drunk, among these morbid blocks, barracks, people? People who care only about bread and America? Ah, how difficult it is to show your true feelings. These people here, they are all employees, office workers. City folks, mostly. How many farmers have I seen here? Filing cabinets, manila envelopes, carbon copies…

Yes, suddenly it's all silent. The song swallowed in his throat, he went to his room and fell on his cot…

I saw, not long ago, a group of men and women walk out into the fields. They left the barracks and walked out into the fields. One Sunday. They lay down, on their backs, and sang. They had to sing. Alone, in the fields. They had to sing, to shout out their hearts, their pain.

I lie on my cot now, listening to the drunk men singing outside, on the steps, and I am thinking, I cannot sleep. Four men sitting there in the night and singing. Four Lithuanian farmers somewhere in Western Europe, in Northern Germany, in the middle of the twentieth century.

A child was born to Sakalauskaite. Now everybody's laughing at her. The child's father left for Australia months ago. Ran away.

LIFE GOES ON

Now she sits in her room, doesn't even show up in the street, can't take the cruel laughs.

She is not the only such mother in the camp. American soldiers' chocolates are so sweet...

THE GRAND INQUISITOR

Leo: "And—maybe—everything has been said already. You begin to write—and you laugh at yourself. The point is not to write, but to plant something in others. I am beginning to feel disappointment with modernism. Art is the greatest of all the lies. Now, it's harder for me to get back close to the earth than before. Sometimes I feel so alone I want to howl. You go out into nature—at least you can embrace a tree, feel something real. But among people—with what convulsions can you hold? You can't even howl like a wolf, alone. God—if he is in the works, in planning... Rilke, ah, he was a good man, when he was young, but he got old and got entangled into the spiritual too much, got caught into the dead spot of seriousness. *Auslöschung.* Der *Cornet.* The shortest road from extreme to extreme.

"I don't know how a human being should live... It's necessary to drop a lot of dead weight, in the world. Rilke didn't drop weight from the right side, got out of balance.

"Remorse is identical with change. That's a lot. Take off the Good and dress up in the Bad. What is Good and what is Bad? In the beginning was the lie...

"Of course, spiritual life is higher. But it's impossible to reach maturity without passing through childhood, when one is a child."

Petravičius: "My child, don't keep dreaming of fame."

Leo: "I am going to see M., I am sitting in the train, and everything is falling, spilling out of the banks: how

213

can I put it all in words? And I am thinking: Suppose they know it all, and more, only do not permit it to go into usage. Maybe they are inquisitors. They will kiss you, and will drink vodka with you: how else to tell a child that, yes, we searched, and we found nothing, and we went for a drink?

"*Es ist so.*

"So, I at least shout a little bit. No, not for the glory—I shout abstractly, against man, against those who are coming after me. I am taking from you, and you are taking from me. The greatest moment is that of contradictions.

"And then—maybe darkness is everywhere.

"Every little plant—always into the sun. Only man says: NO!

"Both are gangsters, those who are on the right and who are on the left. Both are equal. In that sense—it's second death... The others will remain slaves forever, without their own personal tremblings—they become little fragments. Goethe will remain, and a few others, but after ten circles of fullness even he will dissolve, nothing will be left.

"It's terrible, when you begin to make separations between man and machine, books. I'd like to work on this. Somebody has to dig out the coal, to do this and that, somebody has to do all the work. The question, the only question is that of the criterion of happiness, the meaning of the world, essence. These are the burning questions, and not what we are going to eat, drink. Today I said to Vladas: In your house, ah, I can really feel the Sunday... He didn't understand that."

Adolfas: "Why didn't you get up and hit him on the head?"

Leo: "They talk about eggs. Vladas is fiddling with the radio. Ah, we'll look into each other's eyes, and we'll

sink into the earth. We began talking about emigration, livelihood. Vladas says: It is necessary to have a minimum in life. But we don't even know what life's minimum is, and maybe it's not even necessary to know it. In our spasmic bodies our spirit is moving even in larger spasms (too early we begin to correct and bridle it). The awesomeness is the beginning of beauty. Everybody's complaining that millions are perishing, dying. But one day, some day, they will say, proudly: Ah, those were the times!

"Don't be afraid of your kinship with the beast."
Algis: "Your theory asks to love animals… Maceina is lucky: he takes God *a priori*, he sells himself, to gain peace and happiness of faith. Everything's answered easily. And so do the communists: they have Marx."

Leo: "I inherited so much from you—so many nights and evenings, as with Baudelaire and Christ. The world has never been too gangsterish to me—it caressed me—but I am afraid that the caresses won't find anything caressable in me…

"God has not only himself, but also me… Maybe I'll stray a little bit to the side. Who knows, I have no compass. So I want to vomit a little bit, it helps. If you concentrate it all into yourself, collect too much, it will be still worse. It's eating me same way as those who are working with radium. I feel I could vomit best by writing—but I'll wait for thirty years to write, and on the 30th I'll write. But the chemical reaction maybe would have happened on the thirty-first…"

Algis: "It's necessary to know—Stanislavski! (he lifts his finger)—how to produce a reaction by artificial means."

Leo: "When I call Valéry a shit, I don't put him down. But if I have any Valéry in myself, then it's sitting deep at the bottom. It is splitting my lips, or maybe I split under those lips. Ah, one can pass through any fence, as a dog. Ah, I attacked Valéry, Rilke, ah...

"I say, I'll sit down, I'll write it all down, my theory. But they'll chase, send me from one to another and they'll suggest: the train is leaving at such and such hour. And then, I believe sometimes that it has been all done, by others, but buried. But I also believe that I am the first one. I am howling, sometimes—I feel, one side of myself is too heavy. In order to keep the balance, I have to shift, to turn the whole of myself. So you search for chance moods, events. Maybe a manuscript from Algis. Like one who is in love: you sit somewhere on a tree stump and you believe, you wait, always and everywhere.

"Ah, I just remembered that I forgot to shave. Same with my life. I am walking through my life, and everybody's looking, who is this shabby guy. I am lame, like Byron. One is afraid to make judgments based on the peripheral. But that's not what I am afraid of. Every effort, all the energy is wasted on the apparatus, and nothing is left for the work itself. You don't know how many glimpses make up one's life.

(Silence)

"Yes, yes.

"I am talking, talking myself to death, by myself. Comparisons. Parallels. Sometimes you feel like two. And never know what happens. You don't know how much else you needed to add, so that the heart...

"Today I looked at Vladas' face and had many fantasies. You keep pulling into yourself, always, in every

216

possible way, and then think: when am I going to digest it all?

"You don't have to possess it all—it's enough to sniff at Leonardo da Vinci, the smell of laurels. To Baltrušaitis, one single look inspired all his Pakopos poems.

"You can't have everything. But sometimes it's good if they just show it to you. Sometimes I am afraid to restrict, to lose myself in one single road. Ah, miserable days of old Europe, despite its unions and... Just like people: lives, gets old, childrens' children die...

"Either you uproot it completely, or you let it be. Like trees: ah, thick branches...

"Rilke also wrote that Christ was only a sketch of God's possibilities. 'I am the one who will be and I am the one who is,' said God... But which one is the true one? Ah, after all, Rannit writes truly, when he says, one can write 20 volumes but writes only three; and another, can write only three, and writes 20.

"In Germany—no, there is no village. Jesus, Maria! Radio everywhere, music, cafe, a train into the fields, you can't walk... Civilization is a terrible thing, in the sense that we have covered the earth: a carpet under our feet... There is no more earth under our feet. Or, perhaps? Again, a question, another question... You pull at this, you grab that, you toss around—like the whole humanity does—and you see: ah, drop everything and let it all burn, let it burn.

"I am looking at those who are out of work, standing, waiting for their poor pay checks, and they survive. And I am afraid to look at them, I am afraid to meet their eyes.

"Evenings I still pray. Not only from routine. But I am thinking: there was Christ, and Buddha, yes—and we do not know, really, what would remain if you'd take them away. So, there is another essential question.

"The West could save itself if it could say: What we have is only as milk on the lips.

"But if you say that, they'll tell you are a heretic. And another will say: No, there is nothing there, it's zero.

"The Soviet Union will tell me: You lack one screw... Same with the speech of Truman. I read it and I laughed.

"*Hosanna! Aistis*. Ah, world, how beautiful and how fragile you are!

"*Man kann das nicht anpassen, lieber Bruder, du bist noch zu klein*. My German... I should learn German... I don't want to talk with the people in the street, so I don't have that fluidity of speech."

Algis: "And that is bad."

Leo: "But that's how I am."

(Silence)

Algis: "Inspiration has emitted the smell of roses to Jonas."

Leo: "To contaminate the others with insanity... The problems of the cadres..."

(Silence)

Leo: "Take idealism... Explain it inside... It's fine, for you, who are lying on your beds and have no need to answer—like water coming from earth. But when everything collapses, in me, I have no choice...

"No, decision making is not for everybody. But those who are progressing with their decisions, those should think. What does it all run into? Fideism? Existentialism? Existentialism is an old thing. I read Lancelot. And Bergson. Where are they? What do they really have real in place of materialism? Give me 30 volumes, I'll read them, if there is in them anything uniquely new. But there isn't. I see that it's all a sieve. So I stick my fingers into the holes. Should I fix the sieve or throw it away?

"Americans say, the atom bomb is their only weapon. Which means, without it Europe would have been taken over: because they have nothing but the bomb to save it. And if there will be a war—they'll drop it. The only question is, is the bomb really that terrible? If it is, then all my anxieties, my kickings are for nothing. I'll be beaten, swallowed up by time, like a little tiny drop. All geniuses are guinea pigs, they have to go through all the sicknesses so that others would know—like Dostoyevsky—people have no courage to throw away all that glitter, sparkle; they are afraid to be caught acting but they keep acting...

"Ah, specialists survive now. But we have, none of us, none of us have any profession. That's why we aren't happy. Like being sober among drunks—it's a curse: to walk out or get drunk?

"I cannot believe in the impossible. Rubashov wavered, had no more strength to believe in faith within the limits of the impossible. Everything got so overloaded, complicated, that now I don't know immediately, how to reform the West. And if there is anybody else trying, they face the same.

"I stole so much: I devoted so many years to myself. I melted myself, thinking, hoping to produce gold. I am my own experiment—and no experiment. I am now so far from it that I can speak about it. Marconi went far, too, began communications with the cosmos. He arrived suffering from it physically."

(Adolfas is standing, leaning on the stove. Algis is sitting on the cot, silent, leaning. Jonas is typing.)

Leo: "I turned the knobs: no music. I remember, how we children used to listen. 'Why music sometimes doesn't speak,' she asks me. 'Isn't it the same sometimes

219

with you?' 'No,' I said, no—because I was afraid to lose music. Like losing God.

"Ah, good man. A school girl. One side of her face was burned. I used to pray for her. There was happiness, heart.

"Ah, what will come now, into these barracks—without those wide distances into which you can fall—what will come now to me?

"I had one, two, three specializations. Now I threw them all away. I have only questions. Earth is no longer earth: it's concrete, stairways, plumbing, water pipes…

"Ah, Jerusalem, Jerusalem, don't cry for me…

"I really would like to study, go into this question … but…

"They bury volunteer soldiers at government expense—but here I am going to death voluntarily…and…

(Silence)

(The water pipes are making a silent hissing noise.)
"And the cobwebs begin to cover all your experiences.

"Fear maybe is a good thing. I am sorry for the people…

"*Mitleid*. Sympathy. Pity. *Mitleid* is a curse. We think too much. Always with books, always books, books, books.

"But to return to the earth—that we can't do either. No response. So you go back to the books.

"If I'd study mathematics today—I'd know why I do it. But now I have other burning questions.

"But then, maybe, there will be a moment when everything will be the same. So you throw the dice and you go where it falls.

(Silence)

LIFE GOES ON

"Do you think I wanted to talk here with you? Ah, to see this one, or that; to visit... Ah, the whole Lithuania is a scarf of Veronica...

(Silence)

"I am afraid, and I am trembling, hoping that this wouldn't be the hour of death for Lithuania. Or maybe only me, only we experience it so ominously.

"Vaižgantas shouted, on his death bed, his last words: Save Lithuania!.

"Ah, speech is maybe a knife that cuts through me and throws everything out—

"Similarly, between grain and bud. Goethe was a terrible materialist.

"I could live more on him, read, but I am afraid that he may crumble.

(Silence)

"So, let's move the earth, men..."

Adolfas: "Do you think that poets could ever move the earth? Don't be silly. All your talk: at the beginning a lot of noise, and then: again a poet. Lyric."

Leo: "They say my character is terrible, and melancholic, and choleric. So that I don't think I am so totally lyrical. But a poet, yes, yes.

"I think the fault with me is not having enough to eat. If they'd fatten me up, all lyricism would go away, evaporate.

"And what's happening with this tall one (Algis)?"

Algis: "With him, like in an ice box, everything's frozen. Time froze it."

Leo: "The heart stopped, eh?"

Algis: "No, no."

Adolfas: "He took it seriously..."

Leo: "Other writers go somewhere, get drunk. And we... Ah, but Miller is also a pauvre man."

Adolfas: "You think he didn't go through enough before he got to his conclusions?"

Leo: "How old is he?"

(Silence)

(Leo sings.)
"I am singing, and they—silent, like shits."
(Leo looks at Adolfas' hand.)
"Ah, what a terrible hand."
Algis (to Jonas): "Tell what it means."
Jonas: "I'll tell you in a week."
Leo: "Algis will have a surprise in a week."
Algis: "What do these wrinkles mean?"
Adolfas: "Your hand is normal."
(Everybody's studying their hands, mostly wrinkles.)
Leo: "They still believe in vipers."
Adolfas (to Jonas): "Write down that he still believes in vipers."
Leo: "The best parts he's skipping, not writing down..."
Algis: "He lacks a few screws, Jonas. He gets that way pretty often."
Leo: "Look, he can't keep up with our talking, can't write it down... Stop writing. The record has ended. I turned off the record.

"Jonas is writing world history, but he won't be able to finish it in his lifetime. It's O.K. to publish it after death, but please will you show it to me now?"
Adolfas: "A typical phenomenon of capitalism. He, Leo, is creating, and he, Jonas, is exploiting it."
Leo: "A parasite..."

Algis: "And what about you? Don't you exploit? Don't you do the same?"

Leo: "Oh, yes. And when I can't suck from the others, I suck from my own memories..."

(Again he's studying his hand.)

Algis: "Fin. Finis. Finish."

Leo: "As for myself, I am going to wait until the end."

7. IN BETWEEN

The author visits a mental hospital. A drunk man opens his heart, he cannot hold his homesickness. More about drunk singing... D.P. camp home routines... Emigration. Friends are departing for distant countries... D.P. camps are getting emptier. Loneliness. The Kassel/Mattenberg camp is transferred to Schwäbisch Gmünd. Daily life in a D.P. camp. Boredom. Summer.

April 30, 1949

Went to Merxhausen for lung inspection.

In the same ambulance: An idiot woman, several "normal" women, three children, a middle aged man on a cot.

Through the broken ambulance windows the road dust is coming in, settling down on us. Ah, but the blooming of the apple trees! All along the road the apple trees are in full blossoms. Two men are fixing a sowing machine. Potato bags in the fields, women planting.

We spend six hours in the hospital. It's very slow. I met some people who have been here for weeks. They are cursing the doctors for keeping them so long. They have to keep a certain number of people in the hospital in order to get a certain steady amount of supplies and money. It's a business.

Next to the hospital—the insane asylum. Those who are not totally mad, go to work, help the farmers in the fields and gardens. I saw them returning from the fields, at noon; an hour later I saw them leaving again, with their backs bent. They all seemed to walk as if the sheer burden of their miserable lives weighed them down. My memory of the insane is that their postures are somehow more bent than those of the "normal" people; they have more misery to carry.

They walk apart, singly, like geese. Their faces are plump, watery, shiny, pumpkin-like. With their eyes looking straight down into the very center of earth. One suddenly stops and begins to laugh. Just for herself. It's very normal here to laugh for one's own sake and pleasure. Another one is having a conversation with an invisible partner. Some greet me. Several, very young ones, keep turning their heads around, looking at me, giggling, flirting. They touch their hair, and again giggle. Some of the hospital patients told me that they are mad about men, they do everything to get them, they cry, they ask them to go to their rooms at night. I was also told, that there are some who actually go to their rooms, or meet them in the woods.

One of the idiot girls, every night, goes to the woods with a little trumpet. She says, whenever she blows her trumpet, she sees little pigs coming to her. She blows it again—and away they all run. Otherwise she is almost normal. You talk to her—she is absolutely normal. But the evening comes—she has to take her trumpet and go into the little woods, next to the hospital, to work with her little pigs. The real idiots, they never let them out. They remain locked behind the iron fence, in the garden. They press their faces to the iron bars, among the weeds and flowers, and they watch the passersby—patients, doctors, farmers. They smile, they giggle, they insult, they invite you.

All these idiots are German. But as we passed them on our way from the truck, jabbering in Lithuanian, one girl suddenly began to shout after us in Lithuanian. She heard us, she recognized her language even in her insanity. She ran towards us, so excited that she tripped and fell. The other insane comrades began to laugh. She

picked herself up, and, pressing her face to the fence, begged us to come and talk to her, we are her brothers. She didn't speak German at all, we were told. And she was totally mad. Only the language part was sane. The nurse lead her away.

"She does that to all Lithuanians," the nurse said.

They checked me and rechecked. They found some kind of mysterious calcium spots on the tip of the right lung. They looked at it and they looked but they couldn't tell anything. I'll have to come back once more, on Monday.

The guy who came with his own bed, remained in the hospital. On our way to the hospital he was giving us all kinds of tips: how to stand in front of the x-ray machine, how to breath, etc. in case one wants to fake a sickness; how to fool the doctors and the x-ray machine. To be admitted into hospital he thought was an achievement worth working for.

"I've been 1000 times through this," he said. "Everywhere. I have x-rays from everywhere, but I don't show them to the doctors. On purpose. I myself, I know everything, but I want to double-check. I want to know if they really know what they are doing. I want to know what they say. Anyway, I am very sick, asthma, heart, lungs, everything," he said.

I walked through the patients' rooms. Small rooms, huge halls. Walked around the building. I tell you, if I'd have to spend a month here I'd become really sick. And, probably, lose my mind, too. Maybe that's why they built the insane asylum next to the hospital. The smell of the medicine in the air, the enamel, the smell of x-ray it's all very terrible. When the ambulance left the hospital grounds and turned again into the little, stinking, muddy, dung street—I filled my lungs with air...

April, 1949

A hen belonging to Mrs. Poškus strayed away and joined the hens of the neighboring building.

"Pshsh pshsh, go back to your own!"

"Maybe you can catch her in the evening..."

"Sunday morning I let her out and she disappeared. The other one I am keeping in the bathroom now."

"My hen lays eggs every day, I keep her in the house."

People are walking, slowly, home, from church. Vilainis passed by, almost fell on something. Razminas, with a little girl in his arms, rushing somewhere. Skomantas, like a ship in wind, with his arms swinging wildly. An old woman dressed in black, all shoulders and no body. Three young schoolgirls, with their scarfs flying in the wind. The mother of Vladas, deep in her thoughts—both of her children left her, they are far away. Sound of plane.

May 3, 1949

"He speaks so beautifully—but so stupidly."

On May 3rd of this year, there were 1650 Lithuanians in the Mattenberg D.P. camp. Total 2202 heads.

May 6, 1949

A new epidemic: everybody's trying to undermine everybody else's emigration. People are making telephone calls, writing letters to the camp's administration (Americans) intimating that this or that person was a Nazi, or some similar incriminating thing, so that very often a totally innocent person is investigated, humiliated, emigration delayed until it all proves to be a work of some crackpot, for personal revenge.

"The fire wood is being distributed today. . ."

Sirvydas was refused a visa because the camp's police didn't approve of his occasional drinking. As if nobody drinks there in the U.S.A. Sirvydas hit the table with his fist, and said: "I'll kill you all, I'll get every person living in this camp to sign a letter supporting my good character (A curse)." And he did collect the signatures. And they gave him a visa. But they forced him to go through it all.

Under our window, in the street, a drunk man is singing to children. Then he talks to them:

"No, Lithuania won't perish! Lithuania will wake up again."

"Ah, my Lithuania is covered with blood, swimming in blood. My country is in misery and blood. Ah, don't forget Lithuania, children, don't forget it..."

Then he sings again. He is very drunk, and tears are rolling down his face.

Another drunk man is sitting by the wall, on the sidewalk, watching his friend. The children are listening with great curiosity and entertainment.

More people gather.

"Why do they allow drunks talk to children?" moralizes one, angrily. But the drunk man is talking with the children very sweetly. He is very happy to have somebody to talk to, to speak out his heart, his pain.

"Ah, our country is swimming in blood. The fields are no longer green there, they are red. My heart is in pain..."

For two hours he talks and sings. Later, some women come and chase him away, gather their children. He walks away, his legs are not holding, he falls, gets up again and walks middle of the street. Some children come after him, pull his coat, tease him, from all sides. So he tries to walk faster, to escape them. He falls again,

picks himself up, continues. I can hear the voices of women:

"Drunk like a pig. Came to teach our children to drink. Go and sleep, you devil."

May 7, 1949

The day is beautiful. The sun is shining from behind the clouds, the blue is spreading.

In the street, a girl is beating a blanket. Somewhere the bells are chiming. Our neighbor's hens, one by one, are leaving the basement, looking for something to peck at.

Upstairs, somebody's moving furniture. Maybe they are sweeping the place. Outdoors: a gang of children just ran by, shouting wildly.

May 9, 1949

Again, wind, sleet, rain.

Reading Hans Carossa. Arno Holz. J. R. Becher.

Clothes line, across the street, shirts, blankets plop in the wind, making soft fluffy sounds.

Spent the evening with Giedraitis, printing photographs. Before leaving, around midnight, I thought I'll say goodnight to his wife. I opened the kitchen door— the children are sleeping, and Mrs. Giedraitis is kneeling by her bed and praying, in her nightshirt. Suddenly a wave of memories flooded me. I remembered my mother, praying like this, every evening, by her bed, and father, too. For the first time since I left home I saw somebody praying. Just like my mother used to pray, late at night, after the day's work done, with the head down, hands put together...

Silently I closed the door without her noticing me and I walked out into the night.

May 10, 1949

The firewood is being distributed today. The streets are full of carts, hand trucks, often pulled by excited children.

The weather cooled down. Old women, who live alone, are pulling the carts themselves. Children help to push. The smallest is proudly sitting on top, riding the coal bag. The electrical saw is squeaking and howling—longer logs are being cut to smaller pieces, the stoves here are very tiny.

No date, 1949

Ah, my slow, gray Lithuanians! Will it be easy for you to become Australians, Brazilians? Won't you miss the birch trees, and the willow trees? And what will happen when you suddenly miss them?

May 17, 1949

The Yugoslav policeman, tall, black hair falls on his eyes. He is carrying on his back a big bundle, a blanket which he holds by its four corners, a gray army blanket.

"*Jetzt werde ich mit dir Schluss machen, ja, ja.*" ("I am finished with you, yes, yes.")

Close behind him walks a woman, with a suitcase and a small bundle. The woman is small and shabby.

Both are walking in the middle of the street, he talking all the time, shouting at her; she silent, not a word.

"Ah, you, you run with all the men around, you (A curse) (Another curse) (*Ëb tvoju mat'*, *kurva*), with teen-agers. A mother is looking for her child, can't find him, you disappeared with him. Shame on you, shame. Look, people, look at her."

"Over 300 D.P.'s are leaving for the Memmingen barracks..."

The Yugoslav is trying to shame the woman by making a spectacle.

He stops in the middle of the street, puts down the bundle, runs to a window with three women peeking out. *"Ja včera dežurival v policii—a ana mit fremdem Mann geht—ja videl. Schämt nicht."* ("I did the night work, as a policeman, and she with a strange man—I saw her. No shame.")

He speaks half Russian, half broken German.

He stands below the window and talks to the women. His woman stands in the street. She looks German by what I can see. She makes slight attempts at defending herself, but with no effort, no energy.

"Where did you see me, ah? I didn't walk with any stranger..."

The women in the window are attacking the Yugoslav, defending the woman.

"You imagined it all," says one.

"Ah, he has been after her all the time, always accusing her of running after strangers. A bandit! Doesn't give peace to a poor woman."

"Frau, wo gehen sie jetzt?" ("Woman, where are you going?")

She doesn't answer. The Yugoslav picks up his bundle and with large long steps continues his walk down the street.

The woman follows him, tries to keep up, half walking half running.

"Ja, isch werde jetzt Schluss mit dir machen!" he shouts.

From his talking I can make out that he's going to take all her belongings out of his room and leave them all by the roadside.

No, she is not German. She is Yugoslav. She is his Yugoslav wife.

Her face is all pale, hungry. Her blouse, her dress all

crumpled, messy.

"She is his wife," informs a woman from another window. "It's his own wife that he keeps always dragging, pushing, cursing. Jealousy, it's jealousy."

For another half-an-hour the women in the street stand in little threes and fours, talking in excited voices, cursing the Yugoslav.

Bought half a kilo of sauerkraut, our main meal these days.

A woman comes walking through the rain, pressing a large empty plate to her side. Down the corners of buildings noisily run streams of rain water. At the other end of the street—music, *bayan*. A man in green pants, hands in his pockets, runs by, his head pulled into his shoulders, wet. A girl runs by. A voice from the window:

"Where are you running? Lost your key?"

The girl keeps running without acknowledging him and without turning.

A man, all wet, slowly walks by. I know him, it's Gražys. Another man, in a gray suit, black hat, hands in his trouser pockets, lifting them up so that the bottoms wouldn't get too soaked. From the window I can hear a man's voice singing:

"*O, Zuzana, širdis mana,*
koks gyvenimas gražus"
("Oh, Suzanne, my sweetheart,
how wonderful life is—")

The rain is subsiding. More children visible in the street, some in the doorways. A man in shirt, no jacket, is leaning out the window, tries to look down. Opposite, a little further, through an open window I can hear a girl singing—not too loud.

Two men are walking.

"O.K., let's go."

"Wait a minute."

Another, a third man, is shouting at them, he's trying to catch up with the other two.

"He is not home."

"Not home? Shit."

All three walk away. Two wear raincoats, the third man is in a plain jacket. All three whistle as they walk.

I don't hear the rain anymore. Only the roof drain pipes are still running. A distant thunder, far away. Voices now are fresh, and clear, you can hear them very far. Like summer evenings in country villages.

"Don't throw, no," says the mother to a child, in the window. The child is holding something in his hand with the intention to throw it out. I don't see what it is. The mother is holding his hand.

"No, don't."

Two girls run out, chasing each other.

"Don't throw, I tell you." Voice in the window.

Algis' sister Gigi passes by. She keeps walking along the very edge of the sidewalk, very very straight.

A woman with an umbrella under her arm.

The young boy who has troubles with his hearing, passes by.

A train whistles. A man in brown suit, he moves his head up and down, in deep thought, and he moves his arms in great arcs, as he walks.

The girl dressed in red passes by for the third time in ten minutes.

A child with a flashlight.

"Give me the batteries, I'll change them."

"I have a better one."

"Give it to me. I only want to see if it lights."

"Buy."

IN BETWEEN

"Come here, Vytukas," a woman, mother of the one with the battery.

Time: 8:45 PM.

The German woman, the one who's from Bavaria, married to a Lithuanian in the camp, passes by. Two dirty-faced little girls are riding down the steps on their behinds, step by step, bump bump. The woman who lives across the street from us, returns home, wet. I see her husband is crossing the street, walking into our building. I bet, he's coming to visit us, to borrow some books.

May 26, 1949

"Is our truck coming?"

"There's plenty of room inside, not too full."

"Don't take it, leave that cart."

They are stacking everything neatly into the truck. A wooden suitcase. A box with iron handles and gigantic locks. A bag with blue stripes. A pail, folding bed, mattress, brush for cleaning the floor, a mop, a tub tied up with a bag, probably full of knick-knacks. In the cart three brooms wrapped up in a blanket. Two chairs, a tiny table (tea table?), two more mattresses rolled up in thick bundles. A cat. A saw.

"Dad, where is your stick?"

"Let's go, let's go."

"Already?"

"Is the truck leaving?"

The old man, our neighbor, is walking through the empty rooms, here and there, as if he has lost his head or something. He is walking from room to room, staring vacantly, looking for something that he thinks he forgot—doesn't want to leave anything. He has been packing for days, waiting for the truck, slept on the bare bed

frame, with no mattress. But now he still thinks he may have overlooked something.

Over 300 D.P.'s are leaving for the Memmingen barracks. 130 left for Australia. Good-bye. Streets full of junk, newspapers, behind the barracks mattresses are smoldering, trucks move from door to door picking up piles of belongings, children are running around like headless chickens: a terrible havoc. Some of them were born here.

Balvočius is ironing his pants, in somebody's abandoned room. Somebody left an iron. Those few who still remain here have practically an entire building each. We helped Tvirbutas move his boxes into the street—they are leaving for Memmingen. Groups of teenagers, school girls, boys stand around saying last good-byes, talking.

The old man decided to take his iron stove. So now three or four of them are dragging it out, like ants. People stand around, laughing at them, but they are determined to take it with them.

May 27, 1949

About 600 D.P.'s left our barracks today. A long train stood waiting in Niederzwehren. A strong rain fell. Practically only Adolfas and myself came to the station to say good-bye. The weather kept everybody away. And then, maybe it's because we two are not real D.P.'s: in some way, we consider ourselves as symbolic D.P.'s, so we have to be here, even if nobody else is...

Miškinis and Morkus, both totally drunk, came up to us, as we stood there. Both were barely holding their tears. Or was it just the rain.

People sat in their compartments with sandwiches on their laps, the children's noses pressed to the windows. We stayed a little while with Tvirbutas, and suddenly

there was nothing more to say, we sat silently. I stood at the window, looking out into the rain. I pressed my finger on the window pane and it made a squeaking sound. Then we said good-bye.

In the last car—the officials. Right now they are standing outside, gesticulating, talking about something very loudly, arguing. I find out that it's about the restaurant car. The man in charge is totally drunk, he forgot to get the provisions.

The train began to move. It was raining. We stood in the station and waved. Some waved back. We were the only ones, we two, in the empty station, and it was raining.

For four years I lived with these people, saw them every day. They were part of the same D.P. experience. Will I ever meet any of them again? You meet, you walk for a while together, and then you split, each his own way.

In the evening Adolfas and I walked through the barracks. It was cold, the wind was blowing wet scraps of paper. The windows empty, dark, the rooms in shambles, empty. Last night everybody was still here, each of these rooms was still alive. We lifted our eyes to the windows where Tvirbutas used to live and where we had spent so many hours of our lives. We cannot believe it yet, there is no feeling yet that those rooms are all empty.

In the morning they swept the streets, removed the empty boxes, junk, and when I looked out the window, down the block, it seemed that everything was just as it always was. Only some of the faces were missing. It had rained like this before, too. Somewhere I can hear radio music. Somewhere a child is crying. Life is going on as before.

I HAD NOWHERE TO GO

May 30, 1949

Our neighbor, the old man, Debesaitis, and his woman, have left for Memmingen. Albinas, their son—about thirty years of age—is now alone. Alone and free. Nobody will tell him now how to behave, when he comes home drunk, late at night. Always drunk. Or when he brings home his women—now he's free to bring them.

Tonight, early in the evening, he came home, with a brown towel on his arm, totally drunk.

He stands by the door:

"Hell—what's this towel on my arm? Who gave it to me? Tomorrow I'll…"

He stuffs the towel inside his shirt and stands in the corridor swaying. Our door is open, for some draft, it's very hot today. I am reading, but I am watching him. He catches my eye.

"You, you understand," he talks to me. "Don't get angry, it's not important that I am drunk. I am a finished, fallen man. Two bullets I got, one here, next to my ear, another close to the eye, here, look, see? They are still there, the shrapnel.

"Don't be angry, don't mind that I am drunk. I know, you are intellectuals, I know, you always want to teach people, morals. Which one of you is older? I served in the Lithuanian army, I was a lieutenant. Come, I want to show you everything…"

Adolfas and I follow him into the ruins of his room. We stand a little bit awkward, uncomfortable, looking at him, listening.

"Here, a photograph, from the Gaidžiunai training camp, look. Let's be frank. I am always frank. I'll show you everything."

Albinas now needs a soul to talk to… Very intimately, he wants to talk… And he is totally drunk. And we are

240

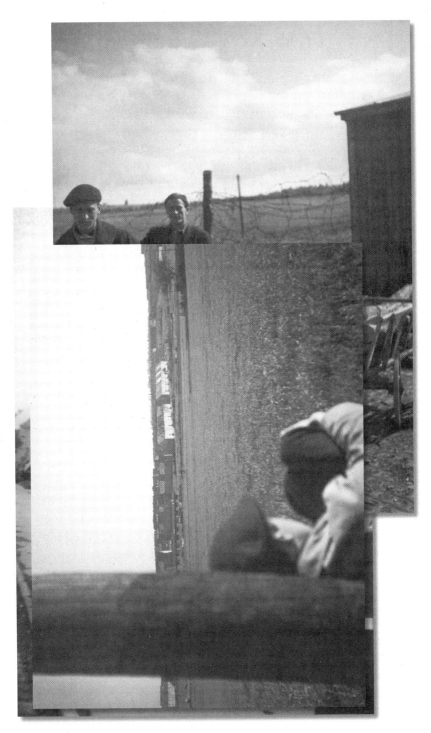

Adolfas, overlooking Mattenberg D.P. camp

totally sober. We make an attempt to get into his mood, world, but we are doing very badly. But he may not perceive what we perceive, so maybe it's O.K.

"For two years we lived here together, but we don't know each other... So, now, we are getting to know each other... I am living this way, you live that way... I lived here with my parents, but they didn't know me. Didn't know how I lived. Ah, I am a fallen man, don't look at me. You, writers, you'll write about me, I know. Write about me. Write, how I drink. I am totally drunk, don't listen to me. Come tomorrow, when I sober up, around noon. I'll cut your hair. I have a hairdresser's diploma, from Lithuania, from Kaunas. Here, look. I'll cut your hair nicely, nicely, just for you. So, till tomorrow, till noon. Will you come? Will you? I do everything because of that woman... You know, the one who married the ambulance driver? That's the one that ruined my life, that bitch. She ruined me, *kurva*..."

He stuffs the towel back inside his shirt and begins to descend the stairs to the street, we are on the second floor. Then he stops, turns around, and comes back to us.

"Do you want to know why I drink? I drank everything away, sold off everything. Don't think I am bad. I know, you don't believe me. You understand me. You understand me, I know. A writer has to know everything. So write about me, drunk, and how that bitch ruined my life. I didn't emigrate anywhere because of her. You know, these Lithuanians, they are shits, shits, shits. I went to Butzbach, I wanted to go to Australia, and everything was fine. But they went, the shits, and they spoke to the Consul. So the Consul says to me: "How come you aren't drunk today? Are you drunk?" And I say, "No, I decided to stop drinking, mister Consul, Herr Consul." But the Consul says, "It's finished, you can go."

IN BETWEEN

"Lithuanians... Real shits... The Committee wrote a letter to the Consul about me. Against me. Told him I am a drunkard. Shits, Lithuanians, my countrymen are shits. So now I drink just to make them mad, just to show them what shits they are."

He is walking down the stairs now, slowly, holding the towel, pressing it with the corners of his jacket to his belly.

June 1, 1949

It's after midnight. A man in the street, drunk, singing. I can hear him outside, I can hear him walk to the other end of the street, and back again, singing. This time I can hear three voices. Found some friends.

Albinas, our neighbor, comes home. He climbs up the stairs, heavily, I recognize his steps, his heavy breathing. For a long time I hear him talking to himself, in his room, laughing. Now he's smashing something.

In the street the three men are still shouting and singing. Actually, only one is singing, others are commenting on his singing and kicking empty biscuit boxes.

Albinas leaves his room, walks downstairs, slowly, he stands in the door.

"Bandits, you. I'll show you... Why are you shouting here?... Go, you bandits... I can find bandits even in Russia. Come, come, I'll smack you... Come! You, Ivanauskas, Lizaitis, bandits you both. I am alone, and you are five—I am not afraid of you, come, come!"

The drunk men are cursing him. From what I can detect, they are approaching him, to meet the challenge. Albinas runs up the stairs, again breathing heavily, his legs not really holding. He runs into his room, closes the door and begins to laugh. A long, insane, loud laugh. The drunk men go back into the middle of the street, they aren't in the mood for following Albinas. It's only

243

a theater. They are walking now further down the street, cursing him loudly.

Albinas leaves his room and descends into the street. "You, gangsters, I'll show you! Bandits, *jibitvaimat*!" he shouts a long line of heavy international curses at the men.

I can hear the men shouting back at him, from the far end of the street.

"Ah, you came out again? Do you really want to get bloody, really? Albinas, you want to get bloody?"

"Ha ha ha! I am Albinas, but who are you? You are shits, chuligans!"

Again I can hear him climb up the stairs, heavily.

June 2, 1949

Today we waved good-bye to Algis. All our friends are leaving. We stood, both of us, looking at the truck, the women with tears in their eyes. They are leaving for America. America!

I was looking at myself and I was wondering. I couldn't find anything sad for the occasion. It all seemed just another parting. We have overstayed here. Like rotten apples, we should have fallen down long long ago. No drama, no emotion left. Pure plain reality.

They are going, they'll be many thousands of miles from here soon. And we are watching them go. Yesterday evening we walked through the streets, silently, as all other evenings, exchanging a word or two, with Algis. And then we said good-bye. Algis said: "Write long letters."

June 4, 1949

Yesterday we were transferred to the Schwäbisch Gmünd barracks. Our bones still ache from dragging crates and boxes. Not our own: those of our neighbors.

IN BETWEEN

People are crazy. They are taking anything they can put their hands on. Every piece of furniture, everything. Ugly, miserable furniture, something that one should throw away. Are they going to drag it all the way to America? I wouldn't be surprised if they did.

They put us up in an army hall. Later they transferred us to a large army room, with six others, waiting for their emigration papers.

The corridors are being used as kitchens here. They cook on electric stoves. Larger families have stacked all their bundles in the corridors. It is difficult to pass through. It looks like after an earthquake. Adolfas says, an old woman asked him to carry her bundles up, so he said yes, of course, and then he had to drag twenty heavy crates up to the third floor. He said, he saw only green, after that. As for ourselves, we made it in one single trip. We reduced our belongings to four bundles. We pushed them under the beds, and that's it. As I am writing this, I still hear people dragging and pulling, and hammering.

June 10, 1949

Ignas takes out his brown shoes, looks at them, puts them away again. Stands and thinks. Pulls out the brown pair again, takes off his black shoes—his socks are blue— puts on the brown pair, using a shoe horn, is very careful about his heel. From under the bed he pulls out a pair of greenish looking socks and sticks them under the blanket. From under the bed he picks up a brush and shines the shoes. Fixes up the belt, hums a tune from. the new Mozart film (everybody in the barracks is humming it this week). Changes his pants—brown with thin gray lines running down. Changes his hat.

Outside—Sun. Warmth is streaming in through the open window, a sun spot is burning on the white table-

245

cloth, on the sheets of paper. In the yard children are shouting.

Ignas once more comes to the mirror, combs himself, humming all the time. On the other side of the thin wall separating our room from the next, I can hear similar but more hurried preparations for church. Our roommate returns. Ten minutes to ten. The noise of the door opened and closed, steps in the corridor. The shoemaker returns, just arrived from Kirchheim, carries a newspaper in his hand, lies down on his bunk and looks at the newspaper.

"Didn't leave for church yet? I'll read for a minute."

Ignas is spitting on the towel and cleaning his glasses with it. Closes his locker, but the little key falls inside the locker.

"Snake," says Ignas.

He searches for the key, kneels down. Finds it, locks, then unlocks again, takes out something from the jacket's pocket, locks up again. Stands, thinks. Unlocks the locker once more, takes out a tiny flask, uncorks, pours some liquid from the flask on his palm, wets his hair. Searches for something. Peeks into the locker. Keeps digging at the bottom of the locker, in the junk, humming another tune. Locks it up, walks towards the door, returns, unlocks the locker, takes out something I don't see what, locks up the locker, leaves the room.

June 1949

Right now, we are eating. Adolfas brought home some thin pea soup from the camp's communal kitchen. Two of our roommates are playing chess. They started early in the morning, and they are still at it. They manage to play twenty games daily. As they play, they keep humming, the same and the same tune—some German bar song. Occasionally slight explosions, arguments.

IN BETWEEN

Behind the window a child is crying. In the corridor a crowd of women are arguing about their rooms. Behind the wall somebody is hammering a nail. A piece of furniture falls with a thud. Adolfas says it's a crime to call this liquid thing a soup. The child is still crying. Someone runs along the corridor. Etc.

Someone sings, under our window:

"When I get a couple of marks,
I run to the bar for a drink.
Our happiness is a fat wallet
ah, everything else is so bleak.
Behind the ocean lies a fat wallet—
in the dark I steal very well."

A woman with a cup of milk. In the basement a rooster is crowing. In the street a child with an apple. The woman returns with an empty cup.

The woman sticks her head out the window, looks for the child. Green blouse. A man with a suitcase. He is looking for something, is looking at the door numbers. This one, passing by, is a good sportsman, I don't remember his name, I see him often during the soccer games.

Ah, Maželis is going to pick up his food ration, carries a bag. The mailman, with a bundle of letters in his hands and a bag of newspapers on his shoulder. This one, he just ate, he's cleaning his teeth, as he walks, looks very content. The children, barefooted, in red trousers, blue shirts, with sticks in their hands, walking side by side, beating scraps of paper.

June 11, 1949

Ignas is eating soup. Brown, strange looking, it smells horribly. We picked ours up but couldn't eat it,

247

gave it to Ignas. So he's eating it now and cursing the cooks. Gives up, takes it to the toilet, stands, considers dumping it. Stands staring at the toilet bowl. Then walks back to the table, puts the soup down. Says, "I'll close my eyes, I won't look at it, maybe I can eat it—it would be a pity to dump it." Gives it another try. Manages to spoon half of it. Then goes back to the toilet and dumps it out.

Ignas used to make his living as a hunter. He says, his favorite dreams are about hunting rabbits. He is complaining that only twice a month or so he has hunting dreams. Last night was one of those happy nights. So now he is very happy. Says, it was a good dream. He missed the rabbit, in the dream, but he says, to miss a rabbit is a sign of good luck. He just kept missing. Many many of them. The night before, he dreamt cows, they walked along the meadow in a line, like soldiers, eating grass, all lined up. And a bird with a broken beak was pecking at the feathers of smaller birds, so he chased the big bad bird and woke up. "I don't like dreams like that," he said.

June 16, 1949 (Whitsunday)

For two days now, everybody's making wreaths, hanging flowers around the entrances, tearing branches off the linden trees, the trees are full of children.

The young girls—they suddenly remembered their childhood, they have picked up old Lithuanian village customs. They are gathering in the homes, in fives and sixes. I watched them yesterday work on wreaths and ornaments, very excited, singing, laughing, joking—as they were making long leaf and flower chains. Ah! how it smells! The grownups, women and men, like ants they drag them and hang them on doors, around the windows, on these concrete, army buildings. Crowds of children

stand around, watching. In front of the largest barracks building they are erecting an altar: the religious procession will begin and end here.

In the town, the Germans are placing young fir trees in front of every home—that is their custom. In Lithuania they use young birch trees on this day. They placed birch trees in the church here, and the smell was incredible, the smell of young birch leaves. I stood for a very long time, breathing it all in—the birches and the memories.

But today, right now, we are sitting in our room alone, Adolfas and myself. All the others have left for church very early. We two somehow we do not fit there: we are Protestants. But we do not like to go to Protestant churches—we don't like their ceremonies nor their churches. We are neither here nor there.

Outside by the window a bird is chirping. I can't see it. Children's voices. "Listen to that bird singing," says one. I walk out. I cross the yard. Beyond it—piles of fresh hay are drying. How it smells! God's church, this drying hay. Maybe it's even a religion, for me. I pull in lungfuls of the fantastic smell. Somewhere I can hear a radio, church music. The bird is still peeping. Somebody's brought us two pots of flowers. They are on our table now, blue, purple, yellow flowers.

Ah, how the child is crying, with such fear in his voice, in the corridor. His mother is trying to calm him, or is it a neighbor?

I sit down by my typewriter and try to type.

June 18, 1949

The Germans are mowing the meadows, cows are pulling heavy carts full of hay. Women in the fields, with pink blouses, children romp in the hay, a dog is galloping around, nutty.

Ignas is playing chess.

"Hm … what should I do…"

Now they are both silent, for a long time.

"Mine are well positioned."

"I am in a bad shape…What should I do… Ah, I'll take this guy."

Finger knuckles on the table.

"I have to move out of here."

A move.

"Ha. Bad. What am I going to do, what am I going to do. (Pause). I'll give you a check, what happens—happens."

"Give me a check."

"Here it comes!"

"Don't do it, don't do it."

Cleans out the cigarette holder.

"I advise you to take it back."

"O.K., I am taking it back."

Ignas comes home after visiting a friend. Takes off his jacket, lies down on the bed. Covers his legs with a jacket. Hands under his head, for a pillow. Stares at the ceiling.

"Today I didn't eat anything. Drank a glass of beer, and that's it."

"After five, they'll distribute bread."

"I have to leave before five, eh."

"Coming back Sunday?"

"Yeah."

"Ai, ai, what a world," says Ignas. "The whole world is full of anger now. Can't have any conversations. Blurp, blurp, that's all."

He lies silently for a minute, then:

"What's for lunch today? The same and the same. Bread—coffee, bread—coffee, bread—coffee."

IN BETWEEN

Pranas is drinking coffee and eating a piece of bread. At the same time he is reading an American-Lithuanian paper somebody sent him from Chicago.

Ignas gets up, goes to the shelf, is searching for something, is unwrapping some crinkly paper. Spreads some butter on bread, comes to his bed and eats it with coffee, sitting on the bed, his back to the room.

June 19, 1949

Ignas with his shoemaker friend is studying the shoes.

The shoemaker is nuts about anything that is old. Old shoes, old mattresses, anything old he goes nuts about. He has collected from under the beds several pairs of old shoes, sandals, stinking shoes. He has a big bag in the middle of the floor, he's dumping everything in it. He's going to take it all to the Germans, to sell.

"These are good mattresses, give them to me when you leave."

"Take them, take the bed too, a good bed," says Ignas.

"I could get 45 marks for it. A good bed, lacquered. No bed bugs?"

"No. We haven't had any. But other blocks, my God! I am sitting with that old guy, I am sitting, just like this— and I see it's creeping up my trousers."

"He didn't kill them, the dummy?"

"He got used to them, I guess. Hard skin. You can't kill them, anyway, millions."

No date, 1949

Got bored at home. Went to see Jurkus.

Jurkus is preparing to emigrate, is packing, cleaning. Maceina is standing by the window, looking out, with a book in his hand, probably meditating about God.

251

Jurkus is throwing things on the floor, rechecking his books, papers, magazines, a big pile of them on the floor. It's for burning, he doesn't want to take them with him, to America.

Rimeikis comes in. We three sit on the sofa, making funny comments, watching Jurkus work, telling him how ridiculous he looks. We are bored. Petras picks up some papers from the floor.

Jurkus: "Leave it alone. Those are my love letters."

Petras: "Why don't you tear them to pieces?"

Jurkus: "Why don't you do that?"

Rimeikis begins to tear them with great pleasure. He is throwing pieces of envelopes and letters all over us, and up to the ceiling. Opens a drawer, looks for more.

"Should I throw out these too?"

"Wait, don't touch. Don't piss around."

Rimeikis looks at the painting on the floor.

"I could paint one million of such paintings."

Petras and Rimas stand with their mouths open, watching Jurkus tear his papers to pieces.

"Give them to me, I'll take care of them, throw everything into the corner."

"This paper is too thick. I can't tear it."

"Don't throw that one out."

"Eh, Petras, if you don't stop that, I'll take an ax and cut your ass in two."

"What should I do with this one?"

"Throw it out, that one. Ah, maybe not. Put it aside."

For another hour we goof around, watching Jurkus clean and sort out his past, then we decide to leave him alone, look for other victims we could pester.

June 25, 1949

Ignas: "Ah, a good chicken."

Petras: "You must be lying."

Ignas: "What do you mean? Am I going to lie to you when I don't have enough time to tell all the truth?"

A gypsy walks in, asks if we have anything to eat.

Ignas: "Food, always food. But what about a woman, ah?"

Gypsy: "First give me food, then give me a woman. No food—no woman."

Ignas is drinking the cup of beer into which he poured an egg and six spoons of sugar. He refuses to eat today's soup. I, myself, I counted, I ate fifteen spoons. Pure water with some dust in it that sticks to your mouth.

Ignas: "Maybe I'll go and shave."

Petras: "Maybe you better go and sweep the street. A good practice before going to America."

He is looking at Leo's drawings.

"You draw them on your bed?"

Leo: "Man, I have much better ones. But if I showed them to you—your head would begin to buzz. You can look at them this way, or that way, no matter how you look at them they look like shit..."

Petras: "But there is a title underneath, no?"

Leo: "Just for the fool's eye."

June 27, 1949

Ignas: "Bad luck has been following me everywhere this year."

Silence.

Ignas: "Yes, bad luck is following me, I know. I don't know why it chose me, not you."

Silence.

Ignas is looking out the window. It's raining.

Ignas: "But potatoes are growing fine, it's raining and raining."

Ignas stands in the middle of the room, thinking.

Ignas: "But the Kickers lost in Mannheim. And I bet

on them. Always supporting the Kickers. And lost. Shit. Till now they always had first place, in the American zone."

Ignas counts his money.

Ignas: "All I have is one mark and forty pfennigs. Shit, what a life."

He gets an egg from his locker and goes out to wash it. He takes out a spoon, turns it around, studies it: not clean. Goes out to wash it. Stands for a long time in the door, looking at the corridor. He is watching the mailman. The mailman has two postcards for Petras. Ignas places them with the tips of his wet fingers on Petras' bed and, drying his hands with a towel, studies the postal stamps on the cards. Right now he's beating the egg in the cup. He rearranges his dishes, places them on top of each other in a pile. Again he beats the egg, staring at one spot on the floor, about one meter in front of him. Places the cup on the dresser, pushes it further, piles up the dishes on top of each other in a pile, takes out a little bag of sugar, pours some on the egg, then pours some beer on top, fills the rest with beer. Again, for a long time he stirs and beats, scratching with the spoon, with his foot closes the dresser drawer as he continues stirring. Today he received a CARE package, from a friend in Chicago, under the table a pile of wrapping paper, the empty box. He places the cup on the dresser, picks up an empty beer bottle from the floor, walks out to wash it.

Ignas returns, continues stirring the cup. Opens the locker, takes off his "good" jacket, folds it very neatly, hangs it up. Takes off his necktie, hangs it. Changes his shirt—puts on a blue one. Had to dress up to go to the Post Office, to pick up the package. He always dresses up to go to town. Now, with the shirt hanging over his pants, he is studying the lumps of "pure lard" he received. He unhinges the locker door with the tip of his knife,

puts some lard on the hinges, swings them one way then the other, listening for the squeaks.

Ignas: "My, my. Every little thing wants some fat, do what you want. It squeaks like hell—I gave it some fat: it is silent like earth."

Children run along the corridor, shouting.

Ignas takes off his pants exposing his white legs, here and there covered with rare hair. He pulls on a beat up pair of pants and goes back to stirring the cup. On the other side of the wall voices can be heard, loud, but I cannot understand the words. A train passes by, the metal rail noise covers the windows for a second. Ignas is drinking his mixture from the cup. In several good sips he drinks it all up. It took him about an hour to prepare it. He pours some more beer into the cup, twists the cup around, washing it with beer, he drinks it. The cup is the size of about two regular glasses. He pulls away the blanket, sits on the bed, takes off his shoes, places them under his bed, fixes the pillow, lies down, puts his hands under his head, stares at the ceiling.

In the room I can feel the summer heat coming through the windows.

July 5, 1949

Ah, a flock of white sheep is trotting along the hot steaming street, their backs are like silver glittering in the sun. Waves and waves. A Schwab shepherd with a long stick behind them, and a dog, like in pictures, and a little child, and what a heat, what a heat, how it burns—

In the backyard people are sunning in their colored shorts. I can see the woods in the distance covered with the blue summer heat haze. On the roof, on the other side, the black tar is steaming and it's difficult to breath. And the sheep, they are breathing so quick with their nostrils. And a bunch of school children—kindergarten—

with their colored school bags are passing by, past the acacia trees, in a goose line and the sun is pouring down on them. They are crossing the little square now, they are looking at the sheep, a cloud of dust, their line gets out of order. A truck loaded with bricks passes by, a cloud of dust covers acacia trees.

Ah, the heat, the heat. My eyes can't take the brightness of the roof tiles. Someone slams the door, someone is running along the corridor, loud steps. Ah, the heat. My face, my back is covered with sweat. 35° C in the room. A radio is playing behind the wall, right here behind the wall. Eh, who is slamming the door there, who's making all that racket? Ah? The radio is playing. This summer afternoon, summer afternoon, ohooo... Some other time...

I am reading Zweig's *Die Welt von gestern*, also Copland's *Musik von heute*. Also, MacLeish poems, O'Neill's *Marco Millions*, finished Thomas Wolfe's biography in *Der Monat* 8/9, and Kafka. Outside the window a bird is chirping, chirping, and the radio.

July 28, 1949

I take my laundry to the cleaner. I drop the bag on the floor and I hand them a list of items inside. No, they say, no list, take everything out and sort it out in piles.

I am embarrassed, the sweat is running down my face.

"Today is hot?"

"*Ja, ja,*" I mumble.

I thought if I give them a list they may not look at the contents. My laundry is so dirty, so worn out. The others, I notice, they bring it practically clean, white shirts. Mine are so sweaty and dirty, they are all in lumps, black, brown. I am embarrassed, the sweat is dripping down my nose.

IN BETWEEN

July 29, 1949

Saturday. Petras is preparing to iron his shirt, for tomorrow. Ignas is still eating.

"What is the film today?"

"Ah, I laughed and laughed. This young guy is flirting with this girl, in a berry patch, and whenever he wants to kiss her—this old guy pops up from the bushes. Ah, I laughed and laughed. Funny like hell."

Ignas finishes eating and walks out to wash his bowl. The bowl is large, you could put two liters of soup in it.

Petras is sitting, in shirt sleeves, at the table, leaning on his right arm, with a finger of his left hand he moves the ashtray now this way, now that way, humming. Ignas returns, cleaning his teeth with his nail, searches a long time through his pockets. Petras lights a cigarette.

Ignas to Petras:

"*Bitte schön*"—with the tips of his fingers he offers a piece of chocolate.

"I got it from a dame, a fine dame."

"Good chocolate."

"But I had to work hard for it."

"So you did. And done."

"I think I should do some ironing, the pants need ironing. But first I thought I'll take a *Mittagsstunde*."

"Go and sleep."

"How can I sleep if my pants need ironing."

Petras cleans up the table—the ashtray, coffee pot, covers the table with a woolen blanket, picks up the iron from the radiator—there are three irons on top of the radiator, people leave them there when they emigrate—they are rusty—two of them do not work and are much too rusty but nobody wants to throw them out. Petras plugs in the iron, takes a cup and goes out for water.

Ignas pulls up his sleeves, sings basso, bits of melodies, walks around aimlessly.

"I forgot what I wanted to do."

 Thinks.

"Ah, I wanted to throw this one out."

 He picks up from the floor a large bowl full of apple cores, paper scraps, vegetable leaves, and walks out. The wind in the corridor is banging the loosely closed door. On the bed lies a jacket, loosely dropped, inside out. Petras returns with the maroon cup full of water. He whistles, picks up a pile of clothes from his bed, a blue shirt, spreads it on the table and begins to iron it, continues whistling, places the iron on its tail, turns the shirt over, irons. Outside children shout loudly, someone is trying to start a jeep.

8. THE LAST SUMMER
 IN EUROPE

Daily life. Reading, reading, reading... Entertainment...
night life... Daily routines... Leo's Dostoyevskian ramblings...
Last walks with friends... The last days of Europe... The
author goes through the emigration procedures. On the boat,
on the way to America!

July 30, 1949

8:00 AM—getting up.

I am frying onions for breakfast; I mail a letter to
Algis; read Beach.

11:20 AM—more Beach (26 pages).

A letter from Židonyte, from Montrouge, with *Poèmes*
and *L'amoureuse initiation* by Milosz.

Finished reading H. R. Oehlhey's *Der Expressionismus*
(*Das Goldene Tor*, N. 10, 1947). Rehearsal for *Dzimdzi-
Drimdzi*. For an hour and a half watching basketball
game. Shelley's "The Cloud."

11:00 PM—to bed.

July 31, 1949

8:30 AM—up.

Reread Rudolf Blümner's *Vom Sinn des Kubismus* and
F. Karl's *Der Expressionistische Durchbruch zur Humanität
in Deutschland*, George Lecoste's *Die Académie Française*;
Ch. Péguy: *Das Geheimnis der unschuldigen Kinder*, Yolan-
da Bedregal's poetry.

Lunch. Walk in the woods, fields. Taking some pic-
tures. Listening to music (radio).

Casella: *Scarlattiana*; Beethoven's 5th.

Read Milosz.

August 1, 1949

9:00 AM—up.
9:20 to 10:20 AM—at the dentist.
Read Beaurepaire's *Die Zeitgenössische franz. Malerei*, Valéry's *Dialog über den Baum*.
Writing.
6:00 to 9:00 PM—English studies.

August 2, 1949

9:00 to 12 Noon—Kassel. Checked in the American Library materials on Kafka. Read the new issue of *Auslese*, parts of Bernard Shaw's autobiography (Didn't finish school, autodidact, etc.).
1:00 PM to 2:30 PM—writing. Read G. F. Hering: *Franz Kafkas Tagebücher*.
Read Milosz, picked up weekly food ration, visited Dr. Girnius and Maceina. Read Morgenstern, *Alle Galgenlieder*, Wölfflin's *Kunstgeschichtliche Grundbegriffe*.
9:30 PM to 1:00 AM—movies, *Pat and Patachon*.

August 3, 1949

8:00 AM—up.
Breakfast. Morgenstern. F. Kemp's *Surrealismus* (*Prisma* 4, 1947). In Kassel. Bought some apples. Visited Bagdžiunas, borrowed 5 marks from Gobis, received a letter from Algis.
5:00 to 9:00 PM—work on Kafka essay.
Raining, windy, head muddy.

August 5, 1949

Received our emigration number (to U.S.A.). Went to the photographer by the name Schweizer, on Ledergasse.
Worked on English.

THE LAST SUMMER IN EUROPE

Had a dream: We were walking, with Adolfas. Huge gate. Above the gate, as far as I can see, stretches a plateau. A very dark plateau. A man in the darkness is crying in pain. We go towards him and two others join us. I don't know, I don't recognize the people standing at the gate. We come to a dark corner where the cry is coming from. The cry stops and the two men standing at the gate disappear. Two columns emerge and rise above the gate. A voice says: "Through these gates pass the kings. These columns will make us alive and will free the one who is crying, and you too."

August 6, 1949

9:00 to 10:30 AM—Wölfflin.

10:00 to 1:30 PM—peeling potatoes; listening to Mozart from the Salzburger Festspiele. With Jurkus I go into the fields, to the lake. Then again I read Wölfflin (reached p. 220).

August 7, 1949

The weaver (his shop is two streets away) is watching his goat with two little kids (goat kids), grazing on a patch of grass. He says, the goat gives him up to four liters of milk. He says, old male goats piss on their own foreheads, that's why they stink, and it's better to keep them together with the horses, in the horse stables, that helps the horses, protects them from certain diseases. In Lithuania, I heard, the cavalry kept some male goats among the horses; same in the old czarist army.

August 9, 1949

Went to town, picked up photographs. Wrote a letter to Puskepalaitis. Listened to Smetana's *Moldau*. Met Vincas Jonikas. Borrowed two marks from Ignas, four from Rimeikis. The laundry cost me half a mark. Wrote to

261

Leo. Picked up food ration, my own and that of Skučas. Borrowed from Dr. Girnius Charles Terrasse's *Histoire de l'Art* and Waetzoldt's *Du und die Kunst*. Borrowed 5 DM from Jurkus. Read Jonikas' *Raudos*.

August 10, 1949

Two hours in the emigration office and then in the doctor's office. One hour standing in line to pick up fruit. Read Skardžius' article in *Aidai*. Three hours working on English. Two hours with Jurkus and Jonikas talking about bishop Valančius. Listened to Stravinsky.

The food is distributed in the former army stables. A long concrete structure with columns to tie the horses to. Cement troughs for hay and water. A long table loaded with food articles. On the floor—bags of flour, a pile of empty butter crates. At the far end of the table, the flour bags. Everything's covered with a layer of white dust, like in a mill. The food distributors themselves look like millers—their hands, faces, clothes, all white. In shirtsleeves, harassed by long nervous lines of people. For no apparent reason—anyway, for reasons that I cannot detect—everybody's in a hurry. They are pushing their little bags and bowls and jars and then they go home, with half a kilo of flour at the bottom of the bag.

Another table was erected for the distribution of vegetables. The vegetables arrive almost daily and they are distributed daily too. A large blackboard stands outside, by the door of the stable. Every morning they write on it the basic information, such as TODAY FROM 3 TO 6 DISTRIBUTION OF TOMATOES TO GROUPS 7 AND 8—500 GRAMS. GROUPS 1, 2 AND 4 WILL RECEIVE 600 GRAMS.

THE LAST SUMMER IN EUROPE

August 12, 1949

Reading Thomas Wolfe's *The Story of a Novel*.

Went to town, picked up laundry, bought four Kriegsbeinde lottery tickets, three blanks, the fourth one brought me 50 pfennigs. Looked through *Neue Zeitung*, read about Blaise Cendrars.

Read Werner Burkhardt's *Schriftwerke deutscher Sprache*, Vol. II; Hofmannsthal's *Der Dichter und diese Zeit*, George's *Über Dichtung*. Working on English.

"So you are leaving for America?"

"Very soon, very soon. They already finger printed me."

"Me, they did four times, all four fingers."

"I don't believe it. I was told only the thumbprint is required."

"I didn't believe it either."

"You must look very suspicious to them."

"Where are you taking those lamps?"

"To sell. You want to buy them? Good lamps."

"Go, go, don't fool me."

"Cheap, too. Truly. Half price. Two marks each. This one only 50 pfennigs."

"You know where you can stick your lamps…"

"I'll take them to the cooperative."

"Could I leave these lamps with you? Maybe somebody will buy them."

"No, it's not worth it. In five days we are closing."

"Ah. If that's so, then it's really not worth… Good-bye."

He goes to the Post Office.

"Could you take these lamps on consignment."

Post Office clerk studies the lamps.

"How strong?"

"These are 200 Watts, and this one is 50 Watts."

"Can't be. I think it's 60."

"It may be."

Clerk: "Ah, there is more trouble than money with this kind of business. I can't take them. They may break. One looks like it's already broken."

"O.K., I understand..."

"Leave your name, address, if someone asks I'll send them to you."

The man writes down his address, places it on the counter, picks up the lamps, walks out.

He walks along the street, down the street.

I have no idea why I am doing this. I mean, why am I following this man, this lamp business. Making notes. It's a writer's business, though.

August 13, 1949

Every day I take at least one walk through the town. For a while I follow the yellow Post Office truck. Then I sit for another while in the old beerhall, watching Schwabians drink *Most* ("*Prima Most!*"). I stand in the glass blower's door and watch how in the strong heat sweating men are blowing bottles and flasks. Or I turn into the sidestreets and walk until they disappear into the fields and hay stacks and watch the men mowing hay, turning it over.

I am the voyeur par excellence in this town. I don't feel much guilt about it. I feel I paid my dues to Germany. I still can feel it in my bones. They ache. From working in the cold Elmshorn factories I got a chronic cold. So I don't feel guilty watching Germany work. I am on a well-deserved vacation.

Our window looks East—meadows, fields, woods. On our table a vase of flowers (the girls brought them for us—all you need is to talk nicely to them, don't be scroo-

gy). Next to our room, behind a thin wall somebody from Memel is arguing very loudly with his woman (the wall is so thin you can hear them fart). A child runs along the corridor screaming. Adolfas is working on his papers and is humming *"Hänschen klein ging allein."* Our neighbor is baking potato pancakes. I see Dr. Girnius' bald head moving across the square. The sun is rolling on the ground (later it may rain). A *bayan* is playing somewhere. Children shouting. I think I'll close the window, maybe I'll go into the fields.

No date, 1949

While waiting in the doctor's office, I peeked into his diary book. I saw the following entry which I copied:

"The patient is complaining often that he doesn't like life. His mood is low. Doesn't have any friends. Little care and invention is used as far as his personal daily life goes. Likes to read. When walking, sometimes for no great reason, laughs, can't hold his laugh. February 5, 1949 attempted a suicide with gas."

"Get up, you idiot, go to the hospital. I can see that you aren't in your full head. A person of sound mind wouldn't act like this. Beast!"—shouts the Memel woman to her man, behind the wall. I am trying to imagine what the man may be doing, but my imagination fails. Beast???

August 14, 1949

The weather cooled down, yesterday it rained, today drizzling. The nights are cool.

Went to see Hofmannsthal's *Jedermann*, in the town's marketplace. The actors shouted and ran around and prayed and sang. The church clock punctuated the

performance. It was a pretty boring affair. I kept chewing coffee beans to keep me awake. But it was also an experience I won't forget. *Jedermann* on this cold night, outdoors, in the market place, surrounded by these old buildings, and with the voices of hundreds of amateur performers.

After midnight. In the barracks—a dance evening. We stopped at the dance hall. It was filled with the beating of drums, one could hear the fiddle cry. Inside, around the walls of the hall—wooden benches. Young shy girls, women sitting, a few pairs dancing, or just walking, traipsing around and across the place.

I settled down at the bar, ordered some beer, watched people get drunk. A few were singing, their hair falling on their drunken eyes, glasses of beer shaking and spilling. They sang a song I don't remember now. It was so noisy that at the table next to me people had to shout to hear each other. Then they started fighting, at the bar, somebody was beating the little black market guy, and a man behind me, dressed in a black suit, shouted over my head: "Beat the communist, beat him!" Two former German soldiers practically jumped over my head and tried to separate the fighting men, but now there were about ten of them, glasses were breaking, and chairs crashing on heads. Then it all calmed down again, and it was all very quiet and normal suddenly, the little "communist" was combing his hair and fixing his lapels, and his enemy, also a tiny, black haired former soldier (in Hitler's army) kept pulling, trying to free himself from his friends' hold, and kept cursing, and spitting at the "communist." Then came the police, three or four of them, MPs, turning their flashlights into the people's faces.

THE LAST SUMMER IN EUROPE

Then Birutė and Aldona walked in and we found a table, and then again they started fighting right behind our backs, and they fell on our table, and the MPs took the little "communist" away, and as they were leading him out, the "soldier" ran up to him and smacked him in the face, and blood started running down his face, blood was running on our table, on the chairs, and on the little dealer's ("communist's") white shirt, and the MPs took them both away, and then everything became quiet again. The bartender got his broom and swept the broken glasses and mopped up the beer and blood from the backs of chairs. But the women were afraid to stay any longer, and it was getting real late, so we left but we took some beers with us and we walked out, we walked into the night, but inside the band was still playing loud and some were dancing, an old tango melody.

I am sitting now and writing this down. I am sitting on the edge of my bed, with the paper on my lap. Petras is standing in front of the mirror, combing himself and cursing, he says he caught the sleeping sickness, he never has enough sleep. Ignas is counting his money. He says he's going to buy a pen, asks me how is "pen" in German. In the corridor, children are playing with a ball. Adolfas is sitting by the window, writing.

August 23, 1949

A few conditions for my "future" wife:
She should believe in the miracles of Lourdes.
She should like symphonic music.
She should never worry about tomorrow.
She should never put in order my working table.

I am the window pane washed out by rain.

Ah, the pleasures of milking the cows, when you ram your head into the warm belly of a cow...

Leo: "Water has no plans, no ideas, no schemes.

"We have to run through as much as water does in order to become crystals. Do not be afraid of water. The more of it the better. That's how the gold shows. When you have a cold, they say, drink a lot of water... Only the unnecessary, 'useless' acts will redeem us.

"Am I pale? I am drunk with the earth, that's why I am so white."

August 25, 1949

Took a train to Stuttgart. Didn't like the city, we spent most of our day at the movies. Saw *The Thief of Bagdad* (with Conrad Veidt) and *Die Finanzen des Groß-herzogs* (with Heinz Rühmann and Theo Lingen; directed by Gründgens). In town: a lot of construction, parks cluttered, everywhere people out of work, sleeping on benches on their bellies. Disgusting, sad.

Leo came, we listened to Honegger.

August 28, 1949

Reading Saint-Exupéry's *Wind, Sand und Sterne*. Reading Hemingway's *To Have and Have Not*. Troubles with my right eye. Playing a lot of chess.

We walked today, we lay under the apple trees, on the hill, we watched, by the dam, children swim. One fat-bellied man, with black swimming trunks, lay in the water and children kept throwing pebbles at him and lumps of earth, and when some fell too close, the man lifted his finger and shook it angrily.

THE LAST SUMMER IN EUROPE

Then the three of us, walked across the Square, humming *"Aš užeisiu ant kalno,"* and we were all in a very exulted happy mood, and Leo said, "Ah, it pains me to see all those songs go, those songs, and those words which nobody will sing anymore. We are the last Mohicans—we are the last ones from Lithuania."

September 2, 1949

"Lubeckis, he was like that, seven of us lived in one room, but he was such a pisser. He slept on the upper bed, and kept pissing on me. Every time I told him—he got very angry."

"Why didn't you put him into the lower bed?"

"We tried. He didn't go. Refused. And kept on pissing."

Leo is stretching his folding cot in the middle of the room.

"Ate too much sugar today, sleep is not coming."

Leo covers the cot with a gray woolen army blanket, lies down on top of it, not ready to sleep. Ignas is already in bed, sleeping.

"It's twelve o'clock. Where is the key?"

"On the table."

Leo takes off his belt and takes off his shirt. Petras and Adolfas are already in their beds. Petras is still in his clothes, stretched across the bed, not sleeping, is looking through a song book, searching for a song.

Leo comes back from the washroom. He sits down on a stool, hums something under his nose. Takes off his shoes.

The clock is ticking. I can hear it. It's quiet, silent. Ignas turns around in his bed.

The window is open. Distant trucks can be heard.

"Supinsiu dainužė..." Leo hums. "Ah, this one is fine..." ("I'll weave a song out of my dreams...")

No date, 1949

Ignas: "There are only two things I'd like to be in life: either a famous, very famous singer, or a violinist."

Behind the wall the radio is playing something by Mozart. Ignas stands and listens, then says:

"A beautiful piece. This kind of thing moves me. I wouldn't want anything else, I'd give anything if I could be a famous violinist, or a singer such like there never was. You sing—and they all sit and listen to you, with their mouths open, breathless—ah, great, great! To play the violin just for fun—there are a million of those. I'd like to be a great violinist."

He again stands and listens, very serious.

"It's time to get something to eat," he says. "Spaghetti or rice, which will they give us today? If it's rice—I'm finished. I think I will put a curse on rice."

He stands now with the bowl in his hands, a large metal bowl. He places it on the table, walks to the window, stands, looks out, walks back to the table, swinging his arms and breathing through his teeth, performing some mysterious exercise, picks up the bowl, walks to the door and into the corridor.

September 4, 1949

Ignas comes home with a parcel.

"Brother, this is a good package I just got, from America."

He breaks open the box, takes everything out, lines up little bags and cans on the bed and on the floor.

"I could eat it all by myself. Ah, good meat, with bread … ah."

Leo comes and tries to read the labels on the cans.

"Ah, they are vengeful, these people: they don't write letters, but they keep sending me packages. I think I'll take one can to Paulauskas," says Ignas.

"To that woman that comes here?"

Ignas doesn't answer.

"Mmm... Ah, devil—my shoes are pressing my toe."

"You should place those shoes on a chopping block, get an ax and chop them to pieces. What size do you wear?"

"44."

"Oho."

"My shoes are the same size," says Leo.

"How can you compare your shoes with mine? I am a man big as a prick, and he's comparing himself with me!"

Ignas sits on bed's edge, tries on Leo's shoes.

"I will buy new ones. I saw the shoemaker had a pair on sale, beautiful shoes, but they cost 36 marks."

"What should that mean to you? Another package will come tomorrow."

"No, I am not selling anything, I am going to eat it all myself," says Ignas.

He puts a can of ham into his pocket and walks out.

Leo is preparing to shave.

"Jonas is sweating like a pig."

"So are you."

"In Lithuania, the summers were hot, but you worked, you moved, and it was nothing. Here, the heat comes— and you collapse," says Leo.

"Are you going to shave without any water?"

"Why not? See for yourself. When Ignas saw it for the first time, me shaving like this, his eyes popped."

"Much easier with soap and water."

"I don't know. Maybe I should try it. Anyway, I shave only every third day."

"I'd go crazy shaving like this."

"Sometimes it's painful, it hurts. When you drag across it..."

Leo picks up a piece of soap from the window sill.

"Maybe you talk good. Maybe me try," says Leo.

"Where is it? There was that nice paper here."

"Maybe Jonas took it to write poems."

Leo comes back in from the corridor.

"What an idiot. Here I am going to get water, without a cup."

He picks up his cup and walks out. I can hear him sing as he walks down the corridor.

Returns with the cup full of water, stares out the window. Takes a towel out from his suitcase, from under the bunk.

Petras is lying on his bed studying the can of ham Ignas gave him.

"When the plenum gathers, I'll open it. We'll gobble it up like beasts," he says.

September 5, 1949

THE GRAND INQUISITOR

Leo is showing his drawings to Petras. Petras is shaking his head:

"So, you really think about every line you make?"

"Brother, brother… When you talk, do you think over every word you say? It all comes out by itself."

They are silent. Then Leo says:

"One is born this way, another that way. One as wolf, another as fox."

Another silence. Then, Leo again:

"There are about twenty books I'd like to buy some day, but I can't, right now. Thirty marks is big money today. But I spit on it."

Petras: "What are these physics books? What are they all about?"

THE LAST SUMMER IN EUROPE

Leo: "I'll tell you some day, when I am in the mood. But if I just started to talk to you about the present state of physics, your head would just shrink. Some think they speak very spiritually, very abstractly—and another is talking very very simply about physical matters. One says I think it is like this, another says he thinks it's like that. And where is the criterion, where is the standard measure? And so it goes."

Petras: "This sounds like philosophy."

Leo: "Not much. The trouble is physical scientists do not know much about physics, that's the trouble. It's necessary to destroy a lot in this world, there is so much shit. You arrive in the world, and you find it all, and by the time you understand it, you have to go … it's time to die… Philosophers are jabbering, that's all. They surround themselves with a lot of terminology, and when you don't know it and you read them you think they are talking about hell knows what. They know how to keep up a style, a good tone, like shamans used to do—they didn't let just anyone into their circles. But, look, they are talking shit. And the further the harder. So that's why I want to publish my book. But I would like to work more on it, because if you want to hit them, hit them strong and square on the head. But the times are not right, everybody's talking about war. And when I get to America, I know I won't be able to do it for some time. But there is nothing that one can do about it—better to sing, sometimes. The world has no feelings. The hungry look for food. The world is overpopulated, that's the trouble."

Petras: "They'll solve it with technology."

Leo: "How many beets can you grow in a given field? If the technology would be that miraculous, then—yeah… But it is not. So, no beets. You still have to plow the fields, and plant, and… Or—look at China. Americans permit

them to fight, to kill each other... No sentiments... Or Russia: they have nothing but the fear of U.S.A. America has everything, but no place to sell it. So they decide to beat Europe so much that it would howl... Later, there will be a lot of construction going, everybody will need this and that... So, that's that. They know what they are doing. Step on the other. If not, the other will step on you..."

Petras: "So what would you do?"

Leo: "It is necessary to do something. It is necessary to educate the man. An educated man is able to live with very little. But now they say: Let's make more children! I understand Lithuanians: for the Lithuanians, it's a question of having a nation, so they should bear twenty children each. But what about the others—another matter."

Silence.

Leo: "Even the church says: marry and multiply and fill the world... But it doesn't say, no, it doesn't say 'overfill, overpopulate the earth.' To fill—yes, it's true. Boy, oh boy... Very few die young now, and no epidemics, and even the sickest manage to prolong their lives by another twenty years, they sustain them with injections and machines. I am not saying: kill them. How can one give a decent education to twenty children!"

Petras: "There are problems..."

Leo: "To begin with, first of all: nobody is educating. So, you see, I am very materialistic now... I am very very calm now. There were times when I used to get very excited about these matters. Now I can go into the woods, cut trees, I don't write any books. A healthy man doesn't need much: only to be healthy, and to work."

Petras (to Ignas): "You pig, you didn't wash the cup out."

THE LAST SUMMER IN EUROPE

Leo: "You can't break down walls with your head. I will complete my work, I can promise you that, but I'll leave it on my death bed. Now they say, you should know everything and say nothing. But sometimes you can't hold it in, the circumstances arise, and you open your mouth. Now, they publish hundreds of thousands of books. Man reads too many books. I am not talking about novels. They are something else. Ah, there are also people whom you can't educate. A farmer has at least the earth in him. But what do the others have? A hole in their pants. I have met many educated women—but I have found in none of them as much soul as in one simple farmer girl who never went to any school. You can find love on a stocking, on a hair—but where to find soul? No human being there... Of course, there is: but very little. Decor, mostly. Put it down and put a match to it... Modernism, too... So much shit. It has produced so much shit that you can't see the good things through it all. How many centuries have we been painting, and tell me how many good works are there?"

Silence.

Leo: "How late does the barber stay open?"

Petras: "Till six."

Leo and Petras walk out, they are going to the barber.

September 7, 1949

Went to Wiesbaden. Picked up books I had left with Frau Nagel when we moved to Kassel. Wiesbaden looks very autumnal, grayish. Only the Rhine is the same. It was good to see it again. Our old barracks are unrecognizable, covered with shadows and the past. There was some kind of party there, this evening, loud music until four in the morning, people drunk, a very depressing crowd.

275

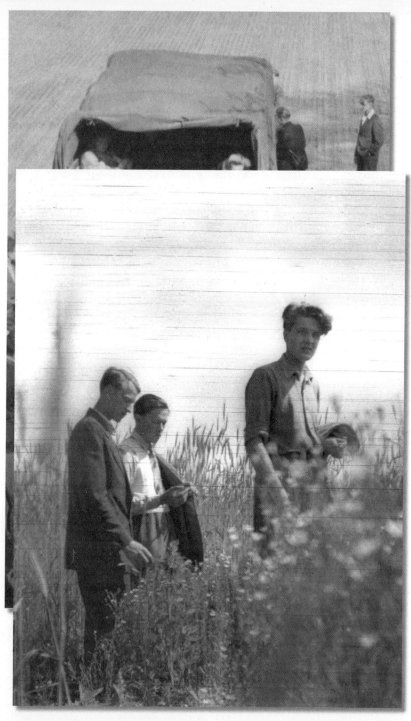

Jonas Mekas, Leonas Lėtas, Adolfas Mekas, Schwäbisch Gmünd, 1949

THE LAST SUMMER IN EUROPE

Left for Darmstadt. Later, for Stuttgart. Saw the eye doctor. Stuttgart still looks dreary.

No date, 1949

Dear Leo:

I delayed the letter, I was trying to collect more money. They had promised to sell your books, but the prices you wrote on them are much too high, there are many books here, and nobody buys them. Jurkus had promised to lend me 25 marks today—but he failed, says maybe later. *Aidai* not only has no money, they are also schmucks. They are still sitting on your poems. Maceina and Jurkus are schmucks, and Girnius too. If you could write something for them, not in your language—they don't understand your language, they kept repeating—but in THEIR language, an article about language (!!) they said they may print it...

You are under everybody's attack here. Jurkus attacks your drawings, and your poetry, and your translations of Rilke. He says, there is no order in them, all chaos, he says, these are his words, "he is in the crisis of his mind." Maceina described you in about the same words, telling Jurkus about your visit to him. He said, you left the impression of a man going through "a crisis of his reason." He says, he tried to force you to formulate your thoughts, their essential points, but you, you kept taking him all around... Still, you have left a sharp and deep splinter in their minds. Now we walk with Jurkus for hours through the little streets of Gmünd, talking about you. And I say to him: "Yes, it's true that Leo hasn't arrived yet at the end of the road. He hasn't summed up himself. But even where he is, is more interesting than the summing-

"So now it was our turn to climb into the truck…"

ups and idiocies of academics. His chaos is interesting, exciting." But Jurkus says, "No, he needs a basis, a firm basis, the chaos moves too much, his chaos is too shaky." He says your problem is that you are going too wide, you won't be able to swallow it all. And I say, "I know Leo, he will swallow it all, he is an intellectual glutton." Then he jumps on your poetry. He says, it's all disconnected, nothing binds it... All I could say to him was that some poetry is not for everybody.

They got very interested in your physics of language. They keep asking me about it. They say, what kind of animal is that?

They don't think that UNESCO would finance your research. And Lithuanian organizations do not even take you seriously enough to recommend you.

Blekaitis passed through, just before leaving for the U.S.A. He wants to form a Lithuanian theater in Chicago. He read your poems—he shook his head, and put them down. Says, he can't understand them, unclear, yes, that's exactly what he said, "unclear." Says, "bad language," "doesn't know the language." And I say, you haven't even read him! You have to get used to Leo's language, Leo makes language! You have to get used to his language, try to get into it. But no, Blekaitis doesn't want to read.

Then he told me he was searching for a copy of Heidegger's *Sein und Zeit*, and I said, what the hell do you need that book for? We cut it up in Kassel and pasted it all on the walls, it's gone... Heidegger is good for a comedy evening... So he says: Ah, Heidegger is great, you just have to read more of him... So I say, ah, now I got you: Why do you attack Leo's poetry, then, without reading it? You have to read Leo to see the beauty of his language collages, the iron logic of his chaos—same as with Heidegger.

I was showing them your last letter—it was like a circus. Like showing spectacles to the monkeys: they put them on the tail…

I am reading *Doktor Faustus*, Thomas Mann's novel. Read Guardini's *Rainer Maria Rilkes Deutung des Daseins*. In Guardini's book there is a lot of you. *Zum Beispiel: "Zur letzten tut das Tier nicht etwas, sondern es tut einfachhin. Es richtet sich nicht auf etwas, sondern lebt hinaus."** I don't know if it's Rilke or Guardini, or a mixture of both. It sounds more like Rilke. Now, Rilke: "Gott ist nicht mehr jener, auf den der transitive Akt der Liebe zugeht, sondern eine Qualität dieses Aktes selbst."***

Have nothing to report about myself. If you'd walk into our room now: ah, the smell of the field flowers— presents from all the girls… Right here outside by the window freshly cut hay dries—ah! my God, how it smells!

If you can come here somehow, on foot or any other way—don't worry, we'll always put you up. There is always a lot of soup and bread, if nothing else, from the communal kitchen. For anything else—there are all kinds of secret places. Jurkus says, he'll help you too, even if you don't know how to write… There are trucks coming here from Butzbach occasionally, if you could get there, they could give you a free ride, perhaps.

September 15, 1949

We were notified that on Monday we'll be leaving for Ludwigsburg's emigration post. Our visas have arrived.

Our old friends… Jurkus, Blekaitis, Mažiulis… They say, it will be sad, it will be too quiet without us. There

* For example: "Essentially, the animal does not act it out; it doesn't aim or reach out for something. It simply acts it out from within."

** "God is no longer seen as the one towards whom the act of love is directed, but as the very quality of that act."

will be nobody to make any noise, nobody to ram shelves against the door, and things like that...

With Rimeikis and Jurkus, we walked into the fields for the close of summer. Ah, what a day, what a day. We gathered flowers, each of us with a bunch, grown men running like nutty puppies into the riverbed, dry by now, to pick just one flower more.

Then we found some huge, lush plant leaves, and holding them proudly over our heads like umbrellas we walked further along the river bed. Then we lay down in the grass, under a tree. It was still hot, and there was such a silence, we heard only the buzzing of the last late summer bees. "What beautiful silence," I said. And it was, it really was. "You can hear distance," said Jurkus, "just listen to those crows... Can you hear them?"

In all this autumn silence, under trees already brownish red, and the sky clear and vast, we sat there very quiet, with little bouquets of field flowers in our hands.

But Rimeikis, he insisted, he had to find a crayfish. He stood on the river bank, staring at the little white stones on the bottom. He'd take his shoes off and look for crayfish, he insisted. "No, no, no, don't do it," we said. "We believe you anyway, we believe that you can catch a crayfish, you don't have to do it." But he insisted, he kept staring at the river, his Lithuanian blood woke up in him. Then he returned and rejoined us, he was carrying a long willow branch and he kept cutting the air with it, with his other arm behind his back.

September 29, 1949

On Monday, September 19th, along with 18 others, we left for Ludwigsburg.

So now it was our turn to climb into the truck early in the morning and look out at the sad crowd gathered

to say good-bye. It was a cold, misty morning. I could not believe yet that this was it.

So we climbed into the truck, some people waved to us—Prof. Bendorius with his wife had gotten up—and the truck moved out.

In Ludwigsburg they put us up in a basement room at the emigration barracks. We see nothing but feet marching by and children kicking chestnuts. Ah, we can hear the chestnuts fall on the pavement.

Excitement everywhere. A lot of promenading. Everybody's in their best clothes... We make the rounds of doctors, who check us carefully, like pigs before slaughter. Filling papers endlessly, answering hundreds of questions, we had already answered hundreds of times before.

The other day, somehow, they lost my emigration papers, the whole file. Panic. They found them next day...

They put us up in a room with five others. A lot of chess, nothing to do. Two of our roommates served in the German army, so we have to listen to their endless stories about thieving and whoring. Through a loudspeaker outside the radio plays loud pop music, American.

October 4, 1949

Leaves of the chestnut trees are falling, all brown red. People pick them up, look at them, their eyes in some distance of memories. These are their last days in Europe. They are all like falling leaves themselves, falling away from the tree of Europe, ready to scatter who knows where. So they stand with the chestnut leaves in their hands, turning them over one way, then another.

THE LAST SUMMER IN EUROPE

I sit on the bench watching them, a little bored. I, too, am somewhere, in between. These are my last days in Europe, too. I, too, am watching the leaves fall.

We are through with all the check-ups. All our papers are ready. We even saw the American Consul and he shook our hands...

Our wooden travel crates are beginning to come apart from being dragged and banged around. The corners of jackets, shirt sleeves are sticking out... Let's hope they will reach the ship.

The old soldier is talking to Zyle. Someone stole his tobacco, someone who just left for New York.

"I hope he'll break his prick in America," he says.

Now they are both sitting with empty pipes in their mouths, discussing various types of pipes. Zyle is sitting on the end of his cot, the soldier on his suitcase. A huge suitcase, painted green.

There are nine cots in the room. On the window sill: coffee cups, shaving mirrors, scraps of paper.

October 7, 1949

On Monday we signed our visas. Waiting for the ship from Bremen-Grohn. All our belongings—247 kilos—we gave to the shipping people yesterday. When they discovered that nine boxes were loaded with books and only one with clothes, they made a hopeless gesture. "*Verdammt wenig*" (too damn little) said the functionary. Opened one box of books, looked in. Everybody came to look, five or six of them stared at the books. The functionary picked up a volume of Rilke, dropped it back in and closed the box. "O.K., next."

I HAD NOWHERE TO GO

Yesterday early we left for Bremen—for our boat!

"Oh, hell, I forgot to trim my nails..."

"That's O.K., you'll look more American."

Opposite me, slouched in the corner, a priest is reading a Herlitz English grammar book. In another corner of the car an ex-nazi soldier, already snoring. The lamp is maybe 5 watts, a gas lamp.

"Ah, we covered a lot of miles..."

"What is important is we're moving ahead..."

The train stops in the fields, in the dark, with only the engine huffing and making a lot of noise.

"Ah, difficult to tell. She was so beautiful... But a real fox in the store..."

The train ran all night. I slept in my seat, on my suitcase, very uncomfortably.

The morning was coming. The fields were covered with a thick mist hiding the last images of Europe. I could see only a narrow railroad strip, occasional silhouettes of trees, heaps of vegetables and leaves stacked out in the fields and around the farmhouses.

Ah, Europe, that's all you have left, the late autumn days. Your summers are gone, Europe.

The sun rose slowly, shone through the mist shyly, timid before the vastness of Northern Germany, low lying plains full of salt and wind and loneliness. The windmills seated on the hills, their arms criss-crossed...

I have to look at this landscape, I have to drink it all in. I have to look at it with one hundred eyes. Six hundred eyes silently are looking through the train windows.

We arrived in Grohn at 2 PM.

The mood is that of a holiday. People are walking

284

aimlessly, waiting. The radio is playing loud. I have a feeling I am neither in Europe nor in America. I feel like I am in no place, on the brink of an empty space between misery and dreams.

While waiting for the boat, we visited Vegesack, a small fishing town on Weser. They bring the herring here. The harbor is full of dirty little fishing boats, it reeks of unsalted, rotten fish.

Our ship, the *General Howze*, is already in the harbor.

We are leaving tomorrow, we have been told. People are gathering in large crowds in front of the bulletin boards, searching for their names.

October 19, 1949

We are on our way!

We left Bremerhaven. Along the coast a strong autumn wind blew. It blew and tossed everything. It pulled and tossed the hair of the D.P.'s standing in a long line waiting to board the ship, standing for the last time on Europe's soil. All eyes were focused on the big white ship that was going to carry us to Paradise—a white swan!

We were given cabin E-9, somewhere on some lower level or deck of the *General Howze*. The *General Howze* is carrying the 100,000th D.P. immigrating to the U.S.A, an Estonian with two children. Our leaving was delayed by two hours while the I.R.O. and other officials spoke into a bouquet of microphones, croaking out greetings on the occasion of the 100,000th D.P. I was the 100,001st D.P., so I wasn't that important. Photo reporters were crowding the pier, you could hear cameras crash on the cement, and the 100,000th D.P. stood there with his little family very shy and very embarrassed, blinking, not knowing what to do, with flowers in his hands until the

comedia was *finita* and they were permitted to board the ship. The "press" squeezed into their "machines" and the pier again was empty, only the wind blew as before, and a few pier workers raised the gang plank and unmoored the ship. It was exactly 3 PM. The ship exuded three hoarse hoots from its three fat chimneys. A couple of people, not more, waved from the shore. The harbor, the pier was completely empty. No, nobody is here to see us out… Nobody will really miss us here. Just a few harbor workers, in their blue overalls, faded from too many washings, stood on the shore as the ship, at first very slowly, gradually faster and faster began tearing itself from shore, from Europe.

There were tears in a few eyes, while I could read some melancholic thoughts in others. But mostly the eyes were still unbelieving, incredulous, even shocked by the fact that they were really on board, and the ship was moving, moving towards the sea—the open sea—and that soon they would no longer be in Europe. Yes, finally the war is over…

But nobody took it as dramatically as I am describing here. A D. P. has become used to arrivals and departures, to settling down then moving on again. Members of one family, workers in the same slave factory, friends from living out years in the same room… You attach yourself only to break away again, to part, each bound for a different direction in the wide world. Friendships, words, children, kisses—abandoning all to oblivion or to memory. There is no time even to remember it all… There are always new places and new people and new miseries.

"I'll write you, you wait for my letters, wait for my postcards, soon—as soon as I arrive—as soon as I settle down…"

THE LAST SUMMER IN EUROPE

They don't know that they'll never really settle down. No, never. Some part of them will never be really there, a part of each of them will stay on in the old country never allowing them to really settle down elsewhere, to really grow roots. You'll keep moving, brother, you'll keep moving and running and you'll die with homesickness in your eyes.

The last banks of the Weser went by fast and soon only a few fishing boats still gave sign that there was land somewhere close by. Mountains of waves kept rolling and rolling, hordes of white horses foamed and galloped.

By the evening the wind subsided, but then it came back during the night and the ship moved lurching slowly. The ocean foamed and whistled all night and we rolled in our bunks, the iron beds clanked and squeaked.

Already on the evening of the first day you could see Lithuanian farmers vomiting in every corner. My God, what are Lithuanian farmers doing in the middle of the Atlantic ocean, puking into the waters of the Atlantic...

In the morning the sweet-sour smell of vomit pervaded the entire ship, below deck and above. On every side you could see them walking slowly, leaning out, white-faced, pale.

I keep looking at the ocean and yet I can't describe it. I am amazed by its power. Jump in—you are a pure nothing, nobody will notice you, maybe not even a fish. It has to be the primary element, all right, moving and moving, heaving and heaving, breathing deeply and angrily. Now it's light green, now blue, now, again, back to dark black. And now it's like white milk, it shoots up, like the beer of Semeniškiai, fresh-drawn from a keg...

Ah, the power! Now I understand Byron and Mickiewicz.

I HAD NOWHERE TO GO

The waves are throwing our *General Howze* around like a tiny twig. The storm has been raging since we left. The ocean is huge and terrifying. The North Sea wants to claim us as she has claimed so many others. Mountains of water, wave after wave spilling over the hulk of the ship. My clothes are drenched in salt. Now it has started raining and snowing.

The cliffs of Dover are on the right, like white walls. On the left the lights of the French coast. Because of strong opposing winds it took us all night to pull through the English Channel.

Now we are leaving the last lighthouses of Ireland. A threatening, black coast line. We see the last fishing boats. Now there is only water on water. And rain. And storm. Only an occasional seagull or dolphin.

Now I can really feel Europe fading away. At the same time I am being taken over by an animal fear. It tells me that I shouldn't be leaving Europe, that I am committing some kind of transgression by leaving the land of my spirit and body. There is something in nature, in the plants and animals which tells them to stay close to their birthplaces. They cling to them with their claws, they fight back, they hold with their roots.

But then, I think, as I stare into the raging Atlantic, and as I try to rationalize and excuse my drifting away from Europe, perhaps that's how man differs from animals and plants that he can and has, and probably must cut himself from the ground which made him, in order to grow into a culture. It must have been so since Adam and Eve… Away from Earth, from Paradise or the Womb, into culture… The second birth.

It also seems, that nature itself helps out humans who decide to undertake such transitions. The power of

the ocean—or simply the power of plain distance, vast distances across land—act as a kind of anesthesia against the pain of the past, against all of past memories, and ways of living, and culture—it's like a tearing scream—when it pains you, you scream, and it makes it all somewhat easier to take—so much easier to make the fatal transition, whether chosen or imposed.

I am sitting here in this small cabin. I lie in my bed. The ship is rocking heavily. A strong wind is blowing. I went out. I stood against the wind, and I couldn't breathe. So I am back in the cabin. I can feel a huge loneliness surrounding me. Even with all these people around me, I am hanging in space by myself. No contact whatsoever. The cabin. The ventilation sound. I feel the presence of the ocean beneath me, very very close. This invisible presence is stronger than anything else. I can't even think or concentrate, although there is nothing in the room really to distract me. It took me three days to begin to get used to this feeling. I am beginning to collect myself, to fight back. I am fighting space and air. And water.

I am reminded now of our Enormous Blue Room, and what we said. We said, "It's so easy to talk here, to be here; ideas are in the air, the spirit is in the air." Here, there is nothing but air in the air. I am totally alone here. Everything depends now on me. Me and the Atlantic. Rough, powerful, monstrous. Homer knew a lot about this empty air and its threats.

For three days I've been in this strange, somnambulistic state. Only now, on the fourth day, I am beginning to be conscious of my fight against the ocean demons. My silence and passivity are like that of a dog, a sick dog. The sick animal retreats, curls in some dark corner, makes himself invisible. I act the same way.

In my still somnambulist state—perhaps only because of it, and through it—I am now reaching into the immediate vastness around me. I am trying to make some contact with insubstantial phantom thoughts floating somewhere in the air—the only conversation I can manage to make now. Well, there are 1400 other D.P.'s on this ship. But I feel like a lonely, shipwrecked man. Maybe a Flying Dutchman. The other passengers have all been claimed by Oceanus. I am completely alone on this ship.

Mornings, from 8 to 10, and in the afternoons, from 3 to 4 I am working. And I am paid in dollars! I am cleaning the lower deck. There are eight on our team. Dust, vomit, stink, smell of disinfectant. But we are paid, so we are not complaining.

The worst part is this unrelenting swaying, rocking. It's worse on the bottom than up on the higher decks. But this is the fourth day of our crossing and at least for myself I can say I have mastered the sea rhythm and am moving quite freely, the dizziness in the head from the first three days is gone. Once only did I vomit. I was standing in line to pick up my pay, my first dollars, and suddenly the ship made a sickening movement with its tail. I rushed to the door and there went my breakfast. After that everything was fine. I went to the lunch and devoured everything with the usual "Mekas ferocity" as they call it here. The vomiting may not have been caused by the ocean at all: maybe I was allergic to my first dollars.

First shock of America:

While helping in the kitchen, I discovered that I was helping to dump barrels of egg yolk into the ocean. When I expressed my shock, I was told by the kitchen workers that they use only the egg white; they don't serve the yolk on this ship.

THE LAST SUMMER IN EUROPE

We are moving and moving, and there is neither beginning nor end to these waters.

A rabbi sits on the steps, leaning on the railing, reading an old, beat up prayer book. His face is white, gaunt.

We stand in a circle and sing. We sing for hours. There is nothing else to do. Our songs drift off into the Atlantic. For hundreds of miles they trail behind us, over the waters, lost among the waves, sad Lithuanian songs.

We are beginning to pass some ships. Must be some islands nearby.

I am standing on the deck watching seagulls, I listen to their sad screeching cries.

I am also sad, but I am not crying. I am trying to keep my seagulls locked inside.

9. NEW YORK

The author arrives in New York. Visiting employment agencies, searching for work. First job. Out of work. A lonely miserable Christmas. The depths of Brooklyn. From job to job. The author buys a movie camera. Anxieties. Instabilities. Long walks through the nights of Manhattan. Memories of Stalin. The loneliness of an immigrant.

October 29, 1949

Yesterday, about 10 PM the *General Howze* pulled into the Hudson river. We stood on the deck and we stared. 1352 Displaced Persons stared at America. I am still staring at it, in my retinal memory. Neither the feeling nor the image can be described to one who hasn't gone through this. All the wartime, postwar D.P. miseries, desperations and hopelessness, and then suddenly you are faced with a dream.

You have to see New York at night, from the Hudson, like this, to see its incredible beauty. And when I turned to the Palisades—I saw the Ferris wheel all ablaze, and the powerful searchlights were throwing beams into the clouds.

Yes, this is America, and this is the twentieth century. Harbor, and piers ablaze with lights and colors. The city lights merged with a sky that looked man-made.

In the North there was a massive cloud, then it thundered, and lightning cut through the cloud lighting it up briefly, and then falling on the city to be incorporated into New York's lighting system. This gigantic manifestation of nature became just another neon sign.

Early this morning there was a heavy fog over the harbor. The city appeared and disappeared. The statue of Liberty appeared for a moment—to greet us!—and

disappeared in the mist again... Slowly, the ship moved into the very heart of New York.

The ocean was still in our ears, in our flesh. We were both dizzy and ecstatic, as we touched the ground.

According to the immigration papers, we had to board a train for Chicago. And that was our sincere intention. We had nowhere else to go.

Algis came to greet us and help us to the train station.

We stood on the elevated platform at Pier 60 looking at the New York skyline. And we both said it, at the same time, Adolfas and myself: "We are staying right here. This is it. This is New York. This is the center of the world. It would be crazy to go to Chicago when you are in New York!"

The decision was swift and final.

We thought for a moment about our jobs in Chicago, the bakery, and the apartment waiting for us, and all the good people who are ready to help us there. Security against plunging again into the unknown. And we looked again at the New York skyline, and we said, "No, we aren't going anywhere anymore. We've had enough travelling. We are staying here."

Algis agreed to put us up in his parents' apartment until we found jobs and a place of our own. We loaded our bundles into a taxi and proceeded to Brooklyn, to Meserole Street, in the very heart of Williamsburg.

November 10, 1949

Now I ask myself, is this October or November? And what day is it? The days got lost. The end of my second week in America is coming to an end.

For two weeks I've found no time to sit down and write. It has been constant running. Looking for work, searching for a place to live. This is not a D.P. camp any

longer. Nobody will feed us, nobody will keep us: now we are on our own. This is it. So we did a lot of running around. Now, for the second day, I've been working. So life is beginning to look more normal. And brighter, too.

It would seem that ten days is a very short time. But it also can feel like an eternity.

The intensity of the experience, minute by minute, has stretched these ten days into what seems like months.

In the Employment agencies, there are hundreds of little desks, and hundreds of people looking for work, with their eyes on the bulletin boards, reading the tiny labels with job descriptions. For two weeks we sat on those sad benches, and moved from table to table, from one board to another, and kept hearing: "Nothing. Come tomorrow." The eyes get blank, the face becomes long, apathy sinks in. Work, work, work. Sometimes you come very close, you almost have it—and then it crumbles again.

Now I have a job. I am an "assembly worker" at G.M. Co. Manufacturing, 13–08 43rd Avenue, Long Island City. My check number is 431. For two days I have been assembling miniature toys. I am going out of my mind from monotony. My fingers have holes from screwing tiny screws. Today, by evening, I could barely grasp them, I have blisters on all my fingers.

Saw the Van Gogh show at the Museum of Modern Art, I revived.

November 16, 1949

Another week is over. I am still working at G. M. Co. For two days I screwed little screws. For another two I drilled little holes. For yet another two days I drilled big

holes. During the last hours of the day my hands can no longer pull the drill handle. The only way I can still continue is by pressing the handle down with my whole body. Chest and stomach muscles are all on fire. After you gain a certain momentum, you work automatically, from inertia. You put it in, you pull the handle, you press it; you put it in, you pull the handle, you press it—all day long. You can't think. Thoughts are jumping around, like dead sparks, with no center—one thought here, one thought there, one thought still somewhere else. One minute later you don't know what you thought a minute ago.

We have a thirty minute lunch break. There is a room here, with dirty steel shelves to put our clothes. Here the workers chew their sandwiches, or they squat on empty barrels, in their oily and greasy clothes, their hands eaten by rust, and they shout, one louder than the other, I can't understand anything, and they play this game all the time: throwing dice, and pennies into the middle of a circle. All I have to do is to close my eyes and I am back in the Elmshorn barracks.

There is a gang of fatso girls working here also, they do the packing. They pack, they cut, but most of the time they giggle, with their teeth showing. Or they sing under their noses, in high voices, and they have been going after me like fat flies. But most of them are so fat and so ugly that I try to ignore them or joke them off. But the more I joke, the more they stick. They are all very uneducated, from poor families, bad bodies.

The smell of steel and iron pervades the place. I carry this smell out into the street, and sometimes I think that maybe the whole of New York smells like steel. Steel has a smell. Steel is not eternal, no. Steel also dies, like wood, like grass. Steel and iron turn to dust.

NEW YORK

I stood, early this morning, leaning on an iron beam, in the subway, and a steel coolness ran through my body. Later, in the street, I saw a man lying on a pile of Daily Mirrors, on cement and steel, the steel was his bed. He was lying there, curled, close to the steel, on the concrete.

December 5, 1949

Still with G.M.Co. Putting together scissors, pliers, screwdrivers, but most of the time I don't even know what. When we get an order of drills, the palms get covered with blisters, I can't touch anything, even with gloves. They keep rotating the workers from one table to another, but it's of little help.

The fingers are working automatically. They lead their own automatic lives. I may as well let them. Who cares about the fingers. I leave them alone. They keep moving. To stay sane I try to think about something. I begin by thinking about the objects and activities closest to me, around me, following them with my eyes. Then, at some point, I take off, and I begin to think about yesterday, about the day before, and dare to go further and further out. Suddenly I catch myself dreaming, making plans, completely unconscious of the activities of my fingers. I have no idea what they did in the meanwhile. Maybe they strangled somebody. I wouldn't know. I am not responsible for my fingers at all. I am a space traveller.

I am taking off again! Next to my knees the radiator is boiling. I am standing at a long table, with my back to other workers. The radiator sizzles. Behind my back a monotonous noise. In another corner some women are singing, their voices are very high. It's their own form of space travelling. They must be off to somewhere.

Went to see *Firebird* (Balanchine).

I HAD NOWHERE TO GO

December 15, 1949

They let me go. Orders are not coming in. Now I am again crisscrossing Brooklyn, North and South, East and West, and deep into Manhattan, and Long Island, searching for a new job. From factory to factory, from shop to shop. I visited a few museums, I thought they might need ushers, or cleaners. Tried the Botanical Gardens. But it's difficult before Christmas, that's what they all tell me. There are too many others like me. Wherever I go, there is someone else before me, with a crumpled newspaper in hand, looking at the same street number.

December 17, 1949

Through the YMCA—a very clever move: I told them that I belonged to a European branch of the YMCA and that I had lost my card—I got a job at Emerson Plastics, 567 East 38th Street.

The shop is in the basement, the place is stacked, from floor to ceiling, with plastic Pepsi-Cola advertisement plates. My job is to apply glue to the inside part of the plate, put the label on, and pass it to the next guy.

The working table is so wide that I can barely reach the other side where the Pepsi plates are being constantly fed to me. I have to hold myself with the muscles of my back, to balance myself, when I pick them up. After two hours of work I can barely bend. The other two workers, next to me, keep shouting at me and cursing. They are real bastards. They keep speeding and I just can't paste the goddamn labels that fast. I keep my teeth tight, angry as hell, with the glue running all over me, over my hands, shirt, and down my pants. But they won't slow down. They are real bastards.

NEW YORK

December 19, 1949

Got fired. The two bastards got me fired because I caught up with them. This morning I caught up with them. I began piling up the goddamn Pepsi plates on them, for sheer revenge. I couldn't believe I could do it. I did it from anger. There is a certain technique to everything. You just leave your fingers alone, and they become part of a fantastic machine. It takes a certain intelligence to do it, but I knew I could beat them. I knew that in the very end they would be beaten. That's what I wanted to show to those two bastards. I proved that I, too, could become an animal, under pressure...

Anyway, they got angry. In front of me, they told the owner that I was lazy, that I was only faking at being a busy worker, that I was slowing them down. So the owner gave me an envelope with twelve dollars for my three days of hard work and told me good-bye. I spat on the pile of the Pepsi-Cola plates and walked out. The streets were busy with pre-Christmas activity, a cold wind blew from the East River.

December 21, 1949

Visited a German Employment Agency, on 74th Street. Tried to pass for a German, played on their emotions, a new trick. They don't speak German there, I discovered, so they don't see my accent. But too many people are looking for jobs. The Agency has nothing. We are living on milk and bread. And an orange. An occasional plate of soup. You don't need much when you don't work, they say. It's not true. After a full day of job hunting I feel more tired than after a day of chopping wood.

This morning I saw an ad telling that the Roxy Theatre was in need of ushers. I was there early but about twenty others were there already, standing by the door.

Williamsburg, Brooklyn, December 1949

They know New York. They were standing by the wall with newspapers under their arms, in their winter clothes—just like in the thirties' movies.

At ten o'clock the door opened and they let us in. Somewhere in the dim depths of the theater, I had no idea where, someone was playing organ. Loud, it filled the entire theater. They told us to line up in a half circle. A man, manager of sorts, stood in front of us and scrutinized us. The organ kept playing. The music was uplifting, large. Maybe Bach.

The man lifted his hand and pointed with the finger at several of us, asking to step out of the line. Seven, he said, he needed only seven. With a theatrical gesture, like an orchestra conductor, he motioned to the rest of us to leave the theater. Since the magic finger didn't stop on me, I walked out with the others.

To be more precise, what happened, really, was like this: As we stood there, in a circle, and as the manager's magic finger kept moving along the line, and was approaching me—suddenly, for no good reason at all, my nose itched and I scratched it. That was it, that was my fatal move. The goddamn nose. The manager's finger passed me.

The Warren Street employment agencies are swarming with people. Before Christmas everything's dried up. The agents are standing in the doors of their tiny offices, they don't even let you in: nothing to offer. They make hopeless gestures, explaining, sympathizing, even if only mechanically so.

I was looking at them. It's not fair to say that these people are mechanical, I thought. These agents, as they are going through their mechanical motions, as they are constantly being approached by new applicants, as they are battered by this sea of hungry, shabby, desperate

people—their mechanicality acquires slight human traces, they become subtly humanized. Even machines could grow hearts and eyes if constantly exposed to so much misery.

December 26, 1949

Never had such a miserable Christmas.

Walked out into the street. Couldn't stay home—too lonesome. The streets were empty and cold. Grand Street was empty and cold. The wind was blowing newspapers. There were patches of dry grass. Nobody spoke about snow. There was no snow.

We stopped at Ginkus' Candy Store. We said, maybe some live soul is there. But no. Only two or three women buying candles and Christmas wrappings.

But Ginkus was there.

"Looking for something?"

"No," we said, "we just got bored at home, came to see what's happening."

Ginkus, bless his heart, bought us a beer, and we drank to his health. The beer was cold, we sat and drank, and we looked into the mirrors behind the bar, and at the women, and the candy bars, bored.

The street was cold. We could hear fragments, bits of Christmas songs, from the radio, or maybe a record player, from some window across the street, brought our way by snatches of wind, somewhere in Brooklyn, at the very end of the world.

December 27, 1949

For two hours I ran around, through Williamsburg, trying to borrow some money. We have to eat, Christmas or no Christmas. We have to pay ten dollars for the room by today.

I gave up.

Depressed I walked along Grand Street.

In front of the Ginkus' store I bumped into a girl in a red coat. I recognized her, we came over on the same boat.

She stopped and asked how things were going. Bad, I said.

"Come with me," she said.

We went to her room and she lent me twelve dollars. Twelve dollars!

"I'll be paid on Thursday, so it's O.K., take it."

I took ten dollars to the landlord. So he says:

"My goodness, how tired you look. You must have toured the town, seen a lot, it's a great town."

No date, 1949

Dear Leo:

If you were a straight, average worker, I'd write you: Go to Australia, or Brazil, anywhere. Forget America, cross it out. Do you want to sit in employment agencies and look at all the people searching for work, clasping the ad pages? One work day is the same as a piece of gold, it means bread. With six or seven dollars one can survive for a week.

But there is no work. Markets are shrinking. China is gone. Things are getting "slow." It's better for those who have been here for many years. Even when they are out of work they get money from the unions. But for us, new immigrants, it's misery. So forget America and go to some other land where the economy is not based on export. Go to Australia.

That's what I'd say to a simple worker.

But you are a poet. So I say:

I HAD NOWHERE TO GO

Come to America! You'll experience the miseries of one great dream: capitalism. It's worth it. In Europe, somehow I always felt I was an exception, never like anyone else. I was either a D.P., a Lithuanian, or a poet. Here, suddenly, whether standing in lines, sitting in smoke-filled Warren Street employment agency rooms, or lost in the 42nd Street crowd, I am just another worker out of work. No different from anyone else. One in the crowd. One of many millions who, each evening, on returning home without a job, throws a jacket in the corner, collapses on the bed, and skips through the latest newspaper reading items about vacations in Florida...

January 5, 1950

From 7:30 to 5:00 PM I worked at Bebry Bedding Co., my new job. Directly from work, still covered with factory dirt, I took the subway to the 13th Street and Fifth Avenue, to see The *Blood of a Poet*. Before the show, in a luncheonette near the Fifth Avenue Cinema, I stopped for a hot dog. Everybody is staring at me, they think I am a bum.

I walked into the bookshop next door to the theater—a clean neat bookshop, old books. I felt like a surrealist intruder among these clean NYU students, books, girls, with my blue army D.P. jacket which I still wear. I haven't earned enough money yet to change my clothes.

Later I had a long walk through the downtown streets. I was reflecting, replaying all of last week. And the entire week, it seemed to me, was stretching now behind me, like a huge blank emptiness. I would prefer to simply cross it out of my life. The tower is falling, falling. I don't know when it will crash.

NEW YORK

No date, 1950

This morning the radio played Bach. I sat and listened as the great classic music filled my room. I wanted my life to be like this music, one great fugue.

That is the power of art.

Imitation of Art. Imitation of Christ.

No date, 1950

Now everything is clearing up for me.

The last two nights I slept all right. I haven't had a good sleep for so many years now; the last time I slept well was in that cool room of my childhood.

Still, yesterday I doubted everything. There was nothing stable, and I kept falling, falling, without crashing...

January 1950

Dear Vladas:

I still can't evaluate all the new experiences. Life's stream has been too swift, the changes too radical. It's all very raw. My eyes still linger on the images of last autumn in Europe as I looked at it through the windows of a rushing train.

After three months in America—I don't know America yet, and I can only write a few words about it.

First we worked in a restaurant (Adolfas), then in a plastic factory where I was swindled out of half of my salary. We have changed our apartment five times already. We have spent at least a month without any work, looking for one. We have already accrued more debts than we have earned in pay. I have seen thousands looking for work and not finding any. I sat with them on the benches reading *The New York Times* ad pages, bums

were lying next to me, right there, on the sidewalk, and a ceaseless stream of cars moved along the street not giving a damn about anything. Here it's like climbing up a ladder: people on the higher rung don't see the lower rung anymore, even if they stood on it as recently as yesterday.

We haven't found a dream here, not yet. To see the dream, you have to know the time and the place. It may happen at the sports stadium, or maybe at a night bar, in Times Square, or on some small Brooklyn street. You don't see it when you look for it. It's not for tourists. You see it only in the newspaper headlines and in the lines of poets. What we see is dirty and monotonous, and very very unextraordinary. It's in Europe that they chew gum. Here I see workers sitting, with blank faces, and with clumsy hands, as they turn the pages of the *Daily Mirror*. And they rush into the subways to go home.

February 22, 1950

Hail and wet snow fell into my face, and the wind was sharp. But it was good to walk like this, to feel the wind and snow on my face. I walked into a little luncheonette and ordered a cup of coffee. I looked at the wet window. I felt good. Then I walked out again onto Bedford Avenue. The snow was still falling.

I looked at the snow-covered church steeple. Suddenly I had a great desire to walk into the church. I walked in and knelt in a wooden pew. The priest was passing out the communion, marking foreheads with ashes. Ah, this must be Ash Wednesday. I am not very conscious of holy days.

I sat in the church for a long time. Now it was empty, everybody had done their duty and left. I stood on the church steps looking into the street. There was the street,

NEW YORK

and there was the snow, and the cars, and the wind, all very real. Williamsburg, Brooklyn, America.

I continued walking, and the snow and hail kept beating my face, but it didn't matter at all, neither the time, nor the wind, nor the cold. I was completely happy, and I walked, occasionally shoving the snow with my foot, feeling it, like a schoolboy.

I walked through the Brooklyn night.

No date, 1950

On Lorimer Street where we live now—a tree grows right in front of our house—we have board but no bread—our landlord has a very special way of torturing us.

Every morning, exactly at six, when we come down to wash our faces and shave, he sits there, in the corner of the kitchen in his brown sailor's sweater, leaning on the table, while we go about our business, and he talks to us all the time. It's always a monologue, we don't say a word.

"Ah, I know, it's so much better to come home from work than to go to work..."

"Ah, you'll have to work on Saturday too..."

All the time he talks about work, how hard it is to work, and how nice it is just to sit home. I get so angry sometimes I want to throw a shoe at him.

March 1950

"Was wir 'Illusionen' nennen, ist vielleicht eine seelische Tatsächlichkeit von überragender Bedeutung. Die Seele kümmert sich wahrscheinlich nicht um unsere Wirklichkeits-

307

*kategorien. Für sie in erster Linie scheint wirklich zu sein
was wirkt…"* * Carl Jung.

I hope some day to become more real… How could I
avoid it, living in this age of reality… How am I to last
long with my unreality? My hope is some day to walk, to
make at least one step on this earth and say: Ah, now
I really feel it, I am really walking the earth, and not
dreaming…

March 22, 1950

In the cafeteria, after I had finished eating, I stayed
a little while, watching the people. I felt good, life was
looking brighter. Without knowing it, I began to hum a
tune.

I was awakened from my daydream by the voice of a
man sitting at the table next to me.

"Singing?" he said.

"Yes," I said. "My belly is full, I am happy, why not
sing?"

"But your song doesn't sound like you're happy," the
man said.

I suddenly realized that I was, in fact, humming one
of the saddest folk songs I know, "Oi varge, varge, varge-
li mano," it goes, "Oh the misery, the misery of my life,
when will it end, when will it end…"

Hell, I said, those Lithuanian songs, they are always
so sad. There is always a tear in them. Even when you
think you're expressing your happiness, no, they aren't
happy songs even then. Lithuanians have always been in

* "What we call illusions is perhaps a reality of the soul of immense
 importance. The soul obviously does not care about our categories
 of reality. For the soul, in the first place, actuality is what produces
 an action."

the path of bigger neighbors, always trampled by them. Now, even our happiness has a different color, always tinted with a tear. Here I am, bursting with happiness, and this guy here sits and thinks: "I wonder why this man is crying, why he sings so sadly. A terrible thing must have happened to him…"

Yesterday we visited Professor P. He said, he had received a request to investigate the Mekas brothers: they must, most certainly, be communists. We told him that it made no difference to us any longer who says what, we got used to being called communists, crazies, and what not.

Walked home in rain. The streets wet, puddled.

Doing a lot of reading. Eisenstein.

Today at the Museum of Modem Art we saw four avant-garde films. I liked especially Dulac's *La souriante Madame Beudet.*

Joycian in its concentration.

Also saw *Ballet Mécanique*, *Entr'acte*, and *Ménilmontant.*

March 29, 1950

It's raining badly. We are working outside. Unloading iron slabs and coal from trucks.

In the afternoon, back to the machines, inside.

Carl is working on the machine next to me. An Estonian immigrant, a D.P.

He thinks. All the time. I can see it from his face. I watch his face all day long, and I can see how it changes, according to what he thinks. Sometimes he makes very funny expressions, with his face, his lips. He doesn't know it. He's too deep in his work, he's in a trance, like

me. Only that I am watching this movie, I mean, his face. He doesn't know I am watching him. When he's working, he sees nothing, he hears nothing.

Suddenly he begins to talk. My God, it's a talking movie.

"I am very curious if she is married by now or not."

"I don't know," I say. I don't know why I am taking him seriously.

"It would be stupid not to marry. Girls like her shouldn't wait long," he says.

I have no idea, he's talking about his fiancée, his daughter, or his neighbor. Anyway, she is in Estonia, and he's here, by this fucking machine.

Again he is silent, for a long time. Again he is chewing his lips, frowning, screwing up his eyes, thinking something. Then he speaks again:

"Hell, I am curious what she looks like now. What do you think, is she married or not?"

A stupid question. It's stupid even for an immigrant. But I have to say something.

"All my girlfriends got married long ago, I am sure. It would be damned stupid to wait for me to come back, gray hair, toothless," I say.

Again he is silent. A silent movie.

The favorite joke in the shop is to lock someone up in the bathroom and tie the door up. They split laughing. Very very funny. Dumbest joke possible. The one on the inside has to crawl out by the window, they won't untie the door.

Sometimes, they see someone go in, they come to the window and throw water on the poor victim. What's really annoying, they do it through the ceiling, right on the head, there is a hole in the ceiling.

It's that kind of place.

NEW YORK

April 1, 1950

The weather is getting warmer. During the day it rains. The nights are cool. On my way to work I need a scarf.

Whenever it rains, I go into a depression.

I keep asking: What's all this for? What's the point to my life here, doing what I'm doing? To live in order to work? This work produces nothing. It's like working in a forced labor camp, in Elmshorn. Time passes, week after week, and so it will keep on while I slave working in the factories, in machine shops, drinking copper dust, enveloped in an endless loneliness. And there won't be any British to liberate me either...

My writing? Why write if nobody's going to read it?

And when these thoughts crowd in on me, I sit down at the table, helpless, with my arms hanging down, or walk the streets. Everything's the same to me, nothing has any meaning. People are stupid gray, cynical, muddy. I see them run through the streets, rush past me, a huge blind muddy river of humanity. I look at the traces of sensuality and stupidity around their lips, eyes. Work. Bread. Sex. They have their world and they are O.K. This is their world, not mine. Definitely not! What price am I paying to become one of them? What am I betraying? Will I be able to hold up against it?

Today, however, I am at peace and I don't want to think about it at all.

No date, 1950

In a Lithuanian restaurant, on Union Street, in Williamsburg.

"He came after me, and gets served first..."

"I like him more."

"So you don't like me, eh?"

"What's it going to be today?"

"Cabbage, beets, spaghetti."

"And after that?"

"Tell me first, what soup?"

"I told you already."

"What do you mean? You told me nothing."

"Cabbage soup. Ay, one has to tell you and tell you and tell you."

"And after that?"

"After that? Hm, what do you call it…"

"How does it look?"

"With the dough on the outside, and meat inside, you know…"

"Dumplings?"

"Maybe I'll go and look. I will take a look. I have to see what it is."

He goes into the kitchen. Comes back.

"Dumplings, all right. Give me a lot of them. I am very hungry. Haven't eaten anything good since yesterday. You see how I respect your cooking? It's like a communion."

"Now, now. Just stop talking. I am bringing it to you. Sit down, stop walking around."

A SHORT STORY

There was a man who kept searching for a melody he thought he had heard somewhere long long ago.

Then—he found it.

It was only one note, one tone.

One tone, one note he had heard once:

it was his own brief cry in a dream.

Dear Mrs. S.:

Forgive me for not writing to you sooner. I received your letter some time ago, but could find no time to write.

We have been doing a lot of filming. You understand what that means, in our case, I don't have to give you long explanations. In Hollywood, it's much simpler: it's done with money. There are no problems there that money cannot solve. But we are trying to do it with our own last miserable pennies, in the few minutes we have available. Most of the people here think we are crazy. They say, cinema has made us mad. But today, if you don't want to sell yourself for money and work work work (for money money money) (I read not long ago, somewhere, Hoover said, "If you want to make money you cannot make anything else." Golden words.)—and if, in addition, you dream about being an artist—then the only way to do it is to become mad. No other way. So it's going very slowly. We tried to borrow money from some rich local Lithuanians. No. They stare at us and ask: "What do you want to buy? I'll lend you some money. Do you want to buy a house? A car?" "No," we say, "not a house and not a car. We want to make a film." "A film? A film? Hollywood makes films, they are made there, not here, you must be mad." And so, no money.

No date, 1950

Dear Mrs. S.:

Life is going on. Nothing new, but we are very busy. Factories, and our film obsessions.

We have joined a couple of experimental film clubs, just to find out more about what's going on and to meet people. We even screened some of our footage for them. Robert Flaherty, whose words mean much more to us

than anybody's in Hollywood, read our script and liked it enough to write a nice note. Money he can't give us: nobody wants to sponsor his own films these days, he says.

So much for cinema. What we are really craving most is snow. We promised to visit you when it snows. But snow is not coming. Every morning we run to the window—and it's rain! Smog, mist, rain—anything but snow. And when I look at the New York sky, I can never really fathom it. It's so theatrical, the sky of New York. It looks sometimes like snow-gray, like "it's coming, it's coming." But no, it's only the neon lights, it's only my confused eyeballs.

But I like New York, its sky and its theatricality, everything fits so perfectly in this city.

Adolfas is still working in the bed factory. The only difference is that now he is no longer just a worker: he has been promoted to foreman of the entire floor. As for myself, I am out of work again, since yesterday, and I am spending most of my time on Warren Street, where the employment agencies are. But I am usually lucky in finding jobs, because I don't care what they give me. I take anything. I am almost certain that by tomorrow I'll have another, and usually, very strange, job. You see, these are the privileges of not having a profession...

I am smiling at being reminded here of a recent remark by B. that some of our "artists have been forced to change professions." What is he talking about? How could an artist ever "change his profession" when he hasn't got one to begin with? To be a poet is not a profession: it's a madness. The charlatans can change their professions.

Anyway—my method here is to stay "on the run," from place to place, from job to job, and study life and people. To see more, to experience more. Without any plan I walk the streets of New York, among cars and

lights and crowds and noise. It is true that this job hunting business can really bring one down. But still I have this tremendous sense of freedom. I can leave my jobs whenever I want, or let them fire me—I have no fears that I may not find another job. I have become very adept at job hunting. Go and see the world, said my uncle. And I am doing just that.

April 20, 1950

I go for long night walk, in order to get out of the factory day.

I walk and I wander through the network of streets, neon lights and night crowds.

This woman on the corner, she was shouting at me: "Ay, why are you so sad?"

Lady of the night, you haven't seen me really sad. Right now I am in my happiest mood.

I continue walking. How could she really understand the depths of my sadness.

May 1, 1950

We went to the Metropolitan Museum, with Algis. We walked through the galleries as through a store. We were amazed how little we saw there that we needed. It's a Macy's. But we spent some time with Velázquez and Cézanne.

It's raining. We walked through the empty park kicking at squirrels.

We took the double-decker bus down Fifth Avenue to 42nd Street, checked what's playing in the movie houses, found nothing appealing, went home.

At the factory, the French guy comes to me today and says:

"How come you always look so dissatisfied with everything?"

"Well, why not?" I said. In truth, I was surprised by his question. I thought I was hiding my true feelings very well. "I am dissatisfied with everything," I said. "With the factory, with the way the world is going, and with the way my life is going right now."

So he says:

"Ah, you don't know yet the real dissatisfaction— dissatisfaction with your own wife. That is the worst of all. But now we are splitting. I'll have to pay her $2,500."

Saturday, finally, we got our own Bolex 16. Klybas lent us $200. Kavolis lent $20. Till now we have been using a rented one.

For three hours we stood watching the Loyalty Parade...

In primary school they used to tease me, they called me "the girl," because of my fragile physical state in those days. Girls used to ask me for help whenever they needed any, they identified with me. But I always thought, as the years pass, I'll become more "manly." But now I see that those traits of the "childish" and "girlish" are among my essential traits... It's a quality of sensitivity, of feeling. It has nothing to do with masculinity.

June 4, 1950

The week's depression is continuing.

I tried to read Pudovkin, but I had to drop him after 30 pages. I couldn't concentrate. Tried to read Mistral. Then worked on *Lost Lost Lost*, but dropped everything.

What for, what for? I keep asking.

Turned on the radio—the music is painful. Music has always been painful to me, it always tears me to pieces.

NEW YORK

Went to a restaurant, but left everything on the plate, had no appetite. I have no idea what's happening to me. I haven't eaten for two days. Something is sitting under my chest and doesn't let me swallow. Last month I lost five pounds. Which is very unusual with me. No matter how much I eat, or how little, my weight usually is the same, 154 pounds.

I left the restaurant. I could maybe kill an hour at Algis'. So I went. I found Adolfas there too. But Algis had gone to Manhattan, and Gisela, his sister, was busy with her boyfriend. So we both walked out and helplessly stood in the middle of the street, in the middle of Brooklyn, not knowing what to do next. Ah, maybe the earth will split and swallow us. Why, why aren't we just like all the other immigrants, why aren't we satisfied with their pleasures and joys? Here we stand, in the middle of Brooklyn, two souls out of place.

We took a subway into Manhattan. Gawking along 5th Avenue. Looked around, walked to Central Park. Hot. Crowds of people walking through the stinky bird pavilions, staring at animals. Benches full of old men and women with newspapers and books on their laps. With dead eyes they stare at the passersby.

I looked at these people and I was terrified. I asked myself: Do I really want to be like everybody else? Do I really want to belong to this kind of world? Here are the everybodies.

I can well imagine that this is not their first weekend sitting on these benches. They sit like this every Sunday, with the same boredom, the same newspapers, small talk.

We came home around 5 PM. We stopped at Algis' where we had left our raincoats. Algis' mother said:

"Are you planning to go somewhere? To see some nature?"

317

We went home. Worked on *Lost Lost Lost*. Read. Re-typed some manuscripts. Killing the day, waiting for it to come to an end.

MEMORY

Ah, the days of spring when the air begins to vibrate and the lumber piles against the barn wall begin to crack, in heat. White, it's so white when I stare at them, so white.

I am a little child sitting in the drying, spring yard, watching the white lumber stacks.

June 7, 1950

By the machine, in the factory, I have a lot of time to think. Or rather brood. There are days when the work is hard, and there is a lot of it; when you can't think at all, you have to concentrate on what you are doing. But mostly they put me on the bolt machine, the work is light and simple-minded, the hands work by themselves, automatically, and there is nothing to do for the head. So you think about everything, every little detail, you run through the entire day, then you start further away, dissolve in dreams, plans.

Today I am thinking about my own instability. My ups and downs. As far back as I can remember. I keep falling into these periods of depression, I walk for days alone, avoiding friends. Or if I happened to be among friends, I sit in a corner, silent.

My friend S. is writing me a letter, from France. "What the hell are you doing in America, in the country of steel, factories, business, and gangsters?" He, whose family and friends have been murdered or scattered to

the four winds by Europe. Stalin is Europe. Hitler is Europe.

How can I forget the many times we've been lost, totally lost among the monuments of Europe. We had the culture, museums, libraries, and volumes of poetry, but we felt at a total loss when staring at Stalinist and Nazi guns. I remember the night, just before leaving Vilnius, when I stood by the window, with Leonardas, and we listened to the steps of hundreds of Jews being led through the empty morning streets. They were being led to their graves. They chanted, as they walked.

Or when I watched, from a distance, a long long train—windows and doors nailed—moving across the landscape, towards the far reaches of Russia. Ten carloads of my neighbor farmers, my classmates, along with others I never knew. My classroom was half empty that morning. Yes, they were on that train. The political instructor took me aside, begged me "not to talk too loud," but she didn't have to tell us that...

A small group of us, students, we sat up that night, and we spoke about the art of Europe, its museums and its music, and how there was one only one thing we wanted: a more humane human being. To stop those carloads of farmers, and our classmates, children. To free those hundreds of people. To interrupt those steps in the early morning.

I remember it all now again, when I listen to my friends, criticizing America. "Oh, America is terrible. We, Europeans, we are human, we are great. America is only steel and iron and glass. And maybe money."

Yes, there is the music and there are the books of poetry. And the poets are always right. They keep reminding us of the best in us. But the books, the culture, the music is one thing, and you, my dear friends, you are another thing... You don't listen to what the books &

music & art tell you... You just go and mess up the world. Yes, yes, you do. You do your own thing.

Hitler and Beethoven. Hitler liked Beethoven...

Maybe he really did. But try to imagine how much worse he would have been without Beethoven!

Dear friends: Haven't we learned anything? I don't mean to say that America is very human. I haven't seen America enough to say anything about that. All I want to say is this: I prefer a human being in love with steel than a Nazi with a flower in his lapel. Or Stalin, walking in a flower garden, as I saw him in a recent Soviet movie.

Man didn't fall away from God: man fell away, is falling away from man.

They say, there are no nights in New York, it's all illumination, neon lights... But, ah! I have seen beautiful nights here...

Humanity went through periods of being nomads and settlers. They have retained these characteristics even today. Myself, for instance, in many areas such as religion, ideas and my life style, I am a nomad. While most of the people around me are settlers, in all three areas.

The smell of wet moss... Say it, break it down into units of space. "Smelling flowers in Alley Park." Their smell dissolved, spread into invisible spaces, vanished in the inner orbits with all their tiny satellites.

Sometimes by chance you touch a tone, a note—and everything reverberates through all the spaces with incredible nuances.

As Dostoyevsky said, we are alive in the glimpses, seconds, when souls really speak, really meet, really see.

NEW YORK

July 18, 1950

I was walking today and thinking: how did I grow up like this? Why should I feel that I can live without any of these people? I do not need them at all. I don't like these people nor their lives. I much prefer looking at the paintings of Van Gogh...

At the same time, it hurts very much not to have anybody here that I could really talk with, except two or three old friends. Leo, Algis, Adolfas—we have nothing to say to each other anymore, we sit silent now, like three mountains, we have said everything to each other.

So I go out into the streets, hoping for grace.

It's hard. It's painful to walk alone.

Yesterday, I sat all evening on the front steps looking out at the street, watching distant harbor lights, pink evening clouds, the dirty front yard. I was drinking in the evening, trying to kill the wrenching pain. I knew, this was an average, dirty neighborhood. It had nothing to do with what life really is. But I had a craving for some kind of life. Like having a cup of muddy coffee in a dingy luncheonette.

It seemed to me that my loneliness emanated from every object, from the sky, from black dirty roofs, paper scraps in the street.

I could walk and walk along these streets, along the river shore, aimlessly and senselessly—as I had done so many evenings here—being just myself and the city. No thirst satisfied, the loneliness the same.

But tonight, this evening I didn't feel like doing it again. I just sat and stared, without really wanting to see anything. To be staring, that's O.K. A frozen pain. I didn't want to think any thoughts.

10. WORKING ONE'S WAY THROUGH BROOKLYN

Walking, walking. Maspeth, Leo's ramblings. Working in a boiler shop. The author's life falls to pieces again but he picks it up once more. Europe vs. America... Wanderings... Visits to Stony Brook...Anxieties...Facing the changes of life's direction.

No date, 1950

Dear Friends:

New York will be in its stinkiest self soon. The last snow has melted, the weather has warmed up very suddenly, all the garbage cans and backyard dirt piles are beginning to warm up and reek. In Brooklyn, where I live, they say that in the summer it takes your breath away... Dirt everywhere, the stench incredible—especially for a nose used to the meadows of Semeniškiai! I am afraid to go out. I can't understand where these terrible smells come from. Times Square, locked in by tall buildings, never gets any clear draft. You walk there and you feel like you are in a smoky bar where they have been drinking and pissing all night.

My life in the factory?

The dressing room. On the floor dirty newspapers stepped on by many feet. Shoes lie scattered along the walls; clothes hang from hooks, blue work pants, jeans, shirts. One after another the men come in, change their pants and shirts, and still sleepy-eyed search out their work shoes under the benches, cursing and mumbling. Then, slowly, and in no hurry, as if on their way to some place they really hate, they climb down the steps into the factory itself and sit down on piles of steel, maybe light up a cigarette, as they wait for the morning whistle.

Bebry Bedding Corp... Home furniture: sofas, beds, Castro convertible beds. Beds with mattresses and beds without. Cheap, will deliver. Bebry. We make the beds and sofas.

I am looking at these men, changing now. I see their hairy chests, legs. Yes, now they are all alike: workers. Nakedness makes them all really equal. No, they never went to universities, they didn't devour books, I know. Carl finished Law, a lawyer. A lawyer from Estonia is the same as the other workers here. His legs, his chest don't show any difference, neither do his muscles. Just another worker.

Today my job is to move the steel slabs. I drag them in from the yard, puffing, but happy for the chance to get a glimpse of the outside.

A SHORT STORY

Three brothers agreed to sign a contract with the devil. But they had no skin on which to write the contract.

So they killed a calf and used its skin to make the contract for the pot of gold, they signed it with their own blood.

But they didn't know how to prepare the skin properly: they didn't have the craft anymore. So in two months it began to reek and worms ate it up. The devil, was mad. The contract was gone.

No date, 1950

No, there never was an age of arts. Whistler says so too. In any given age there are only a few great, individual artists.

Pope Julius paid Michelangelo with his own monies. The cardinals wouldn't authorize Michelangelo any.

WORKING ONE'S WAY THROUGH B.

A SHORT STORY

The secret that the alchemists came to, finally, after centuries of trial and error was that in order for the gold to transmute, after everything's been done, you have to throw yourself, your own self into it.

One thing: the cow didn't know how to spit. That was frustrating.

July 26, 1950

Went to Central Park.

Walked to where they rent out the boats. All boats were out. The pond thick with people.

For a while I stood watching a Scotchman playing bagpipes. I thought he was playing just for himself, but on coming closer I saw a crowd of people standing and watching, and his friend was collecting money in a cup. The Scotchman was playing with his back to the people, facing the bush. His friend was trying to explain to one elderly woman whose face was all painted up, he was telling her something about the bag pipes. I couldn't really understand why the Scotchman was playing with his back to them. Maybe the melody made him remember something sad? Or maybe he didn't want to see all those stupid faces? He played with his back to the crowd, looking past the branching bush into a green valley...

For a while I stood by the pond where children were wading through muddy, polluted water, "fishing," with sticks, string, and nail, a piece of ham at the end. I was wondering how they could ever find a living thing in such dead waters, but they were fishing very seriously. There also was a duck with a circle of ducklings, all very yellow, and two children were throwing crumbs of bread at them and they were determined to touch them. The ducks took the crumbs but didn't get fooled.

On the rocks lay teenagers and elderly men, some with their shirts off. I tried to imagine myself, in their place, lying on my back, looking at the sky. But those days are far behind when I used to lie on my back in fragrant meadows and follow the changing shapes of clouds and how they move with the wind. Now I look at the sky, but my thoughts are off somewhere else.

I stood and watched the children and, in a way, I envied them. I envied them their peace, their games, their belonging here. Ah, yes, here is the key to the happiness: be like everybody else, live like everybody else, love like everybody else, think, behave, eat, and, in the end, die like everybody else. But there is one little trick to all of this: you have to be born here, you must first feel at home here...

No date, *1950*

Stony Brook Lodge.

About twenty people inside. All middle-aged. It was a baptismal party, and the father wanted everybody to be happy. With long comic ceremonies he introduced the newly arrived guests, talking generous nonsense. But silence took over again and again.

They all sat each in their own corner. Occasionally, a sentence came from one corner, then again silence.

The room was large and full of light. I was looking out the window. I didn't look at the people now. For a while I paged through a pile of journals lying on the tea table. Then I moved close to the radio, and began searching for something to listen to, running through all the stations back and forth. Occasionally I'd laugh at one of the funnier lines I overheard. Then I gazed through the window again, towards the shore line dotted with little houses. Soon I was totally absorbed in the window reality. The room, the people, they were outside the frame.

WORKING ONE'S WAY THROUGH B.

The father began reorganizing the room. The meal was being brought in.

I left the window and took a seat at the table.

Then, four of us—Vida, Nele, Nijolė and I—we followed a path in the woods singing and laughing. We walked far, and the evening was cool. Ah, escape.

When we returned, it was dark, and we stood outside by the window. Through the window we could see the same men and women, very mannered, just as before. We didn't want to go back, so we sat on the porch and looked at the bay.

Ah, what peace," said Nele.

Yes, inside, there, they were peaceful too. They were very very serious. Journalists, politicians, painters, poets, doctors… Fragments of their world reached my ears.

August 6, 1950

Not a day goes by that someone wouldn't remark, either joking or serious: It's high time you get yourself a woman. You should have a wife. Someone to take care of you. Now, you walk around hungry.

Hell, I never thought that I should marry for such miserable reasons—just to have someone feed me or fix my bed. My daily needs are so ascetic.

Took a boat up the Hudson.

On the upper deck a group of teenagers sat and sang, accompanied by two guitars. Somebody beat a bongo drum. On the lower level, downstairs, a piano played and was very crowded. People danced, drank beer and whiskey, and the piano player, and everybody was very exuberant, in shirtsleeves, the girls in swimsuits. I stood leaning against the rail, on the steps leading down, and watched them. They danced, and the dances were unfamiliar to me, American and Latin dances.

Yes, this was life. They lived—I thought. They pushed each other, and it was crowded, very crowded, and they kept excusing themselves, and they danced and hummed tunes and words I didn't know. A few pairs sat under the stairs. I don't know whether they were lovers or had met here just a few minutes before, but they were very close, the girl didn't pay any attention to the people around and was in a trance of kissing and I was the invisible observer of all of this. What could I be but a voyeur. A Displaced Person as Voyeur. Immigrant as Voyeur. A good title for my life, right now. That's all I could be, with my shy old world upbringing, here, in this open scene. But this was life, the real life of people with real roots. So there they were, locked in a long lingering kiss, and a second couple, seated nearby, watched them, and then they kissed too. The young man wore a striped shirt, and on his chest it said DODGERS; he was about eighteen. The girl wore a white swimsuit.

For a long time now I have had this fearful thought, I was afraid that all my Lithuanian childhood memories, the European memories wouldn't permit new memories to take root anymore. But now I know that I can get equally attached to new experiences, new places, new moods.

Am I a Gypsy, a citizen of the world, an eternal D.P.? I am collecting without much discrimination and drawing it all into myself from everywhere—no matter where I am—unlike some other Lithuanians I know here. If anyone should try to separate me now from New York, I know it would leave an open wound, or at least a scar—like all the other separations did.

August 1950

I walked home from work on foot. Step after step, slowly. I have a lot of time. I chose a different and longer

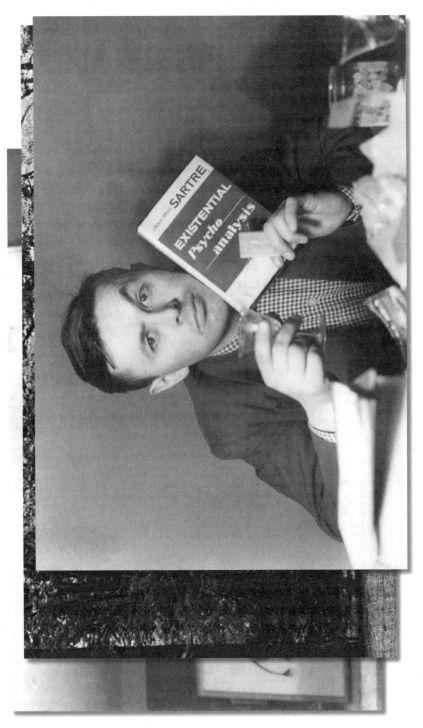

Leonas Lėtas, Maspeth, 1950

route that took me to the river, and I walked along it, as far as I could.

I walked and looked and thought. I watched the ships, and piers, and coal piles on the banks. And I thought what I saw was strangely and uniquely beautiful. And as I walked further, I crossed a large open area overgrown with tall grasses and flowers, yes, flowers, and I looked at them with great amazement and surprise, like meeting an old friend in a place one doesn't expect, and after many many years. I looked at the yellow strings of blossoms hanging luxuriously down from long sturdy stems.

There were also patches of wild chamomile. I was amazed by their whiteness, in all this grayness. And others, so tiny and fragile a blue and were they sweet. I suddenly felt very good. The whole evening was so beautiful and good. The red disk of sun, and the flowers, I took it all home with me and I held all before my eyes until I fell asleep.

When I arrived home, Leo was writing a letter to his wife. On the table in front of him, I noticed, lay a bunch of white flowers. He said, he'll put them in with the letter. He looked at me, when he saw me coming home with a few blue flowers in my hand, all collapsed by now, and we both laughed. Sentimentalists.

August 1950

I now understand why Rilke used to run away from every place, every town, every woman. Whenever he used to begin to feel that they were becoming too close, too inseparable, he used to run away, so he could be alone again, just with himself. He lived with one hundred separations. He could do that, because he had one woman to whom he always could run to, in his desperations. A woman who, later, many years later, became his wife.

WORKING ONE'S WAY THROUGH B.

But my woman, that woman, is Lithuania. The only thing is, I cannot run to her except in my dreams. My loneliness is huge, painful, and hopeless.

September 3, 1950

Maspeth.

I am alone in this big house. Ah, sometimes it's good to taste the loneliness, not only when you are alone in the crowd, but also when you are really really alone, like I am now, in this empty house, which we rent now, with Leo and Adolfas, and a young Lithuanian couple, in Maspeth. Every room is empty, every floor. Everybody has left, gone to the movies.

Leo was the last to leave. He paced and paced in his room, for a very long time. He packed up all his books into a suitcase, locked the suitcase—I have no idea why— then walked out into the street.

"Going for a walk?"

"No—to live."

"Yeah?"

"Don't lock the door. If anybody comes, tell them the owners will be back after seven..."

I was alone.

I began walking from one room to another, I walked through all the rooms. Just to really feel the aloneness, the fact that every room was really really empty.

In the morning with Adolfas we went to the Lithuanian church. It was raining. We stood under umbrellas and nobody seemed to rush home. We stood in the rain talking, exchanging news. These are mostly new immigrants, D.P.'s. There were three pairs of newlyweds, they ran out through the rain and into the waiting cars and zoomed off.

I HAD NOWHERE TO GO

For an hour I sat at the Ginkus Candy Store drinking beer and Mazalaite came and we gossiped about this and that. Then Adolfas came with Algis and Bagdziunas and they bought ices for everybody and left for the movies.

I went home and here I am, sitting alone now and writing.

At Ginkus', Augustinas was sitting and drinking beer. I said, what's up, and he said, I think I am in love. So what are you doing here, I said. And he said, "I am going," and he left.

Then a man walked in. Gabe is his name, he said. Came from fishing. "Did you catch any?" "Ah, no, none, the rain started pouring, went home."

I left Ginkus' and stopped at the Tautininkai Club, on Union Street. I found Augustinas there nursing a beer, alone by himself, with a chess board in front of him, playing against himself.

A SHORT STORY

They sit, the three of them, in one room, silently. Each one knows that the other one is thinking and is watching and is seeing him through and through and truly. So they sit like mountains, silently. They have chewed and cut their teeth on life and now only silence is left.

September 5, 1950

GRAND INQUISITOR

Leo: "Whatever I do, is failing, failing... Humanity is going in a blind direction, from inertia... But it won't admit it. But I am saying openly: I lost it. I lost the game. No, I didn't lose against myself: I am perfectly O.K., myself."

Adolfas: "So you lost against whom?"

Leo: "I lost against the world. In a certain sense I lost my hands and my legs. I see it, but I am helpless to do anything about it."

Adolfas: "Just tell it. Tell it to them."

Leo: "They will think I am an idiot."

Adolfas: "Maybe they'll say, bravo! bravo! Why didn't you tell us that sooner?"

Leo: "For instance, if I had spoken about it to you…"

Jonas: "Don't speak to us about it. We all have our little horses. Speak to simple people."

Leo: "I'd only do harm to myself by doing so."

Adolfas: "Are you sure that what you want to tell them you can put in understandable language?"

Leo: "I am sure."

Adolfas: "I haven't noticed that kind of talent in you."

Leo: "I can't or I don't know how?"

Adolfas: "You don't know how. But I don't know your capabilities."

Leo: "Till now, nobody has challenged me to talk. But now maybe some will. Once you go through this sickness, you don't have to go through it again. And then—you can't act by yourself; you need an audience, or a partner. Now it's all a soliloquy—not much use of that."

Adolfas: "Soliloquy is an entire category of drama. It can go for an entire evening, with climaxes, resolutions, many climaxes."

Leo: "The reactions to it will be the same. Ah, we are only a miserable drop in literature, true."

Adolfas: "Ah, we are talking every evening the same and the same."

Jonas: "But differently."

Leo: "I don't blame you that you want to speak now through cinema: but you shouldn't blame me if I am going to choose silence from now on. A new circle…"

I HAD NOWHERE TO GO

Adolfas: "Right now we are writers, we aren't film-makers yet."

Leo: "It took us two years to do what we did in literature. But now we need silence, like Rilke before the *Duino Elegies*. Ten years. But Jonas writes and files under the pillow, doesn't publish. It's the same.

"It's a big miracle, everything that is man. The cosmos, and everything is the same. Einstein lived just for himself. I begin to shatter now, piece by piece, not all at once. I look at my early writings and I can't believe I wrote it. But I also see my limits, where I end. Yes, there was some pose and acting, too, but…

"Yesterday, I took this young lady home, and you know what colors I saw in her—colors that I like and which you can find only in living people. Colors, nuances that come out like water, by themselves, they sprout, they spurt out. But we, we absorbed so many such color streams, from people and from Einstein and Valéry, that very often we disconnected our own lives—we… I remember, as a child, I opened the Bible, and it said: Those who search will find…

"Eh, you can understand me… But the essence—that can only be felt. Books—I can write ten of them. But it will be only a photograph through my eyes."

Adolfas: "But one can feel it…"

Leo: "Feel the chronicle, but not the life. Ah, I said to Žibuntas, brother, now there is so much written, that anyone who is searching, will find…

"Ah, Christ lived with all his atoms. We should be even more so…

"Loneliness? The Bible says, two will be one in body, but the soul will be with God…

"Ah, who will wake up the sleeping princess…"

Jonas: "When the accumulation will reach the proper intensity, it will come out in thunder…"

334

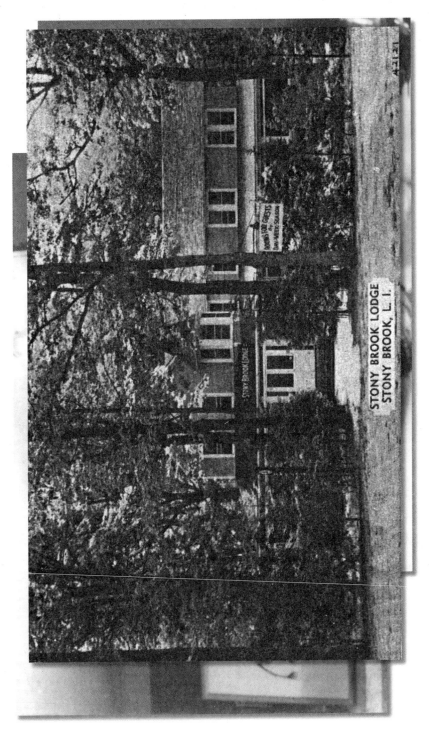

STONY BROOK LODGE
STONY BROOK, L. I.

Stony Brook, N.Y.

Leo: "What do the volumes mean? Hemingway, it would have been enough one Kilimanjaro story, that's all. Film? It has no future, you can laugh at me."

Jonas: "Nothing has a future."

Leo: "Film is intellectualism, looking from outside."

Adolfas: "Some day, everything will be wiped out, not only the people."

Leo: "The world is not so easy to wipe out."

Adolfas: "Film to me is equal to anything else."

Leo: "It's exposed to the same crises, though."

Jonas: "Intellectualism in cinema will have its own crises."

Leo: "What have you seen that you liked?"

Jonas: "Dulac."

Leo: "But how many are there who will understand her?"

Adolfas: "Angels in heavens will."

Leo: "When we want to shoot down the plane, we don't shoot at the plane, we shoot slightly ahead of it, we figure it out... Same with human life—we have to know where the world will be at the next moment—to know where you want the bullet to hit... But in cinema..."

Adolfas: "Same with poetry."

Leo: "Do people read much poetry? I hope people will grow up and won't look at painted pictures; instead, they'll live."

Adolfas: "Don't worry: they live. It's you who do not."

Leo: "Are there many films suitable for all, from 1 to 100?"

Adolfas: "Same as with books, paintings. They see Van Gogh, or, still better, Klee, and they say: Ah, what beautiful doodles. And sculpture, Brâncuşi: they don't even look at him."

Leo: "But my thoughts are such I always want to be silent."

Adolfas: "No, don't. Talk."

Leo: "I don't want to ruin my nerves."

Adolfas: "You don't ruin my nerves, no."

Leo: "Ah, we have eaten too many devils, all of us. One stands up and walks out, and the other thinks: Ah, devil, maybe he found something... Ah, the forbidden fruit, always."

Jonas: "But the guy is only going to the toilet..."

Adolfas: "Why don't we go to bed."

Leo: "And I say, I can't. I can—but it's not serious."

(Leo goes to the piano, stands, then sits down, improvises. Adolfas goes into the kitchen, opens the ice box, gets some juice.)

September 11, 1950

We sat, today—talked and talked, Adolfas, Leo—and we dramatically concluded we had come to a dead end. We declared our own bankruptcy. We thought it was strange, almost funny, that at our age, at the age of twenty five and some, we had reached the end and it wasn't clear any longer which way to go from now on, or what living meant if it meant anything at all. At best, it was a miserable compromise. Or was it just a draw? No, we didn't have to wait to reach 40 to enter the dimmest thicket of the woods.

We now thought that up to this moment, this Thursday evening, we had lived our lives right and had nothing to regret. That much was clear to us. But now, the new environment, the life around us had begun to thicken, to press against us like a wall. To live our lives justly, correctly and intensely, we really couldn't see, suddenly, how we could do it without drastic corrections in our directions. Out of the woods!

Krach. Finita. Total breakdown. Everything has to be changed. The Big Crash. The Big Knife. Maybe one more step along the old road, but that's about all. Good-bye, good-bye Europe... Now we are entering the unknown, at the open sea called America... The moment of another separation is here.

September 12, 1950

Stony Brook. I am sitting in a chair watching the rain and it's all the same, now. The rain is real. From the inside onto the porch and onto the woods the radio carries the sounds and culture of the city.

September 25, 1950

Yesterday, Alina assaulted me with many questions. Because of her questioning, I came to realize the immense changes I have been going through during the last few months. I have changed, my thinking is changing. Just a few months ago I'd have agreed with everything that Alina said, I was so sure of everything. I had firm opinions, very firm, on everything. As firm as Europe... Now, everything has broken to pieces, opinions have fallen, everything is new. I am again ignorant. When I listen now to conversations, or read the papers, I am amazed with what confidence and assurance everybody is speaking about everything. Man, soul, God, cosmos. It would seem, from listening to them, that they have it all at their finger tips. They can touch it, measure it, photograph it, weigh it. They give the impression that everything has reached its end, nothing new will ever happen. Are we in Hell?

I preferred not to respond to most of Alina's questions. I had no answers. There is no school of philosophy which I can claim; no direction in art I can cling blindly to. My ideals? I don't know what they are any more.

WORKING ONE'S WAY THROUGH B.

No date, 1950

For the last three weeks I've been working at the Cupro Metal Corp., in Corona, Queens.

"Bring the wires downstairs."

"These are to be topped."

"*Merci.*"

"Are you French?"

"No."

"Do you like French girls? You know, French girls make like this..."

He puts his finger in the mouth and sucks it.

"Oh, man!"

The sound of the drill next to me drowns suddenly all the other sounds. A high, shrill, powerful drill sound that seems to go into every cell of the body, making every drop of blood vibrate, shaking every corner of my brain.

IF ONLY ONE METER IS USED connect black wire to red wire and blue wire to white wire. Install one twin conductor N.12 cable to fuse block. IF SEPARATE METERS ARE USED install two twin conductor N.12 cables, one for red wire and white wire to the "off peak" meter. IF TIME SWITCH IS USED install jumper connecting terminals "A" and "B" on top thermostat. Fuck you. Fuck you.

September 27, 1950

Today I am working outside. Making crates. Wooden crates. Pine wood, good for the nose.

We took two truckloads of boilers to the railroad station. It's a special privilege, to be working on trucks. Better than drilling boilers or stuffing them for shipping with the goddamn itchy fiber glass stuff.

Jim, my black co-worker, helps me nail the crates, and we both load the truck. Jim is the driver.

We pass La Guardia airport. We turn the truck radio on as loud as we can and we go. Sometimes we stop for coffee. No rush. Once you leave the shop, there is no more rush. Nobody can see us. Usually I sit on top of the truck, on the boilers, and I sing at the top of my voice. I sing in Lithuanian.

"Are you married?" asks Jim.

"No."

"Why not?"

"I have plenty of time."

"It's time, it's time. You have a girl?"

"Oh, yes, I have." (I don't, actually, but I figure it's better to say I do.)

"Is she nice?"

"Terrific."

"That's good. You blow tonight?"

"Yes sirreee." (I am thinking: What does he mean by "blow"?)

"Fine blowing in the United States?"

"Good like Nedick's," I say. (I am thinking: Does "blowing" mean farting or fucking? But I don't reveal my confusion.)

We unload the crates into a transport car. We do it slowly—my black partner doesn't like to hurry, and I follow him.

Right now he is smoking. Smoke break.

"John," (they always call me John here) "you drink whiskey?"

"No. But I drink a lot of beer."

"Beer is good, it makes you blow. How many times you blow in one night?"

"Hell, I don't count."

Silence. He smokes. Then:

"Do you like this job?"

"It's O.K."

"Fuck this kind of work. I like cooking. You cook at home?"

"Sometimes."

September 1950

My job is to clean the boiler holes and screw in the nozzles. My hands are black from tar. The worst part is that you come in the morning and you find all the boilers lined up for insulation, left for us by the night shift. We hate this part of work, we hate working with the glassy, deadly insulation stuff. We work with gloves, but even so, no place is safe from the glassy dust. You keep scratching yourself. For weeks I didn't understand where that itching was coming from but yesterday my black co-worker explained it to me:

"It's the fogging insulator, John, it's the fogging insulator. It can kill you. Don't breath it in, the fogging stuff."

October 1, 1950

Last night I paid a visit to Dana. Her cousin came, we started arguing. It all started when he mentioned the army. I opened my mouth. I said, I didn't want to fight for any existing government system. That started it all. For three hours they kept chopping me. As the conversation progressed, it became clear to me on how many matters I had no opinions at all.

"Why did you come to America if you don't want to fight for it? You had to make up your mind about it, before coming here, no?"

"I came here by chance," I said. "Pure chance. I made no decisions one way or the other. Circumstances of war. If not for the war, I'd be in Lithuania."

"But you chose America."

"Somebody in Chicago made up the papers. The United Nations Refugee Organization paid for the boat. They wanted me to go to Chicago, to become a baker. Hacket's Bakery. But I saw the lights of New York and was seduced by them. Fuck the bakery. So it's all chance. Then, there was the curiosity. A curiosity has nothing to do with making up your mind. I was curious about America, I have to admit it."

"I find it all very childish. We all came here after making up our minds, seriously. We had made up our minds to become citizens of this country. We were running from communism."

"Not me. I ran from the armies of war. I ran from all the war and postwar confusion where lives do not count. I don't like confusion. I ran from a sense of self-preservation. It's not a political act: it's an animal act."

"But America doesn't need people who want to use its good life and do not want to defend it."

"I may decide to defend it when I get to know it better. Right now I don't know America. But I still support it by paying taxes, like you. And I am not even a citizen yet!"

"But you have your first papers?"

"No. I don't."

"So what are you going to do?"

"I am not thinking about it. I don't want to be a citizen of any country. I am a Lithuanian."

"Nobody nowhere is going to keep you like this."

"We'll find it out. There are all kinds of people in the world. The world needs all kinds."

"If you don't want to fight for the democracy, go back to Soviet Lithuania."

"I want to study America first."

"I know many people in Europe, many refugees who really wanted to come to America, and they couldn't. Yet

you are here. And you don't even appreciate it. What a shame."

"Sorry about that. I wish others could have come instead of me. Really sorry. One place I really wanted to go, was Israel..."

"What?"

"I wanted to go to Israel. Seriously. But they said they had no quota for Lithuanians. So we applied to Egypt. They rejected us for the same reasons. So we signed up to work on a boat that was cruising between Sydney and Le Havre. While we were waiting to be called up, this man sends us these papers, to come to Chicago... I am very curious how strongly you yourselves made up your minds to come here?"

"I was serious about coming here. All of us were. All except you."

"I am not so sure I can believe you. I am not sure you really knew what you wanted. A person is too complicated a being to come to such precise decisions."

"Serious people make precise decisions. But you are living like a child. You aren't going to tell me that you left Lithuania without making serious decisions."

"I wouldn't necessarily call them serious. Those were desperate decisions. A sense of survival, a sense of self-preservation led me out into the West. And then, there was my uncle who said, I should see the world. Go and see the world, he said. I was going to study while the world was trying to figure out which country belonged to whom. Athens used to be the world, then Rome, then places like Florence, and Paris. And today it's New York."

"And what is your aim in life now?"

"None. Absolutely none. I am still studying the world, as my uncle so wisely advised me."

"How can you live like that? You should learn some kind of profession."

"But I don't like any of the professions."

"It's not important, to like it. The profession will make life easier."

"My life is easy and I have no profession. My needs are zero. I work for a month, and then I live three months without any work, as long as the money lasts."

"You'll end up a bum."

"If, according to you, a bum is a man who is content living on a minimum, with a minimum of property, minimum of exploitation of others, and minimum of exploitation of this planet—then I am a minimalist and the bums are my true friends."

No date, 1950

Leo is climbing upstairs. Towel on his neck. He is singing in the bathroom right now. In the upstairs living room—radio music.

Later, in the kitchen:

Leo: "See, I washed out the plate, I put it on the table—and it fell to pieces."

Ignas: "Bad luck. It will cost you ten dollars."

Leo: "Only ten dollars? Can I break a few more at that price?"

Ignas: "Stop! Stop! He's crazy. He says ten dollars is nothing. He'll break all my plates. What am I going to do then."

Leo: "You are right."

Ignas: "If one is married, even if one's crazy, they take him for a sound, normal man."

Leo: "I am running right now, I am marrying."

Ignas: "After twenty-five, even if you aren't married, you are taken as a serious man."

Leo: "In that case, I am O.K. as I am."

WORKING ONE'S WAY THROUGH B.

No date, 1950

He has time to contemplate the pebbles, and what about you ... always in a hurry...

Humanity is playing with toys that aren't for them, not yet...

Modernism? Our deliverance is in conservatism.

They'll go to the moon. Then, they'll return home to earth and will be happy to find earth again, happy like children.

I plowed the fields, and I was happy without cinema. What does the city give to a farmer? Money? A nail? A bicycle? A handkerchief?

Whatever the past was, I admit, it was not much... But we have fallen below even that...

Three women are sitting in the waiting room and very lyrically they talk about Lithuania. We—the three of us—we still have our books, culture, etc. But they have lost everything.

October 3, 1950

I am looking at my fingers. They look strange.

For last five minutes I have been studying them. I have been trying to write with a pencil. But my fingers do not really grasp the pencil properly. Not like they used to a year ago. From working in the factories, my fingers became stiff, they don't bend, they have lost the subtlety of movement. There are muscles in them I haven't seen before. They look fatter. Anyway, I can't hold the pencil, they are clumsy. So I go to the typewriter and begin typing, with one finger.

My co-workers are all from Brooklyn. Simple workers. Very poor people. They all have the lowest paid jobs. They all have crowds of children. Bruno, an Italian, asked

me yesterday if I'll be working on Saturday. Hell, no, I said, I won't work on Saturday. He said, he will work, he has ten—believe it or not—ten children. He said it like nothing, like a simplest thing: ten children.

When they talk, every other word is "fuck you." It's not a curse word. It's a mood note, just a sound, a sound with a million different nuances. A nuance for each occasion. With that one little expression, fuck you, one can express absolutely everything, every little thing that takes place in the factory. Or even more complex concepts and notions. Have you a girl? Fuck you. Help me here, fuck you. Twelve o'clock, fuck you. The drill broke, fuck you. What do you think about Stalin? Fuck you. See you tomorrow. Fuck you.

Yesterday all day we were working on the truck. We made five trips to the railroad station, fuck you. Hot, fuck you. Sweating like pigs, fuck you. The bags are slippery, the glass stuffing sharp, our hands are cut to pieces. In the middle of the street, in Queens, the bags started falling off the truck. We stopped the truck, to collect the fucking bags. We decide to leave some bags on the street, we just can't fit them all on the truck. They leave me to guard them. You, fuck you, you sit here and watch the fucking bags, and we'll go to the fucking station. Sit and watch the girls, fuck you. But they don't rush to the station, no. They keep fussing around the truck, looking at girls.

They settle in against one side of the truck and start eating bananas, throwing the peels right there on the road, hoping that someone would step on them and break their neck.

October 13, 1950

I stopped at a cafeteria. Strange to hold a fork or knife. My hands are used only to the heavy steel slabs.

When I pick up a fork, I can't even feel it in my hand, it's weightless, I have to actually look at it to see if I am really holding it.

When he was looking at himself, he could see many new colors. Colors that he didn't know before coming to America.

These people, here, these people are the blood of this city, they fill the gigantic capillaries of this city.

"I only have to learn to read it," he thought, as he walked.

He looked at the Palisades, at the lights, and he thought it was a huge metaphor. But he couldn't fully grasp its meaning. But it was there for him to read.

He knew that during the next five days he would get angry again about it all. But this was still Sunday.

October 18, 1950

I stood in front of the Latin Quarter, and crowds were pushing around the entrance. Broadway was one big river of humanity. Men, women, sad teenagers, long lonely eyes following the passing girls. Pale neurotic types with their eyes locked on the five-cent nudie movies in the pokerinos.

2 AM it was the hour for "taking you home," "going home," and the teenagers and sailors walked arm in arm with their "women," and the women giggled. At 2 AM in the morning, it seemed, to me, one of the lonely souls, that everybody was walking in pairs, and every smart woman had found her man, and any man worth his pants had managed to hook up with a woman… Only the poets are free…

At 3 AM in Times Square, I was supposed to meet Léo and Adolfas. I crossed it left and right, I looked all around for them, in the heart of Times Square. They

weren't there. They told me later, they got so bored they went home and were snoring by midnight.

For an hour I stuck around. Drank some beer, ate a piece of pizza. Then I took the subway homewards.

At 4 AM in the subways I was alone with old men, cripples, and teenagers taking their girlfriends home. They were sleepy, yawning, tired. At Queens Plaza, there were three young couples sitting on the sidewalk, waiting for the Ridgewood bus. The bus didn't come for an hour, and the teenagers sat with their girls on the sidewalk, and they were very tired, and the fun of the evening, the excitement of being together had already faded. What remained now was tiredness, and the wish to get home as fast as possible. But they knew they still had to take their girls home, and only then would they go on to their own destinations, in the far reaches of Brooklyn.

October 20, 1950

All these mules who work with me, with their muscles bulging out, it's true, they can carry loads of steel three times bigger than I. But as the day goes, they begin to collapse, one by one, and I am still moving at the same steady speed. In the evening, they are cursing, they can barely drag their legs.

So they look at me, in amazement, and they talk, and they can't understand it. Where does it all come from, they ask me. Just to tease them, at the end of the day, when they have all collapsed, and when there is no longer even a need for more steel in the machine department, I begin to throw steel slabs in a wild fury, carrying twice as many as I usually do.

"Are you crazy or something?" they shout at me. "Go home, it's the end of the day."

I ignore them and keep dragging the steel slabs.

"Enough, enough!" they shout. "Haven't you had enough?"

"No," I say calmly, "I need some exercise, I don't get any at home."

So they shake their heads. They think I am totally out of my mind.

No date, 1950

I continued walking down the street. There was no hurry of any kind. I had nowhere to go. Occasionally I stopped to look at the movie posters, store windows. I looked at price labels attached to the brims of hats. Do I need a hat? Maybe I should buy a hat. No. Maybe next time. I have plenty of time.

Now I am standing on the street corner, watching a man selling chestnuts. I study how he prepares them. I like the smell of the roasting chestnuts. I inhale it deeply. I cross the street and I turn towards Broadway. The Broadway of movie houses, theaters, junk shops, cheap joints.

I stand for a long time before I cross the street, letting all the cars go by. Let them go. Oh, there are days when you are so filled with contentment, when you take everything with an even hand and give out equal amount to everything.

There is absolutely no place for me to go, nowhere to rush. After all, it would be foolish to rush, for a man who has come here all the way from Lithuania. Wouldn't it be foolish to come all this way and then rush through Broadway? Once you have come a distance like this, it becomes totally unimportant where you are, here or there, one block further or one hundred blocks further:

it makes no damn difference. Or how many hours this way or that—not important at all. Ten years will pass, I may find myself in a completely different place, who knows, and it won't make a bit of difference, as it doesn't make any difference now. Once you leave your home, you are never home.

In front of me is a bookshop. The sign says: "Where Wise Men Fish." I turn towards it.

October 22, 1950

George didn't have to come today, but he came. He came at noon. He walked around the factory in his Sunday suit. He looked terrific, George.

"Where have you been, George?"

"Had some business to do."

I sit on a pile of lumber and drink my milk.

Jim comes, stands in front of me and looks.

"Yesterday I took John home. I won't do that ever again: he bothers every girl he sees in the street. He stops traffic."

They always call me John.

"Is that true, John?"

"The trouble is there are too many girls running loose in the streets," I say, playing a macho. I have to compensate my otherwise thinnish person.

"You see? Didn't I tell you?"

I finish my milk and pull out a book from my pocket.

They look at me. Or rather stare.

"You know how to read?"

"No. I'm just looking at it, to see how it's made," I say.

"Just looking?"

Now they are all lying on piles of lumber, with their feet resting on the side of the truck. Five more minutes to the whistle.

"You sleep?"

"I never sleep during the day," I say.

"I do."

Jim sits on the lumber with his feet dangling. He has a hammer in his hand and he keeps time by hitting it on the lumber, making music.

"Take a break, Jim. You'll ruin my nerves."

Alex grabs the hammer and throws it under the truck. Then he lies down again on the lumber and stares at the ceiling.

"If not the beams, one wouldn't know it's a new building," he says. "The walls are like an old house."

The floor cement is still soft. They finished it only yesterday.

No date, 1950

Jim is dragging a heavy piece of steel. He is smiling.

"Working, boys."

I come in with a power drill. I sit on the boiler and begin to clean the holes.

"Ground bases for these two."

"You make too much noise, boy."

Jim always calls me "boy." Jim is black.

The drill makes a terrific noise. My whole body vibrates, from the intestines to the brains. I hold on, I press the drill into the boiler, with my entire body, and I feel my every molecule vibrate.

"You like fishing?" says Alex. "On Sunday I am going with my father. You can join us."

Again we drill.

"My mother is German. I told her about you, she wants you to come to our house. She loves everybody who speaks German."

"Thank you."

"Got any fishing tools?"

"No. I never fished in my life. With a hook, I mean..."

Lunch break.

"What is the matter with you, John? You eat too much peanut butter."

"Yeaah."

"It's good for you."

"Good for my stomach."

"John is happy today. Got plenty of peanut butter."

No date, 1950

"Cold today."

"That's from the steel. This damn steel."

"Today is warm."

"Fuck you. It's cold."

"Where is George?"

Jim lets out a whistle and turns his thumb at the toilet door.

"He hasn't learned anything in three weeks."

"But there is nothing to learn here."

"You said it."

"Fucking George. Whenever you need him, he disappears."

I pick up a nail and hammer it into a crate. George and Jim, they are working on the boilers today, I am working in the yard, outside. It's still warm, the autumn sun. To one side, overhead, the train rattles. Jim laughs. We shove the boilers into the wooden crates and puffing and cursing we drag them into the truck. Jim is in the truck, pulling them up, and I am underneath, lifting and pushing up. I am supposed to be the strongest on this team, so I get the brunt of the loading work.

WORKING ONE'S WAY THROUGH B.

October 28, 1950

"Somebody's crazy."

"Don't look at me when you say that."

Now they are unloading a truck full of unfinished boilers.

The truck is long, deep. Jim stands on top of a row of boilers, kicking them towards us. The Yugoslav and me, we are the mules who carry them inside. Like ants. Jim is lazy, he doesn't want to bend down, so each time the boiler falls on the truck floor a cloud of coal dust shoots up into our faces.

Windy and cold. The Yugoslav is not happy that the boilers are rolling towards us wrong end. He hates to turn them around. He curses Jim, but he fights back:

"There are many of you, and I am alone here and you want me to turn the fuckers around. Somebody's crazy," he says.

"Don't look at me when you say that, I told you," blurps the Yugoslav.

Jim laughs. He laughs all the time, sort of a giggle.

The Yugoslav angrily picks up the boiler and tosses it into the pile.

We carry the last boiler in. We pick up the boards, Jim jumps off the truck, walks inside searching for Alex, the foreman. But Alex, as usual, has disappeared. Just when everybody needs him. Everybody's yelling for him, all over the place.

Paul is doing a lot of standing and puffing today. He ate something bad, his stomach is sore. We have to finish fifty 20-gallon boilers today, and that's no joke. The worst is that they broke the electrical drill, the fucking night workers. Now, to screw the elbows into those holes, without redrilling them first, is some fucking job. You jump around the fucking boiler, this way and that way. With nothing on it to hold on to, it's like trying to hold an eel.

You can't hold it steady. When the boss doesn't see, one of us sits on top of the boiler, that helps. When he sees, we can't do that: we are slowing down the works, he says.

On our hands—tar. The elbows must be dipped into a bucket of tar, before we screw them in—it holds water better that way. In the evening, it's impossible to wash it off. No matter what we use—benzine, turpentine, soap—we have leftovers on our hands for another day.

October 29, 1950

I am sitting and thinking. Today is the first anniversary of my arrival in America, to New York. One year.

We had the luxury of being D. P.'s. We had the luxury of tasting New York from inside, as immigrants. We held many different jobs, observed the workers of many different professions, working together with them.

We didn't allow ourselves to waste a single hour. No rest. We attended every new theater performance, every play, every opera, every ballet, every movie that was playing in New York during that one year. We went through the galleries, museums. All with one mad purpose: to catch up with our wasted years, to know America, to grow roots in New York, to experience it fully, to absorb it with our eyes, ears, bodies. We spent many days looking for work, sitting in smoky employment agencies. We spent many nights walking the streets of New York and Brooklyn.

Ah, only the dead know Brooklyn, it's true. But we have been a part of its rhythm, we have been part of it, for a year.

No, this is not Europe. There is something else here that we haven't found in Europe. Ah, Europe … existentialism, communism, Ortega y Gasset…

WORKING ONE'S WAY THROUGH B.

To Americans, it is incomprehensible and they don't understand how people in Asia and in Europe can still be so barbaric: KZ, NKVD—you can't explain it to them. They don't believe it when you tell them that there are concentration camps all over Soviet Union even today. How could anybody do that, they say. They think you are some damn conservative slandering a progressive, well meaning, nice socialist country... Good hearted they are, the Americans, but totally naive, uninformed about totalitarian countries. Idealists...

You tell them what Stalin did in the occupied Baltic countries, or even in his own country, and they listen to you like you are Gulliver telling stories about invented lands. American politicians are as naive about the realities of the Soviet Union as the simple, working people I meet in the factories.

Sometimes I think that the innocence, naïveté, idealism and blind faith of the Americans—as opposed to the unscrupulous cunning of the Soviets—is a natural characteristic of higher civilizations and cultures. That's why they go down. The Greeks went down.

But here I am. I have chosen culture over barbarism, fascism and communism.

The other night we stayed up late. We couldn't sleep. We talked and talked about America.

All the expressions that we have heard in Europe so many times, all the put-downs of America, such as its materialism, the unrelieved boredom of its architecture, automation, conformity of people, love of money, capitalism, the Bowery, gangsters and skyscrapers—everything now begins to appear in a different light. We are beginning to distinguish nuances.

355

In Europe, we had textbooks, full of praise of the past, so heroic and great that there was no need to do anything today, except start another war... And when Europe destroys its cities, it rebuilds them to look just like before. Very very admirable.

I am well aware that my reactions to America are very contradictory, conflicting, even schizophrenic. One day I am totally in tune with it, another day I am totally lost. It's not easy at all. I'll have to fight it out for myself.

As if symbolically, it was autumn, when we left Europe, and when we were crossing Germany, by train, it was the harvest time. The fields were richly covered with summer fruit.

Later we sat in the Ludwigsburg library, and looked through volumes of Plato, and Valéry, and Apollinaire. We felt autumn both in nature and culture. We said: Ah, this is good time to leave, this is really the time...

No, we knew we weren't going to Greece... No Plato in America. I am in a country where museums are still in their very first stages of existence and there is more Europe in them than America... Theaters, symphony orchestras, ballet companies, they are just forming, they are not 100 years old... Everything is still young, budding...

People spoke to us about American materialism. But we are more and more amazed, every day, when we read about new theater and ballet openings, new symphony orchestras. We know, America is far too practical to do it all just for the sake of doing it: there must be a demand for it.

And then we saw our first Balanchine. And we thought, my God, who has a ballet like this? Or Frank Lloyd Wright.

And then we sat in the auditorium of the Museum of Modern Art, and the auditorium was full, and we watched … what? Not a Hollywood movie but a program of avant-garde films. And we knew that America was no longer Europe.

This is all concrete, new, strong. This is not a dream at all, this America. And if it is a dream, then this is a dream I want!

Europe is full of empty talk, bravado, rhetoric. It all meant something a long time ago. But it's all meaningless babble now. Throw it all away—Europe will be the emperor without clothes.

In one's youth one dreams and sees visions…

I am not amazed at all when I hear Europeans laugh at American visions. The old always laugh at younger generations: it's a routine of theirs.

November 10, 1950

I stopped at Alina's. Alina's boyfriend, a medical doctor, came along, so there was a lot of medical talk. Then somehow the conversation turned to the Korean war and I said, ah, yes, war is nothing very special; I am not interested in war.

They all jumped on me. "You aren't human," they said. "Just consider," they said, "the mothers whose sons are now in the war." I said: "What I really meant to say, is that peace doesn't depend on the good humanistic intentions of people. Those who decide on the matters of war don't give a damn about it: they are politicians. No matter how much you cry about it, you can't change it. So I have learned to laugh at it—such are the times. The poet's position today is very much that of a court jester."

I HAD NOWHERE TO GO

So the doctor begins to laugh:

"Ah, Professor Kolupaila says, wars may be caused by sun spots."

"He may be right. More than you think. Everything depends on everything else. Very often the full moon steals my sleep. Don't you sometimes lie awake during the full moon? I do."

So Alina says:

"I spoke with one American. I asked him why he doesn't go to Korea. And he says: 'But I fought in one war, I did my duty; now let the others fight.' "

So I say: "No, he didn't go to war because of his own decision: he was drafted. He had neither the courage to refuse nor the courage to volunteer. Today, in Korea, it is the same. As for myself, I don't want to do anything unless there is an inner need, an overriding reason, an understanding."

"You are demanding the ideal. You are asking too much from people."

"I think that is the least you could be asking. I read somewhere, probably in Ortega y Gasset, that after idealism and religions, where man always projected himself out into somewhere else, outside himself and into the future, now the time is coming when man will project himself right here and now. We need to realize that we live on earth. First we have to learn to live on the earth."

The doctor: "But in America we have a high standard of living."

Me: "But no social order. I am for a certain amount of planning and control. Overpopulation inevitably will lead to a series of disasters."

Doctor: "You sound a little bit like a socialist."

Me: "I find it totally silly to fight certain tenets of socialism. Such as, for instance, the population control.

358

Realities will force us to embrace them sooner or later. But it may be too late..."

Doctor: "You are speaking completely like a dialectical materialist."

Me: "That is very possible."

"So why did you leave Lithuania?"

"That has nothing to do with it. After all, neither communism nor socialism will ever work. I am not too sure that Christianity will ever work: people don't practice it, it's all on paper. Same with communism: it's only paper. The Soviet Constitution is the biggest shit-pile of paper of all. Not a single paragraph is being observed, neither the spirit nor the letter."

November 13, 1950

Leo: "Man is only man, not more. Like any nature, any reality. Squeeze some poison into his blood—he's finished. Concentrate as much as you can—they'll put some poison in your mouth and you'll be dead. Man is a little shit, that's all. One will hit you on the head, another will add—they'll kill you eventually, no matter what."

(Adolfas enters.)

Adolfas: "If you have been reading anything, or writing, I am apologizing very deeply." (He speaks in a stilted, official, sotto voce.)

(A pause.)

Jonas: (hanging a picture of Saint Mary on the wall) "This is what we need."

Leo: "Hang it, hang it—it's a free country. You can hang it, if you want. You can hang it even if you don't want. Nobody will have headaches because of that."

Adolfas: "But they'll have headaches from your talking."

Leo: "That is nothing new; you won't have headaches about that."

(Now all three lie on their beds staring at the ceiling. The windows are open. The birds chirp, outside under the window some women are talking.)

Adolfas: "I foresee a bad end for you: you'll want to write, and you won't be able to die..."

Leo: "I am afraid of that too, like Sisyphus."

Adolfas: "All ships will recognize you, from Europe to America, from America to Europe, from Europe to America—all your life."

Leo: "Shut up. Tomorrow I'll begin to live." He sings: "Oh, no, not today; oh, no, not here..."

Jonas: "No, no! Boy, he found a song for himself..."

Leo: "Oh, the dogs... It's already one month and three days since I left Europe..."

Adolfas: "Europe is missing you already."

Leo: "One can get nuts here."

Adolfas: "Don't worry, you won't get crazy. You have the antidote. Some want to get out of their heads, and they cannot. Others enact madmen. Very easy. I have worked out one little routine, I am keeping it for a good day."

Leo: "Everybody knows those tricks, nobody believes them."

Jonas: "You are a living example of it."

Adolfas: "Some day I'll put on my act. Very very quietly."

Leo: "Ah, the tomatoes are ripe in the garden..."

(Stares at the ceiling.)

Leo: "One half shadow and four eighths snow..."

Adolfas: "Pretty cold."

Leo: "It means, we are halfway to Australia."

Jonas: "Where the hell am I?"

360

WORKING ONE'S WAY THROUGH B.

Christmas 1950

Ignas heard him come down, stuck his head out of the bathroom, and said:

"Santa Claus was looking for you."

Walking into his room he saw a necktie box on the table. He opened the box and sure enough there was a necktie, a terrible scream in crying colors, the most tasteless necktie he had ever seen, he thought. In disgust he put it back into the box. Then he stood by the table and looked at the pile of papers, a mess of papers, and the bookshelves, and then the Christmas postcards.

"Ah, my second Christmas in America! If this is life, then I better quit," he thought.

He sat down and opened the first book he could reach and tried not to think about anything, neither Christmas nor himself.

The book was a little volume of sayings by Confucius that Algis had given him last Christmas. He read the first random saying.

"If you know not life, why speculate about death?"

Leo came down from visiting Ignas and without stopping went to the kitchen.

"Surviving?" he said, as he passed, half seriously half jokingly. Ah, they were all clowns in this house of D. P.'s. They all knew very well who they were and who the others were, and they knew the incredible, unbearable separation which could be bridged only by clowning.

December 31, 1950

He left the auditorium with a repellent taste in his throat.

He walked along the avenue, all the way to the park, looking at the people.

Here I am, right in between Scylla and Charybdis. That's where I am, I am between two bad choices, he

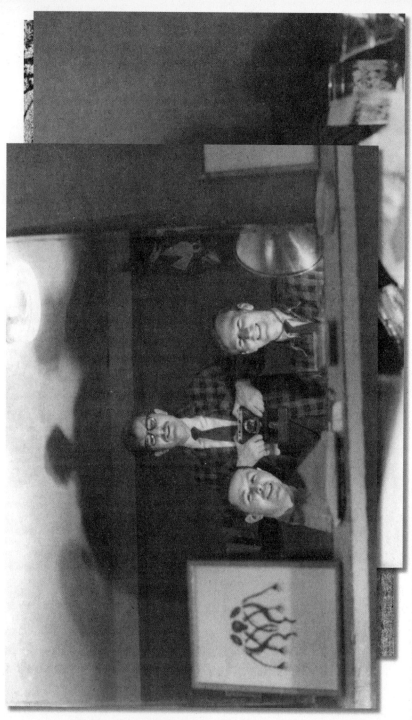

Leonas Lėtas, Adolfas Mekas, Jonas Mekas, Maspeth, 1950

thought. These are my friends, my compatriots, the people I know, my little circle in which I still live. Shallow and drying remnants of a displaced, betrayed, raped nation.

He needed air. He couldn't breath in this atmosphere.

Now he was on his way home, in a crowded subway. He was angry and he wanted to argue. He was taking Nijolė, George's sister, home, to the very heart of Brooklyn.

"I told you that all my ideals have crumbled and that I want nothing here. Everything I ever wanted is there, there. Here, everything's much the same. I don't care much about any of it."

So Nijolė says:

"You sound just like a bum."

She pointed at the bum in front of them.

"I am a world bum," he said.

The bum was drunk and he talked loudly, gesticulating wildly.

No, he wasn't very drunk, the bum, but he was grumpy, he spoke angrily to the man sitting next to him. He said, he didn't like his looks. He didn't like him staring at him like that, he wasn't a circus freak.

No, I can't go back to these meetings, these gatherings of semi-friends. No, I can't go back to them.

This bum, I respect him. I respect this bum. He is cursing this man, and I am not sure what for. But he expresses himself clearly. I respect bum's tenacity to continue despite the laughs and looks of pity that are cast at him. I am amazed that they survive. In the morning on my way to work, I find them outside, by the door, sleeping in the snow, with an empty bottle under the arm. They live on nothing, and they are nothing.

Yes, yes, I go to these meetings from patriotic duty, inertia. I spend long evenings with my compatriots. But

I have nothing in common anymore with these people
and they make me mad. They are no longer Lithuanians:
they are aspiring businessmen. Their faces, and the tone
of their voices insult all my senses. But I have no courage
to leave them to their sad fates. To leave them forever
and ever, never see them again.

11. BETWEEN SCYLLA AND CHARYBDIS

The author begins working at Graphic Studios. The nights of Brooklyn. Leo destroys his writings. The Graphic Studios gang. Life with the old immigrant on Linden Street. The dying generation of immigrants. Coney Island. Wanderings. The author wonders what will become of him.

January 14, 1951

Yesterday I went to eat with Len Perskie, my boss at Graphic Studios where I now work as a messenger boy and all-around-hand.

We talked about Charles. Charles is our chemist.

"Nobody else would hire Charlie," he said.

He is almost blind, makes mistakes, Charlie. Each time he weighs the chemicals, he calls me to check the scales. All he does, and does really well, is stir them.

Charles is about 50. A bachelor. The other day Charlie said he bought a TV. Now he watches it every evening, all alone.

"I sit and I watch. Sometimes, the wrestling becomes so tense, or a good comedy. But I sit and there is nobody to laugh or argue with about the baseball game. It's boring to watch TV by yourself," he said.

He fusses for a long time around the scales. The portions of the photo chemicals are small, it takes him a long time to measure and see, with his weak eyes. When he's all done, he calls me to double-check it.

In the morning he sweeps the studios, sprays green dust. Tiny bits of negatives stick to the floor, cannot be swept up easily, get attached to the old wooden floor. And the red tape, you can't sweep up at all, it just sticks to the floor, you have to bend down and pick it up with

your fingers, every piece, and you have to be careful of splinters, the floor is old. The green dust helps a little. Sawdust mixed with oil. Charlie sweeps and then stops and surveys what he has done, searching for green dust islands.

All six of us we go to eat at Paradise, a cheap luncheonette. Charles walks with us to the corner, then says, no, he'll go to the Horn & Hardart today. But I know he's going there because he feels easier there. He has troubles reading the menu. He looks at it a long time, he sits and waits until the waitress comes and asks him what he wants. Roasted beef on toast, white bread, coffee. Ham on rye bread. Lettuce or tomato?

On his way back he always buys the *Journal-American*, and everybody's waiting for it. When we are all back, Al and Phil will ask Charlie: What's nude? And we take up the search for the nude picture, there is always one planted somewhere in the *Journal-American*, we just know, it never fails. But not Charlie, who is crazy about dog and cat pictures. That's what he's looking for, in the *Journal-American*, and if he finds one, he walks around showing it off to us, telling us how sweet pets are. His hands, when they touch you, they are like dough, so uncomfortably flabby. Whenever he runs out of things to do, he stands by Lizzie's table—she is thirty, unmarried, petite—and giggles.

Henry is no more than 25 but he is already old. He serves as an "elder" in his church, in Chinatown, eventually he wants to study theology, to work as a missionary in Africa. His camera and working table are cluttered with Sunday School pamphlets. He speaks softly, piously. Walks most of the time on the tips of his toes, like a stork looking for frogs. He also spends a lot of time at Lizzie's table. He stands right behind her, runs his hand down her back, scratches her neck, giggles. He constant-

ly reproaches me for not having a savings account and why I am not collecting receipts for things I buy. When I drop them into a waste basket, he retrieves them, saves them, and brings them to me a few weeks later, asking me to keep them. He says I'll end up badly, one of these days, because of my lack of practicality.

January 15, 1951

He is drying the prints. Charlie is squeegeeing them and laying them flat on the floor.

He is me. I don't know why, but lately I often refer to myself, in my notes, in the third person.

"It's good for the wood," Charlie laughs watching the water spread on the floor. The floor is old and splintery.

Charles gets an idea. He stands and thinks. Then he picks up a piece of paper from the wastebasket, tiptoes to Lizzie's table. He places his elbows on a pile of photographs, puts down the piece of paper, and slowly and clearly begins to write. He writes "YES," and then he writes "OUI." Then he underlines both. Shows it to Lizzie.

"In French it means Yes and in English it means We. Isn't that strange?" he says.

Then again he stands silent for a long time, staring at the piece of paper.

Darkroom. Earl and Chuck. Today they have nothing to do. They have been sitting since morning without anything to do. They talk. Chuck is telling all about his soldier days.

"I'd like to revisit all those places again some day."

"What for? You ought to see something new."

"Ha, ha. I want to see my children. You know? I have left children behind in every town, in München (he pronounces it Munschen), Frankfurt, and in London, and in France."

They all laugh, but Chuck is very serious.

"They are all bastards. But I want to see them," he says.

"Some day maybe they'll bring you money," says Charlie, and giggles.

Dupont sent a salesman to intern with us. He has nothing to do and is very very bored. He walks from one to the other, stands, stares, sometimes asks a question, and goes to the next table. He is not too interested in what he's doing. They sent him here to learn how photographs are being made, about different cameras, different papers. But he goes to the telephone and for half-an-hour talks to his girlfriend. Florence, our desk girl, is angry, she says he ties up the phones.

"Call Dupont and ask them to pay for his calls," says Perskie. You never know when he's serious, when joking. Now he pours some red dye on the glass, thins it out with the brush, begins retouching a color negative. He doesn't trust anybody with that part of the work, particularly when it has to do with color separations. His fingers all red, he bends over the table, his brush makes a silent funny noise.

By the door, mysteriously smiling, stands Henry, looking at Lizzie. He is leaning on the drying drum.

I got on a subway and I rode for half-an-hour. I had nothing to do. I was drinking in the night, the emptiness and the loneliness of a sleeping city. As I got off the train, I saw three Blacks come up on the platform, and a boy with a girl. They stood leaning on a chewing-gum machine and talked drowsily. Then the three Blacks began dancing on the subway platform. They whistled and danced and laughed, and it was surreal to see it at five in the morning in the empty station in the huge silence of

the sleeping Borough of Brooklyn. It was full of strange poetry.

I stood on the corner of Union Avenue and Grand Street waiting for the Maspeth bus and I didn't see a single soul. It was so quiet. Then I began noticing, in the shadow of a building, across the street, two figures, a man and a woman, and they talked in whispers, and then the man left her and began crossing the street, and I could see that he had no legs, I could hear his wooden crutches clunk in the night, and I was wondering what this man without legs was doing at such a late hour stalking like a ghost through the empty dark of a Brooklyn street.

The bus was empty and I said good morning to the driver but the driver said nothing, he was tired, grumpy. Later at another stop, an old man came on with a brown paper bag in his hand, maybe a night watchman going home.

January 25, 1951

Newsweek, eleventh floor. The same tiny receptionist girl, typing. Boy, they keep them busy here, even the receptionist has to type.

"Good morning. How are you this morning?"

"Terrific."

The girl keeps typing.

Newsweek busy with the next edition. Typewriters clacking in every corner. It's a pleasure to walk past them all, carelessly. Messengers have their own privileges.

I walk straight to the editor's desk:

'Anything for me?"

The man points at a small package on the corner of the desk.

I take the package and walk back, retracing my steps through the maze of typewriters, past the typing receptionist, and out into the street.

Now, during the holiday season, the streets are full of beautiful girls. There are more of them than ever. Last night there was some snow, so now they all had pulled out their water boots—it's a rare occasion to show them off to the world… Yes, the boots do fit them nicely… I remember Mikšys, he said: "Maybe I don't know what New York really has, it may have nothing. But one thing I know, it does have beautiful girls."

It was lunch break at Graphic Studios. The four of them were walking to the luncheonette.

"I am crazy about New York," he said to Henry, staring at the Empire State Building. "I can walk through this city for hours and not get tired. I spend hours in old bookshops around Astor Place, and I watch the ships unload, and the bums sleep stretched out on the sidewalks—"

"I am not crazy about it," says Henry. "Some day I'll go to Africa, far away from all this." He dreams of going to Africa and opening a church there or something.

"You are crazy," says Henry. "Everybody knows you are. I don't know how they let you into this country."

January 27, 1951

Coming home I found Leo sitting by the table with a paper bag between his legs and tearing to tiny pieces, very methodically, all his documents, papers, checks, clippings, including those about himself, posters for his shows, letters, manuscripts, absolutely everything.

On seeing me come in, he smiled and kept at his work.

BETWEEN SCYLLA AND CHARYBDIS

"These are the last things that bind me to the world," he says. "It's a pleasure how easy it is to break these ties."

Karalius, the super, comes in. He pulls up a chair, sits down in front of Leo, watches him tear up the papers.

"He is tough," he says.

"Oh, yes," I say. "You can't buy such men with money."

Leo smiles, squinting one eye.

Karalius: "Why are you doing this?"

Leo: "I am working physically now. I have a lot of time and a lot of money. I can do whatever I want now. A free country. The only thing you need in America is your head."

He tears the papers and whistles.

"These things," he points at the papers, "are like poison, like drugs. You get used to them, can't quit."

Karalius: "If a man can't control himself, that's lower than any animal."

Leo: "Do you want these papers?"

Karalius: "No. I don't read too well."

Leo: "Take these big pieces, they are good to start a fire."

Karalius: "You are right."

He picks out the bigger scraps.

Leo: "That's my boy."

No date, 1951

I walk in, with a wet umbrella. *Visión*, we do negatives for them.

"Are the covers ready?"

The girl shakes her head.

"You'll have a long wait."

"It's O.K., I like to watch people working," I say.

The office is busy, typewriters are clacking.

Humberto Arenal, frozen over his typewriter, think-ing.

"How long have you been in America?" asks the girl.

"Eleven months," I say.

I know it's fourteen but it's easier to pronounce eleven. I am not sure how to pronounce fourteen.

"What's your real profession?"

"My profession? Hmm … I can do about anything. I can weave baskets and fishing nets, I can milk cows, I can plow the fields, I can train horses, I can make very good potato pancakes. I can do many things."

Peggy keeps marking up the photographs. When she's done I'll have to take them back to the Graphic Studios, all the way down, to 22nd Street. *Visión* is on 53rd.

"You don't dream photographs?" I ask.

"No. I leave my work here."

"I don't. I can't. I carry everything with me," I say.

"It's no good," says Peggy.

Again silence. It looks like Arenal had his thoughts collected, he's typing very fast now.

One hour later, in the street.

I walk down Lexington Avenue. It's raining hard and I jump over the puddles.

There is nothing more beautiful than New York when it's raining.

I am standing on the sidewalk, waiting for a bus.

In the street, among the rushing cars, I see a man drunk, his face totally blanked out. He is pulling a cart full of junk, mostly newspapers.

A box falls off the cart, its contents spill out on the street. Office receipts, loose sheets, processed checks.

The bum stops and begins to gather up the papers, stuffs them back into the box. Cars have to go around him.

He collects most of them, places the box back on the cart, then climbs up and sits on top of the box, presses the papers down. He sits there, with his entire body weight, very relaxed. He decides to sit there for some time, conversing with passersby. He feels very fine and comfortable and he likes his life today. He talks to the people waiting for a bus, to the taxi drivers trying to veer past his push cart.

"Keep the city clean from this shit," he says. He points at the receipts still swirling in the street. But he doesn't rush to pick them up, he sits on the box.

Lights change, a stream of people spills across the street. A black guy is pushing a cart stacked with rolls of fabrics. He is pushing right across the stream of people, oblivious of them. He is the only thing that matters, and he knows it, fuck the people.

The bum is still sitting and talking. But I can't hear him anymore.

"What do you call this?"

"Cow."

"Cow."

"Yes. Female is cow. Male is bull. Cow and bull."

"And two?"

"Cows."

"Cows and sheeps."

"No. Two sheep are sheep. No s's."

"That's because sheep are stupid. There is no difference between one sheep and five sheep."

I keep leaving half of my Coca-Cola. I never finish the whole bottle. That makes Henry mad. He keeps pestering me, every time:

"Why don't you drink your Coca-Cola?"

"I had enough," I say.

But that never works. He can't understand it. Why anyone in his right mind would leave half of the Coca-Cola.

"You paid for it, no?" says Henry.

No date, 1951

It's time to close the place. Henry stands by the door, looks back at me.

"Home?"

"Home."

"Who cooks for you? You have a girl?"

"No. Myself."

"Are you a good cook?"

"No. Just coffee or tea, that's all."

"No soup?"

"Soup? Seven years, I forgot soup. Coffee and bread. Butter. That's all. Eggs. Raw eggs."

Henry stands by the door, thinking. He watches me, as I collect my dusty hat, scarf.

"You should find a girl for yourself, to cook."

"I am happy as I am."

"Are you happy?"

"I am."

Now I am thinking. Am I happy? Truly? This god-damn Henry. He always sets me thinking. Henry is Chinese and he's very practical and paternal.

All these years I have been eating, but not like other people. Born at the wrong time, that's all.

I begin to walk back and forth across the by now empty studios, with my hands behind me, and with my hat on.

I am listening to the radio. A familiar tune. "Every day to myself I say..." I freeze for a moment and listen.

What does this song remind me of? Edersee. Yes. Edersee.

"Let's go, let's go," says Henry, still standing in the door. He doesn't pronounce the letter "t" in "let's." Purposefully.

Henry watches me. I can imagine what's going through his head. "What's this man John, what's he thinking now, this strange man John."

I am thinking. Should I go home. What am I going to do at home? Maybe I should go to see a movie. Or go and find myself a girl, as Henry advises me. How do you find one? One that cooks for you?

The radio is playing another song. The radio is hot, I can smell the plastic.

"Aren't you going home?" says Henry.

"What's the difference? What's the difference where I do the thinking, here or at home?"

Henry looks and says nothing. After a while he says: "But it's time to go home. The place is closing. It's time to go home."

Henry opens the door and slowly steps out.

"Good night, Henry."

Henry closes the door, still looking at me, perplexed.

February 22, 1951

The radio is blasting. One of us sets a station in the morning, and it goes, all day long. Everything—music, commercials, news. It keeps going. The main rule is not to touch it.

Today is a half-holiday, George Washington's birthday. Little work. Earl made coffee, I went out and bought honey doughnuts, one hot cross bun, one jelly doughnut, one pecan ring, one sugar doughnut, and one coconut danish. These are all very precise requests. It's all from

Horn & Hardart. Now we all stand or sit around the mounting table, swinging our legs down from the table, gossiping and sipping coffee.

The table is covered with photographs. A big job for Dupont. We talk about everything, just to talk. Kaiser is sitting on a bag of hypo, leaning against the wall.

"Are you tired?"

"Oh, yes, I am pooped out."

"It's still only morning."

Lizzie stands in the middle of the room. No pasting up work today. She's eating the pecan ring.

"He had a girl, a beautiful girl, everybody whistled when she walked by," sings Kaiser.

Kaiser leaves the hypo bag and starts across the room.

"Oh, Mister Lamm, Oh, Mister Lamm," he sings as he walks.

"Oh, Mister Lamm, you are a scam," adds Lizzie.

"That's very good," says Lamm, our cameraman.

One of Kaiser's legs is shorter, something happened to it in the war. So he walks sort of sideways.

The place reeks of turpentine. Earl got some ink on his hands, so now, for the last half-an-hour, he's been trying to clean it off.

Henry is leaning against the darkroom door, leafing through a book. *Lives of Plutarch*. Someone left it on the table, he found it, and now is looking through it.

March 4, 1951

Today I went to the Lithuanian celebration held in honor of their only Saint, St. Kazimieras. Met some old friends, from Schwäbisch Gmünd. I don't see Lithuanians very often these days, so it was like a reunion. Only yesterday Mažiulis and Jonikas arrived in New York. The only two still missing are Jurkus and Rimeikis—our

friends from the Schwäbisch Gmünd nights when we used to dance around the birch trees. "Ah, it was always you two who led us astray, tempting us with adventures. When you left, we fell back into our solemnity," said Mažiulis.

So we walked through the streets of Brooklyn, Leonardas joined in, we drank a lot of beer. Then we decided to look up a girl who, they said, could play Chopin. We found her, finally, she was working as a linotypist in a printing shop. So we talked about Chopin with the printing machines clucking around us, the smell of ink in the air. She had been a pianist before she came to the States. Now she is a linotypist—she is still working with her fingers, she said...

No date, 1951

Subway.

Opposite me sits a man. His legs are crossed, his nose in a newspaper. He is working on a crossword puzzle. With one hand he is stroking his chin, he is thinking. He wears a red scarf, black glasses, brown corduroy jacket, black shoes.

The seats are gray, worn out. Windows black, from soot and dust. One door cannot be opened, has a sign OUT OF ORDER on it.

There are few people in the car, a woman with white leather gloves, a knitting needle, black-hat, black coat. A bum reading a newspaper, brown beat-up coat.

"Nowadays everything in modern homes is operated by switches, everything except for the children," says the bum.

Silence.

"Is there much snow in the streets?" asks the bum.

Silence.

Nele: "When I finished college, my first job was in a bank. Ah, what a great feeling, my very first job! And a room, an apartment of my own! Freedom, life...

"But the fourth day, I sat among the papers in the bank, and I cried."

"Four days of unrelieved boredom, monotony. It seemed to me I had been there an endless half-a-year. Endless. Will I have to work like this all my life? Is this what I was dreaming, going to college for, just to be doing this? I sat and I cried."

No date, 1951

Some are lying in their beds for months, trying to die, and can't die. It's a terrible thing when you want to die before your time has really come.

Others—they just fall asleep. From old age, or an illness takes them away.

But then, there are others, they cut them to pieces, they burn them, they skin them alive, they peel their nails off—and they live. It's not easy to kill a human being.

They cling to life with every cell of their bodies.

They live, yes. Without eyes, without legs, without arms—surreal lumps of flesh. On wheel chairs, they live, they cling to life—maybe their mouth is still left, nourished through a plastic pipe—in bed for twenty years—but still: life!

They live like corals in the seas, clinging to some rock of life, like sponges, attached to the shores of life.

A SHORT STORY

He left a big fortune, but it's all in writing pens. He used to buy writing pens and stack them in a special room. About the time he died he had many thousands of them and people

couldn't understand why he did it. Besides, he invented a pen
that could write under water—but nobody wanted to buy it,
very few thought they would ever have a need to write under
water...

"He who can come to know the new, through review-
ing the old, can be a teacher of others." Old Chinese
saying (from "China's Religious Heritage," I. C. Yang).

No date, 1951

Ignas was working as a coffin maker, in the mortuary.
They let him go. No work.

"You see, the weather is beautiful, nobody wants to
die. I wish they'd die, give me a chance to earn my bread,'
says Ignas. "The more they die, the more bread. It's a
very simple thing, death."

The old man, Karalius, comes in, the super.

"It's cold out, maybe I should start up the furnace,"
he says.

"You must be dying if you feel cold," says Ignas.

"No, it's the wind. Ah, I did a lot of visiting. Visited
my brother, played with his children a lot."

Ignas: "You know, when you are old, you want to play
with children, the coffin is close."

August 20, 1951

Took two rolls of film to the lab. Moved into the new
apartment, 234 Linden Street. Since Adolfas was drafted
into the army, I've been alone, don't need much space,
had to give up the Maspeth place. Leo's wife came from
Germany, he's got his own apartment now.

My weight: 132 pounds. In the last three months I lost
ten pounds. Heat, work, anxieties.

In Maspeth, it was clean. The trees, the flower garden.
Here I see a dirty, garbage-covered backyard. Italians

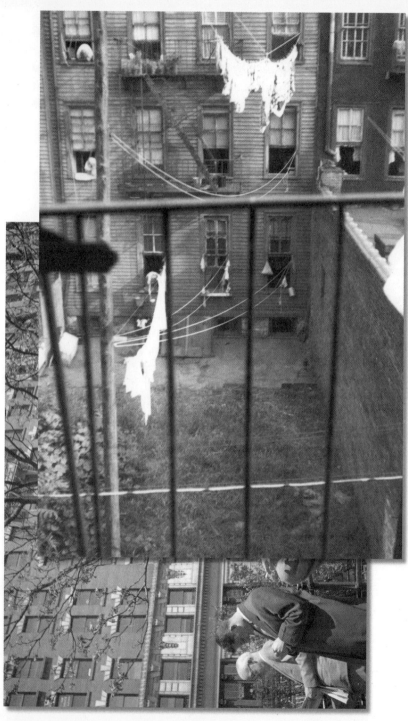

"Here I see a dirty, garbage-covered backyard…"

and Puerto Ricans shout through the windows, children scream. Broken windows, stuffed with rags—they don't give a damn about fixing them, they don't care how they look. Like refugee camps. War zone.

Radios blast across the street, across the backyards, I can't sleep. Television voices rattle day and night.

My room is a tiny cubicle in the back. The old man who rents me the cubicle lives in the three front rooms. He came here from Lithuania, many many years ago.

To get to my room I have to cross his rooms. He is always talking. Sometimes I listen, sometimes I don't.

"You live, and you don't know whether you have a home or not. You have a home, and you don't. Without any station. What a life."

He is criticizing me for not being married.

Donatas is visiting me today. Donatas defends me:

"Augustinas says, if he had married he wouldn't have made so many photographs." Augustinas is a photographer, a great one.

The old man: "What's the use of photographs? The walls will be full, but life will be empty."

"What do you mean—empty? He did a lot of photographs," argues Donatas.

The old man: "I tell you, his life is empty. You come home, a little child meets you, laughs, makes you happy— that's life. If you happen to find a good woman, your life changes. I know it. In every house there is smoke. But you have your head, you have to use it. You give in, she gives in. Only those who drink end up badly."

A soccer game.

Men lounging in dusty grass around the field, near the girls with grass stems between their teeth.

"Tell me, explain it to me. Who is winning?"

"Hell knows. Just watch. Do you think I know?"

Hot. Humid. Clouds of dust surround the field, settling on the leaves of acacia trees.

No date, 1951

The old man:

"The children, little children, they send them into the streets, on parades. They have to turn their heads that way, this way... What idiocy, what barbarism. If I were Stalin, I'd say: What's happening, brothers, what is all this nonsense for? A picture is hanging in the bathroom, and you have to pay honors to it? Only in the Czar's time was it ever like that."

His friend: "Everywhere it's like that where they rule without people electing them."

"Yes, when they get there by force, sure."

"A man comes from nothing, and disappears into nothing... Stinks for a couple of days, and you have to bury him. Stinks."

"Ah, maybe I'll go now."

"Thanks, Kostantas, thanks that you visited me. Now you know where I live."

He takes the cripple down the stairs. Then comes back.

"I met him in the street. Cold, and he's walking alone. Invalid, poor man, alone in the world. So I brought him in. Said, take a look at my apartment. They beat him up, when he was young, now he is a cripple. But you see, even for him there was no place in Lithuania, he had to run to save his life, and him, a cripple. Oh, Stalin..."

"I bought this bread at Sodija, on Union Avenue."

"No, it's not the same bread. Not what we ate in Lithuania."

"I know it's not the same."

"It's only good to stuff your belly full."

"Ah, the Lithuanian women! They made the bread, ah, the smell of the Lithuanian bread! On maple leaves. Where can one get such bread here?"

"I heard that in Canada they are still trying to keep up their Lithuanian life; They make bread for themselves. At home."

"Some are baking it here, too, I know. But it doesn't taste the same."

"They can't get the real rye flour. They get all kinds of blends. My brother works there. They mix flour from three bags. The taste is different."

"Ah, the women of Lithuania… They knew how to make bread. And kugelis, they used to hand-grate the potatoes, cut in some bacon, ah! Those women used to work hard. And they did a lot of work, alongside the men. And then, the men come home, and roll around, lazy. But they still have to take care of the vegetable garden, and the chickens, and the meals. And every year, another child. Jesus, they led hard lives. Yes, Kostantas, that's how the world is made. But this kind of world is changing. Be whatever you are—Catholic, or socialist, or devil—but be with the people. There are all kinds of people. Ah, political parties never do anything good for the workers, they only exploit the people. They reach the top—and they begin to act like kings. If the people were united, there would be no more wars.

"All of us are born naked, and we all die, no matter what. After two days you stink, and they have to stick you under. I was in the hospital: there they lie in beds and croak. Nature has no pity.

"Take Stalin to a concentration camp, show it to him. When he sees it he'll drop dead even before his time to croak comes.

"In America, the President, see, he drives around with striped shirt, no sleeves, just like everybody else, goes fishing. But the Pope, they carry him on their shoulders..."

"Such is tradition."

"But a stupid tradition, from the days of slavery."

The old man talks to his neighbor.

"How are you?"

"Give me a dollar, I'll tell you."

"Money, ah? Work for it."

"I work more than you."

"On the broads."

"I worked, they fired me. They say, I speak too slow. They fired me because I don't speak fast, you know? The boss is a hot little shit, he just jumps around all the time. Says, you speak too slow."

"Too bad for the children."

"Saturday, the half day you weren't in or what? Out drinking?"

"We drank only until four..."

"Yoh... Mickevičius was lying under the table."

"Ah, what a beautiful man he was, Tumas, but paralysis got him."

No date, 1951

The old man talks half to himself, half to me:

"The life of a young man is O.K. As for myself, my best times are already gone, now I am just an old man. Just an old man sitting here like an ass. Shit.

"When you are young, you are gay. My cousin just got married, so I could still dance. I used to get some women here too. When you are married, at least you know what you are working for. You should marry, Jonas. Get some

children for yourself. Without children—no good. You know, nature. Nature takes care of us all.

"The world is rotten … rotten…"

I am eating. He sits at the other end of the table, leaning his head on both arms, looking up at the wall.

"Nothing has any value. It's O.K. to kill old people—but why are they killing the young men? Like little dogs, they take them somewhere down to the cellar, and they kill them. Like they killed the Tsar. Maybe he was guilty, did some things wrong—but why kill his little daughters, children, why? Animals. Rotten, rotten is the world."

For a while he says nothing. Then he resumes again:

"For me, there are only two truths: to be born and to die.

"The children would clobber me if I were to bring home a new wife. But every man sometimes does something foolish. It doesn't take much—man is foolish to begin with. And if you add just a little more–there he goes.

"Oh, Jonas, Jonas, if I'd have my woman now, ah, it would be good for an old man. You get used to a woman, life is different with a woman of your own.

"The child came back home, after four years in the Pacific. I was upset, he was upset. Nothing was the same. His mother was gone. You know, a child, it hurts his heart. Cried. Now he got used to it, has his own wife. Yes, yes."

He sits at the table, open cans of food, bread. He spreads some peanut butter on bread, eats, stares at it, sighing loudly. Then he talks again:

"When my wife died, our son was in the Pacific. When he came home after four years, the house was empty, his mother was dead. I alone walked through the empty apartment. A couple of weeks we lived together. He cried,

you know, a child, it hurt his heart. Dying, she wanted to see him so much. But you think the Army would send a boy from the Pacific to America? So she got used to the idea she wouldn't see him again. She was sick for several weeks, before she died. She said, 'I wanted to see him very much, but now it's all the same. I am going to die soon anyway, now it's all the same.' Ah, she was very sick. Oh, Jonas, Jonas, I am telling you, what a woman she was! When she arrived at my house, my parents grabbed their heads.

He lived with me a couple of weeks. Not my child, you know. I married late, I was already fifty. But we got very close. Ah, Jonas, Jonas, if you'd only know what a woman she was. The children would kill me if I took another wife. I didn't have any children with her. Two came from the first husband. But they were like my own children. I loved them like my own. When I saw him leave for the Pacific, we both cried. When he came home, after five years, she was already dead. He cried, a child, it hurt his heart, you know—a child. Later we both walked through the rooms, and we were so alone, just the two of us. For myself—it was so—so, I was old anyway. But for him, it was very sad. Came home, old friends had already settled down, nobody to drop in on,—you know, five years separate and break apart a lot, friends and neighbors. You have to start your life all over again.

For a few weeks he walked from one room to another. One day he walked out, said nothing, he came home late, and said: "You know, you are like a father to me, I will tell you everything openly: I can't take these empty rooms anymore, I can't. It's boring, and empty. In the army, I got used to living in a crowd. Now, I can't stand the emptiness. I have to start living somehow.

He walked out, in the evening, late, and I didn't see him for a whole week. I really thought that maybe some-

thing had happened to him. But Saturday evening, late, he comes home, and not alone, but with a woman. And what a woman! I was old, but I envied him. And he says, 'Meet my wife.' And he says to her, 'Here is my father.' Then back to me: 'When you have time, please visit us, we live there and there.' And walked out.

"So now I was really alone, walking through the empty rooms. Empty. Boring, even for an old man. If the woman would be still alive, if not for that illness... Now, in old age, and me alone, I just sit and wait for death to come. I go to the park. I sit there until evening, meet a few more old men like myself—and that's how the time goes. Jonas, Jonas, if I would only have my woman now, for my old age... Ah, you get used to your woman, life is different with your own woman..."

No date, 1951

The old man's brother with wife came to visit him. Early in the morning, a beautiful day. Ah, the old man is busy, offers coffee, eggs. Takes cans, everything, drags everything from the ice-box. Then they drink coffee and talk.

"Ah, yes, he died..."

"The devil keeps pulling away our friends."

"And what's wrong with Kakšiute? Sick?"

"Cancer. Nobody knows. Close to the end, weighs only ninety pounds. Says, she can't eat anything. Sometimes manages to go out for a walk."

"I'll tell you. Three times they took Stasys to the crazy house, and he still lives."

"Drink some coffee."

"Dudėniene also separated."

"She is crazy."

"But gorgeous. Both are fighting for the same man. He comes, so mother and daughter fight for him. She resembles her father, such a little thing."

"Keršutis lived with them for some time. I thought maybe he straightened out that family. A beautiful man. And both middle aged. But he looked around and walked out."

"More coffee?"

"Yes."

"Beer is healthier than coffee."

No date, 1951

He continued walking along the Coney Island board-walk.

On both sides there was water and people. Like flies they covered the sand and the water. Sun umbrellas and swimsuits dotted the beach in a confusion of color.

He walked further, where he saw the sign REFRESH-MENTS. Bought a bottle of Coca-Cola and stood watching the fishermen. They were lying on their bellies or leaning on the sides of the bridge with their long fishing rods stretched into the water. There were hundreds of them, and the smell of fish bait pervaded the air.

He walked and sipped his Coca-Cola. But he didn't see any real fish. They have been here since early morning, fishing like this, staring into the water. They were total-ly involved in what they were doing, a really mad patience, he thought. All fishermen are idealists. They do it from some kind of mad obsession, hell knows what, very very admirable. It's pure idealism, to stand and bake like this in the sun the whole day without catching a single decent looking fish.

He stood on the bridge and looked down into the dirty water. The water was full of people. They splashed

and scrambled, climbed up on each other's shoulders, tumbled into the water on their backs, with no evident purpose, they ran out and into the water.

A man in red swim trunks was holding his girlfriend, and she was heavy and fat, and he was holding her high upon his shoulders, and then they both tumbled into the water. A middle aged heavy woman was slowly wading deeper and deeper into the waves, she wore a long blue skirt which floated up until the water reached her chin.

Hundreds of children rolled and galloped on the beach, and splashed in the shallow waters, chasing each other. A young man, holding his girlfriend by the waist, was teaching her to swim, or maybe only held her just to hold her. His chest was completely covered with black hair and the girl was tiny and thin, she wore a whiteswimsuit. A Jew with his belly falling out, his back, belly and arms all hair, stood in shallow water absentmindedly, on two thin wobbly legs, bending from the weight, his trunks barely hanging between his belly and his knees.

He left the bridge and walked along the beach.

For a few minutes he stood and watched the parachute jump. Then he continued past the merry-go-round and the ferris wheel, past the hamburger stands and the ice cream carts and the shooting galleries that covered the shoreline. People moved along past it all aimlessly. They walked just to be walking, it seemed to him. Some sat by the water's edge and on benches, hot in all their clothes, neckties and heavy skirts. They sat like that for hours staring, with their backs to the games, merry-go-rounds and the ferris wheel.

He descended to the beach and now he was walking along the strip, through a mass of one million people, stepping over piles of litter and food cans, sandwiches, ice creams, newspapers, Schweppes bottles. One million of them, lying on their bellies in hot sand, with their feet

in the sand, with a comic book in one hand, and with the other embracing the girlfriend, wife, neighbor, dog. Couples were lying in embraces and kisses, oblivious of everything. He walked right through this throng, his feet sinking in soft hot sand, he walked across this whole colorful hot smelly mass of bodies, feet, mouths, breasts, trunks, umbrellas, radios, children, the *Daily News* (Sunday edition), and sand. He stepped across all the collapsed empty bodies, fat bellies, teenage girls with apple breasts, their noses in *Mademoiselle* or the *Daily Mirror Sunday Magazine*, towels around their necks, totally motionless, frozen in some midsummer Coney Island daydream. Tiny, shriveled bodies, and fat and heavy bodies, girls of thirteen, in their light swimsuits, and women surrounded with children, all too many of them, bambini, bambini. Out of shape bodies, with sides bulging, bellies falling, young men in tight macho trunks and long muscular legs, fatsos, with round faces and round bellies; and others all grown-over with hair; and dry ascetic types, creatures all bundled up in towels; and white, washed-out bodies brought out for the first time into the sun, squatting on the sand, wearing sun glasses with books in their laps; and old men, all dried out, all shriveled and wrinkled, with thin legs, dry arms, timidly touching the water like a last baptism, wading, standing, looking around, ready to cross the Styx.

He walked right through, stepping in the warm soft sand, stepping over the bodies, on the hot edges of blankets, walking across this vast mess of one million people—the number was headlined in Monday's *Daily Mirror*—on this hot Sunday afternoon.

A little bit back from the beach the play and game area was filled with teenagers and psychopaths, those who have nothing else left in the world. They stood in front of the refreshment stands, played in pokerinos.

Soldiers, sailors, alone and with women stood in front of girlie shows deciding whether to go in or not.

In the midst of it all, right there on the beach, with their placards and trombones, the Salvation Army played. One played accompaniment on accordion, the others sang. Then a woman began talking, preaching. She called on everybody to awake! awake! Awake from this sinful worldly life. She shouted loud, and with passion, almost in a trance, it was very very believable. She saw all of Coney Island sinking in sin, bathers, fishermen, and all, and she shouted: SIN SIN SIN! and called them to return to Jesus. A crowd of people stood and stared at her, and ate their hot dogs, and a few Salvation Army girls walked around passing out the *Gospel Herald*.

Right behind them someone else was shouting, calling the crowd to a show that was about to begin, "where you will see a turtle girl and a gorilla woman." He was offering one thousand dollars to anybody who would not get to see what he was promising.

The train was hot and dusty and the floor was covered with scraps of newspapers and peanut shells and a little crowd of Puerto Ricans stood in a circle and sang and clapped hands and plucked guitar, and three girls in dungarees with round breasts danced in the middle of the circle, some boogie-woogie thing, and they sang in a monotonous and even rhythm, the same and the same melody, and the girls kept dancing, they were light and tireless.

No date, 1951

He walked along 14th Street and he couldn't decide whether to go back home or continue walking. He walked to the end of the street where the slaughter houses were, hooks and blood puddles on the sidewalk and men in

bloody long aprons. He stood for a while, studying the bloody street. He looked at the sheep, now slaughtered, hanging upside down, their white wool bloody now.

He turned around and walked all the way back and turned onto East 3rd Street. He stopped and looked down into the basement window. Yeah, I worked here for that Altman Co. guy, I can still smell the lead pipes. Closed up now, dark.

I got a dime out and stepped into a telephone booth.

"Hello?"

"Hello."

"Is this Peggy?"

"Peggy's not home." Clunk.

Ah, Peggy. I don't really know her. But she is something familiar, like this street. I have been here before, and to have been somewhere at least twice, is more than I can say for most of the other streets. That's why I am here. The craving for something familiar, some memory of something.

Ah, this goddamn desperation of a D.P. That's what this is, I said to myself.

I left the phone booth and started walking east. The street must end somewhere. I'll walk and walk until I see its end, that's something. This is Friday evening and I have nothing else to do and nobody to see.

No date, 1951

We walk together, the whole bunch of us, to eat. Earl, Jack, Henry.

"Do you really like rain and snow?"

"What do you mean? How can you dislike snow?"

"Snow is dirty," says Earl.

"You people are crazy. Snow is white."

"It's you who's crazy."

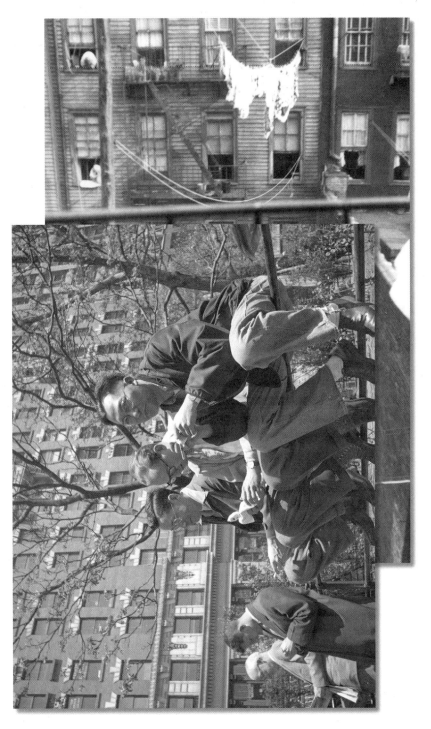

The Graphic Studios gang during lunch hour, Madison Park, 23rd Street

Howard, he stands in the middle of the room, staring at the floor. He looks tired.

"Wake up!" he says to himself, loud. Then he turns to me:

"Have you ever stood like this, with your eyes fixed on the empty space, without any thought or feeling? I was, just now."

He picks up a bottle of developer, walks into the darkroom, and closes the door behind him.

No date, *1951*

"I am reading last week's jokes," says Florence, our telephone receptionist.

"Did you watch TV last night?"

"Toscanini?"

"No, no. I watched horse races."

"Oh, boy. I'm talking about Toscanini."

"Horses jump over things, it's more interesting."

"Saturday night watch Channel 13, it's very interesting."

"What's on?"

"Women wrestlers."

"Oh, boy."

Charlie laughs, sort of giggles, you can't call it laughing. He goes back to mixing chemicals. He comes with the mixing stick in his hand and says something to Paul.

Paul: "You saw your widow last night?"

Charlie laughs. He has no front teeth.

Silence.

"The weather is depressing."

Muggy. Miserable. Not much work done at the Graphic Studios today.

BETWEEN SCYLLA AND CHARYBDIS

No date, 1951

Today we are all going home at 5:30. For half an hour we walk around with everything put to place, killing time, telling jokes, looking at the clock. The boss is not in today. Some are with the hats and coats on, they have been so for the last half an hour, waiting, bored.

"Let's go, let's go!"

Somebody, a joker, puts the lights out.

Then he switches them on again.

"Let's go!"

"Don't worry. I'm in no hurry."

"My wife is waiting. This morning when I left she was still sleeping. I haven't seen her since morning."

"I am in no hurry. I can stay here for the night."

"You can stay. I go."

"Your girlfriend is waiting for you?"

"My girlfriend just got married."

This damn language. When you can't speak good English you have to lie or be a goddamn clown, you can't say what you really think.

We put the lights out and the whole gang leaves the place at once.

No date, 1951

I was eating breakfast, 9:15. A guy comes up and says, "I have a picture to show to you." "What picture?" "Just look," he says, "it's Monroe. Make a copy for me." "What for?" I say, "this is a bad picture, there is no action in it." "It's pretty, anyway," he says. "She has nothing on," I say. "Oh, yes, she has the radio on," says the guy. "It's an old joke," I say. "Give it to me," Jack says. "I'll give you a five dollar deposit, you keep it if I don't bring it back. I'll bring it back, I swear." "Oh, no," says the guy, "you can't

get this picture anywhere in town, I got it in the country, don't fool me with your five dollars, give me ten," says the guy. "I'll make you a copy," says Jack. "Sorry, my train is leaving, I have to run," says the guy.

December 1951

I have tried. I have done everything to be just like everybody else. I have tried to be down to earth. Digging my hands deep into the sand pile on Sixth Avenue. Touching the ground in Central Park with my bare feet.

But I remain a stranger here. There is a distance between me and every building, every street, every face.

So I fall back into my fantasies, memories, dreams. Or I clown.

Yes, even the sounds that I hear have a different meaning to me. They evoke no memories. The street cleaning trucks, or the cars. The movements, voices, expressions, shapes. I perceive them but I do not understand them. They call up no echoes in the deep cells of my body, no. Without really understanding it, I walk through this city, day and night. There is no meaning at all in any of this, it just happens, it just is, and so am I but we are like two strangers.

December 25, 1951

I postponed my Christmas until further notice... Until the snow comes.

Today—it doesn't look like Christmas at all. It doesn't look like winter. It's raining.

Walked around the city, here and there. Did some writing. Then went to Manhattan, saw *Miracle in Milan*.

Wandered around the Rockefeller Center. More rain. For a while sat in the Public Library. Then stood in St.

Patrick's Cathedral for a while. Couldn't get into the Christmas spirit.

Went home, did some editing on my film. The right eye hurts. Went out, bought some boric acid. Called Nele, she is not home.

Now it's 5:30 PM. I am on the subway, on my way home. I have no idea what I am going to do. Opposite me sits a girl reading "Opus 21." Nele said she read it and liked it. I am very skeptical about it, it looks like very thin water.

Bought tickets for the New Year's night party. Also, tickets for Shankar ballet. Earlier this week I saw *Saint Joan*, with Uta Hagen, and *Don Juan*, with Laughton, Boyer, Hardwicke; and *Two On the Aisle*.

December 30, 1951

Today Lizzie is working overtime. I have to stay, to keep her company. Those are the boss's orders.

I have nothing to do, only wait. I read a few pages of a book I found on the floor in a closet, but it doesn't interest me. I begin pacing back and forth, from one room to another, all around, until it gets on Lizzie's nerves.

"You make me nervous," says Lizzie.

"I am thinking. You know, sometimes I have a feeling that I am not thinking at all. I'd like to sit somewhere on the top of a hill or by a river, and think for a while. People do that, I have read it in books."

"What are you thinking about, Johnny?"

"Everything, just about. There is so much to think about and I am missing out on so much thinking."

"You are worrying, not thinking."

"No. I have no worries. Not any longer. I regret nothing. I want nothing. I have no great guilt about anything.

I need nothing. Just to keep myself alive. But there is so much to think about."

In my mind I am thinking: Of course, I am worrying. But let's see where this line of conversation will take me.

"What will become of you, Johnny?"

"That's something to think about, too. You see: that was just what I was thinking about: What will become of me. I think that I have already become what I wanted. Should I, or shouldn't I want to become something else?"

"Wow, Johnny, that's a big thought."

She is small, Lizzie. God, how tiny she is.

"One thing I am sure: you are a character. I don't know what you are, but you are a character."

"Yes, but you know, they keep telling me that I need a profession. They tell me, I need a family, religion, a steady job, etc. etc. But I have nothing and I don't even like the professions. I just do whatever falls into my hands and I do it perfectly. But I don't prefer one thing over any other. I like everything the same way."

"I have one guess: you don't like any of them, really, that's why it makes no difference. You must want completely something else, and I don't know what it is and you aren't telling."

I don't answer. I make another round of the rooms, then stop again at Lizzie's:

"Maybe because D.P. life has made me cautious of tying myself to any place. Or, rather, I tie myself down too easily, now. I attach myself to any place. Drop me into a desert, come by next year, I'll have my roots all over the place. So I keep on the run. You see what I am thinking about?"

I take a seat opposite Lizzie and I watch her work. She is our paste-up specialist. She is a very nice woman. But she is only thirty and already an old maid. I know I shouldn't think anything as bad as that, about Lizzie,

she is too nice. I look at her face, hands, her small body, and I think I could never kiss her. She isn't my kind of woman: she is a worker.

"Yes, Johnny," says Lizzie, "we could go far both of us together, we both think the same way."

Oho! Wait a minute, wait. What is she thinking about? We both? I better resume my meditational walk.

I leave the table and I start my walk from room to room again.

A TALE

He travelled a long way to arrive just where he had started. He had travelled a long way, 10,000 miles. He always wanted to know where the road really went. But when he came to the end of the road, he saw nothing but a fresh pile of rabbit shit. So he realized the foolishness of his wanting to know what's at the end of the road, of putting all his life into it, and he thought about his long journey, the effort he had put into it, and he laughed. He laughed with no regret and no hard feelings. He knew he had been made a fool of by someone who liked fooling. For a moment communication was established with the absolute even if just for a glimpse. And then he began his long journey back.

12. WORKING ONE'S WAY THROUGH MANHATTAN

Wanderings continued. Loneliness. The nights of Manhattan. The author films the immigrant community. Visits to Leo's family. Algis' mother. Letters from Brooklyn.

No date, 1952

Peggy: "What day is it?"

Me: "I don't know. I don't care about days. Why should I care about days when years go by unnoticed, empty?"

Peggy: "One day you'll find you are old."

No date, 1952

"What kind of book are you reading?"

I show him the book. Thurber. But Paul is not interested in what I am reading. He's studying the binding of the book, how it's glued together.

"Who is doing the job for them?"

"I have no idea," I say.

Paul says, when he's reading a book, he first takes it out of its paper jacket. "That thing keeps annoying me," he says, pointing at a small wrinkle caused when you open a book, a tiny wrinkle on the spine of the book. "It keeps annoying me, that thing."

Jerry, for several days now, is peddling his watch, trying to sell it. Jerry is the new delivery boy. I am training him to replace me, I'll be doing the camera work.

"It's a wonderful watch. Waterproof. You can put it in water and try it, if you don't believe me."

"I did that already, two minutes ago," says Paul.

401

"No! Take it out! You, guys, you can't do that to me!"
He is almost in tears, poor Jerry.

I deliver a package to *Newsweek*. Ah, the secretaries
of *Newsweek*! Delivery department—there they are of a
lower breed. But the typists, that's something else. They
sit there and they sigh. They envy the fact that I can
travel.

As a rule I have to leave the packages in the delivery
room. But I always manage to pass through and go right
to the secretaries.

"How is it outside?" they ask.

"Beautiful, ah, beautiful," I say, knowing perfectly well
that it's pouring rain.

"I don't believe you."

She tries to look out the window, but she can't see,
the window is half a mile away.

No date, 1952

I leave the *Newsweek* offices, I step into the elevator.

A Black stands beside me, with the *Daily Mirror* in
his hands.

"How is it that greed and anguish and all the evil is
so strong in man," he says. "Like in an animal. Oh, yes,
like in an animal."

Pause.

"Killing one another, thieving one another, hurting
one another. But you be a good child of our Lord, you'll
be a good boy of our Lord," he says. I think he's talking
to me.

The elevator stops and we get out.

"Yes, killing one another, hurting one another."

"It will be all right," someone says. "It will be all right."

"No, it won't be," says the Black man. "You have to make it all right."

"Oh, look, what can you do right in such weather," says somebody.

"What the hell—photography," says Paul. "It is a thing of luxury. I'd like to work somewhere where they make bread, or fish, or build roads. Anything more useful than this."

"Sometimes I think the same way," says Charlie, with the mixing stick in his hand. He stands in the door and listens. "I sometimes think the same. I'd like to build roads and bridges. Then, when you die, the bridges and roads and the rails are left, still standing, something is left that you made with your own hands, something."

He goes back into the hypo room. He is standing there, his white shirt open, a chewed up cigar hanging on one side, stirring hypo, with his eyes off somewhere in distant mind travels.

"You know? Al wanted to leave the city. He was buying a chicken farm. But his wife says, look, what can I do on the farm, it's boring there, and all that chicken shit. So that was the end of that."

"I wouldn't leave the city for chickens either," I say. "Chickens are goddamn stupid. Chickens are no reality at all, yes sirree, no chickens for me. And they stink."

I stand by the window now, looking down onto 22nd Street. I was told to watch for the Railroad Express truck.

"You know, women, they are like a knife under your neck, a burden…" mumbles Howard.

"But what a knife, what a burden! I would like to have one under my neck, a knife like you," says Henry looking at Lizzie.

403

January 13, 1952

Two girls, thirteen or twelve, with red socks, white ballet shoes, waiting for the train, in the subway, on the way home from the class, still immersed in dance lessons, are doing their steps, on the subway platform, very very excited, bubbly. They repeat their class exercises, very very lightly, very involved, completely oblivious of people, subway reality, noise. They are totally in their own dream. Who cares about the people, there is room for nothing else in the world but the two of them and the Muse of Dance.

January 26, 1952

It's raining, it's good to sleep. I sleep till ten.

I read the entire *Sunday Times*—film and theater and literature. I always buy these sections on Saturday.

I sit home until eleven, waiting for the mail.

Do some editing (film).

Go out. Stop at Sodaitis, on Union Avenue. The old man asked me to buy him some Lithuanian newspapers. Sodaitis is mimeographing, puffing, talking to himself, having troubles. He is printing programs for some Lithuanian cultural event.

3 PM. At Whelan's Drugstore, 57th Street and 8th Avenue corner I meet Nele. Trying to borrow some money. No, things are bad with her, no money. She planned to go skating, but it's raining now. So we sit and talk.

We see a Newsreel program. Los Angeles. Cars in the streets, covered with mud. It's amazing the things that can happen in the world, nature runs amuck. And here we sit and drink soda at Whelan's, how boring. Rioters in Egypt, Greece. Nobody knows who's killing whom, who is guilty.

WORKING ONE'S WAY THROUGH M.

I walk Nele to Macy's. There I leave her in the Women's department. Wander around, buy some used film reels. Make a circle, walk some more, stop at Museum of Modern Art, but I don't go in, don't have enough money for the ticket.

Got to get some money.

I take the subway back to Brooklyn. Stop at Lucy's. She is not home. Her old man is alone, walking through the dark rooms like a ghost. The place is so dark, I can barely see him. He saves electricity, doesn't use bulbs stronger than 5 watts.

"Sit down," he says, "she will be back soon, she went to town." This is Brooklyn. The town is Manhattan.

"Did she say when she's coming home?"

"Around six…"

I look at my Bulova watch. Lucy works for Bulova. Twenty to five.

"I think I'll go. I'll see her some other time." A cat on the bed, small, gray cat.

The old man stands with a bunch of old newspapers in his hand.

I walk out. The corridor stinks of cat urine and mice shit, dark. I find my way out with both hands, like a blind man, searching, holding to the walls.

Ah, the heart of Brooklyn.

I shudder. I walk into the street.

It's still raining.

I stop at the Lithuanian club, on Union Avenue.

The owner, as always, she is in the kitchen, with a big ladle in her hand. I cross the dining room and walk into the room on the left, the smoker's hangout. There, through a cloud of cigarette and tobacco smoke I can see half a dozen men playing cards, like always.

I watch them for a few minutes, then I walk out and into the street. I thought I'll find Dagis, the priest, he always plays cards there. Who knows, maybe he'd lend me some money. But he didn't show up today. Tarulis is there, but he has no money.

Walked to Grand Street, peaked into the Ginkus' Candy Store—nobody's there. Walked back to Sodaitis to see if there wasn't anybody there I could talk to—about money, that is. Some crazy guy was arguing about something, about the meaning of the word "to confer" in English, black hat over his totally crazed eyes. I asked if I could use the phone, Sodaitis said yes, a good man.

Made a call to Donatas. He said, I could see him tomorrow at 10 AM. Went back to Ginkus Candy Store, climbed up to the second floor, above the store, paid a visit to Osmolskis. I found only his wife with Paul, the little boy, crawling on the floor. She gave me a book of bad poems, by her brother. Gossiped about Leo. Then I went home. Read *New York Confidential...*

January 27, 1952

Visited Leo. We talked, gossiped, ate, drank beer. His wife used the occasion of my presence to complain about Leo's scragginess, he doesn't give her enough money to buy food. So Leo says, he has been giving her $25 every week, but they have been spending it on anything but food.

"They are always buying all kinds of junk food, not nourishing at all, sweets, always sweets."

He talks rapidly without stopping.

"Who needs desert three times a day?"

Murza, his wife, and her mother, leave to do some shopping. But Leo continues, from inertia:

"They are always buying all kinds of junk food, not nourishing at all. Sweets, always sweets. Who needs desert three times a day?

It's her mother. She is pampering the children. When I don't look at it, she gives them whatever they want. Not real food—junk food. I have no voice at all in how the children are growing, what they eat. If some day you have children of your own, you'll understand what it means to me. Sometimes I want to just go and never come back. I did everything I could, I brought her to America. But now she—they both say, 'Why did you bring us here, we lived better in Germany.' So I say, O.K. I will ship you back, and do whatever you want.

Eh, but don't take me too seriously. My nerves have already been eaten to their ends, they cannot be eaten anymore. But I don't want to just squander money either. Already, at this age, she had to take the children to the dentist—her mother ruined their teeth with all the marmalades. So I say, why don't you buy more fruit instead—buy as much fruit as you want, I have no objections. But no."

His wife comes back. She overhears Leo's last words.

"Fine," she says, "fine. This week you did all the cooking. I come back from work—potato pancakes. Is that a meal after hard work? Only one time during the entire week you had a meat dish. When I cook, I have meat every day."

Leo: "I wanted to bring some variety into our diet. But you—always the same, always meat, more meat."

No date, 1952

I decided to follow up some of the tips from *Confidential*. To see the secrets of New York...

So here I am, on 42nd Street.

I paid a quarter. The man at the door was inviting everybody to see "the woman everybody must see, Laura, beauty in body, the most beautiful woman in town, without clothes on." The crowd was pushing in, and I was carried in by the stream of sad faced humanity into a darkened room where we stood in a thick sweating circle around a tiny stage, where another woman, not Laura, was dancing the Temptation Dance.

No, she didn't dance, she only waved her arms and tried to wiggle her waist but she didn't do it too well because of her fatness and she smiled in her flimsy costume which occasionally, as she moved, revealed different parts of her naked but not too exciting body.

Then the announcer asked everybody to applaud, because Laura was about to come out, and she came out, all prepared to meet the advertisement. She was covered only with a transparent flimsy veil, and as she danced, that is, moved around, she held a cord with an electrical bulb at the end, spotlighting her breasts, buttocks, or some other part of her body, pointing very factually, academically; inviting the onlookers to look, like you'd point out any other object in the room, and we watched or rather gaped and she smiled vacantly, as she stood on the little stage, some five feet from our popped-out eyes, perspiration and sweat.

I looked at the crowd, at the faces stretched up towards the "most beautiful woman in town," breathless, frozen in a voyeuristic ecstasy—they stared at the beauty who, yes, was beautiful, or rather had been beautiful some time ago, but now her body and her beauty were faded, even if still retaining some of their former history, as she stroked her sex and breasts and smiled vacantly. I got involved in her face changes as I tried to read her thoughts, her feelings. I thought I read in it an endless and terrifying boredom. There were moments when her

face was simply overcome with rage, and she was morbid and angry, and the various parts of her body seemed to exude the same angriness.

Ah, she has been moving these arms and legs and hips hundreds of times before, just like this, with the same boredom, same anger. The very walls of the little room seemed to perspire anger and boredom. Imagine, day after day, day after day looking at those popped-out eyes?

Suddenly I had a great sympathy for her. That's how I dragged the steel slabs, at Bebry Bedding, day after day, with that kind of anger and boredom. Just like her, I was prostituting my own life, in a slightly different way.

I walked out and continued along the crowded street. I stared at the huge shapes of buildings, advertisement lights, the streets hiding in their maze, strange lives, lives that went deep, deep, to the very bottom of this city, and I thought, yes, it may go as deep as Hades.

May 24, 1952

With Algis' father, early this morning, I went to Great Neck to film D.P.'s working. Working in the country of their dreams.

Landsbergis, in his khaki army clothes and cap—still looking very much a D.P.—with a brown paper bag of sandwiches. We took a train, to Nostrand Avenue Station. We walked to the house of Gruznis, he has a car.

The morning is beautiful, not much traffic, it took us only twenty minutes to get to Great Neck. Gruznis, full of energy, ascetic, with longish nose, sharp, hard features, is explaining everything, he knows the ropes, he has worked a lot around here, he knows every home.

At Vasiliauskas', a bunch of men stand, waiting for the rest to arrive. In working clothes, with their caps over their eyes, two Russians, one Italian, and a dozen Lith-

uanians, some old immigrants, some new. They are all sort of shabby, unshaven. They pull rakes, shovels, lawn mowers, sacks, blankets, all kinds of utensils from the shack and drag them to the truck. Vasiliauskas himself, with his red lumber jacket, and long pants, as messy and as dirty as his workers, only his eyes are a little bit brighter, he looks more awake.

Merkelis came and immediately rushed to the shack: early comers get better tools, better blankets, machines, rakes. Late comers get rakes without teeth, and shovels that leave blisters on your hands. Under his big hat, and heavy clothes, I can only see his nose sticking out.

Gruznis and the other guy, who was a teacher in Lithuania, came early, they got all their tools and took everything into their own car, and are standing on the side, watching the others.

Now they are all standing in the truck. Rakes, lawn mowers, sacks piled in the middle of the truck. They are only waiting for Vasiliauskas to explain something to a late comer. At eight o'clock the truck is ready to move. The organist is talking about choruses, and some concert that is coming up, but the truck is already going and nobody can hear what he's saying.

Vasiliauskas takes his little dog with him. Through the narrow, tiny roads known only to Vasiliauskas, now right now left, now around, past the houses and lawns— making a stop here and there, and dropping one worker, or two, unloading their tools, moving further, we drive. A rich neighborhood, they all want to keep their lawns and gardens prim, so it's a good business for Vasiliauskas' team.

Merkelis is mowing the grass. A two story home. A beautiful woman stands in the door, she shouts: "Are you the boss?" "No, the boss will be back in five minutes." The woman disappears. Merkelis starts his machine again,

keeps pushing it. It's eight thirty, the dew is still on the grass, his feet are wet. He makes one full circle. The grass is still young, short. Vasiliauskas drops him at this house once a week, every Saturday. Sometimes it takes the whole day. Besides taking care of the grass, he also has to check the earth around the trees, fix it up, clean out around the fences, and the flower beds, too. It's spring, and there is a lot of work, and you need not rush—you can stretch it through the whole day, if you don't rush. Take it easy. Time and money mean nothing to these people.

Who is that woman, the owner. She looks rich.

"You should film her with Vasiliauskas, she'd like that," says Merkelis.

The grass bag is already full. He places a blanket by the fence, empties the bag on it—later Vasiliauskas will collect it in his truck—and continues pushing. He walks a little bit like a bear, Merkelis, heavily, places the bag on the machine, picks up the handles, pushes the lawn mower to the other side of the lawn, towards the house, in the shade.

Vasiliauskas comes back, the truck is empty, all workers have been dropped off. He is talking now to the "beautiful," "rich" woman, under the tree, holding his little dog on his elbow. Another dog, brown, big—it belongs to the woman—jumps around, growls.

The sun is climbing higher, it's getting hot.

The organist. Age 27. He has to cut a very large lawn, trim a very large garden, and the backyard. Almost a field. It's wet there, low. It ends up by a small pond. He pushes his machine and sings. Says, it's better than in a factory. Sun, warm, hot, sweating, but the air is good, he is working for a rich landowner, maybe he owns a factory. D. P.'s, they came from somewhere, hell knows where. They'll keep the millionaires prim and trim.

His chest is open, in shirt sleeves, his hair romantically over his eyes, he pushes the lawn mower and sings. Tomorrow morning he'll play Bach on the church organ, in Williamsburg, the church of St. George.

Gruznis with the teacher, I don't know his name, is digging out a huge stone. The stone is sitting right next to the tree, prevents the tree from growing. So they are trying to dislodge it.

The house is new, there is a lot of work around the house, everywhere, a lot of junk. They have been working here for a week already. They leveled the ground, made up a little garden, raked the yard all around, sowed the grass seeds. Now they are fixing up the water drainage, so that it would look neater. There, the grass is already beginning to come out, fragile green tiny blades. In the middle of the front yard two young birches, coming from the same root, like close twins, with leaves already, they are growing beautifully. Behind the house, on the other side of the road—a whole forest.

The sun is climbing towards noon. The teacher is raking the grass, and Gruznis is still struggling with the stone. It's a small stone, when you look at it, what's sticking out—but he's digging and digging and the stone doesn't even budge. He pulls at it; kicks it, then digs again.

Landsbergis is leveling a hillside. It is a sandy hillside. He has to strengthen it somehow so that the sand won't run down. Vasiliauskas brought earth, stones, sticks, so he has a lot to do. Jurgis is cleaning the bricks. The house burned down, but the bricks are still usable. He cleans them and piles them up in little neat stacks. Working with hammers and chisels. Scorched wood lying around.

Below—the bay. Oyster Bay. You can see some boats, trees, more houses. He stops, gazes at the bay, then picks up another brick and goes cul-cul-cul with his hammer.

Landsbergis keeps working on his hill. A lot of work.

This part looks O.K., but the other side needs much more strengthening. And the whole lower part must be thoroughly cleaned—it looks like a garbage dump.

The owner's wife comes out, brings a chair, sits down.

"The chair sits crooked," she says, "the whole yard is crooked, maybe you could straighten it out."

He takes a ruler, measures all around the chair, the legs of the chair, up to the woman's hand.

"Sure I can fix it," he says assuring.

In the middle of the front yard sits a sand machine and a wooden box with some leftovers of cement. The workers aren't there. In the shade, under a cart lies a dog.

"Look," says the woman, "this cherry tree."

She stands up, walks up to the tree, looks at it. Touches the blossoms.

"This cherry tree is so miserable," she says. "Look how the blossoms are falling down. Maybe you could get some water to it, somehow, fix it up, put earth around it. Something must be going wrong with this cherry tree. The same will happen to all the trees if I plant them here."

Landsbergis comes up, studies the tree, says:

"I will fix it up, O.K., O.K."

It's very easy,—I am thinking,—just get rid of the frog that sits there and guards the pot of gold...

The woman picks up her chair, walks into the house.

Vasiliauskas' truck is already waiting on the road. Landsbergis picks up his tools and walks to the truck. The next stop is to pick up Merkelis, he has to transfer him to another place.

A man is walking down the road.

"Hey, you there, John?" shouts Vasiliauskas. "I am going the same way, jump in."

John scrambles into the truck.

"My truck doesn't have a license yet," he says. "How is business?"

"O.K., O.K. Here we are."

John jumps off the truck, waves, the truck drives away.

May 29, 1952

Stopped at Leo's place. Leo's not home, only his wife.

"He went shopping. This evening he is leaving for Chicago."

"Chicago?"

"Yes, you know him, it came to him suddenly. He decided to go to Chicago."

That was news to me.

"I am going to do some shopping. My mother will keep you company. I'll be back soon," she said.

I slumped into a sofa, by the window. The mother remained standing, leaning the door, silent. She is a gloomy type.

I thought I should try to break the silence somehow. If I say something, I know she won't say anything anyway.

"Are you spending the whole day with children, by yourself?"

"Yes. I take Gytis to school, and then I am alone with Rasa."

"He must be reading by now?"

"No, they only let them draw and paint. They write letters. He speaks a lot of English now. Lithuanian, English, German, all mixed up."

"What kind of books are these?"

"Leo ordered them by mail."

I look through the books. *12 Famous Artists*, a course by mail.

"What do you think of them?" she asks me.

She looks at the books very skeptically.

"Do you think there is anything good in them?"

I can read her thoughts behind the question. Whatever Leo does, is stupid, a waste of money.

"He is only wasting money on his stupid whims," she says.

"They look O.K.," I say. "This is like going to school. He'll save money and time."

She looks at me skeptically.

Leo's wife comes back, with the children.

The children are curious, they want to be in the same room with us. But she chases them out:

"Go, go into the kitchen."

They walk out, very unwillingly.

She doesn't think children belong with grown-ups, she always chases them out when visitors come.

She places a basket of fruit on the table. I pick up an orange and begin to peel it.

"So, he's going to Chicago."

"Suddenly he decided. You know him."

"He said he would be back at seven, now it's eight thirty."

The mother stands by the window, looks out.

"He doesn't need anything. But wants to squander the money."

"Let him go, let him. He will travel around a little bit, he will be more quiet, will tire out. Now he's so nervous, so..." Leo's wife says.

Mother: "He was always like that."

Leo comes home. He is carrying a newly bought suitcase and a coat. He wears the same working clothes, as always, blue jeans. He is unshaven, tired.

He puts on the new overcoat.

"Look, Murza, do you like it? Guess how much I paid?"

"Eighteen dollars," I say.

He looks, then says:

"Looks good, eh? I said, I'll have to buy one sooner or later, so why not now? I have no overcoat."

He opens the suitcase, closes it.

"How much?"

"Maybe six," I say.

"How come you are so good at prices? It's six plus taxes. I paid eighteen thirty for the coat."

"So you are going to Chicago? The whole of Brooklyn is talking."

"Who? Who told you?"

"Oh, everybody's talking," I say.

"I don't know yet. I don't have the ticket yet. Maybe tonight, eleven thirty. Everywhere long lines now, like in Germany. If I get a ticket—I'll go. If not—I'll stay."

"You can always go somewhere else, like Stony Brook."

"I told Murza to go to Stony Brook, but she doesn't want to go alone."

"You know the conditions: a new skirt."

Telephone rings. Leo runs out.

Murza: "What am I going to do there, by myself, in Stony Brook? I don't know anybody there. And he says: 'Go to Stony Brook.' How can I walk around there, alone. He doesn't want to go."

Leo has a long phone conversation. Comes back.

"Mrs. Osmolskis called. Ah, those women... I can't escape them."

He looks at Murza, teases her.

"You are always like this: you get a free day, and you run somewhere alone, by yourself."

"O.K. When the next free days come, I'll let you run somewhere, to your relatives."

"We'll see... I don't believe you."

"True. I'd be happy if you'd go somewhere. You think I am holding you?"

"You, I am not holding you either. Go, go to Chicago. You never spend holidays at home—you always run out somewhere, by yourself."

"Ah, at home—I see enough of you at home, alive, with bones and flesh."

He speaks almost angrily.

I leave Leo's house, walk around. I stop at Landsbergis'.

"Leo must be sitting in Chicago by now," I say.

"What? That one must be going out of his head, I tell you," says Algis' mother, from the kitchen, lifting her head.

Algis' sister Gigi is working on her clothes, straightening them, or something, things that women do with clothes. Her boyfriend, Mamertas, sits with his legs stretched out in the corner sofa. Algis' brother Buzela, I can see him in the other room, he is sitting by the window, reading, his back to the table.

"It's true," I say.

"What's he going to do there?" asks the mother.

"Nothing. To see Mikšys, some other friends. To get fresh air."

"And the wife, he doesn't let her go anywhere. Some father! If he'd only take them out somewhere, into the country, the children—but no, always alone." Algis' mother speaks angrily.

"He gets tired, working. Needs to take time out. It's his character, it cannot be helped," I say. I have to say something.

"Why did he marry, then? If he doesn't like family life, he shouldn't have married. I saw it all along, he was no good. Ah, how much she has suffered, his wife."

The mother speaks from the laundry room. We are silent.

"I remember, still in Hanau, she was walking, pregnant, with a child, she came to Wiesbaden. She meets him, and he is walking with his arm around another girl. Who ever saw anything like that! I would have spat and left. But she has no character. He is always with other women, and she's suffering. I would leave him, then I would have a quiet life. Going to Chicago! And then he comes here, acts like a big good father. Talks, explains. Pfui," she spits.

She speaks now very angrily. We are silent, we look at each other. Mamertas is smiling. After all, some of this maybe directed towards him: he wants to marry Gigi.

"Marriage is a very serious matter, one has to think about it seriously. Now, he has ruined her life, broken her heart," continues Algis' mother.

"Look at Algis. Algis loves Jane very much. Look how he cares about her, cares about every little word, doesn't forget. The other morning he comes running, to iron her skirt. He says, Mom, I don't want to put this on you, I'll do it myself. He would cross oceans for her."

Now she is talking from the living room, she is no longer in the laundry room. She is standing in the middle of the room, very emotional. She turns around, goes back into the laundry room.

Now she speaks smiling:

"When I was young, such was my attitude: If I had ever seen my husband with another woman, I would have spat and walked out. But he has never done that. If a woman comes to him, he talks himself out of her, nicely. Not like Leo: always arm in arm, *spaziering*."

WORKING ONE'S WAY THROUGH M.

June 17, 1952

Ah, they were all from the city, my friends. For them, nature was the summer beach, weekend trips, vacation. To me: it was an endless symphony of rains, wind, snowstorms, mist, dew, and all the hard work we had to do. Getting up before sunrise, the eyes do not want to open, you barely see the cows as you walk through the wet, cool morning grass.

Now, in the city, I get wildly excited when I see a snow flake or a drop of rain. Florence, and all my coworkers at Graphic Studios, they curse snow and rain and run to buy galoshes. They think I am crazy. Lizzie said today:

"He is a barbarian, nature child."

No date, 1952

Dear X.:

I am sending you a few poems. I have no plans to publish them. I have no illusions about the readership for my work outside of Lithuania.

You belong to the generation preceding mine, and you grew up and you wrote, and you knew: all of Lithuania will read you. You always knew that. But we—Leo, myself, Algis—every minute, with every word we write we know that our country is being strangled. Ah, how many beautiful princesses have died!

No, our country won't read us. Nobody will need us, nobody will print us, nobody will search for us. Only a few friends, that's all that's left for us. A few friends.

Therefore, do not wonder, don't be amazed that our writings are not aimed at any public, any reader. There is no public for us. We write neither for fame, nor money, nor honor: none of it will ever come our way. We are writing because we have to write, because we cannot not write.

I HAD NOWHERE TO GO

A MEMORY

My father was conversing with Martynas, our neighbor farmer. Father stood leaning against the working table, Martynas sat at the end of the table. I remember Mother saying:

"You never look into the eyes of the person you talk to, never—you always look past the person."

I was sitting by the stove, on the bed, listening, watching. Father said nothing. He continued his conversation, as always, looking just over Martynas' shoulder—looking somewhere behind Martynas, into some indefinite point in space, to the right, and again pulling his eyes back, into himself, or on the tool he was working with, focusing on the working table, on the wood shavings, on the drills.

Mother: "Never, you never look people in the eyes." For a moment she remains silent, then: "He had to be a carpenter, he had to. I don't know why he ever became a farmer. We would have lived much better... He was so good at what he was doing..."

Father is silent. Mother goes into the kitchen.

They were lying there on the ground, with their faces close to Mother Earth and, goddammit, they didn't learn to understand it, to know it, to love it. Even then, with their faces pressed to the black earth, and bullets zooming past their ears, they thought only about their lost properties.

System, everything's a system. With a good system you can make the monkey into a man, and a man into a monkey. You can skin people alive—with a system, and for a system.

If you have a system, you can skin them even when they are still children, and they'll go through life skinless, they'll live without skins and they won't even know it.

Yes, what a great thing is a system.

420

I change my opinions as soon as I outgrow them.

Reason? When you touch a ball charged with electricity, does the electricity have a reason to discharge itself? Or an apple, to grow, to ripen, to fall? Or to do good to a child? Or to be a mother? To love? To create?

The best things have no need, no reason, they happen, the same as when you release an object and it falls.

June 24, 1952

I still go to their meetings, entertainment evenings. From a sense of duty. But I have nothing I can share with these people any more: only my origins, the past.

They have become so fat, all of them. I can not recognize them. I look, I stare into their eyes for a long time. It looks like someone I knew... The voices, too: I have heard that voice somewhere... But the face—the faces are not the same. Too round, too fat.

July 12, 1952

Can't force myself to work. It's hot, humid.

For a while I sit among the books, then I try to type. I drop everything, go to the window, watch the street. Ah, there is the mailman, maybe he has something for me.

The street is full of people. Linden Street at its busy peak... A garbage truck is picking up trash, men are emptying stinky containers. Two men, in shirt sleeves, crouched under a car, are trying to fix something, their tools scattered all around them on the street and on the sidewalk.

No mail. I decide to visit Leo.

Leo is not home, he went to the Brooklyn Public Library, to visit Algis, he works there. But his wife is at home.

"Leo isn't home, went to the library."

"I had nothing to tell him. I think I'll keep moving. I was just passing by."

"Usually he doesn't go anywhere this early in the day."

"I hear you were visiting your relatives."

"Yes, I visited my Pennsylvania relatives. It's very beautiful there now."

"Alone or with the children?"

"Alone. I can't persuade him. He is such a difficult man. It would be nice to go somewhere—but he: no. Before you know, he's out somewhere, you can't catch him."

Gytis is grown up, a big kid already.

She continues:

"Now it's summer, the weekend comes, it's so hot in the city, you don't know what to do. If only we could go somewhere, let's take the children out. But he will not listen. He doesn't care about home at all. See, this bed: the whole year it has been sitting like this, broken. Before we get to bed, we have to put something under, to keep it from collapsing. But he won't do a thing about it. And the mirror, look. You remember, when we took it off? It's still sitting there, not fixed."

"Ah, what can I say. I have no advice, no matter how I may want to. My opinion is that he can't be changed. It's his character," I say.

"He is just like his father. Algis' mother told me, his father was just like him. I can imagine what his mother had to live through. I wouldn't wish that on anybody."

She sits down in a chair, her voice trembles. Barely holding the tears. I am afraid they'll just explode any moment, and I can never handle such situations.

"See, even the children are afraid of him. He is like a stranger to them. He never brings them anything. No toys. They don't have any toys, they are afraid of him.

Now, if I ever say anything that displeases him, he immediately says: Now you see, there is nothing between us, nothing holds us together, can I just go away now? You can imagine how difficult it is, sometimes. Now, he is again threatening to run off to Chicago. He got a letter from that woman, so he sat for an hour looking at it, read it over many times. You get a letter, you read it, and you put it away: but no, he's into it for one whole hour. So I told him that. I said, I can't stand such treatment. So he says, he's going to Chicago, everything's finished between us, there is nothing but friendship between us, that's all. He told me that I understand none of it. Friendship, he talks only about friendship. He lost his head over that woman. You can read for yourself."

She picks up a letter and hands it to me.

"Only please don't tell him. I only want you alone to know this. I can't tell it to anybody. Only when I visit Algis' mother, we talk heart to heart. Sometimes I call Algis on the telephone, we talk a little bit. But that one, he says nothing. In his heart, of course, he agrees, but you know…"

The letter is on a white sheet, written in pencil, in big flourishing script. The handwriting is not intellectual, not hard-edge rational, but emotional, and very elegant, even obsessed. The letter says: "I am happy to know that you are thinking of me. I know that there is in the world at least one whom I can call my friend, a friend of my fate. You are writing about how lonely you feel. Please write more often, and write about everything. Your Jane."

Something like that, not a quote.

"How does this look to you? Is it really innocent?" she asks.

I sit silent for a long time, thinking, looking at the letter. I don't see in it anything really very guilty; not in the way that she sees it. I know Leo too. The words and

tone in the letter are those of a great friendship: warm, close, and hopeless, desperate.

"I don't think that there is anything very very serious between them," I say. "You know him well, and I know him in some ways: it's his character to be very intimate with people, with anybody. It's not love. His friendships are very intimate. Looking from the side, not knowing, one can suspect all kinds of things going between him and his friends. But it's not so, you know it. On the other hand, I know how hard it can be if he begins to give more to his friends than to you, either in love or friendship."

"Yes." She speaks with the same trembling voice. "He treats me like a stranger. I can't sleep nights. My nerves are all in pieces. My heart, too, and he knows it, he knows that my heart was always weak. When it's midnight and I am still awake, he asks me as if he knows nothing: Why aren't you sleeping yet, anything wrong? So I say, it's nothing, I just can't sleep. The other day I said something—and I am always so careful now of what I say, I don't want to say anything he'd dislike, but you can never know him—the other day I said something, so he jumped up, threw thirty dollars on the floor, and said, 'take it.' I didn't. My heart, I suddenly had such pain in my heart, I couldn't. So he begins to count every penny, every dollar, everything. He told me that I am giving nothing to the family, and I earn nothing, and that he alone keeps the family alive. And what letters he used to write to me, when I was still in Germany! I would have never come here, but he wrote, 'come here, I am going to change, I cannot live without you, come here.' I have maybe a hundred letters from him, two, three times every week he wrote. So I say now, 'why did you write like that, why did you tell me that you have changed.' So he says: 'What do you mean, I wrote you like that?

I never changed, and I'll never change, and nobody's ever going to change me.'

"So I tell him, even Algis' mother advised me to separate. 'Why don't you separate and have peace,' she told me, 'you'll have peace in your head.' But I know, two months will pass, and he'll write again, saying that he can't live without me, I know him. I suffered already so much that it makes no difference, I can suffer another year. Maybe he'll change. Maybe. If not, then I'll see what I have to do. I don't want a single penny from him, I will take care of the children myself, somehow, he doesn't give anything to them anyway, he doesn't love them. One time, when we got into an argument, and the separation was mentioned, he says, 'O.K., why don't you go and sue me? If the court will tell me to pay you, I'll pay; if not—you'll get nothing, not a single penny.' Can you imagine? I don't want his pennies. I won't take anything from him.

"His mother loved me like her own child. When she saw me coming, I remember, she used to meet me like her own child. I knew him from when he was a child. We played together. Then during the war, we separated. But we both ended up in Germany. And one day I received a letter from him. And then he came.

"He doesn't know, has no idea what he wants to be, what he wants to do."

She speaks and speaks. She has to unload herself. Only occasionally I say a word or two. I don't know what to say. There is nothing that I could say, I know that nothing could be changed easily.

"Maybe you are right, maybe you should wait a year and see what happens. If by then you feel that you can't go any longer, then you should part, for the sake of peace."

"I guess I'll wait a year. I'll see, I don't know what to do. He is such an abstinent, difficult man, he doesn't change."

No date, 1952

The 20th century (or was it 19th?) produced Freud and Jung: digging into the unconscious.

But it also produced cinema where man is being portrayed and defined by what we see, by the surface, and in black and white: as if defying both, Freud and Jung. The surface tells everything, you don't have to analyze your dreams; it's all in your face, your gestures, nothing is really hidden, buried in the unconscious: everything's visible... They talk about cinema, about Hollywood as the place of dreams. No, it's just the opposite.

July 17, 1952

Saw *Battle of Berlin*, or whatever the title was. Stalin is walking in his garden, *spaziering*, like Voltaire... Taking care of flowers, boy oh boy... When he speaks, the others listen agreeing, nodding, yes yes yes... And whatever he says, it's all truth, like in a book...

July 20, 1952

No, I don't think I have ever been a good patriot in the way my Lithuanian friends are. Neither is Adolfas. They love their country, their patria. But we two are attached only to Semeniškiai, to our little village, to the countryside and the people and the nature there. It has nothing to do with nationalism: we are regionalists...

WORKING ONE'S WAY THROUGH M.

The weather... The seasons of the year... Little nuances of nature. The color of blooming meadows... Nature is very regional. And don't tell me that this is only romanticism, sentimentalism, etc. It's all very concrete. Our movements, the way we walk. Our accents, the way we talk. Everything is determined, marked by the climate, landscape, the sun in which we grew up. It's not just a memory.

August 24, 1952

Dear S.:

Here I am again, surfacing after a long silence.

The summer passed, the heat is gone, so I can sit down and write a letter. This summer has been insufferably hot. The worst is the humidity. Without it, one may survive it somehow. But now, the heat comes, and you don't know where to run, what to do. You melt, you slump down, you collapse, you become a sponge, the sweat runs down in streams. Whatever you drink immediately comes out in sweat. From the cup directly to the skin. You don't know what to do. So everybody tries to leave the city, whenever they can, and by whatever means they can, cars, trains, buses, planes... You go to the beach: there are already one million of them. A million on every beach, bellies up, towels around heads, melted. Same in the water: no place to put your foot, wherever you step it's a head, a belly.

In the city, when it warms up, the heat releases all the smells. The whole city begins to reek like a huge garbage dump. And then: the thieves, bandits, crooks, JDs, swindlers. At night, on my way home, I walk practically in the middle of the street: if you walk close to the buildings you are risking either a knife in your side or an iron pipe on your head. At night, you always have to lock the

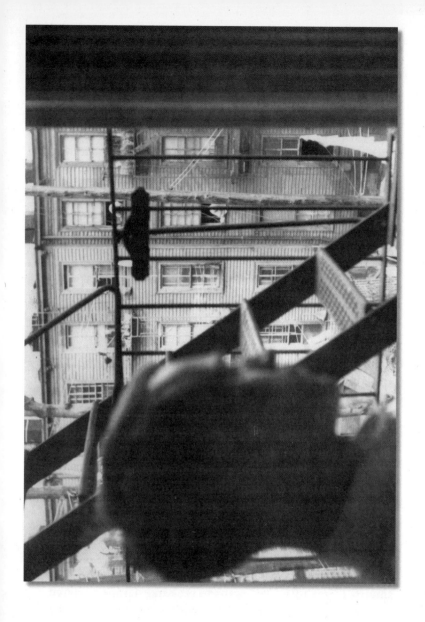

"The window here are not to look out into the world:
they are the eye of fear staring at you."

windows tight. No matter how hot and humid, you can't sleep with your windows open, not even during the day. What a life. The windows have been a cause of a lot of killings and robbings here this summer. The windows here are not to look out into the world: they are the eyes of fear staring at you. You sleep, and you keep looking at the windows. I sometimes think that I live here only from my own stupidity. If I weren't obsessed with film, I don't think I would live here. Now, in September I will begin attending the Film Institute, studying with Hans Richter. I went to see him and told him that I have no money, but I'd like to study with him. So he said O.K., just come. What this will give me, I have no idea. I am not really going there to learn: I want to meet people interested in film.

I am still working in the same place, a photo studio, Graphic Studios. The guy who runs it, Lenard Perskie, is a great guy, and is one of the leading specialists in color photography, so some of the top photographers stop by to talk with him, *Life* magazine people, and some artists, too. Archipenko hangs around. The name may not mean anything to you, but it means a lot to me.

Sometimes, during the weekends, I manage to escape into the country, to some lake, or woods. When in the city, I always film, and film. Now my friends ask me to film their weddings, which I do for them. They all want to have their wedding films. Every weekend somebody weds, so I have a lot of weddings to film. Not for money, just for pleasure. Or baptisms. Otherwise, no matter how you work and jump and move around, life is not too exciting. Everything glides through the surface, doesn't go deep. Days, weeks pass, very very fast, too fast, the summer, one year, two years. Time goes, but the dreams, plans remain in the same place. When Adolfas comes back from the army, we are going to shake our dreams

and plans up a little bit. Our life will have to change, one way or another. Even if we have to leave New York. We'll see. We'll have to make another Five Year Plan. This current one that began in 1948 is reaching its end. I think we have achieved our goals, the "quota" has been achieved. We planned to get our footing in America or some other country, and we did it. We planned to get some profession that would insure us jobs here, and to learn everything about film. When, in about a year from now, the first Five Year Plan will end, all these goals will have been achieved. We are in America. We have at least ten professions... We can work with any kind of machine, we can do photography (Adolfas is in the Signal Corps) or dig ditches... We have much bigger plans for the next five years. And nobody is going to detract us. We are very obstinate and determined. We don't care how much time it takes, we have a lot of patience.

Please let us know the progress of your trip. Send us a postcard. I think it's better that you are going to Canada. Do not regret New York. New York is better to visit or read about than to live in. Like all fairy tales.

September 21, 1952

(From a Letter)

I may be wrong, but my own thinking is that none of us, who represent the young generation of Lithuanian writers, will be able to really develop fully, here, in exile; nor will we be able to unload what we have, whatever we may have, except maybe to a few friends, friends of the same fate. Sooner or later we are all going to freeze, in our journeys into ourselves, tragically, maybe even cynically: without anybody to read us, without a nation. I do not believe in the speedy liberation of Lithuania. There were some courageous people who didn't want to

go into any compromises with life, such as Yesenin, Blok, Mayakovski, at the end—but we, sometimes I think, we live in a fool's hope, and we write, and we publish journals, not because someone needs them but because we want to prolong a little bit our dream beyond the limits of reality.

Do not take this as some kind of expression of pessimism: presently I am in such a mood where pessimism looks like the only realism I can still accept. For what purpose, what the devil I am writing for, for whom, and still more: why publish it? Why and for whom? Who is reading it, who is interested in it? Friends? I have a pile of manuscripts, short stories, but I can't force myself, for the reasons mentioned, to sit down and polish them, really complete them. Same with the Reminiscences cycle, it's sitting there, raw. I wrote them this summer, but there they sit, raw. Rawness as style, my whole life is becoming raw.

But, for real or unreal reasons, let us continue the game...

13. THE ROOTS IN A DESERT
or BACK TO ITHACA

Nights without sleep. The author at the brink of a nervous breakdown. He leaves the Brooklyn immigrant community and moves to Orchard Street, Manhattan. Longing for a real bed after years of army cots... Debates, America vs. Europe. Should he want to be like everybody else? The first new roots.

January 1, 1953

And then, all at once, everybody was shouting in high excited voices. The whole place was a chaos of incomprehensible noise. They were expressing their New Year's enthusiasm... The whole place was nothing but one big noise, embracings and clinking champagne glasses.

I stood with my glass raised, waiting until everybody emptied theirs, and I looked over and past the glasses and past the heads into the crowd. Where was I? In Petrograd, anno 1916? Berlin? Where am I?

At the far end of the hall there was music and everybody was moving in that direction. The place was completely packed, and there were more people trying to squeeze themselves into the space next to where I was standing, hopelessly pushing, knowing that it was totally impossible to push through.

I sat at Dana's and Alina's table. I felt I was an intruder. It was a family circle, bound together even more strongly by the occasion, and there I sat, holding my glass in the air, looking into the space.

A man came and took Dana for a dance. I sat and watched them dance, in this huge crowd, and I saw she was smiling, and laughing, and suddenly I felt envious of people who could make other people laugh and smile.

Here I am, sitting at someone else's table like death that
came to dinner, closed up into myself, like a clam. I was
so closed into my own loneliness that it couldn't be pried
open even with a knife.

Now there were only three of us at the table, two
elderly women, and me. The two women conversed and
were perfectly happy. They were in their sixties, they had
their lives behind them. I looked at the other tables, and
I could hear New Year's greetings, and I stood up and
made an artificial smile, they knew me, but I didn't know
them. I lifted my glass and I laughed, but my mind was
completely vacant. I didn't want to think about anything
or be with them, I couldn't. Come and join us, one said,
but I could already feel the boredom.

I returned to the table and found Vida. She was saying
something to me, but I couldn't hear her. She repeated
it, but I still couldn't hear it, and we sat silently for some
time, while my nervous fingers, I noticed, were tearing
the napkin to pieces. We conversed about something,
saying anything, then I told her that I liked New Year's
dunce caps, I should get one, and she said, she'd like one
too, so we began pushing through the crowd to where
they were selling the caps and trumpets, near the buffet,
but when we arrived, there was nothing there, only some
people standing and drinking beer and the Italian selling
his sandwiches, the colored caps were sold out. I looked
around in mock despair then we began pushing back
through the chaos. I walked behind Vida, she was leading,
and I was looking at the dancing couples. Everybody
spoke in high voices, and some were dressed in ballroom
outfits and neckties and white starched shirts. Chande-
liers moved and swung with the music.

Author, December 1952

Suddenly I felt so totally lost in this crowd, so unnecessary and so out of place, in such disharmony, that I wanted to turn around and run out and be as far away as I could—far from these my fellow compatriots. No matter where, as long as I was out of here.

I took Vida back to her table. There, some tall young guy introduced himself, he said he knew me but I had no idea who he was, and he said he wanted to talk to me about something, and I shouted: TO TALK, HERE? and I stood up and I left the table. I had a sudden desperate craving to find at least one person whom I knew with whom I could really be open. I looked for Algis, he should be here, I thought. I found him on the other side of the hall, he was with Jane, and I pushed myself across the crowd towards them, stepping on people's feet, and excusing myself.

Algis looked at me and he understood everything. He said:

"Intellectuals... Too much intellectualism makes people unhappy."

"I see you manage."

"A random harmony," said Algis.

I wished them Happy New Year and started toward the door. A woman I had never seen before stopped me. She was drunk, and she said she wanted to talk about Cocteau and Rossellini. I said, "you must be crazy."

I looked at my watch. It was three in the morning. I walked into the street.

No date, 1953

In the middle of the night he hears the air raid sirens. Loud, terrifying. But when he jumps up in his bed and stares into the darkness—he hears nothing, sees nothing. A huge silence. Everybody's asleep, the whole

436

street, the whole downtown. The lights in the building across the street are dead, a black darkness looms in the windows.

All night long they come and go, voices and sounds from the past. Voices already distant, of those whom he will never see again. Voices from long long ago. Voices from warm summer evenings, the faraway sound of frogs. The sound of milk pails, the creak of a water lever by the barn, the sound of steps in fresh-washed rooms, the wind passing over the rye-fields, the whinnying of the horses far in the morning meadow. All the voices, all the sounds come and mix together, all night long they come and go, and he hears them, and he sits up in his bed and listens. But when he sits and listens, and hears nothing, he wonders: is this really silence or is it not; there is a sounding in his ears, a laugh he just heard, a heavy thumping noise of earth falling on mass graves, and he thinks he felt somebody's hand on his shoulder, somebody who comes up silently and asks, almost without words: Are we going home soon?

All night long, all night long he wakes up and falls into sleep again, and the voices come and go, sometimes the same voice over and over: Faster! Faster! As in a nightmare. He moves his hand in sleep, but the voice doesn't go away, it's still there, loud, filling the room.

And when; sometimes, in the middle of the night, all voices suddenly disappear—the silence is unbearable, the silence is so loud, so loud and frightening.

March 5, 1953

Long hours of walking without sleep. I was angry about everything, the compromises I have made till now. Now I want only my work. To throw myself into my work. There is no other choice. The other choice is to go mad.

I am not too clear these days about the proper direction or the exact thing I should be doing. I have to burn the bridges once more. The smoke will show me the new direction.

 "direct" poetry
 desperation is not truth

No date, 1953

I promised to help the old man carry some things home. I walked along 22nd Street, carrying the bundles, and the old man walked beside me. The old man was talking and talking. He was about to tell me all his life. But all I could hear was cars and the street noise and my own mind. I tried to be polite, occasionally burping a word or two, but it finally got on my nerves.

"Look," I said, "I can't hear a thing, it's too goddamn noisy."

The old man walked silent for a moment.

"I came to this city forty years ago, there is nobody to talk with," he said.

I tried to sleep, but I couldn't. I tossed and tossed around in my bed. Only towards the morning I fell into an exhausted, deep sleep. But then soon I woke up again. I got up and I stood by the window. I looked at the street, the benches, lights.

Overheard in the street, one bum to another, on Third Avenue:

"This is no place for me either."

Overheard, one bum to another: "I am watching the buildings."

(For entertainment.)

THE ROOTS IN A DESERT...

One bum to another, in passing, almost without looking:

"Are you strong enough? ..."

He continues walking, slowly. The man addressed is leaning against the wall in a dark downtown street. The voice weak but delicate, is that of a friend by inquiry.

Overheard in the street, two old people, a man and a woman, talking. The man:

"You don't realize how old we are."

The woman says nothing.

They say, do not lose the road for the small path...

It depends where the road is leading to. It depends where one wants to go.

There are places which you can reach only through tiny paths. Only the dictators, armies, generals, and people without imaginations prefer wide, "strong" roads. Little paths take you to the gentle meadows, brooks, flowers, cool shadows. I wouldn't like to miss any interesting side paths, patches of greenery. Because, at the end, at the end of the Big Road, there may be nothing but a burned out city... pestilence...

Dear T.:

Four times I sent my poetry books to my mother. Four times she didn't get them. The government of the Soviet Lithuania was seized by such great fear of poetry that it had to confiscate the books.

Ah, you good people! You are always so good. But you permit your souls to be governed by idiots... Ten idiots can do more harm than three million good people can do good, if they allow themselves be governed by the idiots.

439

Yes, but the idiots have machine guns!

Romain Rolland wrote once: Lithuania is green and silver...

Ah, he wrote about your fathers...

There is neither green nor silver in Lithuania any more.

There is only red.

April 15, 1953

Rented a small apartment on 95 Orchard Street. Rent: $13.95 per month. Until I move my things in, I am sleeping in Lilly's empty Essex Street loft. She is away for a week, so she said, use it. As a prelude to the new Five Year plan I decided to quit Brooklyn. So here I am, in the pickle and bagel district.

He slept that night in a real bed. It was a large and soft bed, and as he was thinking about it, he became very conscious of the bed. Look, he thought, when did I last sleep in a decent soft bed, and with the smell of a woman hovering over the sheets? All these years, in barracks, in camps, in hard Spartan army cots, in the fields, and in the woods, on hard wood, on stone floors, on stinking mattresses, like a bum. Now here I lie and with my whole body can feel the softness of the blankets and the cleanliness, which is so soothing, so relaxing, so quieting. He thought he was lying in bed for the first time in his life. It was a strange feeling, a childhood feeling, mother, etc. Yes, there was—he tried to remember but he was falling asleep,—there was a small soft bed with little red feather pillows, in his childhood, when he was six—five—or four—but he couldn't remember any more, it was so far back and so unreal—

THE ROOTS IN A DESERT...

A SHORT STORY

"In some ways we are like strangers," said she.

They were sitting now by the stream in the woods with their feet in water.

"Many times, when I am talking to you, you seem to be somewhere else, not with me. My words bounce back without reaching. I know that it's not because you don't hear me. You are very sensitive, I know that you hear what I say. But you say nothing. All the time I have a feeling as if there is another woman sitting in between. There are always three of us.

"It's very difficult for me to compete with your memory, your landscapes and towns and rivers... I have no place for anything else besides you... I enjoy the stream, the woods, all this beauty—but I love only you."

She looked down into the stream, and then into the woods.

Paul, said nothing. With his hands he picked up some water from the stream and washed his face. Ah!—he thought—ah, this is just like the water of the river of my childhood...

The sun reflected from the bottom of the brook.

Ah, he thought, the days of spring when the air begins to vibrate in the heat and the lumber stacks by the barn warm up and begin to crack... White, it's so white... A little child sitting in the drying yard, looking at the lumber stacks...

July 4, 1953

This evening I visited my neighbor Savel. A Yugoslav D.P., he came here about same time as we.

He was sitting alone in the middle of his empty room and thinking, or dreaming. The room is literally empty. There is nothing in it, absolutely nothing, except for a small table with a lamp on it. Oh, yes, there are also ten volumes of some kind of Encyclopedia, in a wall niche. The walls are bare and empty, save one Chinese print with a mountain scene.

441

"Look," he said, "I like it this way, clean and empty. I can't stand rooms with furniture and things. This room helps me to keep my inner unity."

"Don't fool me," I said. "It's just the opposite: you are split inside into one thousand pieces so you are trying now to heal those pieces together."

"O.K., you may be right," said Savel. "But it's legitimate to try to put oneself together by means of architecture. Maybe that's one of the functions of all art, and especially architecture. Like the imitation of Christ…"

July 6, 1953

Visited Lilly. She moved into her studio. She sublet her apartment, she says she wants to go out of town for the summer. She came home tired and wet. It's still raining. I had to play flute in the other room while she took a bath. Then somebody began shouting from behind the door that the bath was leaking, the water was running down into the apartment below. She came out, combing her hair, and while I was still trying to pick out the tune, we talked about this and that.

"Look," she said, "I am tired."

"Of what?"

"Of everything. All day long I was visiting my friends, family, sisters, mother. I will be happy to leave the city and be alone. I feel so tired of people. Don't you, sometimes?"

"I am bored, but not with people: with myself. When I am tired of myself I run to look for people. That's why I am here now."

"I want only to dance. But I am wasting my time eating, sleeping with these people, with the school, teaching the kids. I should marry the right guy."

"Who is the right guy?

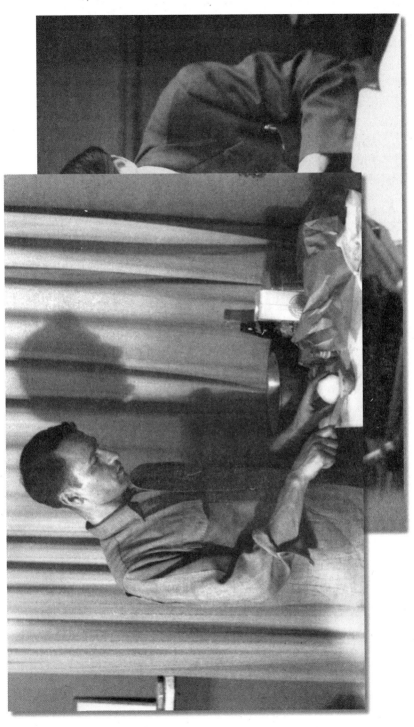

Author, Orchard Street, 1953

I HAD NOWHERE TO GO

"Oh, someone who has enough money to pay for my dance lessons."

"You don't need a man. You need a bank."

"Yes. But I always pick poor men with no money." She thinks for a while, then she said:

"I am still looking for something. But as soon as I get what I want—I drop it. I think my first husband did the same. He got what he wanted and he went away. That's the way to live."

"I don't know any more," said I. "I am very confused about my own life, about myself. I am stuck. I don't understand people. I don't understand you."

"Neither do I. You see what I bought? I spent sixteen dollars on nothing. Just on nothing, just to buy. You know why I am tired? Because I am living like a whore."

Silence.

"Where did I put my comb? I can't find it. I am too tired even to search for my comb. And my hair is still wet. You see, my hair is still short. I cut it, from worry. I am waiting for my hair to grow long. I like long hair. For dancing."

"You never tried to find a job as a dancer?"

"It's not easy. And then, you can't study any longer, when you work as a dancer. You must dance then, the way they want you to dance."

She finishes doing her hair. Black hair. An Egyptian face. You wouldn't think she is a girl from Essex Street.

"You look sad," I said.

"I am always sad when I move to another place. For a couple of days."

"When I was a child, I cried when I had to give up old clothes for new," I said.

"So did I. It's always so sad to leave, whatever it is. So we drag all our lives everything with us: people, things, places… And I would like to live only for dance."

444

THE ROOTS IN A DESERT...

"Life dropped me out of things I loved, the people, places. I don't know, for good or for bad."

"I don't know if that's worse than to be in a vicious circle by myself, afraid to leave off."

"Then don't."

"But I want to dance."

"Then dance. Don't think."

"You are a devil."

On Essex Street the rain was still pouring over the Jewish bakeries and shops and black iron stoop railings.

MEMORY

Red willows. Whiteness. Soft heads of alder woods.

Fragile green leaves, young with April.

Silver of poplars, wild strawberries, red clover fields buzzing with bees, summer heat. The smell of young trees, in the wood clearings, young bark.

No date, 1953

The word "langas" (window) grew into me slowly, year after year, all the way from my childhood, becoming richer and richer in meanings and memories, and they all come back to me when I write that word in a sentence, in Lithuanian. Now, the English word "window" is still very bare and stripped in my mind. When I write "window," it's just a dictionary word, plain and bare, with no memory, no poetry, to me. The souls of English words are still growing in me, little by little. That's why I keep writing, that's why I keep touching them, again and again, on my typewriter, trying to put some life into them.

August 30, 1953

The heat is unbearable. We keep gulping down Coca-Cola, sparkling water, soda, even milk, and water (with some honey, for taste) and nothing helps. Whatever you

drink, it immediately comes out in sweat. I went to the Orchard Beach. I took a crowded, sweating, stinking Lexington line, with one million Puerto Ricans, entire families, including children, carriages, bags of food, blankets. Like war refugees. In any case, half of their belongings go with them.

I was sitting in the sand, in this terrible heat, on Pier 17, with my back leaning flat on a cool concrete wall, looking at the beach. There was no more space on the beach, and people were sitting right in the water. The sand was burning, and you had to run if you wanted to go anywhere.

About three o'clock the water came close to the shore and everybody moved closer to the wall, making the place into a real beehive. Suddenly I found myself in the very middle of a crowd, only the wall in the back gave me some privacy. My neighbors, luckily (this time) were pretty girls. They even offered me one corner of their blanket, for which, in turn, I had to help them look through the *New York Times* ads, *Sunday* edition, jobs for girls—"a good job," they said. Dottie, that's how one of them, the very nice one, but with a nose out of all proportion, was calling herself—Dottie just finished college and wants a "good job" as a typist, or something like that. She knows how to type, that's all she knows, she told me, and I had little doubt that that was the only thing she knew. So I made red pencil marks next to ads that sounded more interesting. Then the girl with the long nose started polishing, filing her nails, and the other one, Flo was her name, wanted to file hers too, but the girl with the nose said, "But mine must be polished, because my fingers will do the work for me and my fingers must look nice to earn the bread." And so they went to work on their nails. Then two guys came, they said they knew them from somewhere, but the girls refused

to know them. They sat there for an hour or so, making stupid jokes, trying to get some closer connection, but the girls were too absorbed in their nails, so the guys went away, kicking sand in people's faces.

No date, 1953

It was time to go home when I came back from a pick up trip. I was all wet and the drops of rain were on the delivery packages.

"Oh, it's beautiful outside," said I.

"It's raining, isn't?"

"That's what's so beautiful about it."

I put down the packages and shake off the rain. I like to say some nonsense like that and see what they'll say. I know they hate rain.

I leave Graphic Studios and I start walking downtown, towards the 14th Street.

Wet pavement glitters under the electric and taxi lights. The evening looks fresh, sensuous.

I walk slowly. At 14th Street I turn left and continue walking. A crowd of tired faces, workers rushing home. Under my feet I can feel the rumble of the Canarsie line. It seems to me that i alone in this entire city am in no hurry. I have lots of time and nobody's waiting for me and I have nothing urgent to do. So I continue walking, the same pace. Here is the evening and the city before me, and I am walking through it, as in a tale from *1001 Nights*.

A SHORT STORY

But there is this tale, I was told once...

I think it was in a dream...

... that when Adam and Eve left Paradise and Adam was sleeping in the shadow of a dark rock, Eve looked back and

447

saw the globe of Paradise exploding into millions and myriads
of tiny bits and fragments—
 and it rained—
it rained into her soul, and into that of the sleeping Adam—
the little fragments of Paradise.

September 10, 1953

 Today is the Jewish New Year, and the downtown streets are empty and even clean. Orchard street is black, cold and desolated. Only the children are kicking empty paper boxes along the street. All the shops are closed, all those little shops, clogged from door to door from wall to wall with rolls of cloth, drapes, shirts, neckties, caps, pots and pans and thousands of small, unnamable things for women and men—all of them are closed today. They closed their stores and they closed themselves in their dark rooms for *Rosh Hashanah*. Even the subway this morning was half empty and I got a seat and I missed several faces which I had gotten used to seeing every morning on the uptown Sixth Avenue F train. They are all sitting now in their dimly lit rooms and thinking about money, the new year, their usual family things, women, their closed shops. I never thought that people could still take their holidays so seriously. I keep forgetting that there are people with traditions, homes, that they have their families in this city, and their memories, which make them feel like they are at home. They have their traditions, their religions, their holidays, their patriotic duties, their families, their friends, their work, their everything. And I stand here in my tiny 95 Orchard Street room, looking out the window, overlooking the street—the ceiling is peeling off, pieces of paint are falling down on the books—I am standing here, trying to let my roots grow into this city...

THE ROOTS IN A DESERT...

The summer heat is gone. We have a wave of cold weather passing through the city, everybody's walking sniffing and coughing, and it looks like the fall is coming. The leaves of the trees are all over Allen Street and the wind is blowing them along the sidewalks, along the streets into which I am trying to let my roots grow—and to the distant blocks where no tree grows and nobody has ever seen a living leaf. Newspaper scraps are pressing against my feet.

December 27, 1953

The telephone rang. At first I couldn't recognize the voice.

"It's me, Aldona," she said.

"Aldona?"

"Yes, Aldona. Don't you remember me?"

I tried to think. Aldona. Aldona. I couldn't remember.

"From Toronto," she said.

"Toronto! I never expected that!"

It was four years ago that I heard her voice last. Last time I saw her was in Schwäbisch Gmünd, she was fifteen, and sick, and fragile. Now, she sounded like a woman, no longer fifteen.

"Look," she said, "I want to ask you something: leave Adolfas here with us for one more week if you don't need him in New York."

"Sure, of course," I said. "He's his own boss."

"Look," she said, "if you look as badly as Adolfas does now, you are on your way to the cemeteries."

"Oh, no," I tried to laugh, "we have plenty of resistance."

We talked a little bit more, then we hung up.

I sat down and I didn't move for a good hour. Suddenly I became aware of our way of living, our irregular and

Adolfas Mekas, Orchard Street, 1953

miserable eating habits, our cold apartment, our continuous running. Etc. Etc. How right she is! How many other people have told us exactly the same. We always laugh it away. Take better care of yourselves, your health. But we are still living like D.P.'s, like in a D.P. camp. How do I look? I don't know. We live and we look like two who are in a perpetual protest against all the stupidity of this century. We protest by assuming the ways of living of all the D.P.'s of the world. And I am tired of it!

March 4, 1954

That evening we were sitting late. Edouard came and, as usual, we went into a long argument about America and Europe.

"You see," said Edouard, "they don't have any conception of life; they don't have sense of its purpose. They are just living for their money, the Americans."

He was walking round and round in the room, shooting his hands out all over the place, flooding us with his unending stream of words. The other day, when I told Capsis about our discussions with Edouard, he said he could not understand how we can take him seriously. To him, to have an argument with Edouard, he said, is like watching a clown show.

But I can't treat anybody like that. To me he is a challenge and a problem which I have to solve or I'll have no peace.

"You have been too long away from Europe," continued Edouard. "You are thinking like Americans. You are no longer a typical European."

"Thank God," said I. "On the other hand, honestly, I think I am still as much a European as you are. The only difference between us is how we are made up. My experiences have made me doubt everything I got from

Europe, including Europe's views of America. You are talking about 'concept of life,' ideals, religion. But what do you have to say for a culture that ended up in two world wars in practically one generation? You are telling me how empty the Americans are, without any 'concept of life,' but what is that concept, and what is that content oozing out from the soul of Europe? Who landed me here? Who made me a D. P.? Who took liberty away from my country?"

"You are making a basic mistake," said Edouard. "Wars are now accepted as the evil part of the human nature, of the human condition."

"Who has accepted it? Not me. That's the trouble with the Europeans today. They always find an excuse for every evil deed," said, or rather shouted I.

"But the Europeans would still prefer that over America. We see where they are going, the void they are going into."

Here he was. We both had come through wars, through occupations, through undergrounds, danger, misery, cast far away from our homes, I from Lithuania, he from Poland. Now, here he is, still a stubborn defender of European traditions and ways of life. And I can't understand it, I thought. I can't see how he can do it. For me, there is no way back. Not since the Blue Room period. I left the preconceived concepts of life on the walls of the Mattenberg D. P. camp. I think Europe is very very sick.

Later that evening we went to see Mikšys. We found him awake, on Meserole Street, in Williamsburg, alone in his empty apartment.

"What's new?" he asked.

"They staged your *Ondine*," I said. He had worked on Giraudoux's *Ondine* as his graduating work, in Stuttgart, designing the sets. "Going to see it?"

"I don't want to ruin my nerves for the next half year," he said.

"Why?"

"America doesn't have a theater. How do they dare to stage Giraudoux!"

"But they have right to try, no?"

"But they can't. Either the artist does the work perfectly or he plays with the fork on the edge of the table."

"But theater grows, develops slowly. You can't expect a young theater to be like an old one. You have to at least admit that America has produced a few outstanding playwrights, which is a basis for good theater."

"How could they have a theater," he said, "they can never have it. They do not have the most necessary thing which is the heart of any theater: the seriousness. They are not serious. Whatever they do is easy, without any seriousness in it. Theater is seriousness."

"Depends on what you call seriousness," said Adolfas. "I think that Americans are as serious as anybody else."

"Shucks," said Mikšys, "they are never serious. They want everything to be easy, happy, superficial."

"You say so only because you know them superficially," I said. "When I met the Italians for the first time, I thought, hell, they are so empty, operatic. They spoke and moved and behaved like actors in *commedia dell'arte*, there was always something pathetic or bombastic about them and their voices sounded to me full of pathos and unreality. But now I know that *commedia dell'arte* is also a variety of seriousness. The Italians are as serious as we are. You are making the same mistake."

"Americans have only four percent of the seriousness that the Italians have," said Mikšys in his famous short cut style.

Then he went to the corner and brought Larousse and read to us what the word "seriousness" meant. Sincerity, purpose behind action or word, etc.

"You say Americans are not serious," said Adolfas, "but I find the European seriousness ridiculous in most cases. They shouldn't be so deadly serious, it would help."

Yes, I thought, they are so serious about their ways of living and thinking and they can't talk to each other even after two world wars, the damned Europeans. They are deadly—they would sooner send millions to the labor camps than change their fucking ideas about some stupid thing. TAKE IT EASY, goddamn, take it easy—I wanted to say, but then, I knew, Mikšys would say: "You see, you want to take it EASY, like the Americans—what did I tell you? Even Henry Miller wrote about it."

"You see," continued Mikšys, "I could say that I am 99.95 percent serious. And you," he was talking to Adolfas, "you are about 5 percent, or less."

And so it went, deep into the evening. Ah, Europe… What have you done to us!

Lilly called. She said, she's going skiing this weekend and could use the fifteen dollars she lent to Adolfas. "No," I said, "he is still in Canada, and I don't have any. And what are you doing now, still taking dance lessons?"

"Not for a while. I am writing now, working on my Harlem novel, and some poetry, and I teach in school.

"Sometimes I think you can get more done by doing six things at a time."

"Believe me, do only one thing at a time if you want to do it well. Write, or dance, but don't do both."

Then we talked about my debts, and then she ended up by inviting me for supper.

"With so many debts you probably did not eat anything this evening. Come, I have enough left for you, too."

Which was true. So I went to see Lilly.

THE ROOTS IN A DESERT...

April 16, 1954

Baseball season is starting again, and they talk now mostly about baseball. I am amazed how damn sure they are about what they are talking about, and I am wondering why they never agree with what the other is saying. Phil, as always, is in retreat, in his word battle with Howard, that's his tactic. When the battle starts, it usually becomes more intense than the real game they are arguing about. I guess that's what baseball is all about.

The current battle has been going for an hour and they just keep repeating what they had said an hour earlier, or at least it seems so to me.

"The only thing I can see is you should get your tubes fixed," says Howard.

"I bet he can't pitch," says Phil, with a very definite voice.

Phil is always betting. It gives more importance to the argument. Howard always begins with mathematics, counting and recounting hits, misses, runs.

"Four and a half, twenty and six with four and a half to go... What do you want to prove?"

"What's the record low? 68?"

"86, you dummy. You see—everything's backward in your head. I said you have to fix your tubes. 86."

"But the Dodgers won the last one?"

"If they pick up two extra games, Philly and Cincinnati, whoow! And he's just from the army, don't forget, and not in shape. Next year—whoow!"

Howard now comes from the other side of the room and stands looking at Phil with an expression of disgust in the best style of *commedia dell'arte* or maybe Kabuki. Phil is sitting on the floor now hammering nails into a piece of wood for some mysterious purpose. Howard stands there with his hands wet, the towel hanging from his belt.

I go to the studio window and begin to scout the street for the UPS truck. It's drizzling again. Tomorrow is Saturday. If it continues like this, there will be no trip to the country.

I look across the street. Pat is sitting by the window reading a book, in the boss's office, in the office across the street. A stupid girl who comes to me when I am eating down at the luncheonette. Stupid like wood.

I keep looking and she looks back and waves her hand. I wave back. I keep looking. Nothing else to do. Slow today.

A fire engine somewhere at the end of the street. Then, silent again. I can hear the radio in the back room—a trumpet, and a singer, a woman singer.

I remember one weekend I spent in the country, by a lake. It was the very peak of summer, and I was sitting on a high slope with my back to the bushes. In front of me, all around me, there were red raspberries, hot and red, deep red. The sun was falling on the slope, and it was so unbelievably quiet and pure. And I heard a radio, far away, on the other side of the lake, and eh, a woman's voice, singing, just like now. You could hear it for miles, across the lake, it was so quiet…

No UPS truck in sight. Must have stuck further up the block.

I leave the window and I go to the bathroom. The place is not very busy today, there are no deliveries to make, and I don't know what to do with myself.

April 19, 1954

It's lunch time and I am walking down 23rd Street towards Fifth Avenue, thinking where to eat. It's hot, Spring underway. I stop at Schraft's, a stop I seldom make, it's always so damn crowded, mostly with young secretary types.

456

THE ROOTS IN A DESERT...

I eat my ham on rye bread, and I drink my Schraft's coffee, I order a baked apple. There is nothing else to do at Schraft's so I leave it and I walk to the Madison Park. I haven't been there since September. There is nothing interesting there during the winter. But now, I see people again straddling the fences, walking in pairs, sitting on benches—as usual at lunch hour.

I sit down on the iron fence and I watch the water fountain. There is no water in it, it's dry and empty now, full of dirt, pigeon shit and paper scraps. An old man is sitting on the ground, beside the fountain, with his back to the fountain, with his hands in his lap, his face down, sleeping. Two women come, with their baby carriages and a two-year-old infant. The child gets its hands all dirty with chocolate ice cream and mother wipes its face and hands with a handkerchief.

There is a young man, seventeen or so, leaning on the fence, looking at the passing girls. The big tower clock across the park shows 1:20. The young man has red hair. Two boys, twelve or thirteen, come with bikes and keep riding around the fountain. Two girls in bright dresses pass by, stop, look at the fountain, go to the ice cream man on the south west corner of the park. Two children come on the roller skates making a terrible noise. The man sitting on the fence, not far from me, reading a paper, drops the paper into the trash basket and walks to the street. It is 1:25 on the big tower clock. I leave the fence and start walking back to 22nd Street.

May 1954

"What are we after? What is our aim in life? Happiness? Self-realization? Security? I don't believe anymore in that," I said. "I think that the only security needed for

457

my life and for my inner balance is to face life as it comes, second by second, to have enough courage to face it or rather receive it, and deal with it, as it comes."

"I just finished writing a book, *The Gap Between the Atlantic*," said Edouard. "I put in it all my criticism of such attitudes as yours; all my criticism of the United States, you know."

"You think you're equipped for passing judgments on the continent you know so little about from direct experience? You are a book man," said I.

"Look," I heard his quick talk on the other end of the line; "you know you don't need to live in a country very long to know it thoroughly. Did you read Kafka's *Amerika*? Not only that: I think that most of the great European intellectuals and writers, Goethe, for instance, knew America better from Weimar than many who were sitting in Boston."

"I don't believe that," I said. "Anyway, I chose to begin from scratch. I often wonder why there is this gap between us. We are both Europeans. There is no need have to talk about any Atlantic Gap: there is a huge gap between Europe and Europe, between you and me. My past, my experiences behind the Iron Curtain and on this side of it, have destroyed all safe and solid grounds. I don't understand any of your arguments. You are using questionable premises, your syllogisms have no ground. For me, your premises are false. I don't know any longer what the standard is. I really don't."

Edouard was silent for a second—which is a pretty long time, for Edouard—then he said:

"Maybe you are luckier than I. You can start from scratch and find, or at least hope to find the truth for yourself. You still have a fool's hope in you, which may be holy. I don't know whether I am happy or I am very unhappy having my old standards. But I believe in them."

THE ROOTS IN A DESERT...

December 30, 1954

To end the year, I revisited Williamsburg and had a beer at Ginkus' Candy Store, on the corner of Grand Street and Union.

Poor, dirty Brooklyn, three years of my life, the room on South Third Street, the rattling of the elevated train.

I remember the nights, how could I forget them, those long evenings spent on Lorimer Street, Marcy Avenue, Linden Street. Long long walks. Lost in Brooklyn and terribly sad. People used to stop and ask me: Why are you crying? But I didn't cry.

Everything was strange and unfamiliar. Windows, doors, lamp posts, stores, faces. There was nothing that I could recognize, not a single street, not a single stone.

And I stood there, in the middle of Brooklyn, lost, on Grand Street, in front of Ginkus' Candy Store, and I was alone, alone and lost, like I had never been, anywhere—and I wanted to howl, like a dog.

I can walk now along the Grand Street, or Lorimer Street, and remember. Yes, here was a red brick house, the windows sealed with boards, and stuffed with rags. The house is no longer here. The house never suspected that anyone would remember it. But I remember it. I remember the old brick house with its broken windows, and the gypsies sitting in the door. I remember the little park under the Marcy Avenue station, the old houses around it, which are no longer there.

And I watched the boys and girls on Linden Street and, ah, how I longed to be one of them, to hang around the drugstores and play the juke boxes—be one of them. How I wanted to feel this street as they felt it, to recognize every corner, every storekeeper, bartender, mailman—to feel myself part of it—to joke together, to laugh, and to shout from the open windows to the girls across the street, call them by their first names—as the boys and

girls in the drugstore did. But I sat there in the corner, alone, in my beat up D. P. jacket, and I watched them and envied them.

I still remember the sadness, on Friday nights, when you hear the music coming, from somewhere, the apartment below, and when you think about all the families, millions of families laughing, conversing, eating, loving, together—and you, here, sitting alone and sad and dreaming about your home seven thousands miles away—sitting alone and sad, without a soul to talk to, only the streets to walk—and if you say something to a stranger, the stranger will look at you wondering, what does this stranger really want.

I remember this now, this cold January, looking at the winter skyline of New York, the city which has enclosed me, in my loneliness; its streets, its docks, its drugstores, and the paper scraps flying in the January wind along Allen Street...

This is the city which I built, little by little, memory by memory, street by street, face by face, step by step. We grew together, the city and I... I am aware, that my New York will never be like anybody else's New York. But let it be... It has saved me from going mad.

So I have another beer and Ginkus says, this one is on me, and we lift our glasses and drink to the New Year.

Immigrants do not "adjust" to America: they, rather, resign themselves to it. They live in a state of resignation. Internal adjustment? No, it's an infernal adjustment...

Today emotion is often confused, taken for spirituality.

Sometimes the horror grips me: We are all slowly dying, our imaginations, our dreams fade, retreat further and further.

THE ROOTS IN A DESERT...

I haven't dreamt lately. I don't seem to remember my dreams any longer.

I am afraid to walk barefooted even in the room, as if some terrible microbes were waiting for me—or I might step on glass splinters...

No date, 1955

Television voices outside; the window open; all night...

Am I really slowly losing everything I brought with me from the Outside? The touch of grass?

We came here in the continuation of an old tradition of early settlers: not for the sake of a better life but as exiles, outcasts, as our only place of escape from sure death.

No, we didn't come to the West for a better life! Nor did we come in search of adventure. We chose the West, America, from sheer instinct of survival, a survival physical and brutal.

Yes, we had seen and tasted life already before we came here, and we looked at everything with an open and sad eye.

Savel.

He is drunk today.

He says, he can't sleep, he keeps hearing the voices of all people who have been killed and tortured, his friends.

He says, how could he sleep with all that whispering going on in the bedrooms.

We sat, with Šilbajoris, we talked about old friends and our own travelled and not travelled roads.

"You see," said Šilbajoris, "you progress, you move forwards via your own inner struggles. But I am walking through the middle, very politely. I don't find any need for inner struggle."

461

I HAD NOWHERE TO GO

Then we talked about drugs. I said, drugs, I tried this and that, once or twice, for curiosity. But they gave me nothing. My whole growth, my center is somewhere else, not on the plane on which drugs work. My conflicts and struggles are either much deeper or more superficial...

Then I remembered Pulgis Andriušis. We walked through Wiesbaden, one night, drunk, and I was leading him through some kind of bushes and weeds and postwar rubble. He was very very drunk, but I was holding O.K. We walked through the barracks, and he was hallucinating and rambling.

"Ah, you aren't really drunk, not like me," he said, "and I look very stupid to you. I tell you: right now I look stupid even to myself. I can see myself very very clearly even now, drunk as I am, because I am a writer. Tomorrow, when I begin to get sober, I'll look really stupid to myself. But it's then that I gain the real perspective, as a writer, into myself. I realize that I am just like everybody else, neither wiser nor smarter. I am maybe even worse than the rest."

We stumbled for a while through the night and bushes and hedges, then he stops and talks again:

"A writer has to drink, today, or else his conscience will become too pompous. An artist has to drink or drug himself, in this society."

He speaks, as we stumble through weeds and piles of broken bricks, concrete blocks—war is still all around us, yes, war which has not humbled the conscience of anybody, and the world is as pompous and arrogant, as it was before.

A SHORT STORY

Someone sitting in his empty tiny Brooklyn flat, playing mandolin, like Brody.

Yes, there was no war!

THE ROOTS IN A DESERT...

Leo looks at his hands: he can't play violin any more.

We look at our hands, not knowing why Leo is looking at his. He didn't tell us why he was looking at his hands; he told me that later.

Yes, there was no war!

August 20, 1955

To buy books... I passed a food store, I saw apples, and plums, ripe, in the window. I have been dreaming since my childhood of eating a lot of fruits, someday... I'll eat and eat and eat until I will not want anymore... It's still only a dream.

A few years ago I had illusions that this is all temporary, that we'll eat our fruit some day. And meat. Today I have no such illusions. I know very well that whatever money we have we'll sink into our films, into *Film Culture*, and what not, walking with empty stomachs. Such is our nature. Or our fate. We are not businessmen. We are poets.

But I realize this, and I know this, and I have no regrets. Only problems... It is my own choice. I don't even really envy those who eat grapes, or plums... I have different pleasures, different dreams...

No date, 1955

I see my older friends, and some who are much younger than me: I see them already settled, already so earthly, almost in the very center of the earth's gravity.

Like Teiji. He is so young, but so earthly.

Only I am still in flight. I haven't reached yet the point of gravity. I am so far off and out, even when I am so close to what's called reality.

My contacts with reality are always so brief, always through such very thin wires... that they become unbearably real, when they come.

How many watts & volts of reality are burning the wires?

It comes always in fusions.

I stood by the window. I looked at the chimneys across the street, the people. No, I can't reach them. I can't put myself in their place, or feel how they feel. Where am I? In what dream?

I want to be like them? How foolish!

Why should I reach into the emptiness... For what?

The noises from the street are coming through the window. Voices from the garage across the street. The Puerto Rican children kicking paper boxes along the street.

I am sitting sad, beaten, lost, and I do not know what to do. I just sit, with my eyes open to the window, ready for the smallest eventuality.

I keep writing. I feel, this is the only thing I can do.

I cannot talk to anybody now. Or, more truly, I don't feel like talking to anybody.

Only when I write, when I sit down by my typewriter I am able to begin to concentrate, I begin to talk, even if it's only myself that I am talking with. But this seems to be the only way for me to break out of this deadly status quo, to try to get myself out, to try to get myself out of this mess, of this night, of this aimlessness, this forest. As I talk with myself, things become clearer to me, I begin, if nothing else, at least, to get some courage to make another step, be what it may, blindfolded.

"Do you know where your real home is?" asked Lilly.

"Not really... Not any longer... Is it Western culture?".

He looked around. The Armenians were still dancing, and the black family was still playing cards, and the girls

in dungarees were still sitting on a pile of ropes reading comics, and the radio played loud.

"My memories. They are out to get me, they are after me. I went through a whole period of my life like in a trance, not really knowing that I was looking and seeing—and now I am like a delayed reaction, now everything's coming back to me.

"I am not worried about the people. It's the objects. Memories of things seen or touched or heard. Images of places.

"I always wanted to go forward. I tried to forget everything. But every little detail remained stuck sharply inside. And now they burn."

"You shouldn't talk like this. You frighten me," said Lilly.

"It's nothing. I am only trying to unload myself. I have to do something about it—there is too much of it, it's getting between reality and me.

"It's all around me, lately, in the air, those sweet voices that got Ulysses. These voices of my past, they creep into my ears, they float in the air, they enclose me tighter and tighter.

"Here is another landscape passing by. People sitting in their light summer dresses, leaning back in chairs, standing around on the deck, playing banjo, and there, in the back, they are dancing their folk dances, for hours and hours, the same movement, the same melody, round and round.

"Is this their way of escaping memories? Or just the opposite? Memories are what make them dance, in a circle, round and round," thought he, now silent.

The Armenians were still dancing. The musician was sitting on the floor, with his instrument between his knees. He kept playing the same one simple rhythm, he played it again and again, his eyes deep, far away, absent,

not here. "Oh, what dreams were passing through his memory, what voices?" thought he.

"Again and again I throw myself into the new, just to forget, just not to hear the voices of the past, making the quest for the new into the principle and way of my life. Sometimes I succeed in escaping, and I begin to live in the present, I begin to become conscious of what I see, what I touch, what I hear. Then back they pull me again and I am out of touch again.

"It seems to me," he said aloud, "that the only direction of my life is always forward. From fear that the past may catch up with me."

"But isn't that the same with all of us?" said Lilly.

"It may be so. But when I look at my other friends, when I look at the people in subways, on buses, in the streets, they seem to have so much more reality about them, so much more control of themselves. Maybe it's only an illusion, my illusions, but they seem to live in the present, in the actual. Only I seem to always reach into the future, live more in future than in the present.

"Every time I stop running and begin to listen, I can hear them, the sweet voices of the past. You don't know how much strength I need to continue running. They come to me, the memories, they close in upon me, and I have to break away from them by force, with another wound. This is their bloody revenge..."

"Yes, Ulysses," said Lilly.

"Dear Penelope," said he. "I am on a boat now. Here is another river, people sitting in their summer dresses, reclining in chairs, standing, playing banjo. In the back they are dancing their folk dances, for hours now, ever since we left, the same melody, the same movement.

"Dear Penelope. I don't know how long I stayed in this city, but I feel it has become a part of me, its streets, its parks, its nights. I feel like never leaving it. Never.

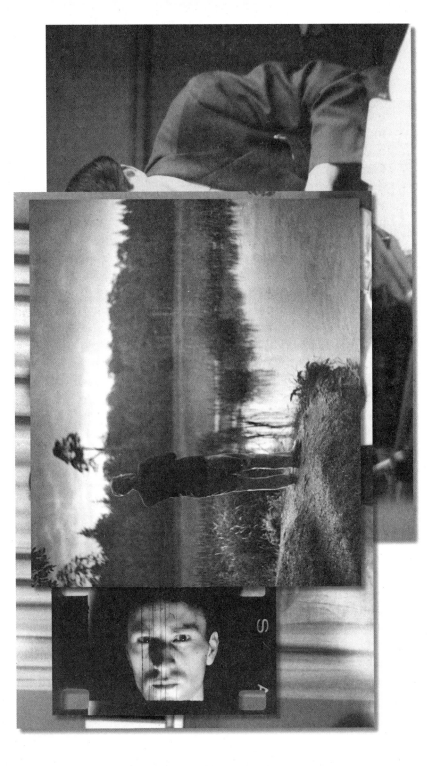

I feel like I am at home again. I wish I would never have to leave this city. Or rather, I am trying not to leave it… I am desperately trying to create a completely new set of memories with which I could fight back the sweet voices calling me home. Home to which, I know, all roads have been erased.

"Yesterday I met a woman. She said, she had travelled all over the world but she never found another place like this. Because this is her home. And she then asked me: Where is your home and where do you come from? I could not answer her.

"Sometimes I feel like a dog. I begin to like any place I stay longer than a day. I begin to like every little town, street I am thrown in. I don't have any one place which would replace all my memories. My memories now come from many places, from all the places I have stopped on my way, and I don't know any longer where I really come from. I may have equally betrayed all the places, all my homes. But you know that I never wanted to travel. I always hated travelling. I am much more stable than they are, those who say: This is my country and here I stay… They hate all places. But I can't leave any without a wound in my memory."

"Dear Penelope. I am very close to Ithaca now… I am thinking very often about my childhood and the places we used to play and walk. First memories. Potato fields. Bee honey. I am coming a long way back through my memories, in search of the home. First I used to remember only what was yesterday. I did not want to remember further back. I was afraid to look back. Only recently I have noticed my memories are coming from further and further back, from the places long gone.

"I am by a beautiful lake, and it's autumn. The sun is falling upon the lake and the woods around me. Nights are cool and full of secrets.

THE ROOTS IN A DESERT...

"Penelope. When I was sitting today and looking across the water, and back, across the landscape, I suddenly had a feeling that my past had caught up with my present. I have arrived almost at the point of departure. I felt strongly my childhood coming back to me. I almost cried. I sat there, by this quiet New England lake, looking across the water, and I almost cried. I saw myself, walking with my mother across the field, my small hand in hers, and the field was burning with red and yellow flowers, and I could feel everything like then and there, every smell and color and the blue of the sky... I was sitting there and trembling with memory."

COLOPHON

I HAD NOWHERE TO GO
by Jonas Mekas

The text follows the original edition I HAD NOWHERE TO GO published in 1991 by Black Thistle Press, New York.

The author would like to thank Vyt Bakaitis and Hollis Melton for helping to edit the manuscript.

© Jonas Mekas, 1991
Spector Books, Leipzig 2017

© for the images
Jonas Mekas, 1991

Graphic design: Tobias Klett, Markus Dreßen (Spector Bureau)

Proofreading: Ames Gerould, Christin Krause

Typeface: Janson Max
(Dinamo + Sam de Groot)

Printing and binding: BALTO print, Vilnius

PUBLISHED BY

Spector Books
Harkortstraße 10
04107 Leipzig
www.spectorbooks.com

By courtesy of LOST BUT FOUND FILM LIMITED, Edinburgh, and Douglas Gordon

DISTRIBUTION

USA, Canada, Central and South America, Africa:
ARTBOOK | D.A.P.
www.artbook.com

UK: Central Books Ltd
www.centralbooks.com

Japan: twelvebooks Co., Ltd
www.twelve-books.com

South Korea: The Book Society
www.thebooksociety.org

Australia, New Zealand:
Perimeter Distribution
www.perimeterdistribution.com

Switzerland: AVA
Verlagsauslieferung AG
www.ava.ch

France, Belgium: Interart Paris
www.interart.fr

Germany, Austria: GVA
Gemeinsame Verlagsauslieferung
Göttingen GmbH&Co. KG
www.gva-verlage.de

The German translation of this book is also published by Spector Books under the following ISBN 978-3-95905-147-7

Second edition, 2020
Printed in the EU
ISBN 978-3-95905-146-0